D0081395

PAINTERS AND POLITICS

PAINTERS AND POLITICS

The European Avant-Garde and Society, 1900–1925

THEDA SHAPIRO

ELSEVIER

New York/Oxford/Amsterdam

N
6758
.S49

Shapiro, Theda.

Painters and
politics

759.06 S52

ELSEVIER SCIENTIFIC PUBLISHING COMPANY, INC.
52 Vanderbilt Avenue, New York, N.Y. 10017

ELSEVIER SCIENTIFIC PUBLISHING COMPANY
335 Jan Van Galenstraat, P.O. Box 211
Amsterdam, The Netherlands

© Elsevier Scientific Publishing Co., Inc., 1976

Library of Congress Cataloging in Publication Data

Shapiro, Theda.
 Painters and Politics: the european avant-garde
 and society, 1900–1925
 Bibliography: p.
 Includes index.
 1. Artists—Europe—Correspondence, reminiscences,
etc. 2. Art, Modern—20th century—Europe. 3. Art
and society—Europe. 4. Art and revolutions—Europe.
5. Avant-garde (Aesthetics) I. Title.
N6758.S49 1976 759.06 75-20954
ISBN 0-444-99012-7

 Manufactured in the United States of America
 Designed by Loretta Li

-

DABNEY LANCASTER LIBRARY
LONGWOOD COLLEGE
FARMVILLE, VIRGINIA 23901

TO MY MOTHER

and to the memory of my father

76—06112

"An artist is identical with an anarchist," he cried. "You might transpose the words anywhere. An anarchist is an artist. The man who throws a bomb is an artist, because he prefers a great moment to everything. He sees how much more valuable is one burst of blazing light, one peal of perfect thunder, than the mere common bodies of a few shapeless policemen. An artist disregards all governments, abolishes all conventions. The poet delights in disorder only. If it were not so, the most poetical thing in the world would be the Underground Railway."

C. K. CHESTERTON, *The Man Who Was Thursday*, 1908

Contents

Preface

From the early nineteenth until the mid-twentieth century, the art world was divided between an academic, conservative establishment standing for traditional principles in training and practice, and a series of combative movements, often lacking theoretical or stylistic coherence, but all wishing to replace outworn conventions in art education, style, and, sometimes, subject matter. The artistic radicals, who came to emphasize more and more their exclusion from society, their immunity from social conventions, and their spiritual and intellectual advance over ordinary men, have sometimes been equated both by admirers and by detractors with political movements of the Left which developed concurrently. Both groups of movements spoke at various times of bringing about revolution within their sphere. Both have styled themselves avant-garde, ascribing to themselves a function of political or artistic leadership and a prophetic understanding of human history and destiny. In politics, liberals, republicans, socialists, anarchists, and communists have succeeded each other (or at times coexisted) as heralds of revolution; their painterly counterparts have been called Romantics, Realists, Impressionists, Postimpressionists, Fauves, Cubists, Expressionists, Futurists, Dadaists, and Surrealists.

The similitude in chronology, doctrine, and tactics is clear. But do the political and artistic avant-gardes have anything more in common than appearances? As will be noted in Chapter 1, many advanced painters have

also been democrats, socialists, or anarchists or have sympathized with contemporary forces of revolution: one need only mention Gustave Courbet, Honoré Daumier, or various French Surrealists. On the other hand, there have also been avant-garde artists who held beliefs totally at odds with those of the political Left. Still, this difference does not rule out the possibility of a consensus in outlook or attitude beneath the level of formal convictions. Individuals such as Courbet and small groups such as the Neoimpressionists of the 1880s and '90s have been studied for their political and social consciousness; an entire generation of progressive artists has not.

This study will attempt to describe and explain the early social attitudes and, whenever possible, more explicit political opinions and activities of a generation of painters who wrought a revolution in the arts and who witnessed technological change, social unrest, and world conflict on an unprecedented scale. It will follow the painters who rejected the Western mimetic tradition in art—the German Expressionists, the French Fauves and Cubists, the Italian Futurists—through their early years, their artistic apprenticeships, and the "heroic" phases of their careers, years in which abstract, expressionistic, and nonrepresentational painting came into existence. This will mean seeing them through the historical period marked by turn-of-the-century imperialism, nationalism, and socialist agitation, prewar prosperity and intellectual ferment, and the unprecedented human and material destruction of World War I and the ensuing revolutionary movements. My concern will be their thinking about society from their adolescence and early maturity (in most cases around 1900) up to the mid-1920s, when Europe seemed to have returned to a state of normalcy and most of them had spent the greater part of their innovative élan.

The history of attitudes and opinions—what the subject *thought* rather than what he actually did—is exceedingly difficult to write, for the historian rarely has any objective controls to apply to his material: How can one verify independently what is in a person's mind? My subjects form a natural group according to the dates of their first artistically mature works, by their common stance as avant-gardists, and by their self-organization into artistic movements operating at a given time, aware of each other, and often coexhibiting or cooperating in other ways. Yet each artist was an individual with his own opinions and his own responses to artistic and social questions. Some wrote copiously about their daily lives, their relationships, their ideas and ideals, and others not at all; for these, crea-

tive works are our only evidence of their broader attitudes. I have counted some eighty full-fledged members of the West European avant-garde between 1900 and 1925, not including surviving Impressionists and Postimpressionists or budding Surrealists (see the biographical sketches in Appendix B): too large a population for a detailed study of every member, yet too small a group for an accurate and meaningful statistical study. The course I have adopted seems to me the only useful one: I have attempted to read as many as possible of the painters' published and unpublished writings, both artistic and nonartistic, searching especially for their attitudes to society, their art, and their public; to recreate their whereabouts, ways of life, and activities on both the individual and group level between 1900 and the aftermath of World War I; and to compare their attitudes to those of contemporary social and political groups. In their writings I have found innumerable idiosyncracies of thought and expression, and yet profound agreement on fundamental artistic and social issues. With very few exceptions—and I mention all the exceptions I am aware of—avant-garde painters were humanitarians, internationalists, believers—often aggressive ones—in artistic revolution, utopians who hoped that artistic and social liberation could somehow be achieved together and in interdependency. Thus on many issues it is possible to speak of the opinion of the avant-garde as a whole, and I have tried to indicate the degree of consensus at every turn. Above all, I have stressed the interconnections among three aspects of the modern artist's career that have usually been dealt with separately if at all: the characteristic life style, often chosen in response to economic conditions; the stylistic predilections, always in opposition to prevailing modes; and the above-mentioned social attitudes.

Not everything in their behavior and attitudes was unique to the avant-garde of the early twentieth century. On the contrary, they shared much with the Realists, the Impressionists, the Postimpressionists, and with younger twentieth-century artists. Indeed, most of the painters discussed here were less overtly political than members of preceding and succeeding generations. What makes them unique is the sheer extent of their artistic contribution. As redesigners of our ways of seeing and representing the world, equal in this perhaps to the artists of the Renaissance, the early-twentieth-century painters laid out new paths that all since them have had to follow in some way or other. While stylistic studies of their work exist in superabundance, no one has tried to trace in detail their relations with the society that brought them into existence and that ultimately accepted and

exalted them. Moreover, their concerns are in many ways those of all artists since the late nineteenth century: though this study deals with artistic styles and political issues now some seventy years old, a cursory glance at contemporary artists' statements on art and on politics will demonstrate that many of the issues described here have lost neither their relevance nor their controversial nature.

The main sources for this study are the artists' own private writings and artistic manifestos, their paintings, and the writings of their more articulate intimates. Memoirs proved extremely useful, particularly those written soon after the events they describe. Whenever possible I have consulted unpublished letters and manuscripts, public records and documents, and have quoted from these rather than from more widely known published sources. Above all, I have based my analysis on the available—and voluminous—primary sources and have read relevant monographs and general studies only secondarily. The bibliography contains a comprehensive, though not absolutely complete, list of the primary sources dealing with early-twentieth-century painters, and also a selected list of helpful exhibition catalogues, monographs, and general works on modern art. All translations are mine, except where indicated otherwise in the Notes.

My cast of characters includes the major innovators whose names are now household words as well as many lesser-known (often younger) painters who worked in the same styles and who were indisputably members of the avant-garde at the time, however slight their talent or originality. The discrepancy in talent was often not evident at the time; "major" and "lesser" artists were often intimates; a second-rate artist might invent a procedure that was later perfected by a first-rate one. The inferior artists or younger followers were, moreover, often more inclined than the major ones to expound their artistic and social points of view and to use their energies in political activism. While setting the avant-garde apart from the artistic community at large, I have tried to avoid judging its members or classifying them, except by their stylistic predilections.

I have already used the term "avant-garde" several times in referring to a definable social group of artists and intellectuals. I shall continue to use it throughout this study as the only accurate generic term available, but I must specify that the painters themselves almost never used it. They all, however, did employ the concept, if not the actual term, frequently referring to themselves as forerunners and foreseers who, comprehending and

expressing their times and utilizing ever more advanced techniques, would be understood only by men of the future. They contrasted themselves to the general public, which they considered unreceptive to their endeavors, and also to the artistic traditionalists opposed to radical innovation and concerned with satisfying public taste. In contradistinction to these latter, the avant-garde, greater and lesser talents alike, had not only a characteristic world view, but also a distinctive life style.

The research for this study was made possible by a Foreign Area Fellowship granted by the American Council of Learned Societies and the Social Science Research Council. The responsibility for this product of their beneficence is entirely mine. Numerous painters, painters' wives and children, and painters' dealers and associates, all of whom are listed in section VI of the Bibliography, kindly took the time to share their reminiscences with me and often to provide me with valuable leads to further material. I am also indebted to a great number of librarians, archivists, and scholars who were generous with their time and expertise. They are too numerous to mention here, but I would particularly like to thank for their forbearance Sig. Sergio Pozzati of the Venice Biennale, Frl. Ingrid Bode of the Schiller Museum in Marbach am Neckar, Dr. Horst Pohl of the Germanisches Nationalmuseum in Nuremberg, Dr. Leopold Reidemeister of the Brücke Museum in Berlin, Herr Hans Hermann Rief of the Heinrich Vogeler Archive in Worpswede, Professor Jean Maitron of the Sorbonne, M. Jean Dautry of Paris, and all the anonymous reference assistants at the Bibliothèque Nationale and other European libraries. Herr Eberhard Steneberg of Frankfurt am Main and Dr. Diether Schmidt of Dresden provided both warm hospitality and expert advice. Frau Ruth Buchholz of Hamburg kept me well fed while I read her husband's correspondence with artists. Frau Doris Hahn of Berlin took me in as a boarder and shared with me her memories of Berlin art circles in the 1920s. Herr Jung Alsen of East Berlin opened his extensive collection of Expressionist graphics and publications to me.

For their helpful suggestions I am indebted to Professors Istvan Deak, Joseph Bauke, George Collins, and Fritz Stern, who read an earlier version of this study as members of my dissertation committee at Columbia University. My friends and colleagues Nathan G. Hale, Jr. and Ann W. Hale and Henry W. Decker gave the manuscript a sympathetic and helpfully critical reading. Edward Hagemann shared with me his thorough knowledge of

German Expressionism. Amy K. Hackett, Robert H. McDonald, the Hales, and Russell Kearns were good listeners when I most needed to talk. Jean Steinberg did an extremely sensitive job of copy editing. William L. Gum, at Elsevier, has been helpful and unfailingly sympathetic. Above all I am indebted to Rudolph Binion, who through example, criticism and encouragement taught me how to write a book.

Riverside, California, 1975 THEDA SHAPIRO

List of Illustrations

Fig. 14. Ernst Ludwig Kirchner, *Nudes Playing Under Tree*, 1910. Munich, Bayerische Staatsgemäldesammlung.

second section follows page 77

Fig. 15. Paul Klee, *"Zwei Männer, einander in höherer Stellung vermutend, begegnen sich" (Two Men Meeting, Each Believing the Other to Be of Higher Rank)*, 1903. Munich, Städtische Galerie im Lenbachhaus. © S.P.A.D.E.M., 1976.

Fig. 16. Pablo Picasso, study for *Les Demoiselles d'Avignon*, 1907. Paris, collection Berggruen. © S.P.A.D.E.M., 1976.

Fig. 17. Karl Schmidt-Rottluff, *Three Red Nudes*, 1913. Berlin, Nationalgalerie. (Photograph: Anders.)

Fig. 18. Emil Nolde, *The Dance Around the Golden Calf*, 1910. Munich, Bayerische Staatsgemäldesammlung.

Fig. 19. Ernst Ludwig Kirchner, *Berlin Street Scene*, 1913. Frankfurt, Städelsches Kunstinstitut, on loan from a private collection.

Fig. 20. Robert Delaunay, *Homage to Bleriot*, 1914. Paris, collection Gazel. (Photograph: Giraudon.) © A.D.A.G.P., 1976.

Fig. 21. Carlo Carrà, *The Funeral of the Anarchist Galli*, 1911. Oil on canvas, 6' 6 ¼" × 8' 6". Collection, The Museum of Modern Art, New York, acquired through the Lillie P. Bliss Bequest. © S.P.A.D.E.M., 1976.

Fig. 22 Luigi Russolo, *The Revolt*, 1911. The Hague, Gemeentemuseum. © S.P.A.D.E.M., 1976.

Fig. 23. Umberto Boccioni, *The City Rises*, 1910. Oil on canvas, 6' 6 ½" × 9' 10 ½". Collection, The Museum of Modern Art, New York. Mrs. Simon Guggenheim Fund.

Fig. 24. Wassily Kandinsky, *Improvisation No. 30 (Warlike Theme)*, 1913. Arthur Jerome Eddy Memorial Collection, The Art Institute of Chicago. © A.D.A.G.P., 1976.

Fig. 25. Oskar Kokoschka, poster for *Der Sturm*, 1911. Krefeld, Kaiser Wilhelm Museum. © S.P.A.D.E.M., 1976.

Fig. 26. Paul Klee, *Warlike Clan*, 1913. Stuttgart, Staatsgalerie. © S.P.A.D.E.M., 1976.

Fig. 27. Franz Marc, *The Fate of the Animals*, 1913. Basel, Kunstmuseum.

third section follows page 166

Fig. 28. Richard Seewald, cover for *Revolution*, 1913.

Fig. 29. Lyonel Feininger, *Uprising*, 1910. Oil on canvas, 41 ⅛ × 37 ⅝ ". Collection, The Museum of Modern Art, New York. Gift of Mrs. Julia Feininger. © A.D.A.G.P., 1976.

Fig. 30. Ludwig Meidner, *Revolution*, 1913. Berlin, Nationalgalerie.

Fig. 31. Ludwig Meidner, *Apocalyptic Landscape* (reverse of *Revolution*), 1913. Berlin, Nationalgalerie.

Fig. 32. GIACOMO BALLA, *The Antineutral Suit*, manifesto, 1914.

Fig. 33. GINO SEVERINI, sketch for *Armored Train*, 1915. Charcoal, 22 ½× 18 ¾". Collection, The Museum of Modern Art, New York, Benjamin Scharps and David Scharps Fund. © A.D.A.G.P., 1976.

Fig. 34. RAOUL DUFY, *The End of the Great War*, 1915. Paris, Musée des Deux Guerres Mondiales. © S.P.A.D.E.M., 1976.

Fig. 35. OSSIP ZADKINE, *Stretcher-Bearers Carrying the Wounded*, ca. 1915. Paris, Musée des Deux Guerres Mondiales. ©, A.D.A.G.P., 1976.)

Fig. 36. FERNAND LÉGER, *The Card Game*, 1917. Otterlo, Rijksmuseum Kröller-Müller. © S.P.A.D.E.M., 1976.

Fig. 37. JACQUES VILLON, *The Shell Hole, Champagne, 1915*. Paris, Musée des Deux Guerres Mondiales. © A.D.A.G.P., 1976.

Fig. 38. OTHON FRIESZ, *War*, 1915. Grenoble, Musée des Beaux-Arts. © A.D.A.G.P., 1976.

Fig. 39. MAX BECKMANN, *The Night*, 1918–19. Düsseldorf, Kunstsammlung Nordrhein-Westfalen. © S.P.A.D.E.M., 1976.

Fig. 40. MAX BECKMANN, *Resurrection*, 1916–18. Stuttgart, Staatsgalerie. © S.P.A.D.E.M., 1976.

Fig. 41. ERNST LUDWIG KIRCHNER, *Self-Portrait as a Soldier*, 1915. Allen Memorial Art Museum, Oberlin College.

Fig. 42. ERICH HECKEL, *Madonna of Ostend*, woodcut, 1915. Berlin, Brücke Museum.

fourth section follows page 214

Fig. 43. KARL SCHMIDT-ROTTLUFF, *Worker with Balloon Cap*, wood, 1920. Berlin, Brücke Museum.

Fig. 44. OSKAR KOKOSCHKA, *Knight Errant*, 1915. New York, The Solomon R. Guggenheim Museum. © S.P.A.D.E.M., 1976.

Fig. 45. GEORGE GROSZ, *Pandemonium, August, 1914.*

Fig. 46. JEAN GALTIER-BOISSIÈRE, *Procession of Cripples, 14 July 1919*. Paris, Musée des Deux Guerres Mondiales.

Fig. 47. GEORGES ROUAULT, "Man is a Wolf to Man," from *Miserere*, 1926. Etching, aquatint and drypoint, printed in black, 23 ¹/₁₆ × 16 ½". Collection, The Museum of Modern Art, New York. Gift of the artist. © S.P.A.D.E.M., 1976.

Fig. 48. FRANS MASEREEL, "The Modern Slaver," cover for *Die Aktion*, 1922.

Fig. 49. MAX PECHSTEIN, *To All Artists!*, 1919. © S.P.A.D.E.M., 1976.

Fig. 50. OTTO FREUNDLICH, *The Birth of Man*, mosaic, 1918–19. © S.P.A.D.E.M.,1976.

Fig. 51. LYONEL FEININGER, *The Cathedral of Socialism*, woodcut, 1919. © A.D.A.G.P., 1976.

Fig. 52. CONRAD FELIXMÜLLER, "Fallen Freedom Fighter," from *Das Kestnerbuch*, 1919.

Fig. 53. HEINRICH EHMSEN, *The Shooting of the Sailor Egelhofer*, 1919–33. Moscow, Army Museum. (Photograph courtesy of the Nationalgalerie, East Berlin.)

PAINTERS
AND
POLITICS

The Modern Painter and Society

I am fifty years old and have always lived freely; let me end my existence a free man. When I am dead, people must say about me: "He never belonged to any school, to any church, to any institution, to any academy, above all to any regime, if not the regime of liberty."

GUSTAVE COURBET, 1870[1]

. . . the greatest and most energetic people of the century have always worked against the grain, and have always worked from personal initiative, both in painting and literature.

VINCENT VAN GOGH, ca. 1885[2]

When they joined the artists' profession, mostly around 1900, the subjects of this study became part of an institutional framework and acquainted with attitudes toward art and toward the world that had been evolving during the four centuries since the Renaissance. Beginning then, the relationship between the figurative artist and society slowly changed along lines unprecedented in the history of art. Painters and sculptors began to spurn the ranks of craftsmen and to identify with the poets and philosophers as intellectuals worthy of high social position. In the nineteenth century, many artists even came to see themselves as prophets or esthetic lawgivers subservient to no traditionally accepted canons of beauty or methods of execution. At the same time, art was also being secularized, reaching a mass audience for the first time not from the walls of churches, but through inexpensive engravings and, beginning in the nineteenth century, through lithographs in the penny press. Artists were now called upon to provide these, and also small works geared to the scale of the home rather than to that of the church or palace, for a growing number of modest and well-to-do collectors. Beginning in the eighteenth century, new institutions such as museums and art galleries came to serve the new art public and to bring that public together with a constantly growing number of artists. As the art world grew large and artists economically less and less secure, a high degree of specialization took place. Each

artist came to identify with a specific segment or segments of the public and many, depending on their personal aspirations and the type of art they produced, came explicitly or tacitly to adopt the world view of a given social group.

The avant-garde was one product of these developments and, from its origin in the mid-nineteenth century, it played a distinctive role in the further evolution of the artist's social position. The history of Western artistic institutions and of the early avant-garde's attitudes to society therefore forms the backdrop to my study.

I

The existence of an avant-garde presupposes a high degree of creative freedom for artists (how else could continual innovation be possible?) and nonrestrictive institutions through which new works can be brought to public attention. Both the freedom and the institutions developed slowly and falteringly between the Renaissance and the nineteenth century, at first in Italy, later and more enduringly in France, and then throughout the West.

From the Middle Ages through the late eighteenth century (or even the early nineteenth in many places), European artists, like all other skilled craftsmen, belonged to guilds. The guilds set the rules of artistic training and employment; they limited the number of artists by controlling the admission to apprenticeships and the bestowal of masterships; they provided members with some form of job security and of sickness, accident, and unemployment assistance. But, despite the fact that artists of exceptional talent were recognized and esteemed, the guilds did nothing to differentiate the painter or sculptor from the skilled woodworker, stonecutter, or engraver.

In the Renaissance, such artists as Leonardo da Vinci, Michelangelo, and the painter-biographer Giorgio Vasari came to believe that the "fine" artist deserved a higher social rank than the artisan, and also that the painter or sculptor should be judged by the ennobling philosophical component of his work rather than solely by his manual dexterity. They and later Italian artists, following a model already established by philosophers and literary men along classical lines, began to organize academies.[3] At first simply an informal meeting-place outside guild jurisdiction where

artists could gather for philosophical discussions or to practice their metier, the art academy eventually began to provide professional instruction. Unlike the standard apprenticeship training, which stressed the student's participation—sometimes on a totally menial level—in actual artistic production, the curriculum in the art academy came to emphasize knowledge— of geometry, anatomy, and the "liberal arts"—as much as the development of skill. Although the various art academies that grew up in Italy in the sixteenth and early seventeenth centuries were still largely accessories of or subordinate to the guilds, the Italian artists of the Renaissance and the Baroque were nevertheless the freest in Europe. As they traveled throughout the West in service to the courts, they carried the academic idea with them, and it was to protect the Italian and French court artists in France from guild regulations that the first enduring art academy, the Royal Academy of Painting and Sculpture, was created in Paris in 1648 with royal sanction.[4]

Even the French Academy did not destroy the power of the guild, which returned to the fore whenever royal power or royal interest in the arts weakened, and which retained the allegiance of many leading artists. The guild continued to play an important role in artistic life in France through the eighteenth century, until it was abolished along with the other corporations in the Revolution. But the French Academy did produce some institutional changes which gradually spread to other countries, providing a framework for artistic practice all over Europe until the late nineteenth century. (By 1790, there were over 100 art academies in Europe, almost all based on the French model.) By arranging subject matter into a hierarchy, with "history" painting (dealing with mythology, religion, and heroic historical deeds) at the apex, and portraiture, genre, animal painting, landscape, and still-life progressively lower in prestige, and by its educational curriculum, which stressed draftsmanship, nobility of subject, and ideal beauty, and was mainly oriented toward training history painters, the Academy elevated its members above craftsmen and endowed them with titles and dignity suited to the Sun King's reign. By instituting the sometimes annual, sometimes biennial Salon (not always, however, held on schedule during the seventeenth and eighteenth centuries), and also a group of art prizes—ranging from an honorable mention for a single work exhibited in the Salon to the Prix de Rome, which financed a young artist's study of classical antiquity for five years (later four)—the Academy provided recognition for talent and a means of contact between artists and the

public.[5] In the early eighteenth century, though, because of the reaction against the Grand Style after the death of Louis XIV, genre painting became as respectable as history painting. By the time of the Revolution, painters, sculptors, and architects of all persuasions could aspire to membership in the Academy; there was no limitation on the number of members, and all were automatically entitled to exhibit in the Salon.

An important change was also taking place during the eighteenth century in the artist's economic condition. However much the artist—in France, and in some Italian cities, at least—could now demand to be treated with respect, he, like the musician, the writer, and the scientist, was still largely dependent upon patronage—and hence in some measure subject to control by the Court, the Church, the aristocracy, or the rising bourgeois professionals, merchants, and bankers. Unlike the guilds, the Academy never attempted to ensure an income for its members, and those institutions or individuals who could maintain resident artists or bestow large-scale commissions were on the decline. By the late eighteenth century, the building of churches and palaces had all but ceased, and the newly rich were more interested in acquiring the old estates and their trappings than in subsidizing new talent. The Revolution and the First Empire gave some French artists a brief opportunity to receive commissions for large-scale, didactic works and to participate in public-works projects. But more often they brought financial ruin, as the traditional patrons emigrated and the new, middle-class ones ceased buying on account of the unsettled conditions. In the long run these developments, together with the Industrial Revolution, helped to complete the artist's creative and social emancipation, placing his product on the open market and turning him into a freelance worker, independent of tutelage but also cut off from regular support. Like the seventeenth-century Dutch and Flemish genre painters (whose works, incidentally, enjoyed a great vogue in France beginning in the mid-eighteenth century), artists now had to work for a considerably larger but less educated and discriminating public than the aristocratic patrons of the past, one that demanded small, mobile canvases on appealing, easily comprehensible themes. Such works were rarely painted in response to commissions; rather, the artist produced what he wished or what he thought was in demand, and then tried to sell the finished product. The artists of the Netherlands had been the first large group to face destitution for want of sufficient buyers, even while still under guild protection; now most nineteenth-century painters were to experience privations under similar circumstances, though without the guild. In 1815 the number of

young artists seemingly undaunted by the prospect of poverty was greater than ever before, and it would continue to rise with astonishing rapidity throughout the nineteenth century. They faced a vital career choice: they could work for the existing art market, producing, in an approved style and small format, the historical and religious works still in demand, or the genre, landscape, and still-life paintings preferred by middle-class and some upper-class patrons; or they could produce what and how they wished at greater risk of destitution.

In the early nineteenth century, as today, many painters chose to seek patrons among the commercial, financial, and professional bourgeoisie, more numerous than before and, now that they had acquired some political power, desirous of becoming cultural and social leaders. French artists had the help, as before, of the French Academy, which the Neoclassical painter and Jacobin Jacques Louis David had suppressed in 1793 as undemocratic and then reinstated a year later under a different name.[6] The new Academy was meant to be more liberal in its organization, instructional methods, and exhibitions, but in some ways it was soon even more elitist than the old one. The number of memberships was now severely limited, and only 56 members were elected to the Academy between 1808 and 1891—in a period when the number of professional artists in Paris alone reached several thousand.[7] In the absence of a large number of art dealers and galleries, artists were dependent for exposure on the Academy's annual Salons, which hung hundreds, and, by the late nineteenth century, even thousands, of works chosen from among still more by juries made up of Academy members, government officials, and (after 1848) artists chosen by previous exhibitors or medalists. The Academy supported Neoclassicism and shunned Romanticism during much of the nineteenth century, and it periodically reiterated the hierarchy of styles, though genre-painting, landscapes, and still-lifes now accounted for the major part of artistic production. Artists not approved of were excluded from the Salons; the Romantics, Realists, and many contemporary landscape and genre painters pursued their careers, often regretfully, outside the Academy and without official sanction.* As the Academy was unable to control the number of youngsters entering the profession and did little to provide them with commissions or incomes, it became less and less effective as the number of artists increased. After 1850, a growing number of dealers began

*Delacroix, who had patrons, important public commissions, and considerable public success throughout his career, was elected to the Academy only in 1857.

to represent artists' economic interests more effectively and to give them more exposure to prospective clients; and in 1874, with the founding of the Société Anonyme des Peintres, Sculpteurs et Graveurs by the Impressionists, rejected artists finally began to organize their own group exhibitions to compete with the official ones.* While France was in the lead in artistic matters throughout the nineteenth century, by the early twentieth century other anti-academic organizations had been formed in Germany, Austria, and Italy as well as France, under such names as Sezession, Salon des Indépendants, and Salon d'Automne.

Beginning with the French Revolution, the constitutional state provided some income for artists in the form of commissions for works, many of which were destined for provincial churches, museums, and public buildings. But since the final selection was made by bureaucrats with the advice of academicians, these commissions most often went to celebrities who were not in financial need, to skilled but unadventurous artists or to unoriginal copyists. There were large-scale projects too, as the state erected the public buildings demanded by the new political and economic system: government offices, museums, theaters, and later, railroad stations, markets, and exhibition halls. But these rarely required painting and sculpture as part of their decor; when they did, it was again the celebrities who profited most. Eugène Delacroix did receive major commissions for ceiling paintings and murals beginning in the 1830s, but these were mainly for churches and former palaces—Saint Sulpice, the Louvre (now a museum), and the Palais Bourbon (now the National Assembly)—and no artistic progressive after him was so honored in the nineteenth century. Edouard Manet was disregarded in 1879 when he proposed a Zolaesque mural, "Le Ventre de Paris" ("The Belly of Paris"), for the new Paris Hôtel de Ville.[8]

Many French artists, and, somewhat later, English, German, and Italian ones, gradually developed a new outlook to fit their recently acquired dignity as intellectuals, their economic autonomy, and their official ostracism: they turned their alienation into a virtue, seeing it simultaneously as self-willed and socially imposed, and asserted their superiority over more traditional artists. They proclaimed the necessity for continual innovation in technique, style, and subject matter. Influenced by historicism, which

*There were three special exhibitions before that: the Salons des Refusés of 1863 and 1864, organized by the government with the permission of the Emperor to placate vocal critics of the Salon jury's choices; and Courbet's one-man show at the 1855 Universal Exposition. (The most thorough account of Impressionism is John Rewald, *The History of Impressionism* [4th, rev. ed.; New York: Museum of Modern Art, 1973].)

stressed the uniqueness of each past era, they began both to try to recreate historical events with accuracy and to find their own time, also closely researched, interesting and worthy of depiction, even in its prosaic aspects. Moreover, they came increasingly to see themselves as especially sensitive instruments of the zeitgeist, endowed with the mission of capturing the contemporary experience. Romantic theory strengthened their conviction that they had only to be themselves to express the condition and aspirations of their times.

Hence the notion of avant-garde, a military term borrowed by the Utopian Socialist Henri de Saint-Simon in 1825 to refer to his revolutionary artist-engineers, and later readapted to fit the revolutionary artists.[9] The artists little by little differentiated themselves from the society as a whole. Some began to dress in distinctive ways, the "dandies" affecting aristocratic garb and manners, while others in their shabbiness resembled the *classes laborieuses* or, more often, the *classes dangereuses*. Many adopted unsettled, "Bohemian," life styles, imposed by economic necessity in many cases, but also by preference. Though glamorized in the 1850s in Henri Murger's *Scènes de la vie de bohème*, early Bohemians were miserably poor and often criminal, many ending in insane asylums and pauper's graves. (By no means all Bohemians were avant-gardists. And by no means did all avant-gardists adopt Bohemian ways: witness Delacroix, Manet, Degas, and Flaubert. The Impressionists lived in bourgeois style and most often depicted each other *en famille*, enjoying jaunts to the country or picnics along the Seine like any of their middle-class subjects.)

Avant-gardists continued to protest their exclusion from the Academy even while vehemently attacking bourgeois taste and manners. But most of them were bourgeois in origin, and they owed their social and economic condition in part, at least, to the liberal philosophies then being turned into public policies in France and England. However much they hated "philistines" (another favorite epithet of the period), they profited from and universally subscribed to the liberal ideals of freedom of thought and expression. While today's public is far more tolerant of avant-gardism, the political and economic climate in which it has flourished has scarcely changed.

II

The social role of art was much debated from the late eighteenth century on, especially by the political Left, and avant-garde artists, well

aware of the society they lived in, were often leftists. In the 1780s, French Neoclassicists, inspired by their reading of Roman moralists and the recent excavations of Pompeii and Herculaneum, produced didactic works that a few years later served to ennoble and propagate the ideas of the revolutionaries: civil liberties and citizenly duties, political democracy, and, later, republicanism. David, the most political of the Neoclassicists, transformed his art in response to the successive stages of the Revolution. He began as a determined republican and Jacobin (his "Tennis Court Oath" was the first "history painting" of a contemporary event[10]); having been imprisoned after Thermidor for his part in the Terror, he became more moderate and eventually supported (and glorified) Napoleon.[11] Later painters were more consistent in their social attitudes, often tacitly embracing the outlook of the leftist opposition party of the moment in order to express their antipathy for established authority. By the doctrine of "art for art's sake," first stated in the 1830s by Théophile Gautier, artists and writers expressed their disaffection by disclaiming any responsibility to depict contemporary society, or to adhere to its ideology or ethical principles in their work. Later, a similar disaffection was expressed more politically by artists who satirized the Establishment or insistently represented social outcasts and the inglorious poor. The French Romantic movement, composed of royalists as well as democrats, evolved leftward, especially after 1830, even—as with Victor Hugo—to socialism. Already in 1819, Théodore Géricault's "Raft of the Medusa" taxed the Bourbon government with negligence when most of the passengers and crew of a wrecked French frigate died on an overloaded, hastily constructed raft. Exceptionally for his time, Géricault championed the poor, the oppressed, and the insane. Delacroix, with his Bonapartist background,[12] rejoiced over the 1830 Revolution that replaced the Bourbon monarchy with the slightly more liberal regime of Louis Philippe, and produced "Liberty on the Barricades," in which he juxtaposed a precisely observed barricade scene on the Pont d'Arcole—replete with corpses, an ardent student with a rifle, and a young scalawag with a pistol—and a symbol of liberty (and France) triumphant: a half-nude, muscular *fille du peuple* holding a tricolor and a rifle and urging the insurrectionists on. Yet it remained for a later generation to depict class conflict: horrified by the June days of 1848, Delacroix retired to his country estate to chase proletarian insurgents and paint flower arrangements.[13] (Most avant-gardists disapproved of the lower-class insurrectionism of the June days as well as of its harsh repression by the government: of the most famous, only Baudelaire, Daumier, and Courbet sympathized fully with

the workers, and Daumier produced no drawings of the events, while Baudelaire became disillusioned and declared himself apolitical soon after.)

By the 1830s, members of the political Left were developing theories of art which eventually influenced artists and intellectuals as well as radicals. Both Saint-Simon and Charles Fourier, the leading theorists of French socialism at the start of the nineteenth century, conceived of artist-leaders for their societies, placing a high value on sensitivity and imagination. Fourier's exemplification of the artist's joy in work and emphasis on sensual pleasure were particularly influential. In the 1840s the young Karl Marx developed his theory of alienation, pointing to the artist and craftsman as workers who, unlike the industrial laborer, found their work fulfilling because they could still take pride in the finished product. By 1848 these ideas had begun to influence artists, many of whom were already opposed to the ultrabourgeois, illiberal regime of Louis Philippe. The King's most effective artist foe was Honoré Daumier, who depicted him mercilessly for years as the "Pear King," exploiting both the colloquial and the botanical usages of the word *"poire"* to brand him as a royal fool with a fleshy face. Daumier continued after 1848 to express his Republican sentiments in caricatures and paintings satirizing the bourgeoisie and sympathizing with the poor and outcast, and later attacked the Second Empire.

Socialist writers frequently demanded a prosaic art that would describe contemporary reality in all its aspects, reveal social injustice, and demythologize the religious and historical justifications used by the ruling class to maintain itself in power. In an influential treatise of 1845, *De la mission de l'art et du rôle des artistes (On the Mission of Art and the Role of Artists)*, a Fourierist, Gabriel Désiré Laverdant, attacked the doctrine of "art for art's sake":

> Art, the expression of Society, manifests in its loftiest flight the most advanced social tendencies; it is precursor and revealer. . . .
> Thus [there are] two aspirations for art: beside the hymn to happiness, the sad and desperate song. Artists, inspire us with disgust for our disorderly countryside, for the dirty dwelling, narrow and smoky, where the family of the poor man grows sickly and bestial. Lay out with a brutal brush all the ugliness, all the tortures which are deep within our society. Protest against misery, violence, subjection. Side with the good against the selfish, with the weak against oppressors, with the victims against the hangmen.[14]

Later on, the peasant-anarchist Pierre Joseph Proudhon was to assert that the thematic content of the work of art was its only important quality.[15]

The demand for realism and commitment on the part of artists has been an integral part of socialist ideology, and especially of Marxist materialism. In the confused and saddening years after the failure of the 1848 revolutions, some artists and writers, whatever their political leanings, became realists. The antidemocratic Goncourt brothers, the disillusioned and determinedly apolitical Gustave Flaubert, the solidly republican Gustave Courbet, Daumier, and others now agreed on the importance of contemporaneity, precise observation, and openness to new subject matter. They began, as only a few, usually isolated, artists had done in the past,* to describe and paint "the heroism of modern life" (as Baudelaire, only briefly in sympathy with Realism, put it somewhat ironically[16]) or, as most of them conceived it, modern life pure and simple—the peasant in the fields, the artisan, the factory scene, the bourgeois in the stock exchange or at home, the confluence of social groups at a theatre or, as in Courbet's "Burial at Ornans," at the funeral of an unknown villager. Realism developed outside France from indigenous tendencies and largely under French influence. Toward the end of the century, Germans depicted factories and workshops, accurately if still somewhat ideally (Adolf von Menzel's "Rolling Mill" of 1875, Max Liebermann's "Flax Spinners," 1887), the travails of the peasant (Liebermann's "Woman with Goats," 1880), or country women in church (Wilhelm Leibl's "Three Women in Church," 1878–81); an Englishman, Hubert von Herkomer, showed aged military pensioners and a striking worker's family ("Sunday at Chelsea Hospital," 1875, "On Strike," 1891); a Russian, Ilya Repin, depicted middle-class family scenes ("They Did Not Expect Him," 1884); and there were many others.[17] Since the Goncourts, for example, were able to reconcile an antiegalitarian political position with a predilection for lower-class subject matter, Realism cannot be equated with republicanism or socialism. But the Realists were revolutionary through their choice of subjects at a time when the middle classes preferred sentimental or heroic scenes and when Louis Napoleon was purchasing studies of nymphs by Alexandre Cabanel for the royal collections.

*For example, the Le Nain brothers in the seventeenth century (who had depicted peasants realistically yet with dignity) and Chardin in the eighteenth. I say "usually isolated" because of one major exception: seventeenth-century Dutch genre painting, which was the product of a society commercially dominated like that of the nineteenth century and which dealt with similar subjects. The Dutch, however, never depicted manual laborers, as Vincent Van Gogh observed in the mid-1880s in a letter to his brother (*See* Stone, *Dear Theo*, p. 300).

At mid-century and for decades afterward, artists, theorists, and design-
ers greeted the rapidly growing industrialization and urbanization of
Western countries and increasing depersonalization of the worker with a
backward and sometimes nostalgic look at agrarian society and domestic
craftsmanship. As Robert L. Herbert has pointed out, Jean François Millet's
peasants are painted realistically and are simultaneously idealized along
religious and classical lines in their fatalism and eternal sameness.[18] Ob-
serving the overcrowding in the lower-class districts of cities and aware of
the large-scale misery caused by unemployment, crime, and disease (the
last cholera epidemic of the century struck Paris in 1849), other painterly
Bohemians also turned to the traditional and as yet unchanged scenes of
their native provinces (where, however, life was not economically rosy
either). Courbet after 1848 frequently got his subjects or compositions
(though not his stylistic techniques) from popular prints.[19] The legend of
the Wandering Jew, turned into a novel in 1844–45 by Eugène Sue, was
often referred to in realistic paintings after 1850, aptly symbolizing the
avant-garde artist.

England and Germany saw a parallel development in architecture and
decoration. John Ruskin and, more programmatically, William Morris,
champions of the people, desired to embellish their surroundings and put
an end to their alienation at work. While English and French engineers and
architects were discovering the possibilities of new industrial materials
such as cast iron and glass in the construction of bridges and public build-
ings, Ruskin and Morris were harking back to the ordered, participatory,
quality-controlling medieval guild and the supposedly anonymous
creators of the Gothic cathedrals for the key to a new, organic relation
between art and society and the possibility of beautiful, hand-crafted ob-
jects for the multitudes. "What business have we with art at all," Morris
asked, "unless all can share it?"[20] He did not manage to say how finely
wrought objects would be provided for the multitudes in a time of rapidly
increasing industrial concentration and rapidly declining hand labor. The
German architect Gottfried Semper (1803–79), also destined to be im-
mensely influential on artistic thinking in the early twentieth century, was
more realistic about the inevitability of mechanization and optimistic about
the machine's potential as creator of beauty. As a post-1848 exile in Lon-
don, he participated in designing the 1851 Crystal Palace exhibition along
with Henry Cole (1808–82), a civil servant who was an innovator in seeking
the collaboration between artists and industry in the design of tasteful,

inexpensive consumer goods. Semper went on to write treatises stressing utilitarianism in architecture and design and to seek mechanical means of producing truly modern objects, but a thoroughly industrial art developed only after 1900, with the Deutsche Werkstätten (founded 1899), the Deutscher Werkbund (1907), and similar organizations modeled on these in other countries.[21]

While Romantic avant-gardists, and even most of the Realists, stressed their alienation by distancing themselves from both the bourgeoisie and the masses through their (often aristocratic) manners and dress, Courbet played the peasant (which he was by origin) in Paris, flaunting his naïveté, lack of education, and vulgar charm among the intelligentsia that congregated at the Brasserie Andler. In his "L'Atelier du peintre" (1855), subtitled a "real allegory" of seven years of his life (that is, going back to 1848), Courbet depicted all his social contacts, from peasant "originals," workers, and Parisian social misfits to his artistic and literary Bohemian friends. What he wished to portray, he wrote, was "society at its best, its worst and its average"; such a synthesis would also amount to "the moral and physical history of my studio."[22] He placed himself at the center of this social cross-section, at work on a realistic landscape of his native province, his back turned on a seminude model, a slightly lumpy, nineteenth-century muse who looks on devotedly. He made no bones about his republicanism or his sympathy for the domesticated anarchism and peasant traditionalism of his friend and compatriot from the Franche-Comté, Pierre Joseph Proudhon. Early in 1870 he refused the Legion of Honor, citing democratic scruples about a monarchical and hierarchical distinction. A few months later he welcomed the overthrow of Louis Napoleon and participated in the Paris Commune as an elected communal councilor, leading in the establishment of a liberal artists' federation that briefly replaced the École des Beaux-Arts and urging the destruction of the Vendôme column, which he considered to be artistically worthless and politically instrumental in the Bonapartes' militaristic and imperialistic ventures. After the overthrow of the Commune he was imprisoned, even though it was never clear whether he had ordered or even participated in the actual destruction of the column. He managed to escape, and left France to avoid paying an enormous fine; he died an exile in Switzerland. In their scrupulous realism, his paintings are anything but propaganda pieces, yet they nevertheless display a partisan urge to dignify the "wretched of the earth" down to the lowliest of rural laborers, the stone breakers,[23] while ignoring traditionally

acceptable subjects. Goya had painted iron forgers with sympathy around 1812, but he stressed their vigor and muscularity in action, not their condition. Courbet, in 1849, emphasized the poverty of his stone breakers, with their torn and dirty clothes, and the unlikelihood of any amelioration of their lot—the energetic young helper sees nothing before him but the bent older worker.

The Impressionists, too, depicted predominantly realistic subject matter, but their art was both less didactic and democratic in intent and more innovative and experimental in style. Painting entire pictures for the first time in the open air, they became primarily concerned with the play of light on natural, industrial, and architectural forms. The middle class at their habitual pastimes perfectly suited the Impressionists' purposes, along with landscape and the daily activities of the lower classes. The aristocratic Degas, the republican Manet, and apolitical artists such as Renoir and Monet depicted the night life of theaters and bars, the petty-bourgeois and proletarian frequenters of dance halls, the middle class enjoying their seaside vacations or weekend outings in the country, and the sheer beauty of landscape suffused with sunlight. While Impressionism never ceased to be realistic, its innovationism eventually transformed Realism, allowing for the treatment of contemporary subject matter in novel, "unphotographic" ways, and eventually, in the later paintings of Monet, dissolving the indisputably realistic subject matter into a blur of color.

III

From the mid-1880s to 1900 the avant-garde carried stylistic innovation in new directions, in part away from Realism, and again approached the political Left in empathizing with the poor and theorizing about revolution. Realism, and its more ideological offspring, Naturalism, were now thriving in all Western countries. In each of these, there were painters who were influenced by the Impressionist technique and carefree subject matter and others influenced by Courbet's stress on contemporaneity or concerned with humanitarian or didactic treatments of the sufferings of the poor. In France, still for the most part the home of the avant-garde, artists were innovating in two divergent ways. One group, led by Georges Seurat and dubbed Neoimpressionists, retained Impressionist divisionism, sharpening the strokes of color and carefully choosing and arranging them in

accord with recent optical theories. The other group, the so-called Postim-pressionists, began to distort natural forms and colors in an attempt to express their individual perceptions or emotions or neuroses. The major exponents of this new approach were Vincent Van Gogh, Paul Gauguin, Henri de Toulouse-Lautrec and, somewhat later, in Norway, Edvard Munch.

Painters from both groups held radical views, expressed in highly individualistic ways in their work. They were influenced by anarchism, the most extreme of the leftist philosophies, which, with its anti-authoritarian, antibureaucratic ideology, and its boundless optimism about men's capacity for cooperation and social cohesion if left completely alone, was just then gaining a large following. Along with the other socialist philosophies, anarchism was based on a belief in man's innate goodness and the wickedness of all previous societies; unlike Marxist communism and utopian socialism, which looked forward to nonexploitative forms of social organization (even beyond the "withering away of the state"), anarchism demanded the total abolition of all nonparticipatory forms of social organization.[24] The most important anarchist theorist of the late nineteenth century, Peter Kropotkin, a Russian prince and noted geographer who lived for decades as an exile in England, greatly influenced artists and intellectuals with his emphasis on personal revolt, his preference for verbal rather than violent ways of expressing it, and a theory of human cooperation based on a Darwinian assessment of mutual aid in nature.

The Neoimpressionist Seurat and his followers, Paul Signac, Maximilien Luce, Albert Dubois-Pillet, and Henri Edmond Cross, were intimates of anarchist theoreticians and journalists such as Jean Grave and Elisée Reclus. So were Camille Pissarro, who briefly deserted Impressionism for Neoimpressionism, and his painter son, Lucien, who, settling in England in 1890, was subsequently influenced by William Morris. The Pissarros and the Neoimpressionists contributed drawings to anarchist publications, such as Grave's *Les Temps nouveaux* and Émile Pouget's *Le Père peinard* ("*Peaceful Pa*"), which was written entirely in street slang, and a few painters occasionally made monetary contributions to libertarian causes.[25] Seurat died young in 1891, without having made any overtly political statement; Signac, Luce, and Cross supported anarchism for decades after. The Neoimpressionists' subject matter resembles that of the Impressionists, with two differences: their treatment of middle-class pastimes (for example, in Seurat's "Sunday Afternoon on the Grande Jatte") was

satirical; and they had a predilection for Paris' northern industrial and proletarian suburbs, with their empty lots and newfangled industrial symbols such as gas tanks, and for the bustle of workers at their unchanging chores. In an article published anonymously in Grave's *La Révolte* in 1891, Signac described their radical purpose:

> . . . by their picturesque studies of the workmen's cities of Saint Ouen or Montrouge, sordid and striking, by the reproduction of the broad and curiously expressive bearing of a laborer next to a pile of sand, of a blacksmith in the light of a forge, or better yet by the synthetic representation of the pleasures of decadence: frenetic dances, circuses—such as the painter Seurat, who had such a strong feeling for the degradation of our era, has made—they bring their testimony to the great social contest which is beginning between workers and capital.[26]

The Pissarros, too, sketched unfortunates; Camille repeatedly painted the busy longshoremen of the Seine with the puffing tugs and barges, as well as landscapes and the Parisian cityscape. Emile Zola's brilliant but self-destructive painter of *L'Oeuvre* (*The Masterpiece*), Claude Lantier, shares the Neoimpressionists' libertarian sentiments and subject matter if not their serenity: his painting of his dead child is based on one exhibited by Dubois-Pillet in 1884, just as his unsuccessful masterpiece, which was to personify Parisian life, is based in part on Neoimpressionist views of the bridges and shipping on the Seine.* Claude's personality is based on Cézanne's. That obstreperous, insecure son of a wealthy Provençal banker, a friend of Zola's since childhood, was every inch a Bohemian but shunned politics.

Gauguin and Van Gogh were also undeniably radical-minded about society, but less overtly and consistently so. Gauguin was proud of his socialist grandmother, Flora Tristan; but his works and diaries contain only vague sympathetic references to unfortunates, a preoccupation with peasant religion and culture, and a grudge against capitalism, under which he had personally suffered, having lost his position as stockbroker in the wake of an economic crisis. Van Gogh was more consciously ideological. His letters to his brother Theo demonstrate an abiding sympathy with workers

*Lantier commits the un-Neoimpressionist act of placing a boat with three nude personifications of Paris in the middle of the Seine; his art is an amalgamation of Impressionism, Postimpressionism and Neoimpressionism, with a lot of Romanticism still unexcised. Monet was as interested in the Seine dockworkers as were Dubois-Pillet and Pissarro.

and peasants, expressed also in many of his early works, and an awareness of their exploitation. As a youth he witnessed the plight of English workers; later, convinced he had a religious mission, he spent two years living with and evangelizing coal miners in the Borinage. As he lost his religious convictions and gained artistic maturity, he expressed sympathy for the workers' socialism and began to hope for personal salvation through revolution—and through self-help, for he began to plan an artists' cooperative which would allow the avant-garde to live, exhibit, and sell without recourse to dealers. Toulouse-Lautrec, though an aristocrat, was also an outcast because of his infirmity, and he certainly sympathized with the prostitutes, performers, and shady down-and-out patrons of Montmartre nightclubs whom he sketched so melancholically.

By 1900 most avant-gardists, even many who continued to advocate "art for art's sake," were at least aware of radical ideologies. There was, of course, no consensus. Naturalist paintings made social sympathies apparent, while Symbolist art did not, and only a few artists and intellectuals held to specific political programs. Such different men as the Symbolist poet Stéphane Mallarmé, the art critic Félix Fénéon, the sculptor Aristide Maillol, and the mystical painter Eugène Carrière, all held radical ideals, even though their works rarely betrayed this. Those of the Flemish naturalist sculptor Constantin Meunier and of the poet Emile Verhaeren reflected similar beliefs. In its alienation from middle-class society, the avant-garde had come to celebrate the common man. There was no agreement over the social role of art, nor any common espousal of political action. But avant-gardists instinctively felt that what was good for the workingman must also be good for the artist. It was in this climate of opinion that a new generation came to artistic maturity.

The Making of the Twentieth-Century Avant-Garde

One's resemblance to one's parents is always strong enough without putting on their clothes.

JUAN GRIS, 1921[1]

No masterpieces, but a solid average, that's what suits our democracy.

JULES GRÉVY, President of the Third Republic, 1879–87[2]

The characteristic social attitudes and political sympathies of the early-twentieth-century avant-garde painters, like their artistic vocations, originated during their childhood and adolescence and were largely the products of deep dissatisfactions with their family situations and early educational experiences. The social and artistic components of the young painters' thinking developed in tandem, often in reaction to the same ideas or experiences. In many cases, their radicalism preceded, and even influenced, their choice of career—or where the artistic vocation dated from childhood, preceded the turn to stylistic innovation.

Although the period during which most of the painters were adolescent—that is, the 1890s—was relatively prosperous and peaceful, it was also filled with political violence and with intellectual ferment caused by the now highly politicized working classes in all Western countries, by the Dreyfus Affair in France (which polarized public opinion on the issues of nationalism and social justice), and by the myriad contending philosophical, literary, and artistic movements spawned by the social and technological revolutions of the nineteenth century. In particular, the proletarian movements were gaining unprecedented visibility, both through action and the printed word; scholars and thinkers were beginning strongly to question the Positivists' belief in human rationality and in progress through science and technology; artists, similarly disaffected with

Positivism and Realism, were retreating into hermetic Symbolism or else expressing radical visions in highly ideological or stylistically novel ways.[3] All of these currents had some influence on the young painters, in some cases a profound one.

In attempting to reconstruct the young painters' family backgrounds, their formative experiences, and their early artistic development, I have aimed at showing the virtual unanimity among them on basic artistic and political issues and the extent to which social considerations affected artistic choices, and vice versa, during their early years. I have not attempted to demonstrate all the formal influences that turned them into innovative painters, but rather I have tried to trace in detail such influences as had a social aspect as well. What mainly concerns me is not how a group of young artists, exposed to a variety of artistic and nonartistic influences during the last decade of the nineteenth century and the first years of the twentieth, developed the styles known as Expressionism, Cubism, and Futurism, but rather the extent to which social disaffection, and even political insurrectionism, were present at the birth of modern art.

I

The first, and by far the most important, of the twentieth-century avant-garde painters fall into two groups according to age. A relatively small number, including Henri Matisse, Georges Rouault, Wassily Kandinsky, Alexei Jawlensky, Emil Nolde, Lyonel Feininger, Giacomo Balla, and Piet Mondrian, were born in the 1860s and early 1870s, and either began their careers in painting or became innovators relatively late in life. The others were all born within a few years of 1880. A third group, born in the late 1880s and early 1890s, were to become second-generation Cubists or Expressionists, Dadaists, and Surrealists.* Like the advanced artists and writers of the nineteenth century, they too came mostly of bourgeois families, especially lower or middle bourgeois. Of the 83 major painters studied

*Appendix B (pp. 232–276) contains short biographical sketches of the 83 principal artists covered in this study. Insofar as it was available, I have included in these sketches information about their social origins, family backgrounds, education, principal places of residence, stylistic predilections, major exhibitions, activities during World War I, political allegiances, and marriages or liaisons. My sources for Appendix B are biographies and monographs, exhibition catalogues, and numerous primary sources, all cited in the bibliography.

here, 17 per cent were the children of musicians, painters, or decorative artists, and many others had at least some artist or artisan in their family tree; in that age of supposed vocational freedom and social mobility, the artist's profession evidently still had a somewhat hereditary character. About 45 per cent originated in the nonartistic commercial and professional classes; though some of their families were well-to-do, others had come down in condition and were unable to give them financial backing, or sometimes even an education. Professions that recur in the family backgrounds are those of engineer, civil servant, administrator, and middling merchant. Only about 10 per cent of the painters were aristocrats (Robert Delaunay, Roger de La Fresnaye, Jawlensky, and Marianne Werefkina) or came from wealthy families (Kandinsky, Sonia Delaunay-Terk, Francis Picabia). Practically all the fathers of the 19 per cent of families in modest circumstances were artisans or in traditional occupations—men facing economic decline in a period of rapid proletarianization and apt, on that account, to stress their vocational and social superiority to workers. Carlo Carrà was the son of some sort of artisan, Rouault of a cabinetmaker, Luigi Russolo of a watchmaker, Karl Schmidt-Rottluff of a miller, Nolde of a well-to-do peasant farmer. Only a handful were the children of common laborers: Fernand Léger of a livestock breeder, Max Pechstein of a factory worker, Otto Dix of a foundry worker, Chaim Soutine of a clothes mender. I have been unable to determine the occupations of the fathers of the remaining 9 per cent. The mothers, rarely gainfully employed unless the family was extremely poor, were often exceptionally gifted, or at least educated, in drawing or music. At least two of them went to work in order to further their sons' careers. Albert Marquet's mother, of peasant origin, opened a small shop in Paris, and Gino Severini's moved with him to Rome, where she worked as a dressmaker. Eugenia Modigliani ran a school, and eventually became a ghost writer in order to provide for her four children, the future painter included, when her husband's business failed; and August Macke's mother ran a boardinghouse to support her family.

Several women joined the twentieth-century avant-garde. Aside from Käthe Kollwitz, who belongs to the previous generation and was already a mature artist in the 1890s, there were Paula Modersohn-Becker, the gifted primitive of the North German artist colony of Worpswede, who died young, in 1907; two female members of the Blaue Reiter (Gabriele Münter and Marianne Werefkina, who were the mistresses of two painters of that group); two Russian Futurists (Natalia Goncharova, the mistress of Mikhail

Larionov, and Vera Popova); an Orphist (Sonia Delaunay-Terk, married to Robert Delaunay); and a Dadaist and later Surrealist (Hannah Höch). Marie Laurencin, the mistress of Guillaume Apollinaire during the early Cubist period, and a sentimental, not firmly innovative painter, might also be mentioned. Their relative number is large for the time, and, while some must be judged minor members of their respective groups, most were both talented and original.

As far as I can determine, about half the painters came from families either larger or smaller than the demographic norm for the period.* Many were only children or had only one sibling, and several came from large families. Many seem to have been first-born, but here the evidence is far from complete. It is also significant that, at a time when society was becoming predominantly urban, the great majority were born in villages or provincial towns; almost all had to migrate to the cosmopolitan centers in which they did their innovative work. Of the most famous, only Delaunay, Picabia, Albert Gleizes, André Derain, and Maurice Vlaminck were born or raised in the area of Paris; only Gustav Klimt and Raoul Hausmann in Vienna, George Grosz in Berlin, Kandinsky and Werefkina in Moscow, and Delaunay-Terk in Saint Petersburg. Religious backgrounds also proved difficult to determine. Most painters rarely discussed religion and seem to have come from nonreligious families. Uncharacteristically, Mondrian came from an extremely pious Calvinist family and Kees Van Dongen from a devout Catholic one. And a few were early deflected from their familial religious belief by reading atheist philosophers or reacting against parental piety. But in most cases one can only assume that the Spanish, Italians, French, Austrians, and South Germans were raised as Catholics, the Northern Europeans as Protestants, and the Russians as Orthodox. Only the Jews among them have been identified, for they were just then beginning to disregard the Biblical injunction against making graven images and to become professional artists. The early-twentieth-century avant-garde included several Jewish painters and sculptors, among them Chagall, Soutine, Modigliani, Pascin, Otto Freundlich, Ludwig Meidner, Ossip Zadkine, Jacob Epstein, and Jacques Lipchitz.

Most painters, then, had childhoods which were "comfortable" by the

*Discovering the family size, position among the children, and religion of all but a few painters proved difficult or impossible. The artists' biographers have often not considered these matters important enough to investigate or mention; and for many painters no biographies or monographs have as yet appeared.

standards of their time. They were adequately fed and clothed and given the elementary education then universally prescribed. While many were apprenticed to various trades, others were urged to complete a classical secondary education and even go beyond it—which several did, not only finishing the *baccalauréat* or *Abitur*, but going on to study the law, engineering, or architecture, or to join the military as officers.

Their security and respectability were just the problem. The revolt which led to modern art began in most cases at home and took the form of the perennial conflict of generations.

Numerous novels, memoirs, and contemporary photographs describe the middle-class society into which most of our painters were born as slow-moving, conservative, and oriented toward the middle-aged—"the experienced." There is virtually no biographical information on the painters' fathers, but we may draw some conclusions about their lives in the middle and late nineteenth century on the basis of general demographic trends. Many of them would have been the first of their families to enter commerce, the professions, or civil service; they would have worked to attain positions of financial comfort and social respectability and to make life easier for their children. Those living in cities would generally have migrated there from the land as young men, or else would have had immigrant parents. Once settled in careers, they would have led stationary and usually peaceful lives: the 1848 revolutions, the Crimean War, Bismarck's brief, local wars, the Paris Commune, the colonial expeditions—the smallest output of violence of any European generation up to that time—would have touched most of them only briefly or not at all. Closer to home, they would have witnessed major social transformations: widespread industrialization, rapid growth of population and literacy, and the emergence of powerful proletarian movements. The most extreme of these movements, anarchism, was at its height during our painters' formative years. Exalting the individual, declaring public restraints undesirable and unnecessary, anarchists terrorized all of Europe in the 1890s by throwing bombs and assassinating public figures.*

The parents' daily lives, for the most part, would have been measured and sedate. The Austrian-Jewish novelist and biographer Stefan Zweig

*Anarchists assassinated President Sadi Carnot of France in 1894, Empress Elizabeth of Austria in 1898, King Umberto I of Italy in 1900, and President McKinley in 1901—not to mention near-misses. The most notorious bomb-thrower was Ravachol, who operated in Paris in 1892.

remembered his Viennese, middle-class surroundings during the 1890s as "an ordered world with definite classes and calm transitions, a world without haste." Unaffected as yet by the speed of machines, men aged early and cultivated the gestures of "worthy" elder statesmen. "Even in my earliest childhood," Zweig relates, "when my father was not yet forty, I cannot recall ever having seen him run up or down the stairs. . . . Speed was not only thought to be unrefined, but indeed was considered unnecessary, for in that stabilized bourgeois world with its countless little securities, well palisaded on all sides, nothing unexpected ever occurred."[4]

Their homes usually displayed what the Expressionist architect Erich Mendelsohn later termed "the sentimental rubbish of the nineteenth century."[5] While the living quarters of the lower classes were overcrowded and unhealthful, those of the upper classes were cluttered and stuffy. The rooms, usually painted or papered in dark colors, were filled with heavy furniture, carpets, draperies, paintings, and *objets d'art*. One need only stroll through the flea market in Paris to gain insight into middle-class taste at the turn of the century: heavy, plush-covered sofas, gingerbread-encrusted étagères meant to hold books or more likely knickknacks, bronze statues of voluptuous maidens with bustles and of nude goddesses with wispy hair. Each object was ornate: the Art Nouveau (or Jugendstil) movement, which greatly simplified design and moved away from eclectic decoration, was only just beginning. The paintings in middle-class living rooms were usually landscapes, portraits of ancestors in formal poses, sentimental scenes of family life, or grand depictions of classical or religious subjects by such celebrities as William Adolphe Bouguereau (1825–1905) and Leopold Karl Graf von Kalckreuth (1855–1928).[6] The clothing went with the furnishings: warm, heavy, and restraining, it made the *vita activa* a virtual impossibility.

Later, painters would remember with disdain the rejection of advanced art by their parents, by governments, and by the prominent, and the acclamation accorded academic and realistic painting* and monumental, ec-

*And not realism of Courbet's variety either. Fernande Olivier, Picasso's mistress from 1904 to 1911, describes the admiration of her family for Bouguereau, "'whose skin tones were so pretty,'" and for Puvis de Chavannes, "because he had decorated the Pantheon, that grotto of the 'greats.' . . ." In David's works they most admired the accurate representation of fabrics. She concludes: "As we know, the French petit bourgeois admires in art only what seems to him an exact copy of nature." (*Picasso et ses amis* [Paris: Stock, 1933], pp. 5–6.) On the other side, the former Dadaist Walter Mehring cites his father's epithets for Postimpressionist works: Cézanne's *"Farbenklexereien"* (*sic*) (daubings) and Van Gogh's *"Farbenbrandstiftungen"* (color arson). (*Die verlorene Bibliothek: Autobiographie einer Kultur* [Hamburg: Rowohlt, 1952], p. 106.)

lectic architecture. As late as 1920, a German Expressionist review sneeringly reprinted Wilhelm II's speech on the occasion of the opening in 1901 of the Siegesallee in Berlin, which featured 32 marble statues of Prussian rulers: "On this day I am filled with pride and joy at the thought that Berlin stands here before the entire world with a body of artists capable of carrying out such a magnificent project. It demonstrates that the Berlin school of sculpture is on a level that could scarcely have been surpassed in the Renaissance." The Kaiser topped even this in his typically cocky manner by adding: *"Any art that goes beyond the laws and limits I lay down is no longer art."*[7] And in 1953 Oskar Kokoschka still thought it important to describe the "confusion of styles" that caused the late Victorians to build "city halls in the neo-Gothic style, parliaments in the Greek,* skyscrapers, hotels, and bathing establishments in imitation of the Merovingian kings. What was good for the past would do for the present as well, so they thought."[8]

It would, however, be too facile to conclude that modern painting resulted from a revolt that was purely artistic. For, even before becoming painters, many of those who revolted had left their families for the Bohemian life, a vehicle for casting off constraints on their youthful energy. After having emancipated themselves they would aim their attacks at the older generation's esthetic blunders; but now they found more mundane faults: their parents' materialism, stuffiness, and ideological narrowness. To the discipline inculcated at home and in school, they preferred a more active daily life, fraught with risks or at least uncertainties; to the security of the family they opposed the fluid relationships and frequent loneliness of the garret; against the widely held respect for property and possessions they assumed an anchoritic stance. They were early aware of the incompatibility of the freedom they sought with their families' habits and ideas. The young Umberto Boccioni chose some lines from Ibsen as an epigraph for a diary he began in his twenties: "To have character and enough strength to live without friends, alone, with your own ideals: that's the liberty that is so much extolled. To this are opposed human conventions, respect for one's parents, for family. . . ."[9] And Van Dongen later recounted Rembrandt's adolescence in accordance with his own, attributing to the Dutch master a similar consciousness of family incompatibility: ". . . he guesses his parents will never see the realization of their dreams; he knows that he will soon leave the mill, never to return . . . sometimes he is pained by the pain he gives his parents by not listening to them. . . .

*A satirical reference to Vienna's neo-Gothic city hall and adjacent neoclassical parliament.

For he dislikes his studies. He dislikes homework, he draws in his notebooks; at home in his room he paints. . . ."[10] Alfred Kubin later spoke of his early hatred of parental and scholastic discipline, and of his desire to lead "an unplanned, untroubled life";[11] Maurice Vlaminck, too, remembered a sense of shame and humiliation at having to line up in school and a resultant "rebellious instinct . . . that made me rear up whenever I was asked to perform as simple a function as that of a piece in a chess game."[12] Late in life Ernst Ludwig Kirchner remembered an early visit to a Berlin manufacturer who, utterly unlike Kirchner's own father, treated his workers—and his children—as friends and lived energetically, even piloting an airplane. "It seemed to me like a fairy tale. . . . Here was freedom, artlessness, and joy. I was invigorated."[13] In a letter of 1902 to Vlaminck, André Derain scoffed at the common apathy and complacency: "In the present age, how many people would consent to spending their lives in furnished rooms, with enough to eat, a place to sleep and something to amuse them a little, remaining polite, honest and tidy—as long as this were sure to last all their lives, without a minute's lapse?" As far as he was concerned, a human being ought to demand more of life "at the risk of not having even that much."[14]

An artistic career seemed one way of achieving the desired social and occupational freedom—as a younger German Expressionist, Karl Jacob Hirsch, put it, "a freedom from bourgeois constraints that had not really constrained me very much."* An artist could vary his daily activities and work according to a self-imposed schedule. According to Marcel Duchamp, "You paint because you claim you want to be free. You don't want to go to the office every morning."[15] Success in the arts demanded extraordinary efforts but, if it came, would clearly be the result of the individual's talent and industry. Otto Mueller stressed the asociality and antimaterialism of the artist in defending his vocation to his parents. He said he would not trade his artistic "feeling" for any "earthly goods." "Let others run their legs off after wealth, fame, and honors," he continued. "I'd rather lie on the grass under flowering trees, buffeted by the wind, observing the hurly-burly among men. . . ."[16]

Many rejected their parents' plans for their future and left school for some sort of formal training in art. While most began to draw as children,

*He was fortunate in that his father, a doctor, was willing to give him a small monthly allowance while he pursued his artistic studies. (Karl Jacob Hirsch, *Heimkehr zu Gott. Briefe an meinen Sohn* [Wuppertal: Brockhaus, 1967], pp. 20–21.)

many opted for the artist's life rather late, in adolescence or even after reaching maturity. Some, unwilling to buck parental opposition, compromised on some para-artistic course or career. The Expressionist Brücke was formed by a group of Dresden architecture and decorative art students whose real ambition was painting. Several others studied applied art. Emil Nolde worked in furniture factories before producing his first painting at the age of thirty. Georges Braque was apprenticed to a house painter, Kubin to a landscape photographer, Mueller to a lithographer, and Oskar Schlemmer to an intarsia craftsman. Others prepared for and even followed nonartistic professional careers until fairly late: Kandinsky was a lawyer and economist of great promise, Matisse studied law, Derain was a student at the School of Mines, Jawlensky an army captain. Still others served apprenticeships or turned to various trades at their family's behest or out of economic necessity. The Italians Carrà, Balla, and Severini worked for years as house painters and decorators, turning gradually to painting canvases. Raoul Dufy served as clerk in a coffee import firm, Hannah Höch did clerical work, Ludwig Meidner was apprenticed to a mason, Frantisek Kupka apprenticed to a saddlemaker, and Karl Hofer apprenticed to a bookbinder.

It was a rare set of parents who readily accepted their child's choice of a career in the arts. The Klees, both musicians, did. And the Duchamp family, in provincial Normandy, is extraordinary both for having produced two major twentieth-century painters and one major sculptor and for not attempting to influence their children's vocations.* It may be relevant that the maternal grandfather had been a recognized engraver. But most parents relented only reluctantly or, in some cases, after bitter disputes.

It is not that artists were held in low esteem. On the contrary. Nor did the parents suspect that their children would opt for the disreputable modern styles, for those leanings were rarely evident at the outset. Most young painters began with academic training and inclinations and only gradually deserted the orthodox fold. Rather, security was given high priority in the late nineteenth century, and few professions were as insecure as that of painter.

*Marcel Duchamp, Jacques Villon, and Raymond Duchamp-Villon were brothers. A sister, Suzanne Duchamp, was also an artist of repute. Their parents helped their children financially, carefully deducting the amounts given each child from his eventual (modest) inheritance. There were six children; each child shared equally in their parents' property and none went hungry while the parents were alive.

If the parents were concerned with making life easier materially for their offspring than it had been for themselves, the offspring, once they had defiantly chosen the artist's life and then rejected academicism, made a virtue of refusing comfort. They believed that materialism promoted bad taste; thus their quest for a purer style became bound up with a renunciation of worldly goods, and they applied to themselves the romantic stereotype of the suffering artist. In 1905 Hermann Bahr, the Viennese critic who was among the first to champion Expressionism, wrote a prescription for the decommercialization and renewal of the arts. "The artist would have to be hungry and outcast again; accursed and repulsed by his family, so that he would turn to art only amid their sighs and attempts at dissuasion; so possessed that, for art's sake, he would be willing to face any privation, any curse, and a lonely death in a ditch."[17] When Bahr wrote these lines, they were already being lived—albeit somewhat less dramatically—by twenty-year-olds in every major European capital.

II

For a few, painting was only a second response to feelings of discontent. Some painters-to-be first went through a period of anarchism. Others discovered art and anarchism simultaneously. Still others adopted and expressed beliefs that were not specifically anarchist but left-wing and radical.

As in any other historical period, there were fashions in reading. It was Nietzsche who taught the young that their parents' soft but uneventful lives were undesirable and who gave them a thirst for action. The Naturalist novelists and playwrights offered a social critique and sympathy for unfortunates; Marx and his followers of various tendencies provided an ideological framework for the analysis of society and an apocalyptic, ultimately optimistic view of the future. Almost every one of the young painters read these authors and more. At their first meeting, Heckel greeted Kirchner with memorized passages from *Thus Spake Zarathustra*; soon he was reciting from Whitman's *Leaves of Grass* to the assembled Brücke, all of whom read Nietzsche, the Naturalists, and various Romantic and classical authors as well.[18] Whitman and Nietzsche were favorites of the young Italian Futurists too, along with Marx, Tolstoy, Dostoevsky, Gorki, the archindividualist Max Stirner, the Anarchist Prince Peter Kropotkin, and the

Syndicalist Georges Sorel, then more widely read in Italy than even in France. (Their mutual enthusiasm for Nietzsche brought Boccioni and Severini together.) French painters likewise read Nietzsche, Marx, Stirner, Kropotkin, and Tolstoy, along with Zola and native anarchists, such as Elisée Reclus. In many cases these literary influences show up in their early—and sometimes even their mature—works.

Where anarchist movements were strong they exerted a powerful attraction on the young, for they combined the socialist critique of capitalist society with an insistence on individual freedom and integrity. In France and Italy, painters such as Vlaminck, Derain, Van Dongen, Carrà, Severini, and Balla adopted an anarchist perspective or even participated in anarchist activities. Even in Germany, where anarchism never seriously caught on, the one significant anarchist movement (in Munich) counted among its following several writers and a young Bavarian confectioner and artistic autodidact named Georg Schrimpf who eventually exchanged the hard worker's life for the even harder one of the painter, producing naïve works held in esteem by the avant-garde.*

Both Vlaminck and Derain were radicalized in reaction against the mandatory military service. Vlaminck, the child of a family of musicians and petty tradesmen in the Parisian suburbs, went through a period of anarchism before he took up painting. Hating the compulsion in the military, he spent much of his service in the officers' library, reading French literature and political theory, and in the company of disreputable comrades. He became violently anticlerical and Dreyfusard, and, back in Paris after his discharge in 1898, he began to frequent anarchist circles with other ex-soldiers "with subversive ideas."[19] He gathered with other anarchists in the offices of *Le Libertaire* and contributed some articles to it. Drawing on his own military experience and, later on, on letters Derain wrote him from his regiment, Vlaminck likened the three-year stint then required to a prison term, complained of the twofold degradation of trainees through brutal exercises and patriotic propaganda, and declared his faith in the

*A fascinating account of Munich anarchism and Bohemia is Oskar Maria Graf's *Wir sind Gefangene* (Berlin: Verlag der Büchergilde Gutenberg, 1928), written when the Expressionist novelist was twenty-five years old. He describes in detail Schrimpf's development, using an alias, Schorsch. The alias is explained in Graf's second volume of memoirs, *Gelächter von aussen* (Munich: Kurt Desch, 1966), p. 7. That Schrimpf was held in esteem is demonstrated by the fact that monographs were already being written about him in the 1920s—including a short one by Carlo Carrà, who was, besides, greatly influenced by Schrimpf's work: *Georg Schrimpf* (Rome: Edizioni di "Valori Plastici," 1924).

message and future of anarchism.[20] By his own later account, he became disillusioned after a few years with the preponderance of talk over action and with the bureaucracy and restraints found even among anarchists, and he decided it was useless to squander his life on a gesture like Ravachol's. He then turned to painting as an outlet for his anarchic inclinations: "What I could have done only by throwing a bomb—which would have led me to the scaffold," he later reminisced, "I attempted to realize in art, in painting, by using colors of maximum purity. Thus I satisfied my desire to destroy old conventions, to 'disobey,' in order to recreate a sensitive, living, and liberated world."[21] His Fauvist landscapes of 1905 and 1906, with their violent brush strokes and heavy daubs of bright color, were the result. In painting them, he said, he disregarded "the conventions of the painter's craft . . . to bring about a revolution in manners, in daily life, to depict nature in total freedom. . . . I transposed everything I felt into an orchestration of pure colors. I was a barbarian, tender yet full of violence."[22] Even a portrait such as "Le Père Bouju" (Fig. 1) gives evidence of his violence.

His friend Derain was already a painter when mobilized a few years later. But Derain's letters to Vlaminck between 1901 and 1903 likewise testify to discomfort with military constraints, to radical opinions on the social question, and to a sympathy for the "canaille," both proletarian and disreputable (prostitutes, beggars, and petty criminals), that was shared by most of the avant-garde then and later. While he never had direct contact with anarchists, his leftist sympathies are manifest in his warm descriptions—in language peppered with lower-class and military slang—of workers and his shrewd assessment of their unreadiness for revolution.* Finding himself on guard duty at a struck mine in northern France, a setting straight out of Zola, he described with sympathy the haggard, misshapen women and the miners, "sweating alcohol" and "as blackened as their pipes, from which they are inseparable." He had earlier told Vlaminck—prophetically—that violence between striking workers and soldiers was inevitable. "The soldier who will soon fire on miners," he wrote around 1901, "is not guilty; neither is the sergeant . . . they'll shoot first of all because they're ignorant, and second because they've got guns. If they were anarchists they'd still shoot."[23]

Van Dongen, too, came under anarchist influence, first, just after leav-

"The worker," he said, "is not ripe for a revolution. Theoretically he's too unconscious of his condition, and practically not unconscious enough."

ing home, while living among sailors and prostitutes in Rotterdam and drawing caricatures for a local newspaper, and then in Montmartre, where he fraternized with fellow artists but worked at various odd jobs that brought him into contact with the most menial of workers: street cleaners, porters, hawkers.

Some of the young Italians were much the same. The painters who created Futurism first met as young workmen (and, simultaneously, art students) in Milan and Rome. By 1900, Giacomo Balla, the oldest, was living outside the Roman city walls, in an area of vacant lots where tenements were going up, teaching painting for a livelihood. He had returned from a recent visit to Paris filled with enthusiasm for Neoimpressionism that he passed on to others. Gino Severini and Umberto Boccioni met in his studio. Aside from their artistic affinities, these three had in common contacts with workers (Severini was doing menial labor at the time) and political radicalism. Severini and Boccioni met with a group of workmen to read philosophy and literature. "As for the connection between the artist and society," Severini later reminisced,

> I must confess that it scarcely interested us; in any case the general Marxist principle according to which man is the product of his environment pushed us, if not to take a direct part in politics, at least to accept the influence of those socialist and communist theories that were then beginning to be seriously affirmed. You must realize that we were living in a period of social movements and demands, of class struggles, of strikes repressed with violence; and all this was seen clearly by all of us with the enthusiasm of youth, the desire for "social justice," with that profound affective sympathy for the oppressed and indignation toward tyrants that is precisely the characteristic of youth.[24]

Carlo Carrà, who met Boccioni in Milan about 1907, did more than philosophize. He had been apprenticed to a decorator at age twelve. At fourteen he was working in Milan, pulling a cart of decorator's tools. He became radicalized by witnessing the widespread social unrest at the time—the demonstrations against the unsuccessful Ethiopian war of 1896, and riots in northern Italy in 1898—by observing the national and political enmities between the workers (of whom he was one) on the various pavilions of the Paris Universal Exposition of 1900, and through contact with Italian anarchists in Paris and London, where he sought work after the Paris exposition buildings were completed. In London he landed in the circle of Enrico Malatesta, the most notorious of the Italian anarchists.

Returning to Milan in 1901, Carrà continued to work as a decorator, frequented anarchist groups and studied political theory. He read Stirner's rabidly antisocial tract of 1843, *Der Einzige und sein Eigentum* (*The Individual and What Is His*), then newly translated into Italian and enjoying great popularity, and also Marx's *Kapital*, Kropotkin, Nietzsche, and the Russian novelists. He participated in discussions—utopian, abstract, and irrelevant to concrete problems, he later admitted—about social justice, more equitable distribution of property, and abolition of large concentrations of capital. He made a portrait of Friedrich Engels in 1901. In 1905, on a commission from the Milan Cooperative of Painters and Whitewashers, he painted an allegorical apotheosis of labor.*

By his own subsequent account he was in turn attracted to, and disillusioned by, each variety of socialism. He turned away from anarchism about 1906, when he was able to quit working and enter the Brera Art Academy on a stipend provided by an uncle. He then realized, he later said, that his vocation was for art, not socialism, but this realization did not impede a continued interest in leftist ideologies, first in parliamentary socialism and then in Sorelian syndicalism. He was befriended by the Italian Syndicalist Filippo Corridoni and, to some extent, remained under Corridoni's ideological sway until he left for the front in 1917.

A few other painters flirted with politics in their early years, sometimes as much through happenstance as through inclination: Modigliani, for example, was proud of an older brother, a Socialist deputy who had been jailed for subversive activities. Political activity was the exception rather than the rule; but sympathy for the poor was far more widespread. For almost every painter, the road away from home led, however briefly, through a period of *encanaillement*.

III

Another way of expressing social discontent demanded less engagement and no party loyalty, and could even bring a living: drawing caricatures.

*"There came about at that time a mania for the so-called 'social' picture," he said, "based on allegory and symbolism, and I was not immune to this deplorable fashion when I did this work. Labor, represented by some half-nude workers among the instruments of their trades, was greatly appreciated by the members of the committee who exhibited my canvas in the center of a wall of their pavilion at the 1906 Milan Exhibition." This work is no longer extant. (*La Mia Vita* [Milan: Rizzoli, 1943], pp. 74–76.)

The humoristic press had been thriving since the beginning of mass journalism in the early nineteenth century. It was not devoid of prestige, having provided a vehicle for such major talents as Daumier and Gavarni. At the turn of the century there were humoristic journals in every country that expressed the views of the various political factions. The anarchists and socialists particularly favored the visual approach—caricatures—as a means of reaching a large public that newspapers scarcely touched—the still semiliterate mass of workmen, peasants, and women.

Many young avant-gardists worked for satirical reviews, usually those with leftist tendencies. Sometimes that was only in order to earn a living, meager in most cases, but occasionally handsome. *Simplizissimus* paid the Bulgarian Pascin 400 marks (100 dollars) per month for his drawings starting in 1904, at least twice the monthly income of most avant-garde painters at the time;* Van Dongen received 800 francs (160 dollars) for an issue of *L'Assiette au beurre* (*The Plate of Butter*) in 1901; and Lyonel Feininger supported his family for years by caricaturing for *Ulk, Die lustigen Blätter*, and the *Chicago Tribune.*† A few painters, such as Feininger, Jacques Villon, and Kees Van Dongen, contributed to conservative as well as radical journals, but even they usually expressed liberal attitudes in their drawings. Feininger opposed the reactionary policies of Wilhelm II, while Villon and Van Dongen generally avoided politics but criticized social injustice.

By this time collaboration between progressive artists and anarchist journalists had become a tradition in France. Along with a noted group of illustrators, some of whom—for example, Jean Louis Forain and Théophile Steinlen—exerted an influence on the development of modern painting,‡ Neoimpressionists had been contributing drawings to anarchist journals since the 1890s, in part out of friendship to Jean Grave. Paul Signac, Maximilien Luce, and Henri Edmond Cross drew for Grave's *Les Temps nouveaux* and for various leftist publications, and on occasion also contributed money to anarchist causes.[25] The turn-of-the-century art world was

*See below, pp. 73–74

† Frantisek Kupka was paid 280 francs (56 dollars) per drawing by *L'Illustration*, but this was a popular illustrated weekly. According to Fernande Olivier, Picasso refused to do an issue of *L'Assiette au beurre* for a large sum. (*Picasso et ses amis*, p. 55. *See also* Louis Chaumeil, *Van Dongen: L'Homme et l'artiste—La Vie et l'oeuvre* [Geneva: Pierre Cailler, 1967], p. 72, Hans Hess, *Lyonel Feininger* [New York: Harry N. Abrams, (1959)], pp. 12–13.)

‡Both Käthe Kollwitz and Picasso, to name only two, were influenced by Steinlen (1859–1923). Two major caricaturists firmly on the Left were Adolphe Léon Willette (1857–1926) and Jules Félix Grandjouan (dates unavailable to me).

full of anarchists: Signac became president of the Salon des Indépendants in 1909, holding the post for 26 years; and Frantz Jourdain, the Art Nouveau architect, and his painter-decorator son Francis were also in Grave's circle, Frantz becoming the first president of the Salon d'Automne in 1903.

Most avant-garde caricaturists in France contributed to *L'Assiette au beurre*, a weekly published from 1901 to 1913. It was composed wholly of cartoons, mostly without text. Though not in line with any single political faction, its comment on contemporary events and manners came closest to the anarchist philosophy. Its title alluded to the inequable distribution of consumer goods, an injustice its contributors were sworn to combat. A prospectus asked: ". . . is it not a duty of art to fight the possessors of the plate of butter and all social wrongs?"[26]

The drawings in *L'Assiette au beurre* (as in *Les Temps nouveaux*, which was a newspaper) ranged widely both in style and content. Stylistically, they varied in quality, effectiveness, and the influences they represented— Realism, Impressionism, Art Nouveau. As for content, there were satires on current events, touching sketches of the poor, attacks on the rich, investigations of public institutions and of everyday Parisian customs and pastimes. The academic Salons were satirized with caricatures of their famous painters. Royalty and politicians were drawn with big noses and bulging eyes. Van Dongen dealt with workers and prostitutes, filling an entire issue in 1901 with pathetic representations of the miseries attendant on illicit love. His view of prostitution, obviously influenced by Zola, was also based on observation. After leaving home at eighteen he had lived above a brothel, which had furnished his first models. His 1901 series shows a young woman, abandoned by her lover, forced to sell herself to feed their daughter, who in time inevitably follows the same path—to an early grave.[27] The Czech Frantisek Kupka, later one of the pioneers in nonrepresentational painting, contributed fierce expressionistic drawings ridiculing religions (Fig. 2), prostitutes, mechanization, and militarism. In an issue entitled "Peace," he drew a humble workman standing defenseless before massed cannons, pot-bellied generals in full regalia, and specters of the various European nations. He warns them: *"Vous devriez bien nous la foutre!"* ("You'd damn well better give us [peace]!")* The series ended with two drawings threatening revolution. The first depicts a corpulent

*An allusion to the Second International's position that the proletariat would not fight in a capitalist war.

capitalist handing out money to the workers, the second a revolutionary throng carrying severed heads marked "private property" on bayonets. The legend: "Sometimes [the workers] can be pacified . . . but not always."[28]

Militarism was a favorite subject. In one of Jacques Villon's drawings, an old man glorifies war: "Yes, young people, war is very beautiful, very noble! . . . And I speak of it without bias, for I'm over forty-five!"[29] Juan Gris similarly depicted an old man lecturing a young one: "In the old days, young man, I was a pacifist. But I have aged, and I have understood that it is necessary to defend the honor of the country." "With my skin?" asks the youngster. "I daresay not with mine!" comes the reply.[30]

Gris contributed regularly to the review from 1908 until his conversion to Cubism in 1911. He dealt with a wide variety of subjects, serious and frivolous, such as foreign affairs, justice, widows, airplanes, tobacco, women's emancipation, even anarchism. However serious the subject, his drawings were gentler than Van Dongen's or Kupka's, and manifested the clarity and simplicity he would bring to Cubism. On the cover of an issue satirizing accepted ideas on suicide he showed two policemen bending over a corpse with a revolver beside it. Nearby, two gentlemen in top hats discuss the event (Fig. 3):

—The man who commits suicide is cowardly, a bad Frenchman, a deserter. . . . The man who commits suicide is unworthy of living!
 —You're right. . . .[31]

In Germany, the future Expressionists did not contribute to similar periodicals. But Käthe Kollwitz, Ernst Barlach, and Lyonel Feininger did, along with the noted left-wing caricaturist of Berlin's proletariat, Heinrich Zille, and Pascin, a Bulgarian Jewish painter who made his mark in Montparnasse in the 1920s. All but Feininger worked for *Simplizissimus*, which followed a policy radical for Germany (though hardly socialist), critical of Kaiser and Parliament. Upon returning from a voyage in 1906 to Russia, Barlach began with humorous sketches of Russian peasants, criticizing through them the Tsar's duplicity toward the lower classes and the reactionary development in the wake of the 1905 Revolution. He then took on German politics. A particularly effective drawing, entitled "Aus dem Kommissionsbericht der Übersichtigen" ("From the Report of the Commission of Overseers," Fig. 4), depicts three frock-coated gentlemen peering about, oblivious of the poor who huddle at their feet in cell-like

hovels. The legend reads: "—As far as the eye can see it encounters pictures of gaiety and contentment."[32] Kollwitz's drawings in *Simplizissimus* resembled her usual drawings and prints. Without caricaturing, she depicted impoverished workers, appending legends in lower-class slang. In 1909 she drew a series of workers' portraits, collectively published as "Bilder vom Elend" ("Pictures of Misery"). A drawing of the same year, "Das einzige Glück" ("The Only Bit of Luck") depicts a sad proletarian woman in bed with her newborn child; her husband, sitting beside her, says: "If they didn't need soldiers they'd even put a tax on children."[33] As for Pascin, his favorite subject all his life was woman. Though he treated many other themes during thirteen years of caricaturing for *Simplizissimus*, none were as frequent or as heartfelt as his drawings of prostitutes (also regular subjects of his paintings). In an early drawing (August 26, 1907) he put two charming urchins on display: "Gentlemen," says the Madam, "I can particularly recommend these two girls, who were raised in a convent in Milan."

In Italy, before the development of Futurism, Boccioni, Balla, Carrà, and Severini drew for socialist and anarchist publications. Carrà drew a touching picture of a woman in the arms of death for a cover of *Sciarpa nera* (*The Black Scarf*) and a portrait of a recently deceased anarchist for *La Rivolta*.[34] In the socialist *Avanti della domenica* (May 1, 1905), Balla published an empathic portrait of an old man much like his contemporary paintings, and Severini published pathetic portraits of workers (February 11 and 18, 1906) and a chilling scene, obviously influenced by *Anna Karenina* (October 30, 1906), in which a proletarian woman throws herself beneath a train (Fig. 5).

While the connection with radical publications was clearly more widespread than direct political participation, only about 20 per cent of the younger avant-gardists drew caricatures. Conclusive proof of their leftist sympathies, however, is the extent to which similar social concerns pervade their early works, up to and sometimes beyond the break that each, in a different way, made with the styles of the past.

IV

Most young painters, at least briefly, studied in art academies or schools of decorative art. Disillusionment quickly set in, especially in the academies, for these imposed the same constraints and preached the same respect for

tradition as did their families. Their teachers like their parents told them that hard work would eventually bring success and set them to copying classical models with painstaking exactitude. They could look forward to a gradual mastery of the craft, slow advancement, and satisfactory but un-spectacular careers. They responded by deserting the classroom for museums which contained old masters and the advanced works of the preceding decades, and for art schools where they could freely draw the models without being subjected to repressive criticism. Instruction in the schools of decorative art was more varied and permissive, and thus it is not surprising that so many future artistic innovators received their formal training at these institutions.

The young painters underwent a series of formal influences, first, in most cases, Impressionism, which made them banish black from their palettes and concentrate on the effects of light and air, and then Neoim-pressionism and Postimpressionism, which led them to divisionism or ex-pressionistic contortion of nature. The influence of Cézanne, leading to a more cerebral and constructivist attitude to form, would come for many only about 1906, the time of his death.

In their choice of subjects they were influenced by the Impressionists' predilection for landscape and the everyday event, and more strongly by Naturalism, then in vogue in Europe and, being permeated by socialist ideas, concerned with contemporary social problems. Reading Zola, Ibsen, Verhaeren, the Russian novelists as well as social theorists, and impressed with late-nineteenth-century pictorial works showing proletarians and so-cial outcasts, the new painters came to reject the subject matter commonly considered beautiful or inspirational in favor of themes provided by the street life they knew, the lowly or shady personages they encountered in the course of their military service or apprenticeships or nonartistic occupa-tions or while living on their own, away from their families.

In their early works, then, most of the avant-gardists, like their avant-gardist predecessors since the mid-nineteenth century, were observers and critics of everyday life. Virtually all of them developed technical compe-tence through observation and representation of landscape and daily scenes, and only a few—for instance, Boccioni, or Kupka—were strongly affected by Symbolism. None were interested in the historical and mythological compositions still exalted as the highest form of art by the academies. Perhaps half of their early paintings were devoted to land-scape, and the other half mainly to still-life, genre scenes, and portraits. When they waxed allegorical it was usually in the form of Nietzschean or

Marxian allegory. Before overcoming the influence of the avant-garde of the previous generation, the formal means they adopted were derivative.

Influenced both by the socialist ideas within her family and by the naturalist graphic cycles of Max Klinger (1857–1920),[35] Käthe Kollwitz based her most successful early works on scenes from the Silesian weavers' rebellion of the 1840s, the Peasant War of the sixteenth century, and the social unrest of French miners—themes drawn from Gerhart Hauptmann, Zola, and others. Her entire oeuvre would be devoted to the depiction of the common man, woman, and child; she said she chose them as subjects simply because she found them more beautiful than their social betters.* Her contemporaries, the sculptor Ernst Barlach and Paula Modersohn-Becker, likewise preferred to depict the common people—without ideological self-justifications. Both were drawn to the North German peasantry. Barlach simplified the forms of robust country women into elegant, nearly abstract sculptures in wood or stone. Modersohn-Becker repeatedly painted stark, often frontal portraits of weary farm wives with chapped hands and wrinkled faces (Fig. 6), and of charming, pale peasant children. So fascinated was she with universal human experience that she repeatedly drew herself while pregnant, even in the nude.

Balla spent the first ten years of his artistic maturity representing the poor and the disabled. His younger pupils, Severini, Boccioni, and others, pursued this same interest, under the influence also of several painters and sculptors of the two previous generations: Giuseppe Pellizza da Volpedo (1868–1907), who depicted the ranks of labor in a monumental painting entitled "Il quarto stato" ("The Fourth Estate"); Angelo Morbelli (1853–1919), author of a pathetic painting of the inmates of a home for the aged titled "Giorni ultimi" ("Last Days") and of other naturalistic scenes; Vincenzo Vela (1822-91), whose bas-relief, "Le vittime del lavoro" ("The Vic-

*"I would like to say something here about the stereotype of 'social artist' that accompanied me from [early womanhood] on. Certainly my art was oriented toward socialism even then, through the orientation of my father and brother and all the literature of the time. But the only reason I chose to depict the life of workers almost exclusively from then on was that the subjects represented by this milieu furnished simply and unconditionally what I found beautiful. Beautiful to me were the Königsberg porters . . . beautiful the generosity to be found in popular movements. People from middle class life held no attraction for me. All of bourgeois life seemed pedantic to me. The proletariat, on the contrary, had a lot of punch." ("Erinnerungen," *Aus meinem Leben* [Munich: List Taschenbücher, 1961], p. 50. Cf. a diary entry of Max Beckmann's of January 30, 1909, when he was not as yet an avant-gardist, printed in *Sichtbares und Unsichtbares*, ed. Peter Beckmann [Stuttgart: Christian Belser, 1965], p. 68.)

tims of Work"), depicted a group of exhausted miners carrying the corpse of one of their number; Medardo Rosso (1858–1928), whose impressionistic sculptures, often scarcely recognizable, treated popular subjects; and several others.* Beyond his interest, common enough at the time, in workers and their lot, and his particular concern with the rising cityscape observed from his studio, Balla was drawn to human subjects only rarely considered fit for painting—the old, the sick, the insane.[36] In a series of paintings entitled "Dei viventi" ("Some of the Living") of 1902–1905,[†] he represented not only sturdy workmen and peasants, but also a beggar, an aged and sick couple, and an insane woman with contorted hands and rolling eyes (Fig. 7). One of his more daring—and successful—pre-Futurist works is "Fallimento" ("Bankruptcy," 1902, Fig. 8), which depicts only the bottom half of a set of closed doors with children's drawings chalked on them: a rather abstract conceptualization of failure and desolation. In "La giornata del operaio" ("The Worker's Day," 1904), he depicted a construction site by day and, abandoned and ghostly, by night. Balla's friends and students also became interested in modern lower-class suburbs and construction workers: nearly every Futurist-to-be painted a view of a rising suburb. This scene in particular became a major part of Boccioni's imagery. In 1908 he depicted himself as an angry young man in topcoat and caracul hat against a backdrop of empty lots and construction sites (Fig. 9). In another, engraved view he included factory smokestacks as well as half-built tenements. In a diary entry of 1907 he paid tribute to the beauty and expressiveness of a simple wine merchant, seen "in a pose that reminded me of [Cellini's] Perseus and which was worthy in all respects of a Greek statue. . . . The wrinkles in his trousers, his jacket and his vest were as musical as a Greek anatomy."[37] Clearly the common man had now become the accepted source of artistic inspiration. As late as 1911, after the painters had turned to Futurism, Balla sought to promote peasant culture and Tolstoian socialism. As a part of the exhibitions celebrating the fiftieth anniversary of Italy's unification, he collaborated in building and decorating the Pavilion of the Roman Countryside, an oversized peasant cottage with thatched

*"Il quarto stato" is now in the Milan City Hall; "Giorni ultimi" in the Milan Civica Galleria d'Arte Moderna; Vela's relief in the Galleria d'Arte Moderna in Rome. Rosso's sculptures, more famous, can be seen in several places, within and outside Italy.
†The collective title, a double entendre, also means "living gods." I have chosen the blander meaning because the series is also often called "I Viventi" ("*The* Living"), but perhaps the ambiguity was intentional.

roof and sides in which were displayed the products of newly trained migrant workers of the Romagna and also some of Balla's paintings, including a portrait of Tolstoy in peasant shirt and views of Romagnan peasant life.

Other painters had a predilection for bordellos and dance halls and real sympathy for the women they found there—women who sell their bodies for a livelihood. The Brücke painters represented these women for years; so did Severini, Pascin, Van Dongen, Larionov, Kupka, and, for a while, Picasso and Rouault. These women typically are treated as fellow human beings, victims, or saints—and not, as with earlier artists such as Edvard Munch or Franz von Stuck, personified as the temptress Eve. With Kirchner, Heckel, Pascin, and Van Dongen, the color is often heightened and the form distorted, but the subject is treated realistically in an everyday fashion, worthy of representation but not extraordinarily significant. Frantisek Kupka, however, elevated streetwalkers into forbidding Egyptian goddesses, in a series of "Gigolettes" ("Wenches") of 1909. In one painting, "L'Archaïque" ("Archaic Woman," Fig. 10), two of them form an impressive frieze against a Paris street.

Picasso showed considerable empathy with the down-and-out, the rejected, and the rootless in his Blue Period portraits of beggars and the insane (they fascinated him as they did Balla), and in his tender Rose Period circus scenes—surely in part because he was just then cutting himself off from his roots in Spain and living penniless in Montmartre. His "Madman" of 1904 (Fig. 11), contorted like Balla's madwoman, is pitiable and yet somehow grand and dramatic; his beggars have a Greco-like mysticism going beyond the realistic handling of their features. Lyonel Feininger's pre-1910 paintings, satirical and fantastic like his caricatures, also refer to social subjects. The "Manhole, I" of 1908 (previously titled "Infanticide") shows an inordinately thin, long-legged worker peering into an open manhole, perhaps on the brink of finding a tiny corpse. In a 1910 drawing of "Arbeitslose" ("The Unemployed," Fig. 12), Feininger used an Oriental type of composition to stress the desolation of a series of bowed, shuffling proletarians. Even Kandinsky, later determinedly apolitical, depicted a scene of social violence in his early decorative style. A tempera, "Panic," painted in 1907, contrasts a calm procession of Orthodox priests in the foreground with a violent scene of cavalry fighting and flaming buildings behind:[38] perhaps an imaginative reference to the "Bloody Sunday" of the Russian Revolution of 1905, when a peaceful procession of

workers converging on the Winter Palace with demands for the Tsar was fired on by troops.

Many of these pictures are thematically similar to, and stylistically not more advanced than, paintings by Toulouse-Lautrec, Gauguin, Van Gogh, or even that antidemocrat Degas, who depicted washerwomen and middle-aged absinthe drinkers with considerable sympathy. Admixed in at least the paintings of Kollwitz, Balla, Van Dongen, and Kupka, and probably some of the others, as in earlier works by Van Gogh, Seurat, and Signac, was the didactic tone of socialism, the conviction that innate human goodness was being destroyed by contemporary society. For most of the twentieth-century avant-garde, direct interest in radical politics and the social subject was temporary. With the exception of some Futurists and German Expressionists, most artists were soon to turn away from such themes and from all pronounced political leanings. But this youthful period marked them. It was to be perpetuated in various ways, covertly in the mature works they were to produce, and overtly in the lives they early chose to lead—and which some continued to lead throughout their careers.

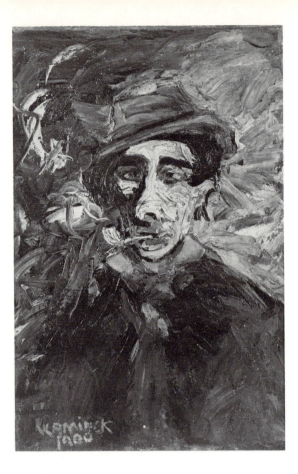

Fig. 1. Maurice Vlaminck,
Le Père Bouju, 1900.
Paris, private collection.

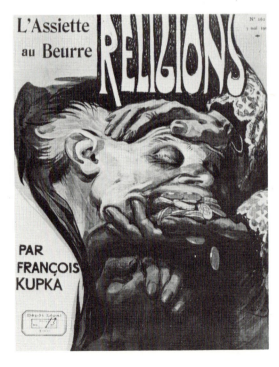

Fig. 2. Frantisek Kupka, "Religions,"
from *L'Assiette au beurre*, 1904.

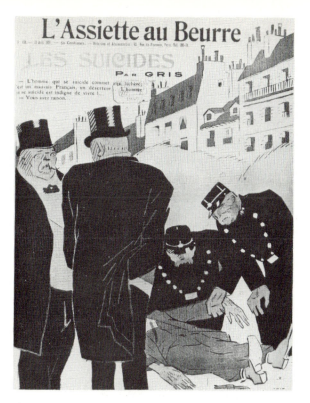

Fig. 3. Juan Gris, "Suicide," from *L'Assiette au beurre,* 1909.

Fig. 4. Ernst Barlach, "From the Report of the Commission of Overseers," 1907. Sketch for a cartoon which appeared in *Simplizissimus.* Hamburg, Barlach Museum.

Fig. 5. Gino Severini, "Tragedy,"
from *Avanti della domenica*, 1906.

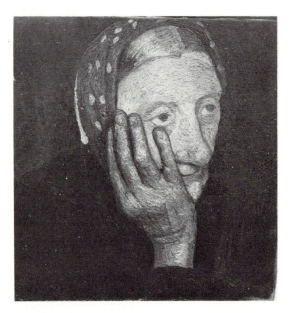

Fig. 6. Paula Modersohn-Becker,
Woman with Red Polka-dotted Kerchief, 1905.
Bremen, Ludwig-Roselius-Sammlung.

Fig. 7. Giacomo Balla, *The Madwoman,* ca. 1904. Balla family collection.

Fig. 8. Giacomo Balla, *Bankruptcy,* 1902. Rome, collection Giuseppe Cosmelli.

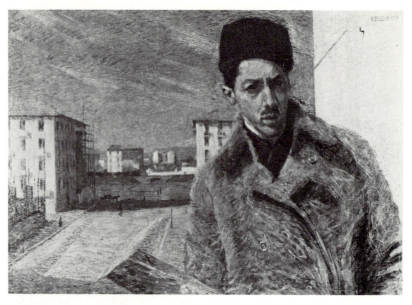

Fig. 9. UMBERTO BOCCIONI,
Self-Portrait, 1908.
Milan, Pinacoteca di Brera.

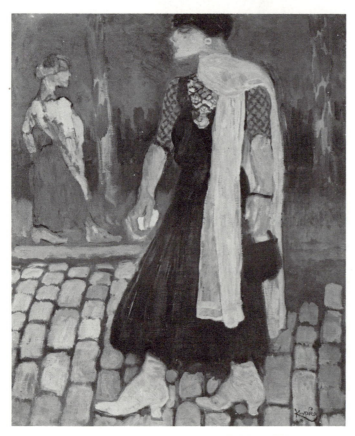

Fig. 10. FRANTISEK KUPKA, "L'Archaïque," 1909.
Paris, Musee National d'Art Moderne.

Fig. 11. PABLO PICASSO,
Madman, 1904. Barcelona,
Museum of Modern Art.

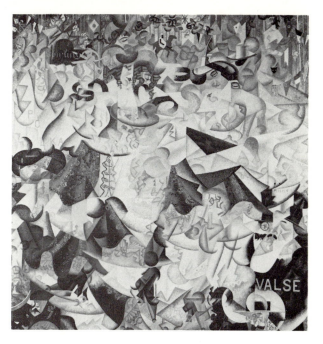

Fig. 12. LYONEL FEININGER, *The Unemployed*, 1910. New York, collection Julia Feininger.

Fig. 13. GINO SEVERINI, *Dynamic Hieroglyphic of the Bal Tabarin*, 1912. New York, Museum of Modern Art.

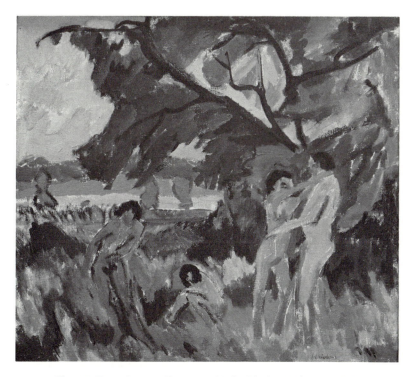

Fig. 14. ERNST LUDWIG KIRCHNER, *Nudes Playing Under Tree*, 1910. Munich, Bayerische Staatsgemäldesammlung.

The Artist's Life, 1900–14

The artist is a sensitive being, shy of light and noise, oft suffering, consuming himself with longing. Almost all men are his foes; his friends, those closest to him, are the worst. To him who shuns the light they are like the police. . . . Strange men are his friends; gypsies, Papuans, they carry no lamps. He sees little; but others see nothing at all.

EMIL NOLDE[1]

About 1900 the young painters began leaving home one by one, usually to attend art school in a European metropolis. There began for them a new life in a new environment, for independence entailed straitened economic circumstances. Almost all of them, wherever they settled, adopted life styles that resembled more closely those of proletarians and lumpenproletarians than those of their own families.

They were by no means the first generation of artists to take on an unsettled and insecure way of life. Existing at least since the 1830s, artistic and literary Bohemia had been made legendary at mid-century by Murger's novel of Bohemian life, and had become even more widely known through the opera based on it, Puccini's *La Bohème* (1896). Bohemians such as Courbet, Rimbaud, and Verlaine had greatly impressed the young with their often dissolute, always disorderly lives. While noting yet minimizing the destructive effects of poverty and squalor, the legend dwelt long on the Bohemian's carefree gaity, his charm, his cheerful acceptance of the vagaries of fortune, his openheartedness and openhandedness. Beyond the struggle with poverty common to the avant-garde of all periods, the artist's life in the early twentieth century—despite numerous memoirists' attempts to perpetuate the legend—resembles this model only in isolated cases. A closer look at the life styles adopted and economic conditions enjoyed or endured by the avant-garde will shed some light on their social affinities and their collective social personality.

I

Young artists settled in Paris, Vienna, Berlin, Munich, Dresden, Rome, Florence and Milan. Some were penniless and determined to live off their art; quite a few received small allowances from home; some had trades they could practice on the side. They met in the art schools and studios where they studied or were introduced by mutual friends, and their often remarkably similar intellectual formation and artistic aspirations drew them together. As they became increasingly critical of accepted academic procedures, inspired by the avant-garde of the previous generation and adventurous in their own attempts, they nowhere found a forum for their ideas except among themselves. To their lower-class neighbors, with whom they empathized and whose economic problems most of them shared, they nonetheless seemed eccentric and incomprehensible, even insane. Almost everyone else rejected, misunderstood, or ignored them. Congregating to discuss their problems and accomplishments, they became fast friends, living and loving, working and enjoying themselves together. Despite their emotional and intellectual affinities, their art was to lead them along many different lines of development. But yet their attachments would continue, even across long distances, by correspondence when not in person.[2]

Soon informal, then also formal, associations came into being, within which like-minded artists shared materials, debated esthetic theories, and planned and financed exhibitions.* The most cohesive of these, Die Brücke (The Bridge), was founded in 1905 by a group of Dresden students of architecture and decorative art who discovered a common penchant for an emotive, personal art along the lines of Van Gogh, Gauguin, and Munch. They quickly came to share models, materials, studio space, work methods, and, above all, a new way of life, considering themselves for some years the heirs of a medieval artisans' commune. They exhibited annually as a group from 1906 until 1913, when discord led them to dissolve. In numerous paintings, one or another of them depicted fellow members

*I do not mean the societies for the sole purpose of exhibiting works not acceptable elsewhere—the Société des Artistes Indépendants, the Société du Salon d'Automne, the Sezession movements in Berlin, Munich and Vienna—which, although founded by small groups of "refused" artists convinced of their own and each other's merit, quickly expanded far beyond the avant-garde and could not efficiently control the quality and stylistic direction of the works exhibited.

working or relaxing together, often in the company of models.[3] In 1909 the Munich Expressionists formed the Neue Künstlervereinigung München (New Artists' Association of Munich) mainly for the purpose of exhibiting; later they formed the more exclusive, cohesive Blaue Reiter (Blue Rider, 1911–14), for exhibiting and publicizing their own and kindred work, as, for example, that of Robert Delaunay, Henri Rousseau, and Picasso.[4]

Inspired by the wish, common among Italian youths at the time, to regenerate Italy morally and artistically, young artists and writers joined the poet Filippo Tommaso Marinetti in forming the Futurist movement in 1909; the painters involved had all been friends for years. Together they exhibited and, more important, given their philosophy, they planned and staged flamboyant demonstrations in major Italian cities.

In France, associations were less programmatic and more fluid. The "Fauves" ("wild beasts"), so named by a critic in 1905, bound in friendship and by their wildly colored canvases, exhibited at the Salon d'Automne and the Salon des Indépendants of 1905 and 1906; the Cubists (without Braque and Picasso, who shunned publicity) likewise functioned as a group mainly in common exhibitions, such as that in Room 41 of the 1911 Salon des Indépendants, which scandalized the public and critics. More noteworthy in France are the groups of artists and writers of various inclinations who either tenanted the same buildings or met regularly: those grouped around Picasso and Guillaume Apollinaire, who lived in or near the Bateau Lavoir in Montmartre and spent Saturday evenings in the company of Matisse's circle at Gertrude Stein's in the Latin Quarter; and the group composed of Jacques Villon, Raymond Duchamp-Villon, Frantisek Kupka, Albert Gleizes, Jean Metzinger, Fernand Léger, and others, who gathered for weekly discussions in the Duchamp brothers' ateliers in Puteaux, an industrial suburb west of Paris.[5]

In the cities, poverty and their social sympathies led most painters to settle in lower-class neighborhoods. For years to come their outward lives would be intertwined with those of workers and anarchists. In Dresden in 1905, the members of the Brücke lived in a former butcher shop in the Berlinerstrasse in lower-class Friedrichstadt. Erich Heckel later stated that the move to Friedrichstadt gave them the pleasant sense of finally breaking with their middle-class backgrounds.[6] (A poster drawn by Fritz Bleyl* for the Brücke's first exhibition, held there, was confiscated by the police, who

*A founding member of the Brücke who withdrew in 1909 to teach architecture.

considered the pubic hair on the nude a threat to public morals.) Munich artists were then meeting at the Café Stefanie, also a rendezvous of the largest German anarchist group. Other "avant-garde" cafés—the Café des Westens in Berlin, the Dôme and the Rotonde in Montparnasse, the cafés in Milan's Galleria Vittorio Emmanuele—were reputedly the gathering-places of the political as well as artistic insurrectionists of the day, though the two groups seem not to have coalesced until the outbreak of the war.

Montmartre was a center for both advanced art and left-wing politics until 1914. The French and Spanish contingent of the avant-garde and the renowned illustrators of the radical periodicals lived there; major anarchist journals, in whose offices sympathizers forgathered, were located there. The Lapin Agile, favorite haunt of *la bande à Picasso*, was known to the Paris police as a hangout for anarchists and miscreants.* An artist colony in the south of Paris, La Ruche, is said to have harbored, perhaps simultaneously, political agitators sought by the police (Paul Vaillant-Couturier, Anatole Lunacharsky, possibly Lenin) and the poet Blaise Cendrars, the painters Fernand Léger and Chaim Soutine, the sculptors Henri Laurens and Alexander Archipenko. Most artists concerned later insisted they had scarcely read newspapers, let alone participated in anarchist activities, in this period.[†] It is inconceivable, however, that the artists and anarchists remained unaware of each other. The anarchists displayed an enduring interest in artistic questions, championing the liberation of the artist from dependence on the capitalistic art market. And the painters for their part, to judge from their empathic depictions of workers, beggars, and prostitutes, clearly sympathized with their lower-class neighbors.[‡]

*In a report of January 30, 1910, the police informant "Finot" writes: "The 'Cabaret du Lapin Agile,' alias 'Cabaret des Assassins,' 4, rue des Saules, run by a certain Frédéric, is often frequented at present by anarchists from the group of Causeries Populaires." (Paris, Archives de la Préfecture de Police, dossier B a/1499, "Menées anarchistes, 1907–1914"; also B a/1497, report of August 23, 1897.) And Gino Severini provides some details: "This cabaret had a sorry reputation with the bourgeois: it was also called the 'Assassins' Cabaret,' and sinister stories circulated about it—for instance, that Frédé's son, a robust young man, was killed one night, for unknown reasons, at the door of the cabaret by several apaches. . ." (*Tutta la vita di un pittore* [Milan: Garzanti, 1946], p. 52. Cf. André Salmon, *Souvenirs sans fin* [Paris: Gallimard, 1955], I, 175, 185–86.)

†But Daniel Henry Kahnweiler, art dealer and intimate of the Cubists, admits that soon after arriving in Paris around 1902 he attended socialist rallies: "I participated, for example, in a demonstration at the tomb of Zola, who had just died. . . . I heard Jaurès, Pressensé, all the great Socialists of the period speak. I participated in demonstrations." (*Entretiens avec Francis Crémieux: Mes galeries et mes peintres* [Paris: Gallimard, 1961], pp. 17–18.)

‡Their attraction to the unfortunate, already discussed with respect to their early naturalism, is evident as well in the mature works of Picasso (Blue and Rose periods), Van Dongen, Vlaminck, Heckel, Kirchner, Schmidt-Rottluff, Nolde, Mueller, and various Futurists.

The numerous descriptions of depressed living conditions in Bohemia bear witness to the passionate conviction and tenacity of the artists and their wives and mistresses. Nonetheless, as the bonds uniting communities of artists loosened with World War I and with the growing stylistic diversity, affluence, and worldliness that followed, many remembered with nostalgia their miserable, heroic beginnings.* Their prewar lives, in most cases, combined a constant struggle for daily necessities with a youthful nonchalance and capacity for fun and mischief. The memoirs dwell on their pleasures and pranks, such as a burlesque party given in 1908 by Picasso in honor of the *douanier* Rousseau,[7] or the use of a mule belonging to Frédé, the proprietor of the Lapin Agile, to paint an abstract masterpiece that was entered in the Salon des Indépendants[8]; but more characteristic of their daily lives was the lack of comfort, not to mention luxuries, and the real hardships endured by some. There was at least one suicide due in part to poverty: in 1908 a young German painter named Wiegels, under the influence of hashish, hanged himself in his Bateau Lavoir studio in a fit of despair over losing or squandering the small allowance he had received from home.[9]

The Parisian avant-garde, the largest and most cosmopolitan, lived on both banks of the Seine; the French, Spanish and some Italians in Montmartre in the north, and the Germans, Russians, some French and a few Central Europeans and Italians scattered in the Latin Quarter, Montparnasse, and other districts south of the river. A few lived in the suburbs for the sake of economy, peace and quiet, or proximity to nature: Villon, Duchamp-Villon, and Kupka in Puteaux, Vlaminck and Derain in Chatou on the Seine, Marcel Duchamp in Neuilly-sur-Seine, and Matisse, after 1910, in Issy-les-Moulineaux. Until 1910 the greatest concentration of painters was certainly in Montmartre. Here, in narrow, almost contiguous streets such as the rue Ravignan, the rue d'Orsel, the impasse Guelma, the rue Caulaincourt, and the rue Lepic, lived several Fauves, almost all the Cubists, the Futurist Gino Severini, and mavericks such as Maurice Utrillo and, at times, Modigliani. After 1910, as some of them began to become known, if not prosper, they started to leave Montmartre for somewhat

*Fernande Olivier, understandably nostalgic for the earlier years since she and Picasso had parted before the war, attributes such feelings to Picasso and his friends (*Picasso et ses amis* [Paris: Stock, 1933], pp. 163, 231). Maurice Vlaminck (*Tournant dangereux: Souvenirs de ma vie* [Paris: Stock, 1929], pp. 175–76) wrote: "I pity those who have never known poverty. I also pity those who have never left it behind. Poverty leaves a deep mark. . . . Dry bread tastes very good when you are hungry, and the lack of money gives things their real value."

grander quarters, usually on the Left Bank, near the University or in lower-middle-class Montparnasse. Although they consistently avoided both the elegant districts on the west and the lower- and middle-class ones to the east, by 1914 the Parisian avant-garde was scattered throughout the city.*

Incorporated into the city only in 1860, Montmartre still resembled a village, with a few fields and with flocks frequently driven through the streets. In decrepit buildings on the quaint, narrow streets, painters inhabited studios without electricity or running water, and with stoves that they often could not afford to fuel. The Bateau Lavoir, at 13, rue Ravignan (now place Émile Goudeau), is the most famous of these lodgings, for at various times before 1914 it housed Picasso, Gris, Otto Freundlich, Van Dongen, André Salmon, and many others of their circle. A description of Picasso's studio there—one of the better ones—gives an idea of what Montmartre lodgings were like as well as a glimpse into Picasso's material circumstances and disorderly habits before 1910:

> A mattress on four legs in a corner. A little cast-iron stove, all rusted, with a yellow earthenware washbasin on top, served as bathroom; a towel, a little piece of soap, were on a white wooden table nearby. In another corner, a poor little trunk, painted black, made a rather uncomfortable seat. A straw chair, easels, canvases of all sizes, tubes of paint scattered on the floor, brushes, receptacles for turpentine, a basin for water-colors, no curtains. In the table drawer was a tame white mouse that Picasso cared for with tenderness and showed to everyone.[10]

Nearly forty years later Picasso reminisced to the Rumanian photographer Brassaï about his hardships in Spain and then in Paris: "I've suffered from cold in my life more than a lot of others! . . . In Barcelona I burned drawings to warm myself And in the Bateau Lavoir! A furnace in summer, an icebox in winter. . . The water froze. . .[11]

Across Paris, near the southern fortifications and the Vaugirard slaughterhouses, La Ruche (The Beehive), so-named for the shape of its central building, furnished other artists with equally shabby but still more pastoral dwellings.† It was established around 1902 by Alfred Boucher, a

*Changes of address were frequent. The best sources of artists' addresses are the yearly catalogues of the Salon d'Automne and the Salon des Indépendants.

†Unlike the Bateau Lavoir, the Ruche has been neglected by historians, though it still houses artists at 2, passage de Dantzig, Paris XV. The major account of its history, not always trustworthy, is by Jacques Chapiro, a Russian artist who lived there beginning in 1924. *La Ruche* (Paris: Flammarion, 1960).

successful artist with a philanthropic bent. Boucher had acquired the land for next to nothing, later bought the *pavillon des vins* from the Universal Exposition of 1900, and, encouraged by a government official, rebuilt it into tiny artists' ateliers—"coffinlike dwellings with limited air space," according to Jacques Chapiro, who lived in one of them in the 1920s.* Later, other buildings were added. Attracted by its parklike atmosphere (there were only a few houses and bars near the slaughterhouses, from which emanated unpleasant smells and noises) and low rent, Max Pechstein lived there for a short while during a visit to Paris in 1908; after 1910 Fernand Léger, Marc Chagall, Alexander Archipenko, and Henri Laurens settled there, being later joined (or replaced) by Chaim Soutine, Modigliani, and others.[†] Living conditions there were—and still are—primitive, but the tenants were often able to avoid paying their rent. Electricity was installed in 1925, with heat and hot water then still lacking. In winter, according to Chapiro, "The few water taps of the colony froze up until spring. . . . The tenants of the 'coffins' and the studios . . . worked while draped in blankets or bundled into whatever old clothes they could get their hands on, content with their internal flame." While the tenants of the Ruche organized exhibitions and amusements, they were not of the same artistic persuasion and did not form a cohesive community. Little groups congregated in the few nearby bars, fraternizing—and sometimes fighting—with the slaughterhouse employees, who considered them lazy and unproductive, but on the whole tolerated them. (One butcher gave Chaim Soutine a side of beef to use as a model, whose odor—it being summertime and Soutine a slow worker—soon permeated the whole Ruche.)

Other painters lived, usually somewhat more comfortably, in the Latin Quarter and Montparnasse, remaining in contact with the Montmartre groups. Matisse lived until 1909 on the quai Saint Michel, near Notre Dame; he then moved to the elegant boulevard des Invalides, where he opened a school, and, in 1910, to a modest country house in Issy. Though

*The Rotonde has three floors, each with a circular corridor and small one-room studios directly off it. On the inside the only light comes from a round skylight in the roof (the lower corridors are dark indeed); but the ateliers, with their big windows looking out on open space and trees, are very light. Blaise Cendrars described the Ruche in the poem "B-atelier," published in *Dix-neuf poèmes élastiques*, 1913.

†The Ruche seems to have held special attraction for East Europeans. Aside from those already mentioned, it housed, up to 1919, the Russian painters Shterenberg, Moissey Kogan, Alexander Altmann, and Michel Kikoine, all of whom exhibited at the Salon d'Automne. Length of tenancy varied greatly. Léger seems to have stayed only a year or less; others considerably longer. (*See* catalogues of the Salon d'Automne and Salon des Indépendants.)

Otto Freundlich moved into the Bateau Lavoir soon after his arrival, most of the German colony, as well as Pascin, Mondrian, the Americans John Marin, Alfred Maurer, Edward Steichen, Max Weber, and others, lived in the then not yet fashionable Montparnasse; there, too, several sculptors, Modigliani among them, tenanted a run-down building of studios in the cité Falguière.

With the exception of Munich, no other city had such colonies. German and Italian artists, some poorer than others, lived scattered throughout various big cities. In Munich, which had no proletarian districts since it had little heavy industry before 1914,[12] the Expressionists first settled in Schwabing, which was already well-known as a students', artists', and leftists' quarter. Kandinsky and Münter and the Klees were neighbors on Ainmillerstrasse; Jawlensky and Werefkina lived nearby, on Giselastrasse; and Marc lived for a while on Türkenstrasse. In Berlin and Dresden, as in Paris, though not in Vienna, artists, some by necessity and others by design, lived in the poorer neighborhoods, though not necessarily badly. The Kollwitzes chose to live in proletarian northern Berlin, where Karl Kollwitz practiced medicine and chose to treat largely workmen's compensation (*Krankenkasse*) patients. But he had a lucrative private practice as well, and their spacious quarters, adjacent to those of the poor, were in the front of the building rather than in the miserable *Hinterhof*.* Even the popular neighborhoods of Berlin—and for that matter, Montmartre—contained a cross-section of society, excluding the wealthy and the upper middle class, but certainly including the petty bourgeoisie. Most Berlin artists lived in small attic apartments in the relatively prosperous western districts of Charlottenburg, Wilmersdorf, and Steglitz, climbing extra stairs but surrounded by people from all walks of life. Wieland Herzfelde, the Dadaist, Communist journalist and intimate of George Grosz, described the artist's life of Berlin-Wilmersdorf during World War I:

> In the four- and five-floor buildings of this Berlin suburb lived merchants, doctors, civil servants—good burghers all. Above them, in the garrets, we, the Berlin Bohemians, lived. . . . Apartments were considered philistine; they were also expensive. And wasn't it charming to gaze at the moon and stars through the sloping skylight? One felt nearer the cosmos, the Timeless, the Immovable, beyond the realm of human control.[13]

*On this point I have the word of Frau Doris Hahn, a onetime friend of many Berlin artists who, as a young girl, was once treated by Karl Kollwitz in his office.

In a sardonic short story, Oskar Kokoschka told of his poverty as a newcomer to Berlin in 1910. "My assets," he wrote, "consisted of the clothes I had on my back, an iron bedstead, a washbasin, a hand towel. . . . On sunday I could fill up on wurst at Aschinger's for one mark. Since I was young and strong, bread and tea sufficed to sustain me during the week."[14] In all the cities, artists moved frequently—probably, in many cases, to avoid paying rent. Max Pechstein followed this practice during a 1908 stay of several months in Paris. Modigliani likewise moved back and forth within and between Montmartre and Montparnasse*, and the Expressionist novelist Leonhard Frank commented in *Links wo das Herz ist*, his *roman à clef* about the prewar Munich Bohemia: "In Munich there were a great many painters' studios. There were also painters who paid the rent. But many could not: at the beginning of every month they moved to a new atelier. Since the studios were already there and some painters actually paid rent, Munich landlords took the risk of renting to them again and again. They were gamblers."

Since their lodgings were usually uncomfortable, if not downright unpleasant, artists spent a great deal of time away from home. There were several places where they could go to socialize, debate, amuse themselves, or even work. They met in cafés, at their dealers' galleries, and in the offices of the advanced literary and political reviews to which their writer friends, if not they themselves, contributed. Notable among these were Berlin's *Der Sturm* (*The Storm*) which, from its beginning in 1910, championed Expressionism, opening an art gallery in 1912, and *Die Aktion* (*Action*), which after 1912 featured Expressionist graphics in its leftist political and literary columns. In particular, Herwarth Walden, editor of *Der Sturm*, was hospitable to figurative artists; besides running the Sturm Gallery, he and his wife collected modern art avidly until 1914 and opened their house to anyone who wished to see their collection.[†] Despite the widespread rejection of modern art before the war, avant-garde galleries opened in every major city, often as a result of encounters between artists and young men of similar convictions but more practical natures. Warm relationships often resulted and endured, as, for instance, between the Futurists and Giuseppe Sprovieri, who opened the first Futurist gallery in

*This is evident from the number of addresses he listed in the Salon catalogues, and has been confirmed by his daughter, who mentions the impossibility of keeping track of all his moves. (Jeanne Modigliani, *Modigliani senza leggenda* [Florence: Vallecchi, 1968], p. 63.)
†The guest book to their private collection, preserved in the Sturm-Archiv at the Westdeutsche Bibliothek in West Berlin, reads like a *Who's Who* of the prewar German intelligentsia.

Rome in 1913, and between Fauves and Cubists and D. H. Kahnweiler, who opened his first gallery in 1907. Since even the independent Salons and Sezession movements held only yearly exhibitions, galleries had by then become the primary places where new art could be seen and its followers meet.

The owners, and often also the waiters, of the cafés, restaurants, and bistros where the artists congregated, befriended them. They were among the first patrons of modern art, occasionally buying works, more often accepting them in payment for food and drink; and often they extended credit. The restaurateur Azon fed the entire Bateau Lavoir on credit; Frédéric, the owner of the Lapin Agile, exchanged drink for poetry or song, and food for an occasional work (a Blue Period painting of Picasso's is said to have hung there); Kathi Kobus, the proprietress of a Schwabing wineshop, filled her walls with works (among them a Franz Marc and a Pascin) accepted as payment or wheedled out of old clients grown famous*; and various (perhaps apocryphal) waiters are said to have extended personal credit or served double portions on the sly. Ultimately, the losses were made up for by the crowds of tourists who came for a glimpse of Bohemia. Many of these cafés made famous by the avant-garde are today worldly, elegant places, long since deserted by their original clientele.

The Italian Futurists preferred the cafés in Milan's Galleria Vittorio Emmanuele; in Munich, the Café Stephanie, on the border between the city proper and Schwabing, was the chief meeting place of the intelligentsia. In Berlin there were many, but the nearly congruent groups of artists and writers connected with *Der Sturm* and *Die Aktion* gathered on the Kurfürstendamm at the Café des Westens, nicknamed "Café Grössenwahn" (Café Megalomania) on their account by the poet Else Lasker-Schüler. When the conservative press attacked this café and its habitués as a bad influence on morals, calling it the ruination of Berlin's image abroad, Herwarth Walden, by then chief propagandist of Expressionism, counterattacked with a pseudonymous, sardonic, extremely provocative "description" of the café, portraying its clientele as all that legend already made them—and more:

BERLIN'S DEN OF INFAMY. "SPECIAL REPORT."
CAFÉ GRÖSSENWAHN.

Timid and fearful, the ordinary citizen hastens past this pit of hell. The respectable merchant, the thrifty pensioner, the brave officer, the deep thinker, the

*She hung them according to the splendor of their frames. Her bistro, named "Simplizissimus" after Munich's satirical review, was located on the Türkenstrasse.

talented theater director, the class-conscious actor, the slow-moving hand-worker, the traditional painter, the classical poet, the frantic driver, the faithful playwright, the tennis-crazy old youngster, the handbag-carrying maiden, and *last not least*, the unassuming ragpicker cast a watchful glance through the revolutionary windows and commend their souls to [the academic painters]. . . . Cold shivers run down their normal limbs, through their healthy blood. For inside they have glimpsed demonic figures sitting. Men with long hair, serpentine, curly locks, flowing ties, Sezessionistic socks, and teetotaling trousers are tasting life to the full. They stretch themselves meaningfully in their sofa-corners, admire themselves and each other in the mirror . . . and, through profligate, decadent coffee drinking, bring German art to the edge of the abyss. . . .

So the day goes by, and then, in the evening, the great orgy of the up-to-date, modern night begins: the mark-gobbling work of putrefaction of the coffeehouse literati. They begin to crawl in from Wilmersdorf and Halensee, Sezessionistic vermin, morbidly sensitive, bizarre fellows, stricken with megalomania. An insane yammering begins. . . . Skylark songs, waving fields of corn, brown clods of earth, buxom country lasses, the call of the seagull, and all the thousand birds that sing in the hearts of our native artists—all the old, sacred stock of art is ridiculed and insulted.

. . . And while menus and wine lists, daily, weekly, and monthly papers, walls and marble tabletops are being covered with shameless, amorous elucubrations, Sezessionistic painters cower on the stairs, doing bad drawings of anatomically established realities. . . . Oskar Kokoschka has brought along some dirt from the street that he needs for a colossal painting; Max Pechstein thinks human bodies are palettes. . . .[15]

But it was in Paris—the birthplace of the avant-garde—that artists felt freest and most at home. Virtually all the advanced painters lived or passed through there before 1914. Every French avant-gardist wound up in Paris, at least temporarily, and a great many foreigners settled there: Kupka already about 1895, Louis Marcoussis in 1903, Picasso in 1904 (though he had already visited repeatedly since 1900), Brancusi in 1904, Pascin in 1905, Gris, Severini, and Modigliani in 1906, Archipenko in 1908, Lipchitz in 1909, Chagall and Mondrian in 1910, and Soutine and de Chirico in 1911. And many more visited, often for extended periods: Kandinsky and Münter from 1906 to 1907; Feininger from 1906 to 1908; Balla and Carrà in 1900; Boccioni in 1906; Boccioni, Carrà, and Russolo together in 1911 and 1912; Klee, Macke, and Marc in 1912. Paris remained the most important meeting place for avant-gardists and the proving ground for esthetic innovations, despite the growing competition of other cities, notably Berlin and Munich.

The Paris districts where the artists congregated were the most tolerant of eccentricities of any in Europe. In Parisian Bohemia, the German art historian Hermann Uhde-Bernays observed, one had "the precious feeling of experiencing a freedom that burst all bounds and limitations." The cosmopolitan avant-garde was numerous enough in Paris to split into subgroups, each of which had its own meeting place. Beginning around 1903, the German contingent—Hans Purrmann, Rudolf Levy, Otto Freundlich, the art historian and sometime dealer Wilhelm Uhde, and famous visitors—joined later by Modigliani, Pascin, and after World War I by the American "Lost Generation," met at the Dôme and the Rotonde on the boulevard Montparnasse. The recently opened Dôme was then a small neighborhood café. "A new arrival," according to Uhde-Bernays,

> who was not accustomed to the atmosphere, felt at first estranged by the nonchalant attitude people had toward the place. Up front by the street entrance sat Madame, selling coffee, beer, spirits, pastries to the customers who ate while standing—workers, passers-by, models. In a trapezoidal room stood shabby black leather sofas. Next to the mirrors were posted newspapers and letters. Later it became customary to hang studies and small pictures. The people, too, seemed without relations or connections. They sat around, spoke or kept silent, smoked constantly, drank one cup of coffee after another, an absinthe, a beer, ate something, drew on the tables or on loose sheets of paper which fell to the ground, played cards. . . .
> Most lived almost constantly at the Dôme—a kaleidoscopic clientele, whores, models, confidence men, today also respectable tradesmen, a few students, many Russians, curious figures among them.[16]

Lyonel Feininger has left a sketch of the German artists at the Dôme.

A few blocks away, at the Closerie des Lilas, on the corner of the boulevard Montparnasse and the avenue de l'Observatoire, French and Italian painters and writers congregated on Tuesday evenings at soirées given by the Symbolist poet Paul Fort: the anarchists Laurent Tailhade and Han Ryner allegedly joined the art crowd which regularly included Marinetti, Picabia, Jacques Villon, Kupka, Léger, Gleizes, Severini, Archipenko, and Apollinaire. In Montmartre, full of popular restaurants, cafés, and bars, the Lapin Agile, a cabaret in which it was often impossible to distinguish between the entertainers and the guests, undoubtedly was the most popular haunt.

In general, the places of amusement and entertainment preferred by the avant-garde were those of simple proletarians, lumpenproletarians, and

petty bourgeoisie. Painters frequented popular dancehalls, such as the Bal Bullier in the Latin Quarter (which also had a student clientele), the Moulin de la Galette in Montmartre, or the Tabarin in Berlin; nightclubs, such as the Gaîté in Montparnasse, where, according to Uhde-Bernays, "there was dancing, but already Negresses and exotic acrobats were doing turns" (p. 360); circuses and boxing or wrestling matches, particularly dear to Picasso's circle. They also enjoyed mixing with the performers, whom they found colorful, exotic, and congenial. During a stay in Paris in 1907, the Munich writer and, later, revolutionary leader Erich Mühsam stayed in a Montmartre hotel on the rue des Martyrs near the Cirque Médrano along with circus riders and Negro performers; so did Severini (perhaps in the same hotel), who later remembered with pleasure "all the clowns, the equestrians, the animal trainers of the circus, people who came from all over the world. Besides this clientele there were the street hawkers of the boulevards and their mates, and a crowd of misfits and people of dubious resources. At bottom it was a most interesting ambience, rich in humanity; I met the most generous and intelligent people. . . ."[17]

The subject matter furnished by the cafés had already been elaborated—albeit more tamely—two generations before by the Impressionists; the artists' nighttime haunts—the bistro, the circus, and the dancehall—had been depicted in the preceding generation by the Postimpressionists, notably Toulouse-Lautrec and Seurat. What was new was, first, the extent to which these surroundings became a part of the artists' daily lives, and second, the connections the painters would make between these settings and their radical stylistic innovations. For although most artists moved decisively away from Realism before 1914, the new forms they utilized were often developed in paintings of "naturalistic" subjects: from the violent contortion of line and color in early Expressionist paintings of dancers, prostitutes, and Biblical "sinners" to the cubistic decomposition of natural forms in Picasso's "Demoiselles d'Avignon" (1907), with its prostitutes and sailors. The works of the Brücke are filled with street, circus, and cabaret scenes, and with dancers whom they studied in such places as the Tabarin. At pains early in his career to find the proper means of giving "pictorial form to contemporary life," Kirchner repeated a few basic subjects (the artist's studio, dancers, street scenes, the circus), progressively eliminating all but the minimal linear elements necessary to denote shape and movement.[18] Even more pointedly, the Futurists repeatedly asserted that they had composed their screeching manifestos for a

modernized Italy in up-to-date urban bars, surrounded by "the noise of crockery, electric lights, call girls, pleasure seekers, and waiters." According to Boccioni, "Effeminate sybarites, cardsharps, procurers, songstresses, whores, and pederasts were seated next to us, elbow to elbow, as we mapped out our program for the plastic and moral regeneration of Italian art."[19] Their style developed largely through repeated depictions of the strolling evening crowds in the Galleria. Gino Severini, influenced by Cubism before joining the Futurists, was inspired by the movement on Parisian dance floors and by "the little working girls and shop girls of department stores with their 'friends,' " and the " 'loose girls,' not yet expert in *la vie galante*, with their 'protectors' " (p. 73). In "Dynamic Hieroglyphic of the Bal Tabarin" (1912, Fig. 13) and several related paintings of dancers, he depicted the crowdedness and frenzy of the dance floor by disintegrating the moving figures into planes and geometric fragments, finally pasting on some sequins as token razzle-dazzle. Only the Munich Expressionists—except for Jawlensky, who painted portraits of dancers and prostitutes—were immune to this subject matter. But that immunity is also related to their life style, for they early stood aloof from both Bohemia and city life.

II

In the last prewar years, avant-gardists moved from smaller cities, such as Dresden, to larger ones, and from traditional cultural centers, such as Vienna and Rome, to more modern settings, such as Berlin and Milan. Vienna in particular, an artistic center in the late 1890s, with a Sezession movement and important contribution to Jugendstil and functionalist architecture, gradually lost its pictorial avant-garde to Berlin, a more vital, more industrialized, though certainly less beautiful city. With the final emigration of Kokoschka during the war, and the deaths of Klimt and Schiele in 1918, Vienna ceased to produce progressive art. So did the Italian art centers, Rome, Venice, and Florence, once Modigliani, Severini, and de Chirico departed for Paris and the Futurists ostentatiously moved to Milan.

Like the Impressionists before them, many of these city-dwelling avant-gardists spent their summers in the country, painting land- and seascapes. The landscape was often a basic component of their imagery.

Only the Futurists neglected it entirely; the Fauves and Brücke alternated between urban and pastoral subjects, while Braque and Picasso developed Cubism in part through similar landscapes painted in different localities during the summer of 1909.* Nevertheless most felt at home in the city and feared a loss of creativity through detachment from urban artistic life. ". . . I no longer believe in the benefits of isolation," wrote Juan Gris to Maurice Raynal on December 11, 1921, from Céret in the French Pyrenees. "One has to be a sage who has renounced everything in order to bear it. Otherwise isolation turns one into a ridiculous and provincial imbecile. I have seen some of the local artists. What stagnation! No, no, I'm not thinking of retiring to the country yet." Some nonetheless did prefer the seclusion of the countryside to the bustle, crowdedness, and the social life of the city, withdrawing—often after many years in the city—into a community of their wives and likeminded friends. They thereby escaped some of the economic hardships of the city, for life in the country was cheaper and easier. But they did not escape innovation: some of the most radical turns in modern art—including Kandinsky's development of nonrepresentational painting—took place in the country.

There were many precedents, going back at least to the Barbizon painters in the 1840s. The Impressionists and, later, the Neoimpressionists, had divided their time between Paris and various rural and seaside locales. Of the Postimpressionists, only Cézanne and Van Gogh (during their last, most productive years) were truly country-based. Gauguin was a Parisian at heart, forced at first by economic circumstances to live in Brittany, but eventually fleeing to the wilderness for good and all. In Germany an artist colony had formed in the 1890s in Worpswede near Bremen, a small and scenic village where impecunious artists managed to live off the land, taking inspiration from the green woods and fields, from thatch-roofed cottages and the traditional peasant culture.

It was mainly painters in Germany who left the city for the country between 1900 and 1914. After some years in Munich, most of the Blaue Reiter moved out to various villages in Upper Bavaria, at first for the summer and then for longer periods, keeping contact through letters, visits, and occasional business trips to Munich. While the Klees remained in Munich, the Mackes never settled there; they visited for extended periods, though living in Bonn and often vacationing in the Swiss countryside. The

*Braque's were painted at La Roche Guyon in the Seine Valley; Picasso's at Horta de San Juan in Catalonia.

Marcs moved to Sindelsdorf, between Murnau and Benediktbeuern, in 1909, and later bought a secluded house in Ried, an even smaller town nearby. Kandinsky and Münter, later joined by Jawlensky and Werefkina, lived chiefly in Murnau after 1909, though they kept apartments in Munich. The Kubins settled in Zwickledt-am-Inn in the Austrian Tyrol. Particularly fond of nature and—except for Jawlensky and, to some extent, Kubin—drawn artistically toward landscape, they lived in considerable isolation and extremely simply, the Marcs eventually quite far from any sizeable town and Münter and Kandinsky in a house Münter bought, without either running water or electricity, and heated only by a single stove. Marc, a great animal lover, kept many pets; Kandinsky is known to have enjoyed gardening, and also to have decorated the walls and the simple furniture he and Münter ordered from a local craftsman. Kubin, neurasthenic and sickly, found cities intolerable and he especially appreciated the quiet. On a 1912 return trip to Paris, he remembered, he was "struck by the large number of cars on the streets, which were taking the place of the old nags; there were more movie theatres, everything was more frantic, the food in the restaurants was expensive and even more adulterated—in a word, everything had been further Americanized."[20]

Various Brücke painters, too, found life in the cities disturbing. Dresden, their original home, offered a centuries-old artistic tradition and vigorous cultural activity, but also a beautiful countryside which they enjoyed to the full, spending their summers painting landscapes, often with nude models, in the open air. Around 1910 they moved to Berlin, which was more cosmopolitan, but feeling uncomfortable there, some of them eventually returned to rural surroundings. Heckel, Pechstein, and Schmidt-Rottluff remained in Berlin but spent their summers on the land, often at various Baltic beaches; Pechstein and Nolde both made voyages to the South Seas just before the war, in search of a Gauguinesque paradise. Otto Mueller moved to Breslau in 1919 to accept a teaching post and for the rest of his days proceeded to paint chiefly landscapes and scenes of gypsy life. Kirchner, after a mental breakdown during the war, settled near Davos, Switzerland, saying he was through with the city and the Brücke* and finding a new mission in the depiction of the Alpine landscape and local

*The Brücke had been dissolved in 1913. Now Kirchner was at pains to minimize the originality of the other members and to deny his own debt to the group. (*See* his letters to the museum director Max Sauerlandt in the Sauerlandt Nachlass, Hamburg, Staats- und Universitätsbibliothek; and Lothar Grisebach [ed.], *E. L. Kirchners Davoser Tagebuch* [Cologne: M. DuMont Schauberg, 1968], *passim*.)

peasantry.[21] He began to dress in peasant garb and, until his suicide in 1938, lived in a crude mountain hut which he decorated with hand-carved furniture and reliefs. Nolde, the son of a Schleswig peasant, a member of the Brücke only between 1906 and 1907, never did tear himself away from the land. He had come to painting late in life and always retained a love of the soil and a suspicion of the city. He once described himself as "a plain old ordinary farmer." When he first moved to Berlin, in 1901, he looked for a studio in suburban Halensee. Dismayed by the crowds celebrating the Kaiser's birthday in January, 1902, he wrote: "This 'city of millions'! No man is near to my heart; I am lonely as never before. These straight, long, hazy streets, all this wretched public—I don't want to be here. . . . I long for the pure life of nature, for sunshine, for the west wind beating the waves against the land."* Though he painted urban outcasts, the peasantry was his preferred source of inspiration. After his trip to the South Seas Nolde settled in his native province, moving henceforth between Denmark and Germany but, aside from winters in Berlin and occasional voyages, staying in the flat farmlands of Schleswig.

City painters usually incorporated the imagery of modern life into their art, even when they regarded it negatively, as did the Brücke. The machine was a basic component of Orphist and Futurist painting, just as street and café life furnished subjects for Fauvism, Futurism, and Dresden Expressionism. But those who moved to the country felt that urban life and newfangled innovations (especially the products of industry and technology) were destructive of the depth of feeling and self-examination required for their "spiritual" art. Macke, contented in sleepy, conventional Bonn, wrote Marc in 1910: "How people used to become immersed in themselves!— hence their great art. Today they become immersed in subways and coffeehouses. But painters flee into solitude and work by themselves. That is perhaps not seasonable and modern, but, I think, it is beneficial for art."[22] Marc, newly arrived in Sindelsdorf and delighted to be away from "that noisy Munich of other years," concentrated increasingly on his two loves, the rugged Bavarian landscape and animals, which eventually became his sole subject matter. Kandinsky and Münter likewise continued to move

*The birthday celebration in the streets particularly offended his esthetic sense: "Thousands of hideous busts of the Kaiser in dead plaster. Such a miserable production leers at me from every second window—the worst possible art. . . . It is swarming with officers in gala dress. . . . On every corner stand three policemen. Let me run away, far from here, very far!" (Nolde, *Briefe aus den Jahren 1894–1926,* letter of January 27, 1902, pp. 38–39.)

away from the human figure and from social commentary (never the Munich Expressionists' strong point). These painters could later claim with more justice than most that they had always been apolitical.

III

The flight of some artists to the country and of others to the poorer quarters of cities had various causes: personal predilection; economic necessity; political affinity; the desire to escape sycophants and critics. Many clung to poverty with an inveterate fear of public recognition. Great art could come only out of loneliness, they felt,* and fame would inevitably weaken an artist's creative power. One could avoid commercialization only so long as one's work remained unmarketable.† But they never actually rejected the system governing the art market. And most came to accept and enjoy fame and fortune.

One group of writers, musicians, and painters had an alternative way of life: the commune. By doubling as artisans, they thought, artists would be able to earn a living, have complete creative freedom and escape the growing commercialization of art and life.

Several young writers, poets, painters, draftsmen, musicians, profoundly devoted to their art, who, without independent means, would live by their pen

*Thus wrote Nolde in a letter of October 20, 1923: "Maybe some future age will see this isolated stance of the artist as precisely what was good and special about our era."

†On October 20, 1923, Juan Gris, in a letter to D. H. Kahnweiler, said about Matisse, "There's no doubt, painters become unbearable when they are successful." With Karl Schmidt-Rottluff, Julia Feininger spoke in 1913 "about work and success, about becoming recognized, and how bad it is when one comes into the public eye too soon, is prized, then outmoded and forgotten—thus practically experiences his own death. Thus he is lucky who is not recognized before he is 50. Schmidt-Rottluff wishes he could go backwards, since he is already somewhat known; he envies you, who are not yet 'public' at all." (Feininger Papers, Houghton Library, Harvard University, transcripts, I [April, 1913], 214.) Feininger himself wrote years later to a friend: "For many years I have quite intentionally avoided too much 'publicity.' 'Publicity,' as they practice it here, must be avoided by the creative man. It is based too much on mode and popular taste, which he cannot make use of if he wishes to follow his course to the end without being sidetracked. . . ." (Excerpt from a letter of December 15, 1953, printed in Stargardt-Marburg, *Auktionskataloge*, No. 555 [1961], p. 949). Kirchner to Helene Spengler: "So-called great recognition becomes me not at all: all my life I have been a pioneer and have never cared a fig what the little people were saying . . ." (Grisebach, *Maler des Expressionismus* . . . , letter of May 8, 1919, p. 107.) Marcel Duchamp recalled that the New York dealer Knoedler offered him $10,000 per year in 1916 for his entire production: "I sensed the danger right away. Until then I had been able to avoid it." (Cabanne, *Entretiens avec Marcel Duchamp*, pp. 202–3.)

and their brush, refuse the compromises and the low actions to which they are condemned.

Little mindful of official endorsement, they ardently desire to keep clear of base intrigues and betrayal of principles. In this spirit, and far from utilitarianism and rapacity, they are founding their "Abbaye"; they are creating—all things relative—a sort of FREE VILLA MEDICIS,* whose guests, tied to no yoke, retaining their individuality, will be able to work in total tranquility, communicating their enthusiasm, combining their needs, pooling their resources.

To increase the resources of their respective arts they are creating and exploiting, in their "Abbaye," a printing and lithographic workshop and an art publishing house, of which they themselves will be the artisans, thereby adding to their intellectual travail the necessary complement of manual labor.

So begin the statutes of the "Abbaye de Créteil."[23]

At once "a phalanstery, a cooperative, and a convent," according to Georges Duhamel, the Abbaye was the product of a friendship which began around 1904 between five young men: the painter Albert Gleizes and the writers Charles Vildrac, Alexandre Mercereau, René Arcos, and Duhamel. Vildrac and Mercereau had been contributors to a short-lived review, *La Vie* (*Life*); Duhamel was writing on the side while studying medicine; Arcos and Gleizes were working unhappily as textile designers in Gleizes' father's factory. Dismayed over their inability to live by their art in a capitalist society, influenced by the artistic and political radicals of the Symbolist generation—Gustave Kahn, Felix Fénéon, Paul Adam, and others—and imbued with communitarian ideas drawn from Rabelais, French and English Utopian Socialists (Fourier, William Morris), nineteenth-century novelists (Tolstoy, Zola), and perhaps also Kropotkin,[†] they sought, said Gleizes, a simple, secluded life resembling the ideal they thought Gauguin had found in Tahiti.[24]

Rejecting, like so many other artists, contemporary social values, they turned toward the workers, with whom, they assumed, they had in common economic exploitation and a thirst for beauty, if not comparable levels

*The Villa Médicis, seat of the French Academy in Rome, was reviled by the avant-garde as the bastion of academicism and philistinism.

†Later writing as an enthusiastic Bolshevik, Mercereau claimed the influence on the Abbaye of social revolutionaries and went on to mention the "pacifism and humanitarianism" of Christ, Karl Marx, Tolstoy, Lenin, and Trotsky. The anachronism aside, this is probably farfetched. But so is Duhamel's post–World War II assertion that ". . . we were unaware of the ideologists of collectivism; we had read only Rabelais, Vallès, Rimbaud, poets, above all poets." (*Le Temps de la recherche*, vol. 3 of *Lumières sur ma vie* [Paris: Paul Hartmann, 1947], p. 42.)

of culture. Many of their early works had dealt with social subjects. Under the influence of the Samedis Populaires, Gustave Kahn's experiment in popular education, Gleizes, Mercereau, and Arcos had established the Association Ernest Renan, a people's university in which they sought to provide workmen with the education necessary for an understanding of contemporary society and contemporary art as well.[25] Duhamel mentions a "Manifesto of the League of Independent Artists" of around 1906 which he signed with Arcos, Vildrac, Jules Romains, and Gleizes, and which was a bitter attack on the current state of art patronage: "French art is wilting under official protection. . . . To the inertia of the masters of the stereotype, we oppose our combativeness. . . . We wish to remain individuals, masters of our concepts and thoughts while at the same time profiting from the advantages of practical solidarity . . ."[26]

They determined to found an artists' colony and learn some manual trade in order to become self-supporting.* The printing of books and engravings seemed a natural choice, for they would then be able to publish their own works. In a manifesto of 1906 they appealed to young artists to join them and help provide the funds necessary to launch the colony. The appeal attracted Henri Martin Barzun, a young poet who was secretary to the prominent Socialist Deputy Joseph Paul-Boncour and who was able to help finance the project. In the fall of 1906 they rented and began repairing an abandoned house set in a beautiful park in Créteil, 20 kilometers southeast of Paris. Here they would live in seclusion and yet remain in touch with cultural events in the capital. They were joined by a printer named Lucien Linard, who had met Gleizes during their military service. Linard was to teach the colonists typography. Each would work four or five hours a day in the print shop and spend the remaining time as he wished. Other artists, including the painter Berthold Mahn, the writer Jules Romains, and the musician Albert Doyen, joined the seven founders temporarily or permanently.† Each brought his own furnishings; several brought their families. Rose Vildrac, Duhamel's sister, did the cooking.

*"All the same," Duhamel said, "we were not so crazy as to imagine, even in our rapture, a life free of all care, even, for instance, from work and wages. We needed a trade and the gospel of Tolstoy guided us to choose a manual trade."

†Doyen later organized Les Fêtes du Peuple, mass celebrations featuring largely proletarian choral concerts. Planned already before the war but organized only in 1919, the Fêtes usually commemorated popular events, such as the Paris Commune, or leftist heroes such as Jean Jaurès. (See Jean Marguerite, "'Les Fêtes du Peuple': L'Oeuvre, les moyens, le but," Cahiers du travail [Paris: (1921)], passim.)

They bought all their food rather than grow at least some of it, a financial blunder which contributed to the demise of the community after a year.* "We took our meals together," Duhamel later reminisced, "affirming in this way the meaning of the words 'brotherhood' and 'comrade.' We experienced with delight the feeling of liberty. We had put our Paris clothes away in the closet. . . . We wore wooden shoes."

In the summer of 1907 they organized a fete in the park of the Abbaye, at which actors recited their poems; they held an art exhibition, featuring their own works and those of the Rumanian sculptor Constantin Brancusi, the Italian illustrator Umberto Brunelleschi, and others. Marinetti and his later Futurist comrades-in-arms Valentine de Saint Point and Ricciotto Canudo were frequent guests at the Abbaye. In all, the Abbaye printed elegant editions of about fifteen books, including the members' own poetry and works of the Anarchist Mecislas Golberg, the writer Roger Allard, and the poet Pierre-Jean Jouve. The first publication (under the Abbaye's imprint but printed elsewhere) was *L'Art et la nation*, a speech given by Paul Adam in 1906 glorifying the arts as the fountainhead of the nation's culture and thus of its history.[27]

The financial planning of the "cenobites" was impractical, to say the least. The print shop never made a profit, and there was no alternative means of support. And, like many utopians before them, they discovered that communal life was neither so easy nor so serene as they had supposed. "We soon understood that we had left our families only to form a new one," Duhamel later wrote. Dissension developed; some members left in the autumn of 1907; the rest held out until, early in 1908, they found themselves unable to pay the rent.

Apart from the few collections of poems, which Daniel Robbins considers an important contribution to Cubist and Simultaneist theory, the Abbaye produced nothing tangibly revolutionary. And few artists chose to follow its example. Yet it was a significant episode. With better planning and organization it could have provided not merely an escape from the city, but a real alternative to the artist's condition in a market economy. It influenced the planning of postrevolutionary Russian and German artists, though no actual communes grew up. Most avant-gardists, however, proved either uninterested in such communes or unwilling to organize as strictly as was needed to succeed.

*Gleizes was careful not to repeat this blunder when, in 1927, he founded Moly-Sabata (in Sablons, Isère, on the Rhône), which continued until World War II and attracted weavers and potters as well as painters.

IV

The avant-garde became legendary less as a result of its works in themselves than for its ability to shock: a reputation for bizarre and unacceptable behavior that went with its bold artistry. Shock tactics were an indispensable part of certain art forms, particularly of Italian Futurism, which sought to force the Italians out of their cultural lethargy, and, beginning in 1916, of Dadaism, which sought through ridicule to publicize the bankruptcy of social, moral, and cultural values that had brought about the bloodiest war of all. The Futurists' *serate* were deliberately loud and riotous, as, later on, were the Dadaists'. Marcel Duchamp exhibited a urinal instead of a painting to dramatize his contention that traditional art forms had become shopworn and sterile. The repeated *succès de scandale* of some artists' demonstrations gave all the avant-garde a reputation for deviant behavior. These iconoclastic manifestations aside, the derision heaped upon their unconventional paintings often spilled over onto their persons, assumed to be correspondingly peculiar. The press of every country labeled them hooligans, neurotics, psychotics, advocates of free love (which a few of them were), and even nefarious subversives of the national spirit.

The private lives of most avant-gardists only mildly contravened bourgeois conventions. In appearance they resembled young members of the middle or working class. The many extant portraits and photographs show neatly dressed young men, usually in dark suits and vests, indistinguishable from young doctors or lawyers of their day—or, for that matter, from other "shocking" contemporaries, such as psychoanalysts or Bolsheviks. Some had, perhaps, dressed up for the photographs; in any case, most dressed to suit their untidy work and popular surroundings. Valuing comfort above elegance, Picasso and Braque customarily sported workmen's blue cotton trousers and shirts. And a potential patron, on first meeting two Brücke artists, thought they looked like ordinary working people, Heckel giving the impression of a tailor and Kirchner, despite his "long artist's hair," of "a regular shoemaker, awkward and stubborn. . . ."[28] Judging by photographs and eyewitness accounts, Soutine, Vlaminck, and Kupka were even shabbier than either Brücke or Cubists; the Futurists wore dark suits to their *serate* (only to have them covered with pasta and rotten tomatoes by their audiences); the Blaue Reiter affected Bavarian country garb for everyday wear; and a few painters, not-

ably Modigliani, dressed elegantly whenever they could afford it. Picasso found Modigliani the best-dressed man in Paris; Modigliani thought Picasso one of the worst.[29] But, not excepting the few dandies, the twentieth-century artist unlike the nineteenth-century one had no distinctive attire—no smock, no beret, no flowing tie.

Many artists did refuse to adhere to contemporary standards of industry, regularity, and social decency and, full of youthful high spirits, demonstrated a mischievous streak that occasionally got them into trouble. The Futurists' frequent brawls, which often led to arrests, were certainly felt to be enjoyable as well as ideologically indispensable. Picasso and his friends delighted in practical jokes, in occasional boisterous public behavior, with Picasso himself occasionally firing a revolver out of exuberance or to get rid of sycophants. The Brücke painters lived openly with models or dancers, taking them to the country to paint nudes out of doors, much to the astonishment of the locals. Some drank and used opium or hashish, but only rarely in excess, as with Modigliani. Paul Alexandre, a doctor and collector of contemporary art who believed in the moderate use of drugs, started an artists' colony on the rue du Delta in Montmartre, where he organized weekly "hashish evenings."

Above all, painters did not appear to work like "ordinary" people, although most actually worked assiduously. The irregular hours they kept were, or at least seemed to them, the proper schedule for the nonacademic paintings they desired: regularity, they felt, would lead to conformity and loss of initiative. Near death in 1926 and condemned to live prudently, Juan Gris, in a letter to Gertrude Stein, fretted: "I'm getting so used to it that I'll turn into a barbarian." On the other hand, Marcel Duchamp, recalcitrant by temperament, took a volunteer's job at the Bibliothèque Sainte Geneviève in 1913 precisely in order to distance himself from the irregular ways of the avant-garde. But usually he made a point of not working, even at artistic pursuits, preferring chess-playing to painting for long periods: in a 1966 interview he confessed, ". . . I have never worked to earn a living. I consider that rather imbecilic from the point of view of economics. . . . I understand that one shouldn't weigh life down with too many things to do, with the proverbial wife, children, country house, automobile."[30] In fact, he was married for a few months in 1927, and did not remarry until 1954, when raising a family was no longer a consideration.

For most artists, their surroundings, their habits, and their art were all of a piece. The Brücke and Blaue Reiter artists created their own surround-

ings by building or painting their furniture and decorating their walls with frescoes—and then included their studios in many of their paintings. The Cubists chiefly painted the simple still-life objects available in their studios or in cafés. On their summertime jaunts in the woods, the Brücke painted their models—and even each other—enjoying the outdoors in the nude, doubtless as their little colony actually behaved on such occasions (Fig. 14). Kirchner reminisced years later that the Brücke's "way of life, profession and work, appearing at least odd to the normal person, was not a conscious 'épaté le bourgeois' [sic] but, instead, a completely naïve, unalloyed necessity to bring art and life into harmony."[31] Pechstein, in a "creative confession" of 1920 that was prophetic of Abstract Expressionism, emphasized the physicality, unconventionality, and ultimate sensuality of the artist's creative act:

> Work!
> Frenzy! Brain shattered!
> Chew; eat, fling; rummage!
> Delicious pain of childbirth!
> Rattling of brushes; at best
> Piercing of canvases.
> Trampling of paint tubes.
> Body?
> Secondary consideration.
> Health of same?
> Can be forced.
> There is no sickness! Only the sickness of work and—let's say it again—blessed work!
> To paint! To wallow in colors, to roll in tones!
> In the chaotic slime!
> Mouth chews at the bitten end of the pipe; naked feet press into the ground.
> Craftily the drawing pencil, the pen, bores into the brain; embroiders the last corner;
> Becomes frenzied and presses down on the white sheet.
> The black laughs devilishly on the paper, grins in bizarre lines and comes to rest in soft planes; arouses and caresses.[32]

In their liaisons, most artists were as conventional as could be—that is, they usually married and often raised families, but also frequently took fidelity rather lightly. There is virtually no evidence of homosexuality, at least of an enduring sort, and most sexual experimentation amounted to no more than a youthful phase. Many painters (Matisse, Severini, Klee,

Macke, Heckel, Feininger, and others) had long and happy marriages; quite a few (Van Dongen, Mueller, Kandinsky, Kirchner, and others) divorced after long marriages or liaisons; relatively few (Picasso, Modigliani, Kokoschka) changed partners frequently, and even they practiced serial monogamy with, perhaps, occasional infidelities. Most had children, but rarely more than one or two; Kandinsky, Duchamp, Braque, and many others remained childless. Several of the wives and mistresses had artistic or theatrical backgrounds. A few were models or dancers; many more, painters or musicians. Aside from those few who became reputed avant-gardists, many of the wives dropped previous studies or careers, often promising ones.

Modigliani, with his miserable, disorderly, and relatively short life, comes closest to the accepted image of the Bohemian: a handsome, generous, gifted artist who, under the influence of drugs and alcohol, tended to become querulous, melancholic, insecure, and suspicious; a man incapable of regulating his daily life, balancing his budget, or of permanent relationships. Yet, for all of this, he was often industrious to the point of fanaticism, producing a large number of carefully executed works during his last years, despite increasing debility brought on by tuberculosis as well as drugs and drink. And, despite his infidelities, his commitment to Jeanne Hébuterne, who bore him a daughter and who committed suicide immediately after his death, was deep and lasting, up to a promise of marriage made just before the end.

V

The misery and insecurity of the innovative artist's life before World War I are undeniable. The memoirs (however misleadingly nostalgic), diaries, and correspondence, and the few figures available on art prices and the cost of living testify to this. But all artists were not equally destitute; nor did all, even at first, lack supporters and patrons.

It was certainly easier for artists in the big cities of Europe to live on little before World War I than it is now. Rents were low, food and clothing cheap, and there were fewer material "necessities." Although reliable figures for the cost of living in Europe before 1914 are not available, the artists occasionally kept track of the cost of things, and there was virtually no inflation between 1900 and 1914. Max Beckmann itemized his expenses

during four days of touring in France in 1904: his lunches and dinners in fairly luxurious restaurants averaged two francs; hotel rooms (with breakfast apparently included) cost about the same. In the poorer quarters of Paris a meal could be had for one franc or even less; Georges Duhamel claimed he managed to eat, take the Métro and occasionally buy some clothing on 60 francs (12 dollars) a month—2 francs per day—around 1905. Gino Severini said he was able to manage in Rome soon after 1900 on a workman's salary of 50 lire (10 dollars) a month; Otto Dix lived on a stipened of 40 marks (10 dollars) per month while attending the School of Decorative Arts in Dresden around 1910; Boccioni paid 22 francs ($4.40) per month for a hotel room in the Latin Quarter in 1906; and Oskar Maria Graf remembered paying even less than that for a modest room in Munich around 1910.[33] A struggling, though not avant-garde, painter in Munich named Adolf Hitler reported his 1913 income as approximately 100 marks (25 dollars) per month, later claiming he had never spent more than 80 (20 dollars) since he had avoided tobacco, drink and women.[34] Ateliers at the Ruche probably cost between 50 and 75 francs (10–15 dollars) annually—4 to 6 francs a month— in the late prewar years. Around 1910, Picasso, already beginning to prosper, nevertheless sent to Leo and Gertrude Stein, who had promised to help him, a reckoning of his expenses for three months:

Azon's bistro [food and drink]	250 francs
Atelier	130
House [apartment]	110
	490 francs [98 dollars][35]

Life in the country was cheaper. Leonhard Frank describes a Bohemian couple living in a room in a Bavarian peasant's house for 4 marks (1 dollar) a month—about the same as rent at the Ruche, which was certainly the cheapest and shabbiest of the Parisian artists' dwellings.

These figures give an idea of the minimum monthly living expenses of an urban painter: between 5 and 25 francs for a studio, 60 francs for meals, and another 50 for drink and incidental expenses—perhaps 125 francs (25 dollars) in all. But this does not include the cost of materials—canvas, paints, brushes—and models' fees. In 1910, skilled Parisian laborers earned comparable sums for working ten hours a day, six days a week: 192 francs per month for the average plumber; 216 for the average carpenter.[36] Memoirs indicate that most painters found it difficult to get enough money

to live on. However, independent corroboration is not readily available. The prices asked or paid for paintings are often documented, but how many were sold per year? It was not unusual for a painter to have to live many months on the proceeds of a single painting, or go for years without making a sale. The worker at least had some security.

There were economic gradations within the avant-garde. Matisse, Picasso, and Kandinsky were relatively well-off after 1910. Matisse, ten years older than most of the others (except for Kandinsky, Feininger, and Nolde, who were his near contemporaries), had steady customers—the Steins and two Russian entrepreneurs, Sergei Shchukin and Ivan Morosov—and, starting in 1909, an exclusive contract with the prestigious Galerie Bernheim-Jeune. Between 1909 and 1915, Bernheim bought his entire production, paying him from 450 francs for a small painting to 1,875 for a large one, plus 25 percent of the profit on sales.* In 1910 he was able to buy a small country house just outside Paris and live in modest comfort. Picasso, though less well off, likewise had buyers, including the Steins and the two Russians: his Blue and Rose Period works attracted many who were later scared off by Cubism, including the celebrated dealer Ambroise Vollard, who had championed Cézanne. In 1908, La Peau de l'Ours, a society formed to invest in the work of young artists, bought his "Famille de Saltimbanques" ("Circus Family"), one of the best works of the Rose Period (1904–1906), for 1,000 francs (200 dollars), then an enormous price for an avant-gardist work.† Nevertheless he remained poor until around 1909, when he was able to leave the Bateau Lavoir for more spacious and comfortable quarters. Kandinsky, whose family had helped him financially for years, was able by about 1912 to demand huge prices for works he considered developmentally crucial. He instructed Herwarth Walden to ask 10,000 marks (2,500 dollars) for his "Composition Number 2," a transitional painting between representational and nonrepresentational art.[37] Beginning in 1908 he was able to pay 1,400 marks (350 dollars) a year for a Munich apartment.

But Nolde was still in difficult straits at the age of forty-two. In 1912 he

*In later contracts the prices rose only as the franc fell: by 1923 they were four to five times those of 1912. (Contracts reprinted in Alfred H. Barr, Jr., *Matisse: His Art and His Public* [New York: Museum of Modern Art, 1951], pp. 553–55.)

†When the society's splendid collection was liquidated in 1914, this painting brought 11,500 francs; in 1931 it was resold for over one million (perhaps 200,000 prewar) francs. (Ambroise Vollard, *Souvenirs d'un marchand de tableaux* [Paris: Albin Michel, 1937], p. 80.)

explained to a friend that he and his wife were no longer in "absolute need," not because of plentiful sales, but rather because they had managed to borrow considerable sums. In a letter dated June 26, 1931, Lily Klee told of her husband's hard beginnings:

> When Klee ended his studies . . . his parents had no savings left to allow him to create . . . as a free man. For four whole years he had to remain in his parents' house, buried in his workroom, in the most straitened financial circumstances. . . . Then we married and moved to Munich: then eight or ten more years went by before he sold his first picture. . . . Klee worked from 1902 to 1919—that is, about seventeen years—before we could even talk about some sort of material independence through artistic work. . . .[38]

One of the poorer Germans, Heinrich Campendonk, told Walden that before the war the Frankfurt dealer Alfred Flechtheim had "bought . . . pictures from me . . . by the dozen—that is, I gave him everything and, when he was able to sell something, he gave me 75 marks a month."[39] Juan Gris was among the poorest of the lot, attaining a modicum of success only a year or two before his death in 1927. Before 1914, he received only 160 francs, and in 1915 only 240 francs, from his dealers for his largest canvases.[40]

Of the less prosperous artists, those living in France and able to sign exclusive contracts with dealers were the most secure. In the beginning it was only possible to sell works piecemeal to a small number of willing dealers and collectors or to display them in a shop like that of "Père" Clovis Sagot, the junk dealer, and hope someone would see and buy them. (That is where Leo and Gertrude Stein first came in touch with Picasso.) Then Daniel Henry Kahnweiler arrived in Paris, made friends with young Fauves and Cubists-to-be, and revolutionized the contemporary art market. Having received a small capital from his banker uncles, and given a year to prove himself worthy of more, he bought up the total output of such artists as Picasso and Braque at low prices that varied, as was customary, with the size of the paintings,* signing exclusive contracts whenever possible. The dealer's investment was small, but he faced an often long and sometimes fruitless wait for buyers. As a rule, the painter received only a

*The various sizes of canvases were assigned key numbers from 6 or 8 for the smallest to 40 or 50 for the largest. The number was then multiplied by a basic figure written into the contract: in Gris' arrangement with Kahnweiler, for example, 4 francs per unit. Thus Kahnweiler paid him 24 francs for a number 6 canvas and 160 francs for a number 40.

small percentage of the eventual selling price, but he had a steady income as long as he was able to work. In Germany and Italy there were no such arrangements. The dealers merely sold on consignment for 10 or 15 per cent of the sales price. In the end, only those avant-gardists who lived beyond the age of forty-five or fifty (though by no means all of those) attained financial security.

In their correspondence with dealers—who were usually also close friends—the artists forever and apologetically asked for money, and it seems fair to conclude that they often exaggerated their misfortune. They typically wrote little about their artistic theories but much about their living conditions and financial problems.* (The scant esthetic perspicacity of most dealers—*pace* Kahnweiler—may account for this.) However, their more personal writings (diary entries, letters to other artists) show a detachment toward material well-being and a fear of prostituting themselves. Picasso and Braque had the courage to stop exhibiting (except in Kahnweiler's gallery) and wait for customers to come to them. Marc and Macke would have liked to do the same. Marc told Macke in 1913: "If I only could, I would exhibit nothing for the next five years. This horrible 'need to sell'!"[41] "I am not discouraged over my own powers," wrote Boccioni in his diary in 1907, "but over my financial means, which don't ever seem to increase without the most ignoble self-prostitution."[42]

However hesitant to exhibit or unable to sell, avant-gardists did nevertheless receive considerable exposure before the war, though they usually met with incomprehension and derision. But a few galleries in the major cities were willing to show them, and even those painters who shunned the salons found places to exhibit. Before the war, the Futurists exhibited in Paris, London, Berlin, Brussels, and Amsterdam as well as in Italy; the Brücke exhibited at two galleries in Dresden between 1906 and 1910 before finding greater opportunities in Berlin; the Blaue Reiter held its societal exhibitions in Munich galleries; more important, the avant-garde organized sweeping international shows, such as the Cologne Sonderbund

*Jawlensky, for example, wrote Walden just before the outbreak of the war: "I had dearly hoped the money would come in, as you said in your letter. I am now feeling hopeless, for I haven't a single penny and it is becoming more and more difficult to get money from other quarters." (Letter of June 30, 1914, Sturm-Archiv, Carton 4.) In an undated letter, Kokoschka wrote Walden: "For the last two months I have been in a horrible situation—I can't seem to get ahead of my debts." (*Ibid.*, Carton 5.) In 1921 Gris asked Kahnweiler for 1,000 francs (200 prewar francs) per month to cover living expenses. (Gris, *Letters*, December 7, 1921, p. 130.)

exhibition in 1912 and Walden's Erster Deutscher Herbstsalon (First German Salon d'Automne) in 1913.

The patrons of modern art were overwhelmingly of middle-class extraction. They were acceptable to the artists either because they too were renegades, like Gertrude and Leo Stein, or because they were comparatively enlightened about art. The most important dealers came of well-to-do families, often Jewish, or had married into wealth. The majority were German. The buyers were an international group, including the Steins (the writer Gertrude, her philosopher-esthete brother Leo, their businessman brother Michael and Michael's wife, Sarah), other Americans under the Steins' tutelage (the Cone sisters, for example, whose magnificent collection of Matisses is now in the Baltimore Museum), the American lawyers Arthur Jerome Eddy and John Quinn, the French doctor Paul Alexandre, couturier Paul Poiret and Socialist Deputy Marcel Sembat, the German professor Eberhard Grisebach, the Russians Shchukin and Morosov,* the English educational reformer Sir Michael Sadler, and the Italian pianist Ferruccio Busoni. The artists of the Blaue Reiter were helped—at times practically kept alive—by Lisbeth Macke's uncle Bernhard Koehler, a Berlin manufacturer who bought out of sympathy and predilection, if sometimes hesitantly.† The Brücke enrolled lay, or "passive," members, who received a portfolio of graphics in return for a fee of 12 marks per year. A woodcut list of members for 1909 includes a few relatives and the supporters one might expect: Hans Fehr, an old friend of Nolde's and professor of decorative arts; Rosa Schapire, art historian and energetic champion of the Brücke; Count Harry Kessler, liberal aristocrat and patron of modern art. But the majority of its 48 members were doctors, architects, professors, and manufacturers. One was a baroness, one an engineer, one a lower court judge, one the president of a county court. However close the avant-garde might have felt to "the people" economically and ideologically, and whatever theoretical support the political Left might have lent them, it was not from those quarters that their meager finances came.

*Their collections are now in the Hermitage in Leningrad and the Pushkin Gallery in Moscow. Matisse reportedly said Shchukin always chose his best paintings and insisted on buying them, even when *he* insisted they were not for sale. (Ilya Ehrenburg, *Post-War Years, 1945–54*, trans. Tatiana Shebunina [London: MacGibbon and Kee, 1966], pp. 105–06. *See also* John Russell, "The Man Who Invented Modern Art Dealing," *Vogue* [September 15, 1965].)

†Much of Koehler's collection is in the Städtische Galerie im Lenbachhaus in Munich. On his philanthropies and his hesitations, see Macke and Marc, *Briefwechsel, passim*.

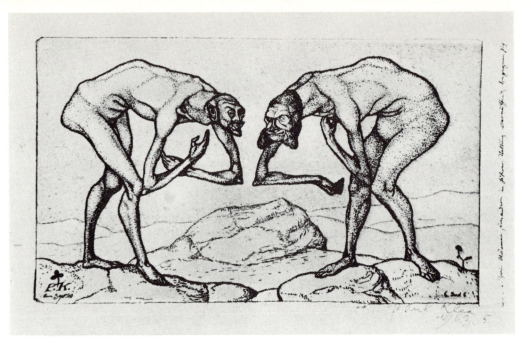

Fig. 15. Paul Klee, *"Zwei Männer, einander in höherer Stellung vermutend, begegnen sich"* (*Two Men Meeting, Each Believing the Other to Be of Higher Rank*), 1903. Munich, Städtische Galerie im Lenbachhaus.

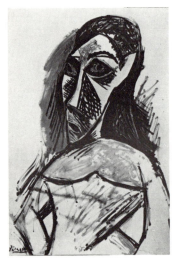

Fig. 16. Pablo Picasso, study for *Les Demoiselles d'Avignon*, 1907. Paris, collection Berggruen.

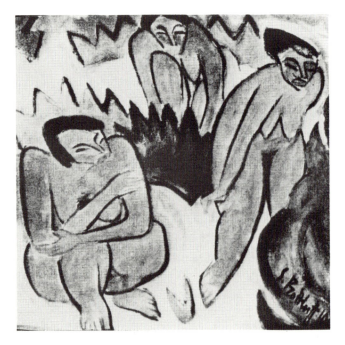

Fig. 17. Karl Schmidt-Rottluff, *Three Red Nudes*, 1913. Berlin, Galerie des 20. Jahrhunderts.

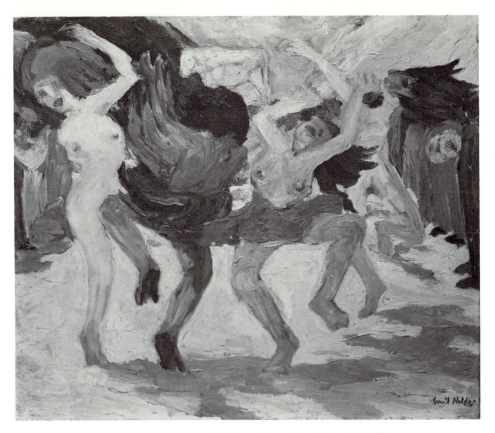

Fig. 18. Emil Nolde, *The Dance Around the Golden Calf*, 1910.
Munich, Bayerische Staatsgemäldesammlung.

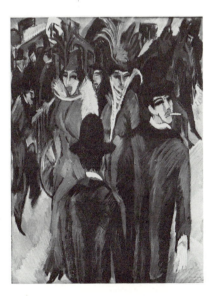

Fig. 19. Ernst Ludwig Kirchner,
Berlin Street Scene, 1913.
Frankfurt, Städelsches Kunstinstitut,
on loan from a private collections.

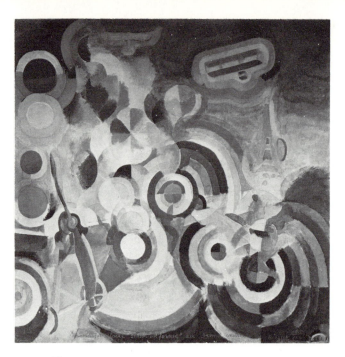

Fig. 20. ROBERT DELAUNAY, *Homage to Bleriot*, 1914.
Paris, collection Gazel.

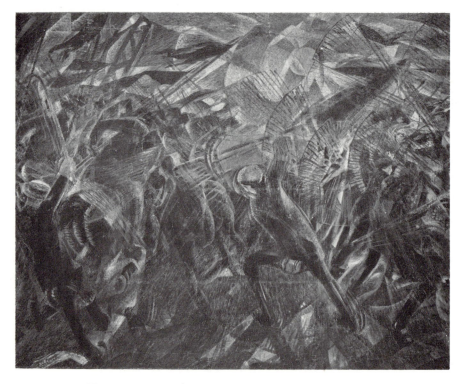

Fig. 21. CARLO CARRÀ, *The Funeral of the Anarchist Galli*, 1911.
New York, Museum of Modern Art.

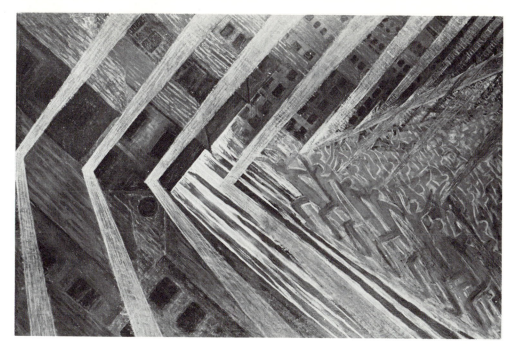

Fig. 22. Luigi Russolo, *The Revolt*, 1911. The Hague, Gemeentemuseum.

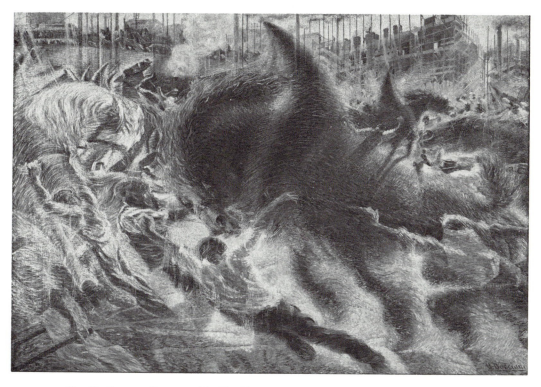

Fig. 23. Umberto Boccioni, *The City Rises*, 1910. New York, Museum of Modern Art.

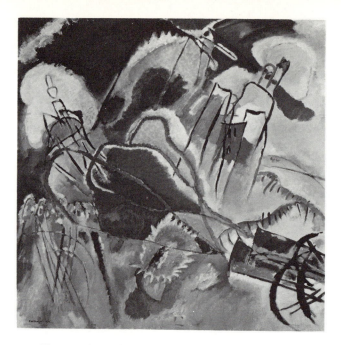

Fig. 24. Wassily Kandinsky, *Improvisation No. 30 (Warlike Theme)*, 1913. The Art Institute of Chicago.

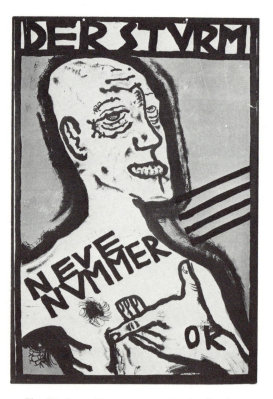

Fig. 25. Oskar Kokoschka, poster for *Der Sturm*, 1911. Krefeld, Kaiser Wilhelm Museum.

Fig. 26. PAUL KLEE, *Warlike Clan*, 1913. Stuttgart, Staatsgalerie.

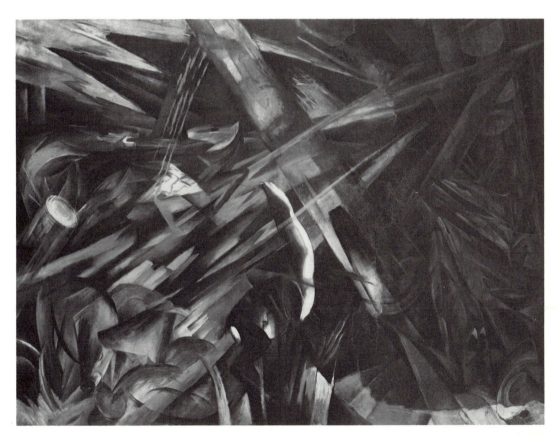

Fig. 27. FRANZ MARC, *The Fate of the Animals*, 1913. Basel, Kunstmuseum.

The Social Content of Modern Art

. . . we should no longer be alienated or disturbed, because the ever-new, ever-developing element—the artist—compels us to change ourselves according to his will and not, like shopkeepers, to regard the things of today as the last word.

ERICH MENDELSOHN[1]

During the last seven or eight years before World War I, many painters ceased to manifest their social sympathies. Ostensibly they were now exclusively concerned with elaborating those styles with which they are today identified, and they almost unanimously deny that they paid much attention to contemporary world events or political questions.

It seems to me, however, that the break they then made with *artistic* traditions, and the terms in which they explained it, resulted at least in part from the same attitudes that had earlier driven them to reject the social ethos of their elders. Their protest now went underground: having succeeded in establishing themselves independently of their families, convinced of the futility of their own and the socialists' and anarchists' attempts at political revolt, and dismayed by the tendency of socialism itself to succumb to opportunism, they sought within their art to correct their surroundings by denying them outright. So, following Vlaminck, Derain, and Kupka, who had early internalized their social revulsion, other painters now ceased altogether to represent both the bourgeois and the proletarian worlds—painted them out of existence, as it were. Still others retained representation but turned contemporary taste topsy-turvy: they represented, and declared "beautiful," the industrial landscape, and they destroyed the accepted geometrical relations between objects, injecting the notion of time (Cubism, Futurism) or juxtaposing incompatible objects

(Surrealism). In their divergent styles, most of them were concerned with replacing the Realists' overwhelmingly materialistic representation of nature either with an "objective" form of representation based on time and abstract physical laws, or with a subjective, highly personal one. Neither version had much to do with visible reality, nor anything to do with the public's expectations of art. Seen in this light, modern art is, perhaps, the ultimate act of anarchism. To be sure, after destroying the old stylistic groundwork, the avant-garde rebuilt on new foundations, but the new art was henceforth based on the perceptions and cerebrations of the *individual artist*—by no objective standard could his contribution be assessed.

I do not wish to deny that modern art was the logical—though not inevitable—extension of certain earlier trends in pictorial representation, such as the Postimpressionism of Van Gogh, Munch, and Cézanne, and the Neoimpressionism of Seurat. I mean that it was more than this—that it also had a social sense of which the painters were at least dimly aware. The evidence for this is the very terms in which they almost unanimously sought to explain and justify what seemed to them a total rejection of the Western post-Renaissance painterly tradition. Whether or not they did rid themselves of this heritage is immaterial here; that was what they desired to do and adamantly claimed to have done. While the social content of a nonrepresentational work may not be obvious, that is no reason to assume it does not exist.

I

Painters expressed disdain for the bourgeoisie and the academicians as strongly while developing their mature styles as during their early period of political activism and artistic apprenticeship. Georges Ribemont-Dessaignes, the French Dadaist and Surrealist writer who had been a novice painter before the war, later perceptively attributed the number and virulence of prewar avant-garde movements to a widespread desire to find "a new, clean, habitable terrain" beyond the confines of the middle class.[2] The "philistines"—"*les pompiers*" (the pompous), as their French detractors dubbed them—were castigated for subsidizing the moribund academy and preferring to patronize skilled imitators rather than bold, original talents. Some avant-gardists felt that the spread of liberal democracy, with its adjunct, universal but superficial education, had brought a decline in

taste and understanding, at least among art patrons. Early in his career, Paul Klee in his diary ridiculed the effect of Swiss commercialism on art. "Democracy with its semiculture sincerely supports kitsch," he wrote in 1906.

> The artist's power was supposed to be spiritual. But the power of the majority is material. Wherever these two worlds occasionally meet it is totally by chance.
> In Switzerland the people should be honest and prohibit art by law. After all, the most honored citizens have never moved on this plane. Here they are real semibarbarians. And the crowd believes the national leaders because there is no artistic community that could publicly get through to it. The 999 *Kitsch-*producers are still so glad to eat the bread provided by their customers.[3]

Many of Klee's early works satirize the bourgeoisie. An etching of 1903 (Fig. 15) shows two bewhiskered men, stark naked, bowing deeply to each other, each thinking the other of higher rank. Another, "Mädchen im Baum" ("Maiden in a Tree"), depicts a scrawny nude girl perched absurdly in the branches of a barren tree, her arms and legs jutting out awkwardly. Klee explained in his diary: "The lady wants to be something special through virginity, but doesn't cut an attractive figure. Critique of bourgeois society."[4] Though his mature works are often noncommittal and always more abstract, he continued, though more gently, to mock the cultural pretensions of the burghers: witness, for example, the watercolor of 1922, "The Vocal Fabric of the Singer Rosa Silber." One of the first fruits of the Brücke collaboration was *Odi profanum vulgus,* an illustrated book attacking philistines.* Other painters chose to shun the public as, in Lyonel Feininger's words, "everywhere equally ignorant and obtuse."[5] And still others created works with the specific aim of shocking viewers. Marcel Duchamp, for one, admitted this as one intention of his "Nude Descending a Staircase"—and he certainly succeeded.

The academic painters, whose works the avant-garde considered worthless, bore the brunt of their attacks. No one denied that academics knew how to handle paint; but their work was considered dry, unoriginal, bound to formulas. They were castigated for their attachment to Realism (Impressionism was only then beginning to influence them, thirty years after the fact); or inversely, for their rejection of everyday life in favor of

*There is no extant copy, so its contents can only be surmised. (Bernard S. Myers, *The German Expressionists: A Generation in Revolt* [New York, Toronto, London: McGraw-Hill, n.d.], p. 109.)

historical events, religious and classical myths, and the stiff portraits now considered outmoded. The avant-garde rejected their techniques as well as their subject matter in the name of modernity and artistic freedom. Boccioni was disturbed by the difficulty of forgetting "all the horrible forms and methods I have learned, which keep me forever a skillful painter";[6] other recalcitrant art students also felt that their academic training had wrought irreparable damage by imposing fixed patterns on their perceptions. (Perhaps this is why many found the *douanier* Rousseau, who had escaped such corruption, so refreshing.) But Juan Gris, having had little academic training, could good-humoredly play the academic. "Nowadays when I have finished working I don't read serial novels but do portraits from life," he wrote Kahnweiler. "They are very good likenesses and I shall soon have as much skill as a Prix de Rome winner. It is a continual thrill for me to know how to do it. I can't get over it, because I thought it was much more difficult."[7] Franz Marc, stating his aversion to "palette art," admitted: "For that too one needs talent, but to me it is frightful."[8] And August Macke, remembering his bad experiences at the Düsseldorf Academy, wondered: "What can a person become who hears himself being told, always with malice, for ten years running, that a nose or a leg is too long or too short?"[9]

With this rejection of the academic went the avant-garde's refusal to construct a standard curriculum for art students, or any fixed body of rules. Not that they were willing to consider just anyone a painter—they proved even harder to please than the academicians. Rather, history would judge: each artist was responsible to himself alone before posterity, and the truly creative were those who represented, by whatever means they deemed suitable, their thoughts or perceptions, conscious or unconscious, substituting some novel world view for the one received. In a letter of 1912 to an art critic, Nolde stated this argument, stressing the Expressionist's attunement to subrational processes:

> There are no firm esthetic rules.
> The artist creates a work according to his nature and instincts. He himself stands astonished before the result, and others with him; and only gradually does the new allow itself to be grasped rationally or put into esthetic rules.
> Art wants to give itself; it does not want to be dictated to, either by the will or by reason.[10]

According to Matisse, writing in 1908: "Rules have no existence apart from individuals."[11] Kirchner's woodcut "Gründungsaufruf" ("Founding Man-

ifesto") of the Brücke proclaimed that "Anyone belongs to us who conveys, immediately and authentically, whatever impels him to create." Thus, the emphasis, among the Germans at least, was on the honesty and intensity of the expression, not its form.

What Picasso and Braque thought of schools and programs before 1914 is demonstrated by their refusal to exhibit. Indeed, in France only the organized Cubists, from whom the two kept aloof, published manifestos and had anything like a common program. Although the exhibitors in the Section d'Or of 1912 had a method in common—the application to their compositions of a classical system of proportions—their paintings were widely divergent. The foreword to their exhibition catalogue read: ". . . a unique thought leads [these artists]: disentangle art from tradition, from its old-fashioned bind, in other words, liberate art, for it is a liberation to enslave it in the artist's personality."* In Germany, major artistic manifestos discouraged programs. A statement of purpose for the first Blaue Reiter exhibition said: "In this small exhibition we are not seeking to propagate *one* precise and particular form; rather we aim to show, by the *diversity* of forms represented, how the *inner desire* of the artist is represented in different ways."[12] Kandinsky was adamant on this point. In the almanac published by the Blaue Reiter in 1912 he wrote, ". . . one must not make a uniform out of a form. Works of art are not soldiers."[13] And years later he was at pains to deny that he had ever fostered "Expressionism" or any other program; he had merely asserted the "principle of abstraction" and had never suggested how others should implement it.[14] In 1914, the art review *Kunst und Künstler* asked a number of young painters to state their artistic aspirations. The replies were published under the heading "The New Program." Erich Heckel stressed his inability to state his goals: ". . . it seems to me that the formulation of a new program is a job for academics, or better yet for descendants who work theoretically and scientifically, not creatively. The unconscious and the unwilled are the sources of artistic power. . . . "[15] He was seconded by Karl Schmidt-Rottluff, who claimed he knew of no such thing as an artistic program. Art was not to be discussed or formulated, but rather *made:* "About myself I know that I have

*The foreword was by René Blum. I have utilized an English translation made by Marcel Duchamp for Katherine Dreier. Dreier Correspondence, Beinecke Library, Yale University. Blum continues: "Here you won't find different schools, you will see only differences in individual sensibility. . . ." The Section d'Or was held from October 10 to 30, 1912, at the Galerie La Boëtie.

no program, only the inexplicable desire to grasp what I see and feel and to find the purest expression for it. Beyond this I only know that there are things that I can get close to artistically, but not rationally or verbally."[16] Lyonel Feininger became furious when, during World War I, he read that Herwarth Walden's *Sturm* would open an art school to teach Expressionism. "The only thing that can keep Expressionism alive," he wrote, "is for each person to discover his individual way to art."[17]

The avant-garde did, of course, have its own programs and was often unbending—at least in its negativism. But a few propagandists, taken with the new painting, did more than the painters to establish firm doctrines, usually in order to make modern art comprehensible to prospective supporters and the public at large. F. T. Marinetti, Herwarth Walden, and Guillaume Apollinaire were brilliant dogmatists and sloganeers;[18] the painters themselves usually produced only modest statements of intent. The journalists both helped and hindered the avant-garde, for in awakening public interest and gaining support they also propagated misconceptions and misleading simplifications of the painters' intentions.

In attacking middle-class taste and academic rigidity, many painters employed such words as "revolution" and "struggle" which were common to contemporary leftist rhetoric as well. Their conception of the connection between art and revolution would become clear only later, and in response to world events; now they were convinced that they were revolutionizing the arts and sensed that their artistic revolt would set them up against society at large. Urging Emil Nolde to join the Brücke, Karl Schmidt-Rottluff explained that it wished "to draw all revolutionary and fermenting elements to itself. . . ."[19] At about the same time, Kirchner exhorted young artists to join the struggle for "freedom of the hand and of life" under the Brücke's banner and fight against the "well-settled, older powers."[20] Franz Marc was similarly polemical on behalf of the Blaue Reiter:

> In our epoch of great strife over modern art, we are struggling as "loners" (*"Wilde"*), the unorganized, against an old, organized power. The odds appear unequal, but in things of the mind it is the strength, not the number, of ideas which is victorious.
> The fearsome weapons of the "loners" are their *new ideas;* they kill better than steel and break whatever is considered unbreakable.[21]

Urging artists to respond to the industrial age, Fernand Léger asserted: "All great pictorial movements, of whatever tendency, have proceeded by revolution, by reactivity, and not by evolution."[22]

II

The innovative painters also came to negative conclusions about the Western art of the past, including even that of their avant-gardist predecessors. This rejection was more general among modern artists than any choice of positive theory or model on which to base their innovations. "I think I am really coming to understand," wrote Franz Marc to August Macke in 1911,

> what it comes down to if we want to call ourselves artists. We must become ascetics—don't be alarmed, I mean this only in relation to matters of the spirit. We must courageously renounce almost everything that was previously dear and indispensable to us as good Central Europeans. Our ideas and ideals must wear a hair shirt, we must nourish them with locusts and wild honey and not with history, in order to get rid of the fatigue caused by our European bad taste.[23]

Not only "Central Europeans" sought a totally new esthetic as a panacea for the sick Western spirit. Like Marc, many rejected all Western painting, from the Renaissance to Impressionism, the entire "retinal" tradition, as Duchamp later called it, accusing it of despiritualizing art by restricting the artist to the depiction of the visible.* Whether they wound up emphasizing formal relationships, as the Cubists did, or the religious and emotional sides of man, as the Expressionists did, they felt the Realists had rejected the traditional and still valid ends of painting—spiritual, philosophical, and moral truth, according to Duchamp[24]—in favor of thoughtlessly reproducing the everyday world. Courbet "did not suspect," according to Albert Gleizes and Jean Metzinger, the theoreticians of Cubism, "that the visible world only becomes the real world by the operation of thought. . . . Courbet was like a man who sees the ocean for the first time and, amused by the play of the waves, never thinks about the depths. . . ."[25] In contrast

*Not that they denied the greatness of many Western artists; however, they declined to follow in their footsteps, feeling that their art had been misused and overused by imitators and needed to be replaced. (But see Albert Gleizes, "Souvenirs: Le Cubisme, 1908-1914," Cahiers Albert Gleizes, I [New York: George Wittenborn, 1957], 13–14: the Cubists were trying, through David and Ingres, to recapture the constructive principles of the Renaissance. Gleizes' view is exceptional.)

to the Realists, Franz Marc said, modern artists were trying to recover, by a new path, the depiction of "the inner life, that does not recognize the demands of the scientifically comprehensible world."[26] It was not so much that artists now turned away from reality. Rather, they redefined reality to include much that is invisible and redefined the painter's task so as to include the representation of the invisible: now canvases were to contain references to the artist's thoughts, feelings, and unconscious impulses, to the perceptions of his nonvisual senses, or to the physical laws governing the universe, heretofore stated only as abstract formulas.

It was against the Impressionists that most avant-gardists reacted most strongly, even while recognizing them as forebears and praising their contribution in its time. Now they were considered superficial for their exclusive interest in the transitory event.* The Cubists found them unintellectual and overturned their preference for color over line and form; the Expressionists criticized their preoccupation with externals and lack of concern with man's emotional responses to nature. The Futurists, bent on depicting the everyday world in action, favored Impressionism, insisting, however, like the others that they were superseding it. Franz Marc explained that *Ex*pressionism, unlike *Im*pressionism, sought to reach "beneath the veil of appearance for things hidden in nature which seem more important to us than the discoveries of the Impressionists. . . . And, to be sure, we seek and paint this inner, spiritual side of nature, not out of a whim or a desire for something new, but because we *see* this side, just as earlier men once 'saw' violet shadows and the ether around all things."[27] And Gleizes, defending Cubism, pointed out that the rejection of Impressionism was a denial of sensationalism in general: "We did not consider Impressionism an aberration. . . . Only it seemed to a group of twenty-five-year-olds, tired of the facility of rapid sketches, that painting should not have to limit itself to sensations. . . . Other human faculties could be added in order to build more mature and definitive works."[28] However

*According to Matisse: "The word 'impressionism' applies perfectly to their manner, for they depict fugitive impressions. It cannot be retained to designate certain more recent painters who avoid first impressions, considering them almost deceptive. A rapid translation of a landscape gives but a moment of its existence. By emphasizing its character, I prefer to take the risk of losing its charm in order to obtain greater stability.

Beneath that succession of moments which makes up the superficial existence of beings and things, and which clothes them in ever changing appearances, quickly gone, one can search for a truer, more essential character on which the artist will base himself in order to give a more durable interpretation of reality." ("Notes d'un peintre," 736.)

different their purposes, the younger painters gained much stylistically from Impressionism, often neglecting to credit the Impressionists with a formal method that could be, and was, easily adapted to their own ideological needs.

Along with the Impressionists' subject matter, painters condemned that of Realism and Naturalism, and thereby rejected their own early production in many cases. It did not suffice, they felt, to reproduce modern life; anyhow, the photographer could now do that far better than the painter.* None of them remarked on the almost simultaneous development of photography and Realism or explained both as by-products of bourgeois hegemony. But, like so many contemporary thinkers, they rejected materialism and its corollary, positivism, preferring to search for the hidden and mysterious rather than accept the patent and obvious. Above all, they now denied that the artist's duty lay in probing society's wounds. Already well before Futurism, Umberto Boccioni considered realistic details only vehicles for communication of the painter's ideas and demanded a universality that naturalism could not provide: "The sensations one finds in the greater part of today's pictures could be observed in any archive of the Ministry of Public Safety or almshouse or hospital, etc."[29] A realist painter could never depict reality, for he was inevitably forced to choose a tiny segment of the real. Among the Expressionists there was an almost Kantian belief in the existence of a hidden essence behind appearances—and a non-Kantian confidence that the essence could become manifest on canvas. "Earlier they painted things that were in the world to see, that one was glad to see or would have liked to see," wrote Paul Klee in a "Creative Confession" of 1920. "Now the reality behind visible things is being made manifest and a voice thus given to the belief that the visible is only an isolated example in relation to all that exists in the world, and that other, latent truths are in the majority."[30] The artist had the right to create forms for his purpose; whether or not they existed by objective standards was

*Duchamp attributes the distortion found in twentieth-century painting to the invention of photography. "Since photography produces a thing that is absolutely correct from the point of view of draftsmanship, it follows that an artist who wants to do something else says to himself: 'It's very simple. I'm going to deform things as much as possible; that way I'll be totally independent of all photographic representation.' " (Pierre Cabanne, *Entretiens avec Marcel Duchamp*, p. 178.) Ilya Ehrenburg quotes Matisse to the same effect: "Do you know to whom modern painting owes a very great deal? To Daguerre, to Niepce. With the invention of photography the need for descriptive painting vanished. No matter how objective the artist tries to be, he can't beat the camera." (*Post-War Years, 1945–1954*, trans. Tatiana Shebunina [London: MacGibbon and Kee, 1966], p. 104. *See also* Herwarth Walden, *Gesammelte Schriften*, I, 143; and Franz Marc, "Die konstruktiven Ideen der neuen Malerei," 527.)

immaterial. In any event, a three-dimensional object would be translated onto a two-dimensional canvas, so it was wrong to attempt to equate a painted with a real object. Juan Gris explained this to the "Purist" painter Amédée Ozenfant early in the 1920s: "Man dies of suffocation in water and a fish in air. Yet both have respiratory organs, though one functions only in the element air, and the other only in the element water. The same applies to the objects in my paintings: if you try to make them live in a world where they do not belong they will die."[31] Kandinsky's introduction to the catalogue of the second Blaue Reiter exhibition in 1912 contained a still more adamant claim for the independence of art from nature:

> *Nature creates its forms for its ends.*
> *Art creates its forms for its ends.*
> One should not be bothered by the elephant's trunk, and similarly one should not be bothered by a form that the painter needs.

The artist thus had the privilege of using, distorting, or ignoring visible reality; he would be representative of his time without depicting its ostensible attributes. In fact, the best artists would, as always, be the instruments of the zeitgeist;* thus—assuming the avant-garde was correct in assessing its own worth—the spirit of the present period was not humdrum bourgeois materialism, but rather something mysterious and new. The artist, then, becomes a leader and prophet, a "knower" one step ahead of his contemporaries—precisely what is implied in the epithet "avant-garde." For Kandinsky, only a handful of artists and thinkers stood at the top of the social pyramid with a view of the way ahead and the ability to convey that view to the lower strata. He characterized the twentieth century as the era of the *Kunst des Inneren* (art of the internal) as opposed to the *Kunst des Äusseren* (art of the external) of the nineteenth century; he heralded the development of "pure art," which would at last, after centuries of realism, free painting from dependence on the external object.[32] While he alone in Germany opted for a nonrepresentational art, Expressionists generally shared his goal of communicating with the observer through style, without need for a subject. "A work," said Matisse, "should bear its entire meaning within itself and impose it on the spectator even before he knows the subject."[33]

*According to Matisse: ". . . we belong to our time and we share its opinions, sentiments and errors. All artists bear the imprint of their age, but the great artists are those in whom it is most deeply inscribed."

III

The painters' iconoclasm and antimaterialism, their hostility, now expressed artistically, to the contemporary world, and compensatory discovery of a "nonobjective world" (to borrow Malevich's expression), can be confirmed and amplified by an examination of their artistic preferences, the arts of other times and places that they singled out for praise or adopted as models. The most immediate influences were the Postimpressionists and Neoimpressionists, who had also reacted against Impressionism and had emotionalized reality or subjected it to scientific or quasiscientific experimentation with form and color. The memory of Van Gogh, the tormented genius, and of Gauguin, the fugitive stockbroker, both unappreciated by their contemporaries, influenced many younger artists not only stylistically, but also emotionally and intellectually. As youths, they read Van Gogh's letters with passionate absorption; later some of them, imitating Gauguin, would attempt to flee the decadent West for greener, more wholesome pastures.*

One discovers from the painters' theoretical and personal writings that, in every country, they sought the key to renewal in popular, archaic, and primitive forms of art rather than the "high" art produced by post-Renaissance Europe. They responded to the simplicity and formalism of the Egyptians; to the spirituality achieved through abstraction, idealization, and distortion in works of the Middle Ages, the Italian trecento, and the Northern Renaissance; to the naïveté and directness of popular art. "Since when have the Egyptians, the early Greeks, the early Christian and Romanesque painters, the Chinese and exotic artists been treasured as great? Only a little while ago they were being excused on the ground that they didn't know any better": thus did August Macke describe his genera-

*The Expressionist poet and critic Theodor Däubler evoked the influence of the Postimpressionists, especially Gauguin, on himself and others in early twentieth-century Paris: "With him the new art, already filled with innocence and delightful charm, emerged as a highly poetic, spiritual revelation. Tropical growths, girls like dreams become form, glance at us ever since from a southern wilderness: resurrected Edens filled with flowers! From Brittany, via Provence, to the quietest Tahitian island in the calm ocean, the painter-poet spilled forth from his horn of plenty flowers, blooms, health-giving fragrances." (*Im Kampf um die moderne Kunst* [3d ed.; Berlin: Erich Reiss Verlag, 1919], p. 19.)

tion's revolutionary artistic sympathies.* They admired the forcefulness achieved by artists ignorant of the Western mimetic conventions or, more often, deliberately rejecting these conventions. They preferred such artists' craftsmanship to Western painterly refinements. Without realizing how strongly they were being influenced by the nineteenth-century arts-and-crafts movement, they were consistently drawn to handwork —more often than not of the most modest and rude sort. The early experience of many painters in the decorative arts was surely influential here. The Brücke artists were inspired by Cranach, Grünewald, and Dürer, among other primitives. Dürer's woodcuts determined their predilection for that medium. Max Beckmann's mature works show the strong compositional influence of Grünewald, and he early expressed a penchant for primitivism. Considering Chinese art too subtle, he wrote in a diary: "My heart yearns rather for a more raw, common, vulgar art, one that is not enamored of the dreamy moods of fairy tales, tender poetics, but rather leaves itself open to everything terrible, mean, splendid, ordinary, grotesque, and commonplace in life, an art that can always be relevant to the realest aspects of our lives."[34] The artists of the Blaue Reiter discovered and avidly collected Bavarian and Austrian paintings on glass (*Hinterglasmalerei*), usually depicting religious scenes in a naïve manner; the Blaue Reiter Almanac illustrated some of these, along with other examples of folk art, works by the French and German avant-garde, primitive sculptures, children's drawings, medieval woodcuts and sculptures, and Japanese drawings. (Many of Wassily Kandinsky's, Marc Chagall's, Natalia Goncharova's, and Mikhail Larionov's early paintings were based on Russian legends and fairy tales.) The Futurists were early attracted to popular art, which they saw at a large Milan exhibition in 1911, as well as in Balla's Roman peasant house the same year. As late as 1914, Carrà stressed the influence the Milan exhibition had exerted on them at the time, but now he denounced it as unmodern.[35] The majority of these works singled out for praise were not considered art at all by their creators. They were usually cult objects—or else utilitarian ones—fabricated not primarily to please the esthetic sense. In praising them so highly, the avant-garde was simultane-

*He qualified his original statement somewhat in the sequel: "So that no one can accuse me of enjoying *only* the primitives, I would like to confess that I am extremely fond of Giotto, the Sienese, the Cologne masters, the early Flemish, the Ferrara school, many Dutch still-life painters, Manet, Renoir, and many others—in all of whom I see a sensitivity for all that lives. The living quality does not always need to be covered up by imitation of nature." ("Das neue Programm," *Kunst und Künstler*, reprinted in Diether Schmidt, *Manifeste Manifeste*, p. 83.)

ously passing judgment on the West: in setting art above and in opposition to daily life, they felt, the West had alienated both the artist and the observer.

In all these art forms painters found an honesty and unpretentiousness that most Western art lacked. "The simplicity of the Egyptians, of Giotto, Franz Hals, Daumier," Macke told Marc, "is what should impel us. A simple thought, dancing bears, reading girls, standing people, flickering or quietly glowing landscapes, red apples, yellow lemons, brown horses."[36] They wished to cure Europe's artistic decadence—and perhaps also its social stodginess—by recapturing the freshness of childhood and starting over with the simplest elements: a limited palette; clear lines; primary volumes. Or so many of them said. Marc told Macke in 1911: "I want to begin like a child, to give my impression in front of nature with three colors and a couple of lines, and then to add forms and colors whenever the expression demands it."[37] According to the young Klee: "I want to be as though newborn, knowing nothing, absolutely nothing, about Europe; ignoring poets and fashions, to be almost primitive. Then I want to do something very modest . . . and some day, through the repetition of such small but original deeds, there will come one work upon which I can really build."[38] And Umberto Boccioni wrote: "Just now I have an idea: 'make my paintings as if they were done by children. . . .' Is it possible to speak to humanity at the point it has reached today with children's language?"[39] Other painters likewise simplified their works in order to concentrate on one or another pictorial element. In the early Cubist paintings color was sacrificed to the investigation of form; Kandinsky sacrificed determinate forms to study the emotive capacity of color and line. In 1912, Klee, whose graceful line drawings and watercolors were essentially childlike, in his diary described the works of the Blaue Reiter, then being exhibited in Munich, as "Primitive beginnings in art, such as one usually finds in ethnographic collections or at home in one's nursery."[40] (Of course, critics persistently ridiculed the avant-garde by harping on the childishness of their techniques.)

Ethnographic collections, indeed, had provided a major impetus to modern art. Founded around the turn of the century throughout Europe to document the cultures of the new—and also older—colonial possessions, their artistic value was unsuspected until a handful of avant-garde artists and writers discovered them beginning about 1904. Interest in primitive art was passed on from one painter to another; but in many cases they discov-

ered it independently in local museums. What is important is the unanimity with which the avant-garde took to primitive art. What ethnologists would continue for a long time to catalogue as curious artifacts of "lower" stages of civilization, the Fauves, Cubists, and Expressionists considered supreme artistic creations, on a par with, or even surpassing, those of the recognized civilizations. The attraction is not difficult to understand: these works provided just that simplicity and *un*naturalism that the artists sought. "I spent a lot of time in the Völkermuseum," Franz Marc wrote in 1911, "in order to study the means of expression of the 'primitive peoples' (as Koehler and most of today's critics put it when they want to characterize our endeavors). Finally, astonished and shaken, I remained fixed before carved figures from the Cameroons. . . . To me it is so obvious that we must look for the rebirth of our artistic feeling in this cold dawn of artistic intelligence, and not in cultures that have already run a thousand-year course, such as the Japanese or the Italian Renaissance."*

Most painters found these works beautiful on first sight and immediately conceived personal uses for their clean, "un-Western" lines and simplified, often crude volumes—usually without the slightest comprehension of the spirit in which they were created and their meaning within their own cultures. While European imperialism extended "civilization" to savages the world over, young Europeans began to turn the tables—calling on the conquered cultures to aid them in attacking and profoundly altering the European one. In Paris, the rage for African and Oceanic art quickly spread after Maurice Vlaminck discovered and purchased some primitive sculptures in a bistro about 1905. Prewar photographs of Fauves' and Cubists' studios attest to the depth of their interest in such art. Its influence varied greatly. The Cubists used it formally: for the most part they did not try to reproduce the native artist's outlook, his

*I have already quoted the sequel, equally important in this context, on p. 90. Marc, more than many others, understood the social and religious context of primitive art. Westerners should not try to outdo the savage at his own game, but rather learn a lesson from him for theirs: "That we want to make pictures out of [these ideals] and not merely colorful columns and capitals and straw huts and clay pots—that is our superiority, our 'Europeanism!' " (Macke and Marc, *Briefwechsel*, pp. 39, 41.) Cf. a letter from Kirchner to Nele van de Velde: It would be bad merely to imitate primitive art, but "the path to our future forms perhaps parallels the one these men have trod." (*Briefe an Nele und Henry van de Velde* [Munich: Piper-Bücherei, 1961], Kreuzlingen, April 26, 1918, p. 7.) There were detractors. (*See* Max Beckmann, "Gedanken über zeitgemässe und unzeitgemässe Kunst," *Pan*, II, No. 17 [March 14, 1912], 501, on the misuse of primitive art by the modern movement. Even in 1953, Kokoschka agreed. "Irrweg der 'Abstrakten,' " *Die Welt* [October 11, 1953].)

creative method, or his material result, but rather to use his simplification of form and arbitrary attitude toward space to emancipate themselves from the Western post-Renaissance perspective. Their works resembled primitive ones only during a brief, transitional period (Fig. 16). Afterward, the primitive influence was internalized and channeled in the service of abstraction.[41] The Brücke painters were influenced more directly by the primitives' subject matter and procedures. Eliminating detail, they reduced the human form to its strongest, most prominent lines and volumes. Their subjects began to resemble primitives in the simplicity and angularity of their features. In 1913, for example, Schmidt-Rottluff reduced a scene of three nudes in a landscape (Fig. 17) to a minimum of representation. Plant forms become zig-zag shapes; women resemble primitive statues with their angular features and conical, pendulous breasts. The Brücke painters had an especial predilection for pagan and Biblical imagery; at their hands even urban scenes took on a ritual quality. This is true of Kirchner's portraits of dancers, and more so of Nolde's. Nolde depicted dancing children, primitive women, and the Jews worshiping the Golden Calf (Fig. 18) in similarly frenzied motion. African and Oceanic art also influenced the Brücke painters' techniques, or rather confirmed them in ones they had earlier chosen under the influence of the Middle Ages. They now favored the woodcut more than ever for its crudeness and the extent to which it made patent the artist's creative process. Following Gauguin as well as the natives, they also carved wooden reliefs, sculptures (Fig. 43) and furniture.* After the war Kirchner, then engaged in making a door with reliefs, affirmed to Nele van de Velde, who had sent him some photographs of wooden figures: "I consider this art much purer, nobler and truer than the so highly esteemed art of ancient Greece, which all of European art has watered down with tasteless estheticism."[42]

Continuing a tradition developed during the nineteenth century, and influenced particularly by Gauguin, many painters set off on extra-European travels: North Africa, the Middle East, and finally the South Seas replaced Italy as the artists' Mecca. Matisse, Klee, and Macke were influenced by the North African landscape and color, both stylistically and in their subject matter.† Just before the outbreak of World War I, both Max

*Some of these are now in the Brücke-Museum, Berlin.
†Matisse traveled to Morocco in 1912–13, Klee and Macke briefly in 1914. It is also worth noting that some painters went to Russia: both Barlach and Boccioni in 1906, and Matisse in 1911.

Pechstein and Emil Nolde and their wives set out for the South Seas. The Pechsteins left Germany early in 1914 to "look for the Elysian Fields" in the Pacific. They settled in the German-occupied Palau Islands; their mission seemingly accomplished, they planned to remain there indefinitely, in a disused native assembly hall they rebuilt into home and studio. Pechstein, the Saxon worker's son, later reminisced that he had easily and joyfully adapted himself to life among the natives and allowed the habits, only skin-deep, of a sophisticated city dweller to slip away.[43] Only the outbreak of the war and consequent Japanese invasion of the archipelago sent them back to Europe.

The Noldes left Germany late in 1913 with a scientific expedition, traveling overland via Russia, Siberia, China, and Japan. Nolde, the believer in the superiority of the white race, was nevertheless mightily impressed by all the peoples he saw on the way, the "un-played-out" (*unverbraucht*) Tartars, Sarts, and Bashkirs, the "unenergetic" Koreans ("incapable of work, but congenial"), the Japanese and Chinese "civilized peoples."[*] Undisturbed in his German nationalism, he was nevertheless disgusted by the patent European exploitation of the Far East[†] and upset by the rapid corruption of the native cultures by the "civilized" (missionaries, soldiers, adventurers). The German and other governments were guilty of negligence in not protecting primitive art and culture. Writing home in March, 1914, he said:

> We are living at a time when the primitive conditions and primitive peoples are going to ruin and everything is being discovered and Europeanized. Not even a small area of untouched nature with primitive men will remain to our descendants. In twenty years it will all be lost. In three hundred, the researchers and

[*]"Japan [is] the Germany of the East, but I do not believe that its people has the depth and substance of the Germans." (Nolde, *Briefe aus den Jahren 1894–1926*, November 13, 1913, p. 96.)

[†]"With unusual energy all the foreign nations are working to tear [China] to pieces; missions, merchants, military are all working hand in hand with cunning, shrewdness and brutality. It is sad to observe how entire countries here are flooded by the worst European trinkets [*Galanteriewaren*], from the kerosene lamp to the most ordinary cotton cloth, colored with the falsest aniline dyes. The best raw materials go to Europe and return, after the cheapest manufacture, as goods that are supplanting the fine homemade products. Our good Germany has its generous portion of this intolerable commerce, but the import and export figures are climbing rapidly at home, profits are being reaped in Berlin, Hamburg, and the industrial provinces, Germany is beating English competition and will become, in the foreseeable future, the powerful German world empire. I'd like to think this is what will happen." (*Ibid.*, pp. 96–98.) Clearly Germans could be excused, others not.

scholars will dig in the ground and tear their hair in order to feel their way to some knowledge of the priceless beings that we had and the primitive spirituality that we today so frivolously and shamelessly destroy.

He wrote a memorandum to the German District Officer in New Guinea protesting the removal by non-Germans of precious native art and artifacts from under the nose of the government.

More important than his complaints was the artistic inspiration he drew from the journey. Conscious of following in Gauguin's footsteps, he set to painting the natives, aware that the result would be unacceptable to cultivated European society: "I . . . am trying to capture something of the nature of the primitive being. I think some of my attempts may be successful; in any case I am of the opinion that my paintings and several watercolors of primitive men are so genuine and severe that they could not possibly be hung in perfumed salons." Accompanied by his wife, he even ventured to paint a savage tribe that had never before seen a white woman. "The natives," he wrote to a friend soon after,

> were such marvelously splendid people. I had my watercolors and painted; some of them soon noticed; others, frankly, did not. Near me lay my revolver with the safety off, and behind me stood my wife, covering my back with hers, also cocked. I have never worked in such a tense situation, but everything before my eyes was so beautiful, so splendid. As [we re-embarked and] the ship once more started across the flat sea, the pages went from hand to hand and gave us so much joy.

IV

Another expression of the painters' negativism toward their surroundings and inherited traditions can be found in their divergent attitudes toward modern life and toward the new imagery furnished by industrialization and technology. Some of them denied the modern world by rejecting its unique imagery altogether; others attacked middle-class culture and taste by substituting the industrial landscape for traditionally acceptable subject matter.

As in their life styles, so also in their paintings did the Blaue Reiter prefer the pastoral landscape to the frenetic city. The prewar works of Marc, Kandinsky, Klee, Werefkina, and Münter rarely contain anything more modern than Bavarian village houses, churches, and landscapes.

Only Jawlensky painted urban subjects, and then only portraits.* The Brücke artists, living in the city, used archaic techniques adapted from the Middle Ages and primitives to depict the alienation and depersonalization of modern life. In the tradition of Poe, Baudelaire, and, pictorially, Edvard Munch, Kirchner several times represented the modern crowd. His figures, bunched together on the sidewalk, remain distant, cold, and anonymous, and face away from each other (Fig. 19). His public squares are large and empty, with streets pointing off in acutely divergent directions. An iron bridge over the Rhine towers menacingly above the few pedestrians on it.[44] In Berlin just before the outbreak of the war, Lyonel Feininger complained of Prussia's brutal modernity and insensitivity. He disapproved of the "celebration of the purely technical, material, scientific," he wrote to his wife. "When everything is run by machinery and electrical energy, will the life of animals still remain to us, undistorted, as a concrete source of motion? Man is already going downhill pretty fast."[45] He turned away from a fascination with modernity during the last prewar years, exchanging his caricaturelike style for a Cubist one and his urban subjects (frequently including viaducts and speeding automobiles) for more traditional and pastoral themes: Gothic churches and other public buildings as well as seascapes. The one German dissenter was the Socialist Ludwig Meidner. Opposed to the influence of primitive art, Meidner instructed his generation:

> Let us admit once and for all that we are no Negroes or early medieval Christians! That we are inhabitants of Berlin in the year 1913, that we sit and talk in coffeehouses, read a lot, know a lot about the development of art history and— that we are all products of Impressionism! . . .
> Let us paint what is near to us, our city-world! The tumultuous streets, the elegance of iron suspension bridges, gasometers that hang like mountains of white clouds, the roaring coloration of buses and express train locomotives, the swaying telephone wires (are they not like songs?), the harlequinades of the advertising pillars, and then the night . . . the big city night. . . .
> Wouldn't the drama of a well-painted smokestack move us more than all Raphael's fires in *borgos* and battles of Constantine?[46]

Many French painters, and of course the Italian Futurists, agreed. The airplane in flight became a favorite image for them, and their new artistic

*Macke, living part of the time in Bonn, went so far as to paint shops and people promenading in city parks—without the negative connotations that the Brücke painters attached to these subjects.

styles served to represent the cityscape and technology. "When you want to show an airplane in flight," Marcel Duchamp later explained, "you don't paint a still life."[47] But attitudes varied. Many Cubists clung to traditional subject matter: the glasses, bottles, violins, and guitars, even the newspapers and wallpaper, suggest a hermetic and rather shabby milieu—the artists' stock furnishings. While the "technology" of the collage was new, the raw materials used in actual collages were not. It was artists influenced by Cubism, the Futurists, and the so-called "Orphists"—Léger, Delaunay, Picabia, Duchamp, and others—who discovered the artistic possibilities of industrial images and materials. In an article published consecutively in *Montjoie!* and *Der Sturm* in 1913, Fernand Léger stressed the necessity for contemporary art to respond to technological developments lest it lose contact with reality and become anachronistic, as medieval art had after the invention of printing. "Contemporary life," he wrote,

> more animated, faster, than life in preceding ages, should be subjected, for the purpose of expression, to a dynamic divisionism.
> . . . modern mechanical inventions such as color photography, cinematography, the profusion of more or less popular novels, the vulgarization of theaters, effectively replace the development of the visual, sentimental, representative, popular subject in pictorial art and make it henceforth totally useless.
> Mechanical means have become so far superior that I consider it ridiculous to want to continue an enterprise with means whose powerlessness is obvious.
> I wonder what all those more or less historical or dramatic canvases at the Salon des Artistes Français can hope to prove against the first available cinema screen.[48]

To represent the dynamism of modern life, painters altered the static Cubist analysis of space. Léger, Delaunay, and the Futurists chose modern subjects—the Eiffel Tower, a soccer team, the airplane (Fig. 20), the automobile—and, more important, represented them nonstatically by breaking them up and reconstituting them to show the play of light on their moving forms. It was a complicated and, above all, sophisticated adaptation of archaic narratives in which the subject is depicted repeatedly on the same canvas in the progressive stages of its history.

Finally, Marcel Duchamp made the ultimate break with past styles and with the traditional distinction between art and life. He progressively moved away from painting, substituting prefabricated objects—the "ready-mades"—for artistic creations. In addition he repeatedly substi-

tuted machine images for humans, satirizing thereby some of middle-class society's *idées fixes*—human individuality and creativity, the sanctity of the work of art, and the spiritual nature of the sex act—and simultaneously satirizing the machine.* Attacking even the artist's claim to uniqueness and indispensability, he inversely also elevated the artist to a position in which he no longer had to make art but could simply decree it, choosing from among available manufactured objects. Unlike the Brücke artists, he put the mythology of primitive peoples and ancient religions in the service of a modern, highly sophisticated approach to art.

Any doubts about the anarchistic and antibourgeois nature of these attitudes to modernity and industrialism should be allayed by an extended examination of the Italian Futurists, the only group of the avant-garde whose art was overtly political. While most painters considered their social attitudes secondary and not a direct influence on their works, many going so far as to deny the importance of any nonformal considerations in the creation of an art work, the Italian Futurists grounded their esthetic in a comprehensive social and political program: the rejuvenation and modernization of Italy.[49] The social themes I have already pointed out in artists' manifestos and tracts are present with a vengeance in those of the Futurists: the hatred of the bourgeoisie and of academies; the rejection of programs and schools; the attack on post-Renaissance art and warmth toward primitive art; above all the enthusiastic espousal of modern life with its crowds, noises, and burgeoning technology. When they cried: "We want to destroy the museums, the libraries, the academies of every sort . . ." or "We want to combat unceasingly the fanatical, unconscious and snobbist religion of the past . . .,"[50] they were proposing a permanent revolution in art and in life—a revolution they knew to be anathema to all that the propertied and governing classes believed in—and were breaking ground for an anti-artistic attitude which reached full expression, after a tentative start in Dadaism, only on the evening of March 17, 1960, in the garden of the Museum of Modern Art in New York, when Jean Tinguely's machine-sculpture, "Homage to New York," destroyed itself. The Futurists themselves had long since become too fond of their own poses

*The first ready-mades date from 1914; about that time Duchamp also began to elaborate the sexual images that would appear on the "large glass" ("The Bride Stripped Bare by Her Bachelors, Even," 1915–23). The bachelors, for example, were represented by a chocolate grinder, a water mill, and some funnels.

and products to take this final step. In their turn they were soon succeeded by younger and yet more strident revolutionaries.*

In every Futurist manifesto and theoretical statement the social message is writ large and clear. Where there is no bombastic tribute to Italy's glory, for example, in the painters' "Technical Manifesto," there is nonetheless a partisan endorsement of modern life, of "Futurists" (*futuristi*) as opposed to "Pastists" (*passatisti*), and the assertion that great artists move in step with their times.† It follows, then, that to create a modern Italian art one first had to have a modern Italy. To have that, one first had to awaken the Italians from the torpor produced by resting on the laurels of past achievements. Many young Italians were agreed about this long before the proclamation of Futurism in 1909.

The Italy of 1900 was still a predominantly agricultural society, in which illiteracy and the mortality rate ran high. Its backwardness and poverty contrasted harshly with the memory and vestiges of two great civilizations, the Roman and the Renaissance. Its "modern" government was a constitutional monarchy brought into being by the unification. The least liberal and most corrupt in Western Europe, it had, in the eyes of the young, failed to carry on the work of the Risorgimento. Instead of wresting the last bits of Italian territory (the Trentino, Trieste, and Fiume) from the Austro-Hungarian Empire, it had joined the Triple Alliance; and its one attempt to follow the vogue of empire-building had ended in abysmal, dishonorable failure at Adua, Ethiopia, in 1896. Italy's chief cities—Rome, Florence, and Venice—were provincial, old-fashioned, hardly cosmopolitan; only now was the industrialization of the North beginning to create a bustling, modern city: Milan. Young aspirants to art, and there were many in turn-of-the-century Italy, felt trapped and stultified in this atmosphere. Emancipation from their own uniformly provincial backgrounds could only be achieved abroad in the capitals of modern culture: Paris, London, or Berlin. Only there could they come into contact with recent artistic discoveries, for no Italian school had come into being since the Rococo, except for some

*As a major branch of innovative painting, Futurism did not survive World War I. As the Dadaists took up its pugnacity and iconoclasm and carried these to an even greater extreme, the Italian painters turned back toward tradition and classicism.

†For example, Boccioni wrote in a diary as early as 1907: "It seems to me impossible that the artists of past eras could have found their state as odious as do the artists of the present. . . . It's impossible that the artists of circa 500 thought of past eras with the same nostalgia as our draftsmen." (*Opera completa* [Foligno: Franco Campitelli, 1927], p. 312.)

regional groups, such as the Tuscan *macchiaioli,* who, influenced by Barbizonian *plein air* painting and Impressionism, depicted everyday subjects. Symbolism, Divisionism, and Postimpressionism had to be discovered abroad, though a few older Italians, such as Gaetano Previati (1852–1920) and Giovanni Segantini (1858–99) had already discovered them and were lionized by the young.

All passed through Paris sooner or later, and some stayed there permanently—Modigliani, Severini, and others less well known. But for many, exile was not the solution to the problem, for once away from Italy they became homesick for its soil and traditions. Unlike the avant-garde of more advanced countries, they were not born cosmopolitans; rather the contrary. This, along with their national underdog hatred of Austria, helps explain the exceptional chauvinistic turn of Futurism. The solution, then, was to change their homeland: to foster its modernization and to make it strong enough, socially and militarily, to win its place in the new world of industry, colonies, and power politics. What was needed was a second Italian Renaissance—political, economic, social and artistic all at once. This millennium was announced repeatedly by the young after 1900—by Giuseppe Prezzolini, Giovanni Papini, and Ardengo Soffici in various publications culminating in the review *La Voce* (*The Voice*), founded in 1908,* and finally, more stridently, by the Futurists:

> To other peoples Italy is still a land of the dead, an immense Pompeii whitened by tombs. On the contrary, Italy is reawakening and an intellectual rebirth is following its political rebirth. In the country of the illiterate, schools are proliferating; in the country of *dolce far niente,* innumerable workshops will henceforth roar; in the country of traditional esthetics, novel inspirations are taking flight.
>
> Only that art is living which takes its elements from its surroundings. Just as our ancestors drew artistic materials from the religious atmosphere that weighed on their souls, we too must be inspired by the tangible miracles of contemporary life, by the iron network of speed that circles the globe, by the trans-Atlantic steamers, dreadnoughts, the miraculous flights that put furrows in the sky, the gloomy audacity of the undersea explorers, by the spasmodic struggle to conquer the unknown.
>
> And can we remain insensitive to the frenetic activity of the great capitals, to

*Prezzolini was more politically oriented, Papini and Soffici more artistic and literary. Papini and Soffici finally managed in 1913 to found a literary review, *Lacerba* (*The Acerbic*), which professed similar goals to *La Voce*'s, and which soon after endorsed Futurism. It lasted until Italy's entry into the war in 1915.

the new psychology of night life, to the feverish figure of the *viveur,* the cocotte, the apache and the alcoholic?[51]

The first Italian Renaissance, too, had had its *modernissimi*—its Christopher Columbus, Galileo, Lorenzo, and, above all, its Leonardo. But now, at the threshold of the air age, they were to be forgotten and replaced by a new generation of geniuses—explorers, inventors, heroes, and artists. The supreme hero would turn out to be Mussolini—but there was no foreseeing this sorry outcome.

There was another important formative influence on the pre-Futurist mentality, which affected each artist or writer differently. This was a group of philosophies and ideologies, both practical and esoteric, then gaining currency in Italy. The most important of these was anarchism and its adjunct, syndicalism, whose influence on the young painters has already been discussed. Their wide contacts with anarchist groups and leaders and their reading of Kropotkin, Max Stirner, Georges Sorel, and such novelists as Tolstoy and Zola, together with their disenchantment with contemporary Italian politics, convinced them that nothing good could come of parliaments. Rather, people would have to take matters into their own hands, violently if necessary, as in the Risorgimento. They grew disillusioned with Italian socialism as, under the leadership of Filippo Turati, it followed a revisionist course and seemed unwilling to oppose the parliamentary regime of Giovanni Giolitti except by empty phrases. To the puissant influence of anarchism was added another—Nietzsche's—and behind that yet a third, popular enough in this age of imperialism—Darwin's. Nietzsche and Darwin, frequently misread and misunderstood, seemed to condone violence in a worthy cause and approve self-help in a way that fell in well with both the anarchist philosophy and the popular mood. None of the young Italians minded that neither Darwin nor Nietzsche had been nationalistic or had advocated violence per se: it was enough that Darwin had said, or implied, that the weak (read: *passatisti*) would perish, the fit (*futuristi*) survive; or that Nietzsche had denounced the "herd instinct" that, in Italy, was fostered by the parliamentarians, the Church, and the complacent *borghesia.* In any case, Nietzsche's brash and violent style was as influential as his message.

Thus matters stood until 1909, when Filippo Tommaso Marinetti, a dapper, mustachioed thirty-three-year-old poet with a genius for polemic, welded all these disparate elements into a flamboyant movement which

satisfied the longings of Italian youth and sent the European art world reeling. He was born (in 1876) and raised in Alexandria, Egypt, the son of a well-to-do, prominent Italian lawyer.[52] As a student at the Jesuit *collège* in Alexandria, he early learned to use his fists in chastising those who teased him about his nationality—surely one of his more formative experiences. Expelled from the *collège* at seventeen for bringing in Zola's novels, he was sent to finish his education in Paris. When he moved to Genoa to attend law school at the behest of his father, who disapproved of his poetic leanings, his culture was more French than Italian, and he continued to write in French for several years, gaining a certain notoriety in Paris for an epic poem of 1902, *La Conquête des étoiles (The Conquest of the Stars)*, and a farce of 1905, *Le Roi Bombance*, heavily influenced by Alfred Jarry's *Ubu roi*, which was presented in 1909 by Lugné-Poë's Théâtre de l'Oeuvre.

Longwinded and turgid, though occasionally biting, *Le Roi Bombance* (translated into Italian in 1910 as *Re Baldoria*) marks Marinetti's decisive turn against socialism, which he knew at first hand as a member of a group that met in the "red salon" of Filippo Turati and his mistress Anna Kulishova, in the Milan Galleria Vittorio Emmanuele. Ridiculing Church (as Father Paunch) and Crown (as King Glutton) in a state that is nothing but a bottomless, collective stomach, Marinetti directs his most virulent barbs against the revisionist Socialists Turati and Enrico Ferri and the founder of Italian syndicalism, Arturo Labriola. They are depicted as the "Cooks of Universal Happiness," Tourte (tart), Syphon (siphon) and Béchamel. Needless to say, the cooks spoil the pie, promising a feast but delivering a famine: perpetuating the eternal conflict, as Marinetti's biographer Walter Vaccari says, "*fra chi mangia troppo e chi mangia troppo poco . . .* "—that is, between the haves and the have-nots.[53]

Between 1905 and 1909, Marinetti was also involved in a grand literary project in Italy: through collaboration on a review, *Poesia,* he introduced much of European Symbolist poetry to Italy and tried, concurrently with *La Voce,* to bring about the awaited Italian rebirth through literature. By his own admission, he decided around 1908 that he would never get anywhere this way, but would have to descend to the marketplace and "bring the fist into the artistic battle" (*introdurre il pugno nella lotta artistica*).[54] There followed a stream of manifestos and slogans, of political and artistic demonstrations—and, finally, a cohesive movement of poets and painters behind the flag of Italy, avant-gardism, and the technology of the modern age.

In 1908 and 1909, Marinetti was twice arrested for impassioned speeches against Austria: once in Trieste, at the funeral of the mother of Guglielmo Oberdan, who had been executed for planning to assassinate Emperor Franz Josef; and again in Milan, after eulogizing Asinari di Bernezzo, a general and minister who was forced to resign after making an irredentist speech to his troops. On February 20, 1909, Marinetti launched the Futurist movement from Paris, publishing in *Le Figaro* the "Foundation and Manifesto of Futurism," in which he praised energy, danger, violence, war, militarism, and patriotism, and declared war on museums, libraries, and feminists as well as *passatisti* in general. A few months later came "Tuons le clair de lune" ("Let's Kill the Moonbeam"), an all-out attack on Romanticism. There followed, during 1910, a rapid fire of manifestos and speeches by Marinetti, by the painters, and by all of them together: the "Manifesto of the Futurist Painters" of February 11; the painters' "Technical Manifesto" of April 11; a handbill entitled "Contro Venezia Passatista" ("Against Pastist Venice"), thousands of copies of which were thrown from the San Marco clock tower on April 27; and the first of a series of staged attacks on the historic Italian cities, culminating in riots and arrests.* Already in 1909, on the occasion of general elections, Marinetti had published a political manifesto opposing clericalism, pacifism, and gerontocracy. A second political manifesto followed in 1911, cheering the Italian annexation of Tripoli and proclaiming proto-fascistically: ". . . the word ITALY must take precedence over the word LIBERTY." Marinetti went off to the front as a correspondent during the First Balkan War in 1912; in picture-poems he dubbed *"parole in libertà"* (words in liberty)† and in journalistic reportage for *Le Figaro,* he expressed his thrill at the siege of Adrianople. And so it went until the outbreak of World War I and beyond: Marinetti proved tireless in provoking riots and dispensing invective.‡ André Gide has left a witty and perceptive description of Marinetti's tactics and seductiveness:

*The sequence of events and publications from 1909 to 1921 is sketched out, albeit sometimes inaccurately, in *Archivi,* I, 471–93.

†Marinetti invented the form, but most Futurists eventually employed it. It slightly preceded and certainly influenced Apollinaire's *caligrammes;* but whereas Apollinaire emphasized word pictures, the Futurists made extensive use of bellicose sounds that are spelled out onomatopoeically and scattered across the page, not necessarily forming pictures of recognizable objects.

‡Among his best slogans: *"Immaginazione senza fili"* ("wireless imagination"); *"Marciare non marcire!"* ("March, don't dawdle!"); *La Divina Commedia è un verminaio di glossatori"* ("The *Divine Comedy* is a wormbed of glossators").

Marinetti enjoys a lack of talent which permits him unlimited audacity. All by himself, in the manner of Scapin, he makes all the noise of a riot after having put on a few doltish readers. . . .

He taps his foot; he makes the dust fly; he swears, he consecrates and desecrates; he organizes contradictions, oppositions, cabals in order to emerge triumphant.

All the same he is the most charming man in the world, if I except d'Annunzio; full of verve in the Italian manner, which often mistakes verbosity for eloquence, ostentation for wealth, agitation for movement, feverishness for divine rapture. He came to see me about ten years ago and extended such incredible courtesies that I was forced to leave immediately afterwards for the country; if I had seen him again I would have had it: I would have considered him a genius.[55]

Marinetti himself later said he had been known as "Europe's caffeine."

Surely many of Marinetti's antics were nonsense, and many concerned Italians refused to follow him though they supported the Futurist goals. Even the patience of the Futurist painters wore thin as Marinetti frequently showed himself dense about their esthetics and too chauvinistic or bellicose for their taste.* But a great showman he was; and his showmanship had meaning. The Dadaist Georges Ribemont-Dessaignes astutely noted in his memoirs that Marinetti succeeded admirably in outraging a public that had built a mystique around art.

. . . One can measure to what extent man's attachment to artistic rites has a religious character [Ribemont-Dessaignes wrote] and to what extent attacks on those rites attack the security of daily behavior. . . . [Marinetti's] cerebral proclamations [consistently] provoked altercations, cries, insults, howls, and blows, with fits of hysterics on the part of charming women of the world who had been overexcited at least as much by the sight of this whirling dervish, this poet of the future with bristly mustache and brilliant voice, as by the defiance of common sense posed by the canvases of Boccioni, Carrà, Russolo, and others."[56]

At the center of Marinetti's philosophy stood Italy's need for greatness. He was the champion of the young: the only ones who, if freed from the bonds of a traditionalistic society, would have the health and energy to

*The statements written by painters are lower-keyed than Marinetti's, yet they used much of the same vocabulary and had become equally bellicose by the outbreak of the war. See the early sections of Boccioni's *Pittura Scultura Futuriste* and Carrà's *Guerrapittura* (Milan: Edizioni futuriste di "Poesia", 1915). The one painter who kept aloof from most Futurist activities (except for exhibitions) and claimed to have always been dubious about their methods was Gino Severini, who, except for a short period in Italy before the war, lived in Paris.

enjoy life to the full. He praised the masses of workers as being part of the active life of the factories and streets—as opposed to the sedentary middle class. He was no elitist: the culture he wished to promote was based on everyday life and, he and the other Futurists assumed, not above the intellectual level of the common man.

Having examined and tested all political philosophies, Marinetti made up his own as he went along and became one of the founding fathers of Fascism. He adamantly rejected monarchism, conservatism, and clericalism—for these would hold Italy down forever, he thought. He rejected the socialists as power-hungry men hiding behind benevolent masks of fraternity. If he was close to any group, it was the anarchists; with them, his nationalism aside, he shared a hatred of parliaments, bureaucracies, and academies and a penchant for violence and bravado. But he could clearly see, well before the war, that something stronger would be needed to revolutionize Italian life than a movement to which organization and discipline were anathema. Declaring that the past was necessarily inferior to the future, he opted for the only force that seemed strong enough to accommodate Italy to the age of automobiles, airplanes, and trams: destruction, by war, revolution, or holocaust, whichever were feasible and would lead to a futuristic result. The slogan most central to Marinetti's thought and actions, then, was "*Guerra sola igiene del mondo*" ("War, the world's only hygiene"). When war came, in 1914, Marinetti, already thirty-eight, did not abandon his philosophy. And when a strong leader came along, versed in Marinetti's own tactics, Marinetti did not abandon him, but became a charter member of Fascism.

What of Futurist painting, beyond the painters' adherence to the goals of Marinetti's movement? That they based their art on modern life was clear long before 1910: Balla's and Boccioni's neoimpressionistic paintings of rising suburbs are sufficient evidence. The difference wrought by their adherence to Futurism was, at first, a renewal of confidence in their abilities and a boldness which enabled them to handle familiar subjects in more original ways. Boccioni, long depressed, felt that Futurism had given him a new lease on life; he was tempted to destroy all his previous works. "Now I understand," he wrote in his diary, "the frenzy, the passion, the love and the violence of which they speak when they say: Create! Why wasn't it so previously? Perhaps I was as I am now, but discouragement and sorrows kept me tied to the ground. . . . How well I understand the words of Marinetti: no work devoid of an aggressive character can be a

masterpiece."[57] There followed in 1911 two capital Futurist works: "La Città che sale" ("The City Rises"), in which he retained his earlier Divisionism, and the triptych "Stati d'animo" ("States of Mind"), in which Cubist elements are combined with linear fields to portray the human emotions as well as the physical motions in a railroad station.

The Futurist pictorial style and theory were elaborated during the next two years, by the end of which its exponents had abandoned Divisionism, on which they had earlier insisted, in favor of Cubist and German Expressionist influences, which they picked up as they traveled to publicize their movement and work.* While they never abandoned the subject, affirming it—as their social program indeed demanded—in the face of Cubism, which they found too abstract and "classical," they rejected Realism. Along with so many thinkers at the turn of the century—William James, Freud, Einstein, Rutherford, Planck, Bergson—who rejected the limitations of nineteenth-century science and discovered aspects of reality that could not be seen with the naked eye or experienced through reason alone, they asserted that modern life could not be captured by picturing discrete moments in time, for it pulsated, flowed, vibrated, and emoted, and the painter must recognize and somehow depict this movement and the invisible forces within it. "Space no longer exists," they wrote in their "Technical Manifesto" of 1910:

> a street bathed in rain and illuminated by light globes sinks down into the earth's core. The sun is millions of kilometers distant; but does not the house we are in front of seem mounted on the sun's disk? Who can still believe in the opacity of bodies when our acute and multifaceted sensibility causes us to intuit the obscure manifestations of mediumistic phenomena? Why should we be expected to continue creating without taking account of our visual powers, which could give results analagous to X-rays?[58]

They sought means of depicting mental states, sounds, noises, and odors as well.

In translating multifaceted reality to a static picture plane they developed various means of suggesting multiplicity, describing movement by

*Their most important trips were to Paris and London in 1912, to open important gallery exhibitions, and to Berlin in 1913 for an exhibition in the Sturm gallery. Walden was much taken with them (to the dismay of the Blaue Reiter); he included them also in the Erster Deutscher Herbstsalon. (See Carrà, *La Mia Vita*, p. 162, and Gino Severini, *Tutta la vita di un pittore* [Milan: Garzanti, 1946], pp. 127–28.)

repeating images (". . . a racing horse does not have four legs, but twenty, and their movements are triangular"), simultaneity by depicting several actions at once, what they called "the intersection of planes," and experimenting with new sorts of compositions which would "put the spectator in the center of the picture," as he was in the center of life. This last procedure, Carlo Carrà later recollected, was suggested to him by personal impressions in 1904 at the funeral of an anarchist, Galli, murdered during a period of labor unrest in Milan. Carrà found himself caught in the crowd as fighting broke out between cavalry and mourners. "Discovering myself without having desired it at the center of the fray," he remembered, "I saw before me the bier, covered with red carnations, wavering dangerously on the shoulders of the pallbearers; I saw the horses becoming restive, and clubs and lances clashing, so that it seemed to me that at any moment the corpse would fall to the ground and be trampled by the horses."[59] His 1911 painting of the event (Fig. 21) recreates these sensations through a contrast of black and red, the colors of the leftist movements, through the energetic, combative stance of the central male figure, through human and equine legs and bodies going in all directions, through repeated references to moving lances topped by black flags. Their movement is accomplished by arcs extending from the lance points and parallel black lines suggesting their successive positions. The over-all effect is reminiscent of Uccello's battle scenes, which also successfully depict movement and confusion.

Social clashes and riots were favorite Futurist subjects, as they showed the movement and interaction of groups of people to the fullest extent— and also, no doubt, because the Futurist painters had broad experience of them. Like Carrà's painting, most of these depict the chaos in a crowd which is either radical and violent itself or is caught up in something unexpected: for example, a mixture of pleasure-seekers in evening dress, miscreants, and police in the Galleria Vittorio Emmanuele. Boccioni's "La Retata" ("The Police Raid," 1910) depicts alarmed people in evening dress, unsure where to turn as carabinieri move in on them from all sides. Russolo's "La Rivolta" ("The Revolt," 1911, Fig. 22) is more advanced in conception and design. In the catalogue to an exhibition in London in 1912, the Futurists explained it as follows:

> The collision of two forces, that of the revolutionary element made up of enthusiasm and red lyricism against the force of inertia and reactionary resistance of tradition. The angles are the vibratory waves of the former force in motion. The perspective of the houses is destroyed just as a boxer is bent double by receiving a blow in the wind.[60]

Here the revolutionary force is depicted abstractly as a sharp wedge of faceless figures, nearly identical, striding forward and sending the solid buildings of tradition literally flying. Clearly, revolution is the wave of the future.

Another important social theme treated extensively by the Futurists reaches its climax in Boccioni's "The City Rises" (Fig. 23): that of modern construction and the titanic power of labor. Labor is here depicted by three enormous, rearing horses and by the men, dressed in simple shirts and trousers, who struggle to hold them down. While the title is ambiguous— the city might as well be rising in revolt—the background of houses under construction makes the meaning clear and relates this work to earlier ones. Unlike Balla, Boccioni retained his fascination with the developing suburban neighborhoods of Rome and Milan. As the men, pulled nearly parallel to the ground by the powerful horses, seem to float in the bright and hazy light, the background offers a sampling of the forces of progress most loved by the Futurists. Sketches for the painting clearly show that, behind the laborers and the houses with their scaffolds, Boccioni included smoking factory chimneys, a train emerging from a tunnel sending a cloud of steam into the air, and a busy street above the tunnel, filled with pedestrians, vehicles, and an electric streetcar. Only traces of these details remain in the final work.

Many other Futurist works were devoted to these modern sights, without other ideological content. Balla and Russolo were interested in depicting the speeding automobile, Boccioni and Carrà the train and tram, and Severini the Paris Métro. They continually sought means to represent the motion of these vehicles (and of living creatures such as swallows) ever more graphically and with less and less recourse to the stationary, "photographic" reality of the object.

V

If, as I maintain, there is a direct connection between the social stance of many painters during their early years and the forms modern art took, it must be emphasized that by about 1910 few of the new painters were consciously political, or even much interested in extra-artistic matters. By then their social defiance, formerly blunt and outspoken, had become vague and indeterminate, and been internalized in their work. It is clear

that they almost unanimously rejected the Western middle-class elite with its liberal but bureaucratic and torpid governments; that they empathized with the workingman and peasant, seeing them as somehow more wholesome and potentially more perceptive than the upper classes; that they wished for a more open and energetic way of life, one which would allow more latitude to individual opinions and initiative. It would be risky to pin a political label on them at this stage except the obvious one of "anarchists," which can be applied very loosely.

It is not even clear that the radicalism of all the painters was leftist: the Brücke painters in particular, and the Italian Futurists in some aspects of their thought, veered toward the philosophies of native blood and soil just then being elaborated, philosophies which wound up on the extreme Right during the 1920s. The early experiences of some of the painters in the decorative arts had the result of both radicalizing and conservatizing them: radicalizing them in opposition to the highly regimented academic training they had to a large extent escaped, and conservatizing them by giving them a love for preindustrial craftsmanship. Here they agreed with Marx that unalienated labor was best—but they did not agree that industrial labor could ever become de-alienated. While the Futurists joyously celebrated industrialism and welded it to their nationalist program, the Brücke painters got from their contact with medieval woodcuts and primitive statues a desire to turn the clock back to preindustrial times. Though the Schleswig peasant Emil Nolde was exceptional in his racism among the Expressionists, they all shared his love of the soil and his unease with urban life—and neither feeling disturbed their advanced approach to painting or acceptance of other avant-garde beliefs.

Most other avant-gardists (including, notably, the Futurists) accepted "progress" and sought in their works to affirm the factory system and demonstrate that it, too, could create beauty. Except for the Futurists, they virtually all shared the libertarian and cosmopolitan outlook of anarchist, socialist, and democratic movements—though they remained aloof from specific political questions. Above all they were cosmopolitan: with really very few exceptions (Nolde, the Futurists) they consistently stood for the brotherhood of all men—especially all avant-gardists—and against the growing nationalism in the last years before World War I. The evidence for this comes not from their esthetic manifestos, but from their pronouncements on various public issues and from a few of their last prewar works.

CHAPTER **5**

The Politics of the
Art World

The spiritual has no homeland. It belongs to the entire world.
ERNST LUDWIG KIRCHNER[1]

The title of this chapter refers both to the internal and the external affairs of
the art world. Without joining political parties or manifesting any special
interest in current events up to the war, artists nevertheless occasionally
expressed convictions akin to those of various political groupings. Through
their decided openness to international and intercultural exchanges and
through the favorable response their theories and habits evoked among
liberals, anarchists, and socialists, most avant-garde painters placed
themselves—if only implicitly—in the leftist camp. In reacting to various
public squabbles over art, and in some of their last prewar works, painters
(often seconded by liberal museum directors and critics) raised many of the
same issues that were then being debated with passion in parliaments:
nationalism, the possibility of revolution, the imminence and ominousness
of war. An examination of the "political" stratification within the art world,
the Left's acceptance of some avant-garde ideology, and various painters'
reactions to world events on the eve of World War I will demonstrate the
affinity between the artistic and the political Left.

I

Since the 1860s, the art world had been split into two segments which
communicated infrequently and never congenially. There were the tradi-
tional, academy-trained painters who were greatly admired and on whom
contemporary society bestowed its laurels (prizes, government commis-
sions, chairs in academies); and, by the early twentieth century, there were
three generations of the avant-garde—the Impressionists, the Postimpres-
sionists, and the more heterogeneous younger groups—who enjoyed vary-
ing degrees of fame or obscurity, fortune or misfortune, and who had in
common their disdain of academics and bourgeois and their youthful
Bohemianism, past or present. Each of these two groups had its own
exhibitions,* its own patrons, dealers, and critics, more numerous and
prestigious on the academic side. Within the avant-garde, by its nature
amorphous and unstable, there were strong differences of temperament
and outlook. Some of the older members, now feted and affluent,
were accepted as forerunners by the rebellious young but also disdained
for their declining inventiveness—the young felt they were trying to slow
or stop the clock, if not, like the academicians, turn it back. The youngest
generation, then, spurned even them, preferring to the official exhibitions
its self-sponsored ones, such as those of the Blaue Reiter and Herwarth
Walden's Erster Deutscher Herbstsalon (First German Salon d'Automne) of
1913, which differed from its French, juryless model in the extremely ex-
clusive selection of the works exhibited. Devoted critics and propagandists
followed the development of each new style and interpreted the painters'
plastic statements to the public. Most interpretation, however, by profes-
sional critics, art dealers, writers, the artists themselves, and even govern-
ment officials on occasion, was less attentive to the formal qualities of
individual works or to their art-historical sources than to issues that today
would be considered extraneous. These issues reveal some of the political
differences between the avant-garde and the rest of the art world.

Most critics of avant-garde painting rejected and ridiculed the seeming

*The academic exhibitions tended to show only works carefully selected by a jury of academy
members; the avant-garde exhibitions were more liberal in their policies. Some had more
lenient and representative juries, others were open to all entrants.

childishness and lack of realism of the works, the painters' Bohemian life styles, and their hostility to academic training. Rarely did a critic attempt to examine the work on its own terms, describe it accurately, and judge it without ad hominem arguments. Even the New York Bohemian Gelett Burgess of "Purple Cow" fame, though drawn to the personalities of the Cubists, was unable to look at their paintings, so strange and new to him, without ridicule: "If you can imagine," he informed his American public, "what a particularly sanguinary little girl of eight, half-crazed with gin, would do to a whitewashed wall, if left alone with a box of crayons, then you will come near to fancying what most of this work [at the 1910 Salon des Indépendants] was like."[2] More important, many critics could not help considering the perpetrators of such odd paintings insane or, worse yet, subversive. Again and again the Fauves and Cubists were attacked—in Paris newspapers and journals, and even at the Chamber of Deputies—as foreigners intent on corrupting French youth or, more often, the French "national genius." A few were foreigners, of course, which lent seeming credence to the argument. In the course of a heated 1912 debate over the arts budget in the Chamber, a Socialist deputy attacked the Salon d'Automne for the eccentricity of the works exhibited and the high proportion of foreign participants. To general approbation he demanded that the Salon be denied the use of government buildings, since foreigners were using them to "discredit French art, whether consciously or unconsciously." It was, he said, unthinkable that the French government should aid and abet "such antiartistic and antinational manifestations."[3]

The Italian Futurists were considered subversive everywhere but at home: there, even those who denounced them as lunatics could not consider them unpatriotic. In Germany, the anonymous author of a 1911 jeremiad called *Die kranke deutsche Kunst (Sick German Art)* likened the modern movement (consisting, for him, of the radical caricaturists of *Simplizissimus* as well as the Expressionists) to a vast revolution from below which aimed to destroy tradition, whose guardian, the Academy, was in the hands of the upper classes, and to replace it with rampant individualism. It was, he said, "an irruption of the unruly masses, the forces from the depths, into the aristocratic realm of Art. A revolution which, perhaps, in its own realm is scarcely inferior to the French one of 1789 in force." "Art is for all, for the People, for the Proletariat!" the new culture-dictators would proclaim. And he described a grisly prospect: "The millions from below grasp the scepter; with laughter and scorn they destroy

everything that might recall former subordination and slavery." For him, art could only be the product of centuries of discipline and experience, passed on from generation to generation through formal, carefully regulated training—through the Academy. As the French had once afflicted the world with unattainable dreams of brotherhood and equality, so the dissolute Parisian painters were now responsible for this latest German tragedy: ". . . this Bohemia of Art has again and again seduced our young German artists into seeking the good among the artistic gypsies of Montmartre."

The avant-garde to a man rejected such frequently reiterated denunciations. They too were concerned with the problems of nationality and class, but theirs was a completely different approach. Many asserted their love of country and willingly bowed to the *Volksgeist.* Franz Marc, for example, wrote August Macke on the eve of the war: "I am a German; I can only plow my own field. . . . You know how I love the French—but there is still no way I can turn myself into a Frenchman."[4] Yet their movements, their esthetic heritage, and their lives were by their very nature cosmopolitan, and they consistently refused to wave a national flag in favor of their own art or in disparagement of that of others. Attacked as unpatriotic, they replied that though the greatest art might originate in a national culture, it transcended all boundaries through its universal message and appeal. As Germany had excelled in musical composition in the nineteenth century, so had France excelled in painting; and to denigrate the achievements of the one was tantamount to denigrating the other.

The avant-garde continually provided opportunities for international exchange through exhibitions in which all the major European movements participated. The French liberal Salons and the German and Austrian Sezession movements had already been doing this since the turn of the century by means of retrospectives and group shows. Now special exhibitions would demonstrate the unity of modern art even more effectively. Perhaps the most important of these was the International Exhibition of the Sonderbund in Cologne in 1912, which aimed at a survey of the newest tendencies and hung over 500 paintings covering the period from Postimpressionism to the *dernier cri*, with, for once, official support.* The star of

*After being denied the use of the Düsseldorf Palace of Arts, where it had held its earlier exhibitions, the Sonderbund was invited to Cologne and given financial support. Members of the City Council sat on the "Working Committee." (Peter Selz, *German Expressionist Painting* [Berkeley and Los Angeles: University of California Press, 1957], pp. 242–43.) The

the show was Van Gogh, with a 125-painting retrospective. In 1913 Herwarth Walden in the Erster Deutscher Herbstsalon, held in his gallery adjacent to the offices of *Der Sturm*, hung side by side paintings by a Russian peasant and by the royal painter to a Maharaja, Chinese and Japanese landscapes, contemporary Turkish works, and works by the major young painters of Western Europe, most of whom Walden had already shown— or would eventually show—separately. French and German drawings and graphics began to appear in 1912 on the pages of *Die Aktion,* the second influential organ of Expressionist literature, more *engagé* than *Der Sturm.* (Its editor, Franz Pfemfert, and Walden allegedly hated one another: Walden thought Pfemfert too involved in politics and insensitive to art; Pfemfert disliked Walden's flashy rhetoric and distrusted his politics. Pfemfert published political articles and literary Expressionism. While most writers who contributed to *Die Aktion* made their leftist sympathies clear in its pages, the painters never did so before the war.) Similarly, the planners of the New York Armory Show of 1913 sought to introduce the international avant-garde to America.*

The split between the avant-garde and the academy on the subject of "national art"—mirroring that between the pacifist, cosmopolitan socialist movements and the moderate and right-wing groups over world affairs— reached its height with a series of controversies over the purchase of nineteenth-century French art by German museums. The stand of the German avant-garde on this issue is surprisingly consistent: liberal painters, critics, and museum directors alike repeatedly defended German museums for acquiring the French works, which they valued above anything Germans had produced. The storm broke in 1911 with two events: the death of Hugo von Tschudi, museum director and hero of the avant-garde, who had worked to promote French Impressionism and modern German painting, and the not unrelated publication of a manifesto criticizing the outflow of capital in the acquisition of foreign works for German museums.

Emperor Wilhelm II and Empress Augusta Viktoria had long been foes

1910 Sonderbund exhibition in Düsseldorf had already included prominent German, French, and Russian avant-gardists.
*See Appendix A for the participants in these exhibitions and in the liberal Paris Salons. Not listed in my table are the Impressionists, Postimpressionists, avant-garde sculptors, and several American avant-gardists (Arthur Dove, John Marin, Alfred Maurer, Max Weber, *et al.*), many of whom exhibited in Paris Salons, the 1912 Sonderbund exhibition, the Herbstsalon, and the New York Armory Show.

of modern art: the Empress, horrified by naturalistic depictions of proletarians and unfortunates, on at least two occasions banned posters by Käthe Kollwitz. And the Berlin Sezession, by then conservative by avant-garde standards, was the only organization of artists not invited to participate in the festivities marking the twenty-fifth anniversary of Wilhelm's reign in 1913.

Tschudi, a Swiss who had become Director of the Berlin National Gallery in 1896, had become convinced of the superiority of French Realism and Impressionism and of the works of younger Swiss and Germans, such as Ferdinand Hodler, Arnold Böcklin, Max Liebermann, and Hans von Marées, over those of the academic celebrities. Encouraged no doubt by a kindred soul, his friend Julius Meier-Graefe, whose critical works familiarized Germans with Impressionism and Postimpressionism, Tschudi acquired several French paintings for the Gallery, mostly through bequests. Predictably, the Kaiser disapproved. In front of the Delacroix paintings, one memoirist relates, Wilhelm became furious and exclaimed that "the Director could show something like that to a ruler who had no understanding of art, but not to him"[5] Tschudi replied that these were the best paintings in the entire collection, starting a conflict that ended only with his departure in 1909 to take over the directorship of the Bavarian State Art Gallery, where he became enmeshed in further controversies for the last two years of his life.

Before Tschudi's death, other German museums had begun to follow his lead. One of these was the Bremen Kunsthalle, under the direction of the urbane, sophisticated Gustav Pauli. In 1910, upset by the Kunsthalle's acquisition of a Van Gogh painting of a poppy field, Karl Vinnen, a local painter, discussed with Pauli the museum's acquisition policies, criticizing its neglect of young Germans and its patronage of French art. A printed manifesto, *Ein Protest deutscher Künstler (A Protest by German Artists)*, addressed to the German art world at large, followed early in 1911. Written largely by Vinnen, it was supported by some 125 other artists, including the celebrated Munich academician Franz von Stuck, the Worpswede painters Hans am Ende and Fritz Mackensen, and—surprisingly—the *Simplizissimus* caricaturist Th. Th. Heine and Käthe Kollwitz. While not denying the worth of recent French painting or of cultural exchange, it asserted that due to a cabal of art dealers and snobs, outrageous prices were being paid for foreign works to the detriment of German art. "A people can reach the heights," Vinnen contended, "only through artists of its own flesh and blood."[6]

The tract could not be dismissed as merely a retaliation of the unsuccessful, which, of course, it was in part, for it made assertions that were by now familiar and that challenged the strongest convictions of the avant-garde. A countermanifesto, *Im Kampf um die Kunst (Battling for Art)*, soon appeared, demonstrating an unusually broad consensus. It contained only individual responses to Vinnen's tract—including those of such varied avant-gardists as the now-accepted Max Liebermann, Lovis Corinth, and Max Slevogt; younger artists such as Marc, Macke, Kandinsky, Pechstein, and Beckmann; museum directors Pauli, Alfred Hagelstange of the Wallraf-Richartz Museum in Cologne, Karl Ernst Osthaus of the Folkwang Museum in Hagen, and Alfred Lichtwark of the Hamburg Kunsthalle; and prominent critics, patrons, and dealers, such as Wilhelm Worringer, Count Harry Kessler, and the Berlin dealer Paul Cassirer, whose representation of Impressionism and Postimpressionism made him an obvious target of Vinnen's invective. Besides questioning his cost estimates,* several contributors noted that Vinnen's nationalistic arguments obscured the real issue: the quality of the works that museums were hanging. And here the disagreement was insoluble. If one allowed the superiority of French over German art during the past century, then, the respondents unanimously declared, love of country would best be served by providing national artists with the best examples so that they, too, might achieve excellence. For the avant-garde, a German art which would rival and even surpass the French could develop only under conditions of total artistic freedom and the fullest possible contact between nations and schools. Through constant challenge and comparison, young artists would eventually produce works that would combine the highest technical competence and a knowledge of artistic tradition with the talent and inclinations native to their race. Instead of the second-rate imitations of French Impressionism that Vinnen and his associates foresaw, there would come into being an original, German art.[†] As Macke put it, "We artists need total freedom and no local sergeants."

*Vinnen claimed, without citing exact figures, an imbalance of payments due to an excess of importation over exportation of art works. He further charged that German museums were paying higher prices for French works than the French themselves. Pauli demonstrated his error by making a list of the Kunsthalle's recent acquisitions, French and German (manuscript list at the Bremen Kunsthalle). Here he showed that only two-thirds as much was spent on French works as on German ones between 1899 and 1910. And Paul Cassirer pointed out that most of the money going abroad was being spent on old masters.

†Emil Nolde, always a nationalist, wrote to this effect in a letter of September 14, 1911: "When our art becomes equal to or greater than French art, then it will also—without any special effort—be completely German." (*Briefe aus den Jahren 1894–1926* [Berlin: Furche-Kunstverlag, 1927], pp. 78–79.)

Similar discussions continued periodically in Germany until the war. The avant-garde rose up once again in 1913 to protest a newspaper article that had attacked "this Russian Kandinsky" in terms by then familiar.[7] The avant-garde was, to be sure, often as intemperate and scornful as its critics, but on no account would it let art and nationalism be mixed.

II

There were other issues besides nationalism on which artistic and political leftists could agree. Just as the innovative artists demonstrated a preference for lower-class surroundings and radical thinking, so the political radicals came to sympathize with the avant-garde in the face of official disdain. Only a few leftists became intimates of the painters or collected their works. But a process of ideological crossfertilization between the artistic and political avant-gardes dating from the 1890s demonstrated on the one hand a great similarity of outlook between the two groups and, on the other, fundamental differences, which would ultimately become irreconcilable.

As the then Radical Georges Clemenceau had been the only official supporter of Impressionism in the 1880s and 1890s, cajoling the French government into accepting the Caillebotte bequest, which later became the nucleus of the splendid collection at the Jeu de Paume, so socialists such as the deputies Marcel Sembat and Joseph Paul-Boncour and anarchists such as the publisher Jean Grave were the only men in public life other than critics and literati who defended and supported modern art.*

Assuming that everything would automatically come right culturally as well as socially once the revolution—gradual or violent—was accomplished, most leftists concentrated on political and economic theorizing and shunned discussions of art. In Italy, Germany, and Austria, it was mainly radical-minded writers who theorized about the contemporary relationship and the ideal, socialist one between artists and society; the ranking socialist theorists remained silent. In France, however, where Marxism,

*This was also the case in Germany. In 1908, in a unique discussion in the Reichstag on the economic situation of artists, a Socialist deputy recommended—with approbation from the Left—appropriating 75,000 marks for artists' stipends beyond what the Länder were already granting in order, he said, to enable young artists to work in total freedom without starving. (*Verhandlungen des Reichstages*, CCXXXI, 119. Session, March 11, 1908, 3767 B-C.)

with its doctrine of the primacy of the economic substructure over the superstructure, had never completely triumphed over indigenous socialist ideas, leftists of every stripe, from parliamentary socialists to anarchists and syndicalists, dealt with the subject in lectures, pamphlets, and theoretical works.[8]

Leftists accepted the painters' self-assessment as now classless outcasts from bourgeois society and granted the avant-garde a social outlook and revolutionary purpose similar to their own. They appreciated the modern painters' respect for handicraft, which they themselves advocated as the artistic form and method proper to a classless society whose citizens would be predominantly simple and uneducated, at least at first. Like many artists, they were influenced by John Ruskin and William Morris and considered the Gothic cathedral the supreme artistic creation, on the fanciful ground that, despite its service to an ideology now outworn, it was built with the skill and participation of ordinary people and functioned as the center of communal life, much like the socialists' own neighborhood houses.

Positing a universal craving for beauty and aptitude for culture, many leftists declared that the proletarian's emotional and intellectual development would begin only when he was free from exploitation and had leisure time. In a speech of 1900, Jean Jaurès granted that even a machine might seem beautiful in itself and be capable of creating beauty—but not to one who is at its mercy twelve to fourteen hours a day without independence or security. The worker was like the farmer who, laboring day in, day out in the fields, never had the repose to appreciate the beauty surrounding him.

Leftists, too, attacked the Academy and the bureaucratic art establishment as sclerotic organs of the capitalist system. Though the bourgeoisie had raised art to a new level when it came into its own after 1789, it was now out of touch with economic and political realities, and therefore culturally decadent. On this point Jaurès was more moderate than others, warmly praising the artistic achievements of the middle class and forecasting still more. But he criticized the art of the bourgeois era on two counts: it was chaotic, lacking any broad consensus; and it was superficial, failing to extend beyond the tastes of the middle-class minority to speak to the people as a whole. There was general agreement that all the great art of the past should be conserved, and that new means should be found to convey it to the people: cheap reproductions; copies of great works, to be kept in

neighborhood museums; "night museums" where books could be read and exhibits viewed after working hours; and organizations like the popular universities founded at the turn of the century which would educate the people at no cost and at a pace compatible with their daily toil. Many such cultural ventures were launched, especially by anarchists and syndicalists, under such names as "Social Art," "Art for All," "Art and Work," and "Art and Science."

Favoring art with overt social content, leftists rarely mentioned the avant-garde. They did not demand social content of all art—some even warned against such a demand—and the artists they singled out for praise were mainly past or present members of the avant-garde, such as Daumier, Millet, Van Gogh, Luce, Carrière, and Constantin Meunier. They demanded innovation and originality in order to counteract bourgeois art; and they frequently asserted that the greatest artists were usually unknowns who suffered privations not unlike those of the proletariat. "The true artist is not a sluggard," said a Socialist in a speech of 1910,

> even less is he a useless member of society. Most often, given the conditions of existence in a society hostile to original and independent spirits, he experiences pitiable anguish and heart-rending privations. The true artist is not the worker's enemy; on the contrary, the two share the same simplicity and aspirations. They are brothers in pain. If one is a manual worker, the other is the proletarian of thought. They should extend their hands to each other like brothers.[9]

Without commenting on the abstraction of modern painting, leftists rejected the class-bound realism and outworn historical, philosophical, and religious pieties of academic art, saying these could only indoctrinate the people, not raise their cultural level. They also attacked an economic system that allowed mediocre artists to become wealthy and famous while great ones died of starvation, having sold for a pittance works that soon after earned their dealers fortunes. A Socialist, Jean Ajalbert, began an inquiry in *L'Humanité* in 1904, inviting artists, professionals, and socialists to comment on a new plan to give pictorial artists some sort of copyright and a share in collectors' and dealers' profits on their works. Léon Blum, then a member of the Conseil d'État, considered the proposal an apt solution to the artist's economic plight. He considered artistic property the most defensible form of private property, since it entailed neither capital investment nor salaried labor: ownership of his finished painting was simply the reward for an artist's hard work. But he emphasized that his endorsement was only made in the light of the prevailing social system, for

the copyright might induce venality on the part of artists. The real solution, attainable only under socialism, would be the complete separation of art from wage-earning. He advocated the "equality of all before labor": all would work equally but briefly at socially useful tasks for their daily bread and, in their ample leisure time, pursue spiritual enrichment. The payment for artistic excellence would be kudos, not the monetary handouts that were currently enslaving artists. In an important treatise written between 1911 and 1913, *Die wirtschaftliche Lage der Künstler (The Economic Condition of Artists)*, the Berlin Marxist Lu Märten urged artists to form unions to fight the accumulation of "artistic surplus value" by dealers and collectors and to demand the institution of a copyright.

On all these points socialists and artists were in remarkably close agreement. Yet their respective arguments foreboded eventual discord. Blum's statement raises one problematic issue. Defending his policy of equal labor in socialist society, he explained that this would keep the artist from occupying an exceptional status, "which would soon come to seem a privileged position."[10] The painters, despite their talk of brotherhood, considered themselves privileged through their talent and imagination; they would fare ill if a socialist regime were to make a serious attempt at leveling, and some of them realized this already before the war. According to the liberal and socialist world views, said Herwarth Walden in 1912, "people are supposed to be ordinary, identical and straightforward. The artist, however, can only arise and endure through the opposite qualities. The spokesmen for the masses are against the Futurists. I expected nothing else."[11]

Other contradictions are apparent in the writings of Georges Sorel. As an ardent individualist he projected for the workers of the future those qualities of independence, self-sufficiency, and commitment that he recognized among artists. Art, he saw, throws a wrench in the Marxist machine; through its love of freedom and thirst for innovation it overthrows all the social theorists' neat prophecies. He considered this a sufficient reason to overturn the Marxist relation between substructure and superstructure and to declare art "a reality which begets ideas and not . . . an application of ideas." The artist, not the artisan who is content to reproduce the same object ad infinitum, could teach the worker about the practice of unalienated labor and the possibilities of the human spirit. He could infuse the worker with some of that "passionate individualism" that politics had dampened and make possible that sense of responsibility and enjoyment without which a corporate society would fail.

Seeming to embrace the avant-garde's Weltanschauung altogether, Sorel nevertheless suggested a limitation that artists would have considered fatal. In a telling footnote to *Reflections on Violence,* written no doubt to placate the leftist reader, he asserted that "the habits of life of the modern artist, founded on an imitation of those of a jovial aristocracy, are in no way necessary, and are derived from a tradition which has been fatal to many fine talents." He berated Marx's son-in-law, Paul Lafargue, for assuming that a dissolute life might stimulate the artist's mental activity and creative ability. So, in the end, avant-gardism was acceptable only at the workbench.

Despite Jaurès' assurances that art had nothing to fear from socialism, since the artists who sought glory were the supreme communists, going beyond the individual and circumscribed to seek universal truth and beauty, and despite the frequent assertions of other leading socialists that art was not expected to be programmatic, socialist thinking already betrayed a tendency to warn artists that their duty was to provide only what the proletariat could understand and profit from. In the face of Jaurès' reverence for art, the Anarchist Grandjouan, himself a commercial artist, threatened the destruction of the Louvre, the temple of bourgeois class culture:

> . . . some night the exploited will descend in a tumult toward the Louvre and will set your historical souvenirs, your "masterpieces" aflame.
> I can hear them, those frightened cries amid the showers of sparks in the blue night. *"Barbarians, vandals,"* the well-meaning, right-thinking bourgeois will cry, *"you are ruining humanity, destroying a civilization!"* "No," we'll reply, *"we're destroying the decorations of your odious civilization."*[12]

This was extreme and certainly not aimed at the avant-garde. Besides, the Italian Futurists were eagerly calling for the same pyrotechnics. But simply in stating that art was the best tool for educating the people and challenging the social status quo, activists were implying that the foremost role of art was propaganda, a thesis that no major avant-gardist would then accept.

III

"In Christmas week, eight months before the outbreak of the Great War," wrote Sir Michael Sadler, the British educational reformer and art collector,

the Russian artist, Wassily Kandinsky, who was then living near Munich, sent me an unexpected gift. . . . It was a non-representational picture, a free pattern of coloured arabesque, explosive and ballistic in its design. We gave it the title of "War in the Air." A year later, by which time we had got only too familiar with bombs and fighting planes, I wrote to Kandinsky in Sweden to ask whether, when he painted the picture, he had foreboded war. "Not this war," he replied, "I had no premonition of that. But I knew that a terrible struggle was going on in the spiritual sphere, and that made me paint the picture I sent to you."[13]

Several of Kandinsky's works from this period testify to the same concern. "Sindflut II" ("Deluge II"), painted in 1914 before the outbreak of the war, suggests a cataclysmic and epochal event as much through its ominous red sun, its agitated black and blue lines and explosive forms, as through its Biblical title. The "Improvisation No. 30 (Warlike Theme)" of 1913 (Fig. 24),* nonrepresentational except for two clearly visible cannons in the right foreground which emit smoke or cloudlike forms that spread over the landscape, confirms Sadler's hunch rather than Kandinsky's denial. Kandinsky later claimed that the cannons were put there only unconsciously and out of formal necessity, not as symbols of actual events. He wrote Arthur Jerome Eddy, the Chicago lawyer, who had bought the painting: "The presence of the cannons in the picture could probably be explained by the constant war talk that had been going on throughout the year. But I did not intend to give a representation of war; to do so would have required different pictorial means; besides, such tasks do not interest me. . . ."[14] Granted that Kandinsky was not consciously interested in drawing cannons, why did he need "instruments of death" in one of his last not-quite-nonrepresentational paintings, and why did he base other works of this period on the Last Judgment and the Flood?

Nor was Kandinsky the only painter preoccupied with impending war and holocaust. Other works, mainly German, attest to a growing tension and the presentiment of some disaster of enormous dimension. Like "The War in the Air," most of these works are vague, referring, perhaps, only to the "spiritual" conflict that the theosophically minded Kandinsky suggests. But a few works with more specific content demonstrate that some painters were not inattentive either to world events or to the ideological sparring of political factions.

*There are two very similar versions of this painting. The one here depicted belonged to Arthur Jerome Eddy, and is now at the Chicago Art Institute; the other is at the Städtische Galerie in Munich.

The diplomatic documents and the writings of public figures in the several years before 1914 are filled with sometimes fearful, sometimes cold-blooded prophecies of a coming war, which the recurrent diplomatic crises of the period, that several times brought the Powers to the brink of a clash, confirmed. What most expected was not a lengthy war which would disrupt the governments, economies, and daily lives of Europeans, but rather something akin to the Franco-Prussian War of 1870—a quick test of strength among the leading European nations which would end with some redrawing of boundaries. The probable course of events once war was declared was debated with apprehension, for various movements of the Left had threatened armed insurrection should workers and peasants be ordered to fight a fratricidal war for the benefit of international capital.[15]

Already in a novel published in 1909, *Die andere Seite (The Other Side)*, the Austrian painter-illustrator Alfred Kubin had suggested an impending European crisis by depicting the cataclysmic destruction of a "dream empire" (*Traumreich*) in the Himalayas, an old-world kingdom in miniature complete with antique European buildings and furnishings, an impassable parapet, a bureaucracy as Byzantine as those Kafka was just then describing, and asocial or neurasthenic inhabitants subjected to a totalitarian, increasingly repressive rule in the name of antimodernism. Destruction comes in the form of a wealthy American, one Hercules Bell, representative of the forces of modernization to which, in Kubin's estimation, old Europe was just then succumbing. Kubin's argument was twofold and contradictory: on the one hand, himself a typical "dreamer," Kubin approved of Austria's old-fashioned ways; on the other, he was suggesting—even before Freud—that overly rigid repression could lead to an explosion of mass aggression and self-destructiveness. Kubin later claimed to have produced the book in twelve weeks, in a trance. When the war came he was horrified to think that his vision had come true—and so it had, in a way, for the war resulted in the destruction of the Austrian empire and the triumph of the Hercules Bells.

The contemporary German poets, too, made war and destruction a central part of prewar works. August Stramm, acclaimed as a war poet after his death in battle in 1915, already mentioned trenches (*Schützengraben*) in a 1913 poem. The young, stormy Georg Heym wrote several poems about death and desolation before his own death by drowning in 1912. In "Der Krieg" ("War") of 1911, Heym depicted the fiery destruction of a city, not unlike that of Kubin's "dream city":

Eine grosse Stadt versank in gelbem Rauch,
Warf sich lautlos in des Abgrunds Bauch.
Aber riesig über glühnden Trümmern steht,
Der in wilde Himmel dreimal seine Fackel dreht

Über sturmzerfetzter Wolken Widerschein,
In des toten Dunkels kalten Wüstenein,
Dass er mit dem Brande weit die Nacht verdorr,
Pech und Feuer träufet unten auf Gomorrh.*

A 1910 Kokoschka poster for *Der Sturm* (Fig. 25) pictured, according to the artist, "a naked, twisted man tearing open his chest wound."[16] Since it was clearly a self-portrait, it later seemed to have been prophetic of the near-fatal wound Kokoschka received on the Eastern Front in 1915. It was copied, or so Kokoschka complained to Walden, in 1911 by Max Oppenheimer, one of Kokoschka's compatriots. (Oppenheimer's version, however, is more realistic in its modeling and draftsmanship.) Paul Klee's contributions to the Erster Deutscher Herbstsalon in 1913 included two ink drawings, "Kriegerischer Stamm" ("Warlike Clan," Fig. 26) and "Das Schlachtfeld" ("The Battlefield"), which I have been unable to track down. "Kriegerischer Stamm" depicts a group of men armed with spears in serried but rather untidy ranks. Drawn as stick figures with Klee's typically whimsical humor, the warriors resemble African natives more than Europeans and are not taken seriously by the artist. But why natives on the warpath just then?

With Franz Marc, the feeling of impending doom was vague and yet unmistakable. He made direct reference to the critical European situation in a 1913 letter to August Macke, mentioning a recent painting called "Die Wölfe (Balkankrieg)" ("The Wolves [Balkan War]"). In 1913 he also painted "Das Schicksal der Tiere" ("The Fate of the Animals," Fig. 27), certainly one of his greatest works. Perhaps Marc meant to convey only the panic of animals caught in a forest fire such as he might have seen in Bavaria, but

*"A great city sank in yellow smoke, threw itself soundlessly into the belly of the abyss. But gigantic over glowing ruins he stands who brandishes his torch three times at the wild heavens

"above the reflection of storm-torn clouds, into the cold wastelands of dead darkness, to dry up the night far away with the conflagration, he pours fire and brimstone down on Gomorrha." English from Patrick Bridgwater, ed., *Twentieth-Century German Verse* (Harmondsworth: Penguin, 1963), pp. 106–8. When the war came many Expressionists looked back to this poem and found it prophetic.

the writhing, screaming deer and horses, the falling tree in the center and
the wedgelike red forms suggesting projectiles as much as flames convey a
sense of menace and destruction that goes beyond the incidental. Heym
had created a similar image in "Der Krieg":

> Und die Flammen fressen brennend Wald um Wald,
> Gelbe Fledermäuse, zackig in das Laub gekrallt,
> Seine Stange haut er [der Krieg] wie ein Köhlerknecht
> In die Bäume, dass das Feuer brause recht.*

Marc's "Das arme Land Tirol" ("The Poor Land of Tyrol," 1913) is more
specific, contrasting the bucolic life of grazing horses in a mountain land-
scape with forbidding images of a graveyard with crosses and an eagle
tensely perched on a tree with wings outstretched.

The grimness and explosive quality of many of these works suggest that
the artists saw beyond the general expectation of a short, contained war,
sensing an impending disaster that would change the direction of human
life as their art was changing that of thought and perception. Robert De-
launay, whose powerful cubistic depictions of the Eiffel Tower and other
Paris landmarks were, though in a lighter vein, also suggestive of collapse,
would refer after the war to this time as "the *catastrophic* period, period of
destruction," suggesting a causal relationship between the prewar revolu-
tion in the arts and the wartime and postwar social revolution.[17] Kubin,
too, later remembered being alarmed as well as exhilarated by the "daring
recklessness" with which the Munich avant-garde accomplished its "crea-
tive destruction and rebuilding."[18]

In fact, in keeping with socialists' prophecies, some avant-gardists saw
the coming catastrophe as revolution, not war, or a combination of the two.
In 1913, some Expressionist writers founded a literary review called *Revolu-
tion*. Its cover bore a red woodcut by Richard Seewald (Fig. 28) depicting a
revolutionary crowd holding a banner labeled "Freedom" and being fired
on by troops. Buildings in the background lean menacingly toward a
square in which there is fighting between workers and a cavalry unit. Its
first issue (September 15, 1913) was confiscated by the police. In it, the
anarchist Erich Mühsam wrote: "Destruction and construction are identi-

*"And the flames, burning, consume forest after forest, yellow bats clawing jaggedly at the
foliage, like a charcoal-burner [war] strikes his poker into the trees to make the fire roar
properly."

cal during a revolution. Every destructive breeze is a creative breeze (Bakunin). A few forms of revolution: execution of tyrants, destruction of sovereign power, establishment of a religion, destruction of old conventions (in daily life and art), creation of a work of art, the sex act." And he concluded: "Let us be chaotic!"—a conclusion he applied in the Bavarian revolution of 1918–19.

In 1910, Lyonel Feininger caricatured a revolutionary street crowd in *Aufruhr (Uprising,* Fig. 29). A band of long-legged, gentlemen revolutionaries with top hats, frock coats, and a red flag saunter down a city street. While Feininger, an American living in Germany, was able to treat such an event humorously, Ludwig Meidner could not. He painted a series of apocalyptic visions which culminated in the monumental "Revolution" of 1913. The canvas is painted on both sides. On one side is the scene suggested by the title (Fig. 30), influenced stylistically by Van Gogh and iconographically by Delacroix's "Liberty on the Barricades." In the center, amid street fighting and explosions, is the oversized figure of a man with a white bandage around his head, seated on a barricade, gripping the staff of a red flag. He is either singing or shouting; he resembles Meidner somewhat, though a more recognizable Meidner looks up fearfully from below. The reverse, "Apocalyptic Landscape" (Fig. 31), completes the representation of the socialist millennium. A nude man rests blissfully on the ground near a campfire and group of tents resembling tepees—the way of the "new man" obviously leads back to nature—while the city in the background is visited with destruction in the form of a tempest. People flee from the houses, which are about to collapse amid the black clouds, thunderbolts, and foaming sea.

The artists' nightmares of war and dreams of revolution were soon to come true. Soon they (and the socialists) would be forced to take a stand on world events and participate in a series of crises. What they actually did during the next five years bore little relationship to their prewar fantasies. Yet they developed a conviction that they had been prophetic, both in the works just described and in their "catastrophic" transformation of modern art.

Artists at War

. . . the present war is nothing different from the evil times before the war. What one earlier went through in one's mind is now being gone through with deeds. But why? Because it was no longer possible to stand the mendaciousness of European manners. Better blood than constant swindling. The war is as much an atonement as a self-willed sacrifice, to which Europe has submitted in order to wipe its slate clean.

Franz Marc, April 1915[1]

Despite their previous pacifist leanings, most painters, like almost all left-ists, supported the war that was declared on August 4, 1914. Convinced, like the socialists, that their respective countries were involved in a war of self-defense, and overcome by the prevailing mood of chauvinism and enthusiasm during the first weeks of the war, most of the avant-garde went off to the front, either as recruits or as volunteer medical aids or ambulance drivers. Many were to serve until 1918; several were to become war casualties. August Macke, Franz Marc, and Umberto Boccioni were killed in battle; the Cubist Roger de La Fresnaye, weakened by his combat experiences, died of pneumonia in the 1920s. Likewise, the sculptor Raymond Duchamp-Villon died of typhoid contracted in the trenches, and the Futurist architect Antonio Sant'Elia died in action.

For noncombatant painters the war proved a difficult period economically. Because the art market stopped functioning, even those who had made a name for themselves found it hard to earn a living. Daniel Henry Kahnweiler, the most important dealer of the Parisian avant-garde and a German citizen, was put out of business by the French government; he happened to be in Switzerland when war was declared, and there he stayed, while his enormous stock was sequestered, to be auctioned off in the early twenties at disastrously low prices. In Germany, the avant-garde fared better: while the market for art works dwindled and one important

dealer, Paul Cassirer, turned pacifist and left for Switzerland, the Expressionist journals survived and continued to publicize the international avant-garde. In his art gallery, Herwarth Walden managed—astonishingly—to exhibit the works of Chagall, Kandinsky, and Francis Picabia during the war, as well as those of Austrians and Germans. Meanwhile, Franz Pfemfert toned down the radical and pacifist stance of *Die Aktion* in order to avoid government censorship or seizure. Relying on satire to convey his opposition to the war and deceive the censors,* he repeatedly published the literary and artistic works of French and Russians. Thus, in October, 1914, he printed two eulogies to the French poet Charles Péguy, dead in the Battle of the Marne, and, in the fall and winter of 1915–16, he dedicated an issue to the culture of each of Germany's adversaries.†

During the first weeks of the war there was a rash of emigrations, voluntary and involuntary. As neutrals, Picasso and Gris were allowed to remain in France, and Feininger in Germany, without fear of conscription. But Chagall was unable to return to Paris from Russia, where he had gone to get married; the German colony left Paris, and fearing internment, the Russians Kandinsky, Jawlensky, and Werefkina left Germany precipitately. Kandinsky was to move between Switzerland, Russia, and Sweden, and finally to remain in Russia from 1916 to 1921; Jawlensky and Werefkina remained in Switzerland, settling in Ascona. A few others, convinced antimilitarists from the start, emigrated to avoid conscription or escape the hysteria and suspicion at home. Thus colonies of émigré artists, writers, and political activists grew up in Switzerland, Holland, Scandinavia, Spain, Portugal, and New York, which at various times harbored such painters as Marcel Duchamp, the Delaunays, Picabia, Marie Laurencin, who had recently married a German, Albert Gleizes, and younger artists who eventually became Dadaists and Surrealists. Duchamp, declared unfit for service due to a heart ailment, and, as an antimilitarist, feeling uncomfortable in Paris, escaped to New York. Picabia, attracted to the New York

*On one occasion he juxtaposed the chauvinistic "Manifesto of the German University Professors and Men of Science" with a curious group of documents concerning the sinking of the Lusitania: a news report of the rescue operations; a propagandistic account of this German "achievement"; a patriotic poem; an article on the English reaction to the event; and an advertisement for a circus which was using the event in one of its acts. (*Die Aktion*, V, No. 22–23 [May 29, 1915], 283–85.)

†The October 23, 1915 issue was dedicated to Tolstoy; the November 20, 1915 issue to British pacifists and poets; the December 4, 1915 issue to Péguy and André Derain, then believed to be killed in action; and the February 19, 1916 issue to the Italian Futurists.

art world while en route to a military provisioning mission in the Caribbean in 1915, deserted and remained for a year with Duchamp. Eventually he and his wife moved around on neutral ground, spending 1916 and 1917 in Spain, then 1918 with the Dadaists in Zurich. Albert Gleizes was mobilized on the first day of the war and was set to work organizing entertainment for soldiers, while his fiancée, the daughter of a former government minister, intrigued in Paris for his release. When she succeeded, in mid-1915, they immediately married and departed for America, returning to France only in 1919.

Most painters, however, stayed and witnessed the slaughter, at first hand or from afar. Those at the front were dismayed at being torn away from the only work they cared for, painting; but they also drew inspiration from the sights and sounds of war or from the fellowship in the trenches. Many continued to paint, or at least sketch, while on active duty. Drawn into the "real world" with a vengeance, thrown into contact with the masses in trenches, hospitals, or factories, painters slowly became more aware of social realities and political ideologies than they had been in years. Their early excitement turned, quickly or gradually, to disillusionment; they were to emerge from the war convinced antimilitarists with renewed confidence in the common man and, sometimes, with only vague hopes for the future, but sometimes with political programs and with faith in movements to carry them out.

I

Marinetti and the Futurists greeted the declarations of war with expressions of joy. But the Italian government declared neutrality, reneging on Italy's obligations to the Triple Alliance. The Futurists, capitalizing on their longtime vocal hatred of Austria, promptly launched a campaign to bring Italy into the war on the side of the Entente. As early as August 6, in a letter to Ardengo Soffici, Marinetti affirmed Italy's intellectual and cultural affinity with France and prophesied dismal results if the government should, against the practical interests of Italians, go to war for Austria. "Obviously," he wrote, "if the Government, contrary to Italian public opinion, should want to lead us against France in pursuit of vague promises of recompense that would later, in case of victory, be haggled over or revoked by our two patrons, a revolution will break out and we will be the ones to give the signal for it with revolver shots in Milan."[2] Within a week

the Futurists, together with republicans and socialists, staged a Francophile demonstration. Marinetti soon told Soffici he was eager "to offer myself as a volunteer or simply as a projectile to be introduced into a long-range cannon—exploding Italian *parole in libertà*."[3] Under Marinetti's influence, Papini and Soffici's literary review *Lacerba* was quickly transformed into a low-priced propaganda organ to fight for intervention in this war of "culture and civilization";* and in September the Futurists issued a handbill containing a graphic "Futurist Synthesis of the War," depicting a Futurist and Allied wedge representing such values as "courage," "energy," "ambition," and "commercial probity" (this last for England!) mowing down the forces of *passatismo*—Austria, Germany, and Turkey, endowed with such qualities as pedantry, brutality, idiocy, and clericalism. On September 16, Boccioni, Russolo, Marinetti, and two others were arrested in Milan after staging two interventionist demonstrations. The Milan prefect, one Panizzardi, took a dim view of Futurist tactics but remained unruffled by the incidents, though he wired colorful descriptions of them to the Ministry of the Interior in Rome. ". . . last night at the Teatro dal Verme," he wrote, describing the first incident,

> after the first act of the opera, the well-known Futurist Marinetti waved a national flag from a box, wishing long life to France and Italy. At the same time, from another box, the Futurist Carrà shook not a flag, but an amorphous cloth of small dimensions with two colors that seemed, as Carrà suddenly let it drop, to be yellow and black. The large audience, busily applauding the singers and Maestro Puccini in front of the curtain, scarcely noticed this event. . . . It was thus an absolutely isolated and individual incident which did not find the least response among the audience, which, on the contrary, reacted negatively when it found out that the perpetrators were two of the notoriously fanatical Futurists.[4]

*The editors' statement of their new policy shows clearly in what light the Futurists saw the war: "If the present war were only political and economic we, not of course remaining indifferent, would, however, have probably concerned ourselves with it from afar. But as this is a war not only of guns and ships, but also of culture and civilization, we are making a point of taking sides immediately and of following the events with our hearts and souls. It is a question of safeguarding and defending all that has grown up in our land. We cannot remain silent. This is perhaps the most decisive hour in European history since the end of the Roman Empire. We propose to express our thought in this liberal avant-garde journal with all the frankness possible given the present restrictiveness. We feel that this is the way of thinking of all the intelligent Italian youth and also of the majority of the people. We want to channel these aspirations and forces for the necessary reawakening of Italy. Starting with this number, *Lacerba* will be entirely political and, to obtain maximum diffusion, will be sold for two *soldi*. We shall resume our theoretical and artistic activity when these things are over."

He concluded, after the second, more flamboyant manifestation in the Galleria:

> Repeatedly here in Milan and in other Italian cities they have taken delight in noisily disturbing scientific conferences and theatrical spectacles, and they always had the worst of it, for everywhere the public has always used its fists and other more persuasive means to shut them up. . . . Last evening, too, in the Galleria, the Milanese public gave clear evidence of its aversion for them.

The sanguine prefect was soon proven wrong. After a few rather pleasant days in jail they were released on the condition that they stage no more demonstrations in public theaters or squares. They desisted until April 11, 1915, when Balla and Marinetti, together with the ex-Socialist Benito Mussolini, who had turned interventionist at the end of 1914, were arrested in Rome at a demonstration which now evoked a considerable following. The Futurists henceforth joined forces with Mussolini's Fasci di Azione Rivoluzionaria. In March, Marinetti had stated in an article published in a Swiss-German literary review:

> *The present war is the most beautiful Futurist poem that has appeared up to now:* Futurism marked precisely the irruption of war in art with the creation of . . . the Futurist *serata*. . . . Futurism was the militarization of the progressive artists. . . . War, intensified Futurism, will never do away with war as the *passatisti* hope, but it will do away with *passatismo*.[5]

He, and Carrà in *Guerrapittura (Warpainting)*, published about the same time, insisted that intervention would not be imposed upon Italy from outside, but rather would come as the Italians' free choice of modernity and future greatness.

Lacerba suspended publication when Italy entered the war on the side of the Entente on May 23, 1915; its editors had broken with Marinetti's Futurists by then yet had continued to urge intervention. Marinetti, Boccioni, Russolo, and Sant'Elia promptly enrolled in the Lombard Cyclist Volunteers, later transformed into an Alpine regiment which distinguished itself in mountain warfare against the Austrians. Balla was past military age; Severini left for Paris; and Carrà served at the front for a short while, then at a desk job, until, unable to tolerate office work, he was sent to a sanatorium for the duration of the war, where he met Giorgio de Chirico and began a new artistic collaboration.

By the time of the Italian intervention, the Futurists had turned to painting war themes, with the blessing, or the prodding, of Marinetti. Already in a collage made during the neutral period, "Manifestatione interventista, 1914" ("Interventionist Demonstration, 1914"), Carrà mixed newspaper clippings chosen for their strong "Futurist" language with phrases from Futurist manifestos and handwritten patriotic exclamations: "Lloongg livve the kiiing," "Loong lllivee the aaarrmy," and the like. Balla produced a series of nonobjective works composed of whorls and wavelike forms suggested by interventionist demonstrations and patriotic phrases. In "Canto tricolore" ("Tricolor Song"), three square, pipelike forms sporting the colors of the Italian flag jut out of the ground amidst swirls of color and a yellow wedge like a thunderbolt striking across the picture from the upper right. Balla also invented the red, white, and green (and again red, white, and blue) *vestito antineutrale* (antineutral suit, Fig. 32) which Futurists wore at demonstrations.

The Futurist war paintings and collages are less propagandistic. Severini, who remained in Paris and, due to poor health, was not drafted, painted the finest of these, "Train blindé" ("Armored Train," Fig. 33). The train is seen from above, its large turret gun and individual riflemen firing over the sides. It is a tribute to the energy and excitement of war without reference to any of the issues involved. Severini did make his sympathies clear in several works based on observation, in which, Cubist-fashion, he assembled and dissected the machinery of war—a Red Cross train, a cannon, factories and telegraph poles, formulas for explosives and poison gas. In "La Guerra" ("War") he grouped the various elements of the painting around three verticals: a factory chimney, an anchor, and the huge barrel of a field gun. In an empty space on the right are crossed French flags and the words "Order for General Mobilization," and, writ large across the bottom, "MAXIMUM EFFORT."

By 1918, the Futurist movement was decimated, never to regain its cohesion. Boccioni had been killed in 1916 by a fall from his horse, and Sant'Elia the same year, in battle; Russolo and Marinetti had been wounded. In 1915, Futurists had participated valiantly in the battle of Dosso Cassina, one of the more successful Italian actions on the Isonzo. Boccioni's description of the battle was typically enthusiastic and ingenuous. "I have been under fire," he wrote around September 1915.

Marvelous! Ten days of march in the high mountains with cold, hunger, thirst! . . . Sleeping in the open under the rain at 1400 meters. . . . The enemy

tried to stop us with a terrible crossfire. . . . 240 *shrapnels* fell on my detachment! They were greeted with ironic laughs. . . . The war is a beautiful thing, marvelous, terrible! Later, in the mountains, it seemed like a battle with the infinite. Grandiosity, immensity, life and death! . . . I am happy and proud to be a simple soldier and humble cooperator in this grandiose work! *Viva l'Italia!*[6]

Only Marinetti, cited for bravery, was able to remain on active duty to the end. There is some evidence that Boccioni was becoming disillusioned shortly before his death,* but Marinetti never did: he even refused to print obituaries of his friends in his new review, *L'Italia futurista* (*Futurist Italy*), on typically futuristic grounds. *"The living,"* he wrote, "the living *only are sacred."*[7]

II

In France, painters departed dutifully for the front, without chauvinism yet not without feelings of pride and commitment. Derain, Braque, Léger, Marcoussis, Metzinger, Friesz, Dufy, Jacques Villon, Raymond Duchamp-Villon, André Dunoyer de Segonzac, and Guillaume Apollinaire went immediately into the army and soon into combat. Vlaminck, at forty, was sent to work in a factory. Most expressed their admiration for the French troops and their willingness to fight against the Germans, whom they deemed responsible for the war. They made no racist comparisons between the French and the Germans; rather, they felt that Prussian militarism had won out over more cosmopolitan attitudes in Germany and now had to be quelled. Picasso, caught by the war near Avignon, where he was vacationing with Braque and Derain, sent Gertrude Stein a postcard in September which bore a photograph of the departure of a local regiment from the city walls. "We are full of enthusiasm in France," he wrote, adding with characteristic playfulness but not insincerely, *"Vive la France."*[8]

Proclaiming as its motto "Propriety in controversy and politeness in hatred," a new journal, *Le Mot* (*The Word*), published twenty issues between November, 1914, and July, 1915. In it Jean Cocteau, Raoul Dufy, the

*"I shall emerge from this way of life with disdain for all that is not art." (Quoted in *Archivi*, I, 373, from an article of August 1916 in *Der Sturm*. Walden claimed Boccioni had written it just before his death.)

Cubist André Lhote, Albert Gleizes, and others expressed their anti-Prussian sentiments in articles and satirical drawings. Cocteau, now identifying his omnivorous "Eugènes" of *Le Potomak* (1913) with the Germans, continued to use them in cartoons of "atrocities" and penned a blast against Schönberg and "German sap." In an allegorical drawing, "La Fin de la Grande Guerre" ("The End of the Great War," Fig. 34), Dufy drew a light-colored French cock crushing a dark German one. He added peripheral vignettes depicting Joan of Arc, a French soldier embracing his girl, a French officer's head surrounded by laurel, a medal, soldiers going off to war, a dead bishop on his catafalque, and a priest being executed by Germans before a house in flames. Gleizes, writing in May, 1915, before his departure from France, denounced "aggressive and stupid Kaiserism" and "pan-Germanism" and wished that, together with philistinism, they might perish wherever found, and that French artists, always in the creative forefront, might in the future be given the invaluable help of public understanding.

One of the military techniques used for the first time during World War I was painted camouflage. The French credit its invention to a painter named Victor Lucien Guirand de Scevola, who, though no avant-gardist, had exhibited in the Salon d'Automne before the war, and who said he had had the idea of dissimulating the bulky forms of war machinery by employing Cubist techniques.* With the blessings of Marshal Joffre and President Poincaré, sections for camouflage were set up under the Engineering Corps soon after the Battle of the Marne; by the end of the war camouflage projects absorbed the services of over 3,000 French artists of all ages and persuasions, from academic painters to the radical caricaturists Forain, Poulbot, and Abel Faivre. Headed by André Dunoyer de Segonzac, who had participated in avant-garde exhibitions before the war and was given command of a camouflage section in Amiens in August, 1915, some members of the avant-garde were transferred to the camouflage corps and spent the war painting airplanes, trucks, and trains and constructing *trompe l'oeil*

*Alice Barthe, article in André Ducasse, Jacques Meyer, and Gabriel Perreux, *Vie et mort des Français: 1914–1918. Simple histoire de la grande guerre* (Paris: Hachette, 1962), pp. 510–11. Guirand is quoted as follows: "In order to deform objects totally, I employed the means Cubists used to represent them. This later permitted me, without giving reasons, to engage in my [camouflage] section some painters with an aptitude—because of their particular vision—for denaturing any sort of form."

blinds—not always without danger, for Segonzac and his team sometimes worked on the front lines. On one occasion they set up a false monument to the dead 20 meters from the German lines; on the Somme in 1916 they constructed and armored an exact copy of a tree that was used as an observation post between the trenches.[9] Older artists, designated "painters on mission to the army," worked behind the lines depicting military events.*

The works that the mobilized painters produced, other than the camouflage projects, fall into two categories. There are some—relatively few—with propagandistic content, like Dufy's "La Fin de la Grande Guerre" and his sketch "Tirez les premiers, messieurs les Français" ("Please Shoot First, Messieurs les Français"), depicting the fraternal relations of French and Scottish regiments in the face of German peaked helmets, and the far more numerous *croquis*, sketches of life in the trenches and the garrisons, many of which were published in two wartime journals, *L'Élan* (1915–16) and *Le Crapouillot* (1915–19).[†] The sketches and paintings that have been preserved have in common their simplicity, calm, and concern for the actors in the drama rather than for the events in themselves. They are matter-of-fact observations of the daily experiences of soldiers; even when they depict the wounded and dying, as in Ossip Zadkine's charcoal sketch of a Russian ambulance with stretcher-bearers carrying the wounded (Fig. 35), there is neither a preoccupation with gore nor an attempt to impart cosmic significance to the scene. If the French painters were concerned with anything more than depicting what they observed, it was to put their vision to formal uses, to simplify, distort, and abstract it in the Fauvist and Cubist ways they had developed before the war. In Zadkine's drawing, the ambulance and the heads of the stretcher-bearers are cut off at the upper edge; the artist focuses attention on their muscular legs

*Among them Pierre Bonnard, who produced a canvas of a ruined village; Edouard Vuillard, "L'Interrogatoire"; Maurice Denis, a large fresco, "Soirée calme en première ligne," and some paintings. These works and most of those mentioned below are on view at the Musée des Deux Guerres Mondiales, Hôtel des Invalides.

†*L'Élan*, edited after July, 1915, by Amedée Ozenfant (Paris: April 15, 1915–[March?] 1916), was a luxurious art review; *Le Crapouillot: Gazette poilue*, edited by J[ean] Galtier-Boissière (Paris: August, 1915–March, 1919; April, 1919–[June 16, 1919?]) was printed on cheap paper and written in popular style. (*See* Clément-Janin, *Les Estampes, images et affiches de la guerre* [Paris: Gazette des Beaux-Arts, 1919], *passim*, for a brief summary of the French art production dealing with the war.) While the majority of the avant-garde produced nonideological works, there were many cartoons and satirical drawings. Even Georges Rouault, a noncombatant, produced an album called "Boches."

and the contrasting inert and flattened forms covered by blankets on the stretchers, with their expressionless and undifferentiated faces peeking out. In his typical style Dufy engraved a scene from his daily round at the Cartoucherie de Vincennes that depicts soldiers seated at their desks, each calmly doing his own job. The ordinariness of the day and the solidarity of the soldiers despite their lack of communication are conveyed by the stillness of the figures, the emptiness at the edges of the picture, and the crowdedness of the center. Fernand Léger did some ink-and-wash drawings of soldiers at Verdun. As in his prewar paintings, the bodies of the men busily engaged in physical labor are abstracted into tubular forms composed of lines and accented areas of wash. This peasant's son was profoundly affected both by the visual stimuli and the camaraderie of the war. He later said that the contact with ordinary men—with their bluntness and colorful expressions—turned him away from his prewar abstraction and toward the monumental figure paintings that mark his subsequent development. "My God! What mugs!" he reminisced about his wartime comrades.

> It's in the war that I got my feet on the ground. . . . I found myself on the same level as the entire French people; as I was assigned to the Engineering Corps my new comrades were miners, ditch-diggers, artisans who worked wood or iron. . . . At the same time I was dazzled by the open breech of a 75-millimeter gun in the sunlight, by the magic of the light on the white metal. . . . The coarseness, variety, humor, perfection of certain types of men around me, their concrete understanding of practical things and of their practical applications to this drama of life and death into which we had been thrown. . . Even more, [they were] poets, inventors of everyday poetic images—I mean of slang, so mobile and colorful. . . Once I had bitten into that reality its objects did not leave me. That open breech of a 75 in the full sunlight has taught me more for my plastic development than all the museums in the world.[10]

He refused to leave the front for the camouflage corps. In 1917, while recovering in a hospital after being gassed, he began to put his observations of trench life on canvas. In "La Partie de cartes" ("The Card Game," Fig. 36), the representation of an everyday activity he had delighted in watching, Léger synthesized the humanity of a group of *poilus* and the cold, polished steel of that 75 by turning his helmeted card players into jointed robots, efficient yet benign. Jacques Villon depicted all phases of

military life from the company office to the trenches, sometimes in an abstracted, cubistic fashion, with vigorous, parallel and perpendicular lines imposing an arbitrary structure on a lively everyday scene—as in "L'Entonnoir, Champagne, 1915" ("Shell-Hole, Champagne, 1915," Fig. 37)—and sometimes in a softened and realistic mode, as in a simple and empathic portrait of a German prisoner of war. The most extreme French view of the war was painted in a white heat by the former Fauve Othon Friesz while on leave at the end of 1915. "La Guerre" ("War," Fig. 38) is a melange of scenes, sacred and profane, ancient and modern, adding up to an apocalypse. Men are killed by cannons and tortured by demons—yet nevertheless given a ray of hope, a rainbow over the Eiffel Tower.

Without being militaristic, the French avant-garde generally accepted the war as an accident of history, an ugly job imposed by the German invasion that had to be done despite the disruption and human cost. At first even Romain Rolland's pacifist essays of 1914, collectively published as *Au-dessus de la mêlée* (*Above the Fray*), found little positive response. As Georges Duhamel later said: "The piece seemed fine to me, the ideas were liberal and high-minded; but such a message came to us at a moment when we could not hear it: we were [caught] in the flames of the fire."[11] Maurice Vlaminck retained the pacifism of his early years. His correspondent André Derain, however, was at first awed by the strong sensations and community spirit* and only later became fatigued and disillusioned. By 1917 his letters resembled those of the young recruit of 1903. "The common herd," he wrote, "are crushed by the weight of pain and misfortune they carry, and which grows every day. They seem to resign themselves to it; and many of them really love the unhappiness and suffering, for they justify their existence to themselves in this way. Out of all this a very high wall has been erected which imprisons many of us, and it doesn't look as though we'll be able to get around it so fast."

As the war ground on, the painters more and more frequently complained of their forced artistic inactivity. Frequently expounding the theoretical brotherhood of men, they never came to doubt the Germans'

*This difference of opinion greatly cooled their friendship. In a letter of April 15, 1915, he wrote: "In this immense upheaval the events which follow one another in spite of human reason and logic are so far-reaching and so greatly surpass the life of one man that, for my part, I am not content to be one mere man, something common, puny, and weak, who laughs about this immensity and admires and cares only about keeping his *sang-froid*." (*Lettres à Vlaminck* [Paris: Flammarion, 1955], pp. 217–18.)

responsibility for the present war. For Juan Gris this was a period of extreme economic hardship and mental anguish. While, as a Spaniard and a pacifist, he felt no personal involvement with the war, he came to feel embarrassed by his safety while his friends spent year after year in the trenches. He was torn between his personal abhorrence of suffering and brutality, his desire to be left alone to work in peace, and the infectious patriotism in the air—linked to a belief in the rightness of the Allied cause. In 1916 he wrote to Maurice Raynal, writer and historian of French avant-garde painting:

> I can't understand as you do this urge to massacre, to exterminate, unless there's an absolute guarantee that it will end satisfactorily. There's no denying that the French soldiers are wonderful, but still some of them have got to survive. . . . Ever since the war broke out, all the civilians I come in contact with have their minds warped by events. There's not one of them intact; all have broken down under the pressure of war. I am amazed by my own stupidity and inability to swim with the tide. My feet are anchored to pre-war times.[12]

Like many others he repeatedly asked, "How much longer?" and on June 4, 1918, he wrote the poet Paul Dermée, about to be drafted: ". . . every day adds a grey hair and even my palette has become earthy."

The sentiments expressed by several French painters in correspondence with the New York lawyer and collector John Quinn were much the same. Tacitly endorsing Quinn's vehement anti-Germanism, they nevertheless complained increasingly about the length of the war. They viewed it as a German war of conquest with France the hapless victim; since it was largely being fought on French soil they never questioned the need to win it. However much they began to rail against the folly, misery, and immorality of war in general, they retained their commitment to this particular one and expressed to their American friend—who was, incidentally, helping them financially whenever he could—their relief and gratitude for the intervention of his countrymen in 1917.

They viewed the war as an experience which, however unpleasant, would eventually provide artistic inspiration. The sculptor Raymond Duchamp-Villon wrote Quinn in 1916: "Maybe this rest imposed on our artistic faculties will be a boon. . . . I have acquired a clearer and surer vision of the path already traced and the path yet to be traced. . . . Without actually being satisfied, I nonetheless have no regrets." Segonzac all but

regretted his relative security in the Engineering Corps, for it deprived him of the sensory experiences of the year before on the Somme: in the evacuated territories where he now was, he told Quinn, the war was less violent. "It is also less fantastic here: no more nights made luminous by explosions (explosion of shells, of munitions depots, of rockets)."[13]

In January, 1918, Quinn's artist-correspondents greeted Woodrow Wilson's Fourteen Points with enthusiasm. They, too, dreamed of a better world after the defeat of the Prussians: uneasy as to what the postwar would be like, they refused to believe that Europe's suffering had been in vain. At war's end, Georges Rouault, a nonparticipant because of his age (he was forty-three in 1914) and infirmity, espoused the hard line that Clemenceau was about to take toward the war settlement. He distrusted Wilson's idealism as tending toward softness on Germany. "I'm an optimist too!" he wrote Quinn soon after the armistice. "But prudently on the defensive! Like our poor *poilus* and with good reason, believe me. . . . Benevolence, pardon my language, is sometimes asinine credulity! . . . Man, at bottom, we know what he's worth—the foul and the *sublime*! There you are: the sublime and the foul, money in circulation during . . . the current, unique epoch. Accuse me of black pessimism if you wish. . . ." Younger painters were more optimistic—and, despite more than four years of hardship, more naïve. Dufy, in letters to Quinn, expressed the hope that the victorious Allies would "succeed in ending war among men forever by establishing concord and justice on earth . . ." and he predicted, "we shall all go back to work for Art and in order to come together in a great universal harmony."[14]

III

The German intellectual community greeted the war with more enthusiasm. True, only the Impressionist Max Liebermann, the Naturalist Max Klinger, the Jugendstil designer Peter Behrens, and older, academic artists such as Leopold von Kalckreuth and Franz von Stuck, along with the Naturalist playwright Gerhart Hauptmann, were among the 93 intellectuals who addressed the chauvinist manifesto *"An die Kulturwelt!"* ("To the Civilized World") to the Kaiser. But, without totally renouncing their prewar cosmopolitanism, younger painters too were caught up in the initial excitement and, once at the front, accepted the war as necessary and

Germany's cause as just, and marveled at the new sensory impressions fate had thrown their way. Just as in their prewar paintings they had viewed nature mystically and religiously, so now they viewed war— seeking spiritual enrichment even in the holocaust. They quickly became disillusioned, however, and reacted with incomparable violence and hysteria; while German troops remained victorious on both fronts, entrenched in enemy territory, some painters were to suffer extreme psychic disturbances while others turned politically leftward. Virtually no member of the German avant-garde emerged unscathed in 1918.

The Blaue Reiter, retaining some stylistic cohesion and much community spirit in 1914, was disbanded, then decimated by war, first by the departure of its Russian members, then by war casualties—August Macke in Belgium in September, 1914, and Franz Marc in France in March, 1916. Kandinsky, saddened by the thought of leaving Germany after sixteen years, undecided where to go, and hoping for a quick end to the war, wrote Walden on August 2, 1914: ". . . now we have it! Isn't it dreadful? It's as if I had been torn out of a dream. I have been living mentally in a time when such things are completely impossible. My delusion has been taken away from me. Mountains of corpses, horrible torments of various sorts, suppression of inner culture for an indefinite time."[15] Of Macke's feelings we know little. He spent only a month at the front, somehow managing, according to his wife, although he "could never stand to see a drop of blood" before then. He even distinguished himself, being awarded an Iron Cross. "[He] sent it to me yesterday in his letter," his wife wrote Maria Marc. "He said I should keep it for him, and if he should ever see it again it would remind him of the most grisly thing a man can ever experience!" "They have to go through the most horrible things," she continued. "For the last fourteen days grenade fire and hard combat. If only he'll come back!"[16] At the time she wrote these lines he was already dead.

Marc, however, left a detailed record of his everyday life and the rather complex evolution of his thinking during the eighteen months he spent on active duty with the Landwehr in Alsace. True to his prewar stance, he eschewed nationalism and hatred from the beginning. But he found meaning and necessity in the war: it was the logical result of already disastrous prewar relations between various nations, an intra-European civil war which would purify European politics and economy and, he hoped, bring about a renaissance of Western culture.[17] In an article written in the fall of 1914, Marc compared the war to the heroic myths of classical antiquity; in

another he described it as a massive blood sacrifice: *"For the sake of purification,"* he said, *"the war is being fought and the unhealthy blood poured away."* The enemy, he affirmed, was not any external foe, but "stupidity and dullness, the eternally obtuse. . . ." Thus hatred of France or Russia was senseless. The war had not been caused by any one nation, nor would the spoils go to one nation; rather, the victors would be Nietzsche's "good Europeans," led, he trusted, by good Germans, who would be wise enough not to rebuild the barriers between nations razed by the war, and who would replace the Christian religion, moribund for the last hundred years, with a creed befitting the twentieth century—*"The European Idea."*[18] An intellectual struggle as fierce as the physical one would be necessary for the "good Europeans" to win out over suspicion, chauvinism, and the decadence that had caused the war. (This intellectual confrontation, he hinted, would be a continuation of the prewar fight waged by "Germany's 'loners' " against the Establishment.) Noting the already ubiquitous fear and suspicion, Marc warned against a victory which would issue in the usual profiteering: "Then farewell to our European dream. The military excuse for a state (*Militärunstaat*) will take its place."[19]

During his first nine months of service, Marc conveyed similar thoughts to his wife and mother, at first predicting an early and satisfactory end to the war, then becoming increasingly alarmed and tense over its protraction. He adjusted to life in the army, at first liking it, then becoming increasingly upset over the separation from his wife and his Bavarian home. He continued to sketch animals. Pleased that the Germans were winning the war, he noted with dismay the eagerness of most soldiers for medals and promotions. He increasingly bemoaned the interference with his intellectual life, but he wrote Maria on Christmas Eve, 1914, ". . . until the war is over I hardly want to come home. . . . I also never regret having reported for duty in the field. In Munich I would constantly have been unhappy, depressed, and dissatisfied and would have gained nothing for my mind or existence at home, surely not what the war has given me out here."[20] Reiterating his conviction that all, not merely one nation, class, or race, were responsible for the war, he nevertheless began to speak out against capitalism and for socialism and individual, mystical religiosity. "I am a Socialist in the depths of my soul, with my entire being," he wrote Maria in June, 1915, "—but not a practical Socialist." What he meant by this last phrase became clear when he then turned to individualism: "The time of the World War is no more evil than a time of complete peace;

the most wonderful peace was *always* only a latent war. But the *individual* can free himself and others can help him: that is the meaning of *personal* Christianity and Buddhism and all art." He frowned on Socialist parties, which were beginning to criticize the various governments. But he granted that it meant little whether people died in war or from competition, on battlefields or "from close air or in mines" and, a month later, in July, that "the ground is today being prepared for the most glorious movement of the Fourth Estate. . . ." Ever more dissatisfied with the war and gloomy over Europe's prospects, he wrote Lisbeth Macke in October:

> . . . my thoughts wander around in a void, unstable, unproductive, full of hate against this war. And what makes this state of affairs particularly uncomfortable is that I am becoming an ever better—soldier! Often I no longer recognize myself; we men are a remarkable sex. Unfortunately the war masculinizes us yet more. I can scarcely imagine you women any more, and that there are children and the life of children!

By New Year's Day, 1916, two months before his death, he was thoroughly disenchanted. "The world is richer with the bloodiest year of its four-thousand-year existence," he wrote Maria. "It is frightful to think about it; and all of this for *nothing*, because of a misunderstanding, because of the lack of ability to make oneself humanly comprehensible to the next man! And this in Europe!"

Just at the time Marc was killed, Paul Klee, antimilitaristic from the first, was drafted. Though a Swiss citizen, Klee was considered subject to conscription because his father had been born in Germany and had kept his German citizenship. Just as Marc had mistrusted Klee's lack of fervor at the beginning of the war, Klee had been dismayed by Marc's enthusiasm: "The soldier's game ought to be more hateful to him," Klee wrote in his diary, "or better yet: indifferent." Klee kept track of his own emotions in his diary. "What the war said to me at first," he wrote in 1915,

> was rather physical in nature: that blood flowed nearby. . . . The stupidly singing reservists in Munich. The wreathed victims. The first sleeve turned up at the elbow; the safety pin on it. That single long Bavarian blue leg striding forth between two crutches.
>
> The realization of the letter of the history book. The corroboration of old picture-sheets. Even if no Napoleon appeared, but instead a lot of Napoleon-ites. There was about as much spirituality in it as dung on a heel.[21]

He produced several war drawings. One of these, "Tod für die Idee" ("Dead for the Idea"), a lithograph of 1915, satirizes the ascription of mythical and spiritual values to the war by both Right and Left. Beneath an unstable set of one-dimensional stick constructions typical of his drawings of the period, Klee placed a corpse, covered almost entirely by scratchy black marks: the meaningless, irretrievably lifeless remains of a human being.

He felt imprisoned in the army, and, despite considerable empathy with his fellow soldiers and interest in their varied backgrounds, he rejected the patriotism they unthinkingly accepted and mouthed. Declared fit for field service, he was saved from active duty only by a quick-thinking friend who remembered that after the death of Marc and some other Munich painters, the Bavarian king had ordered the protection of artists.[22] He was transferred to a factory, where his artistic talent was mobilized in the painting of aircraft. Like Marc, he would not hate the enemy; sent to Belgium on a transport mission, he saw the war zone from the train windows and reflected in his diary, "*La douce France*. What a reunion! Shattering. . . . Poor, degraded country! The past, an implacable line drawn under yesterday. A glittering blade deep in the heart's core" (December 4, 1916). Just as the German government appealed to Wilson for an armistice, Klee heard the rumors of defeat and sensed the slackening of discipline. "The war events sound all too worldly! . . ." he wrote on October 10, 1918. "Will the Western Front soon move itself back to the Rhine? Then we shall go home, what a theme worthy of a hymn! But now it all must really collapse. No one may pick himself up again. The psychological moment is here." Ten days before the armistice he noted his disquiet over Germany's future fate, not at the hands of the victors but at the hands of its own people. "What a moment, the way the Reich stands there all alone, armed to the teeth and yet so hopeless!" he wrote. ". . . we now ought to have an example of how a people should endure its catastrophe. But if the masses become active, what then? Then matters will proceed in the ordinary way: Blood will flow and, what's worse yet, there will be trials! How banal!"

As even their prewar painting, with its raw colors and extreme distortion, might suggest, the Berlin Expressionists reacted more emotionally to the war. The painter most affected was undoubtedly Max Beckmann. In 1914 he was hardly an avant-gardist: his style was still influenced by Impressionism and he took a conservative stand on the artistic controversies of the day. He already had the interest in brutality and torment—

influenced no doubt by Grünewald and other early German painters—that was to become his hallmark; but before the war his depictions of atrocities lacked the bite and sheer hallucinatory horror that they were to develop once he had himself witnessed the full extent of man's inhumanity to man. An engraving of 1914,"Die Nacht"("The Night"), depicts a bedroom murder scene. A dead man lies sprawled half out of bed, reminiscently of the dead worker in Daumier's "Rue Transnonain." It is not clear how, or by whom he was murdered. Other figures stand around aimlessly without giving a clue to the mystery. And Beckmann's feathery drawing style does not succeed in conveying the horror of the scene. In 1918 Beckmann did a painting again called "The Night" (Fig. 39). Now a violent scene is shown in excruciating detail, and the message of the subject is intensified by the style. People packed together in a room whose walls seem to close in, are torturing and being tortured. A central female figure is strung up by the wrists; a male one is being strangled while his arm is being twisted. The screams and moans, pain and writhing are conveyed by the distortion and twisting of the figures. The effect of the extreme angularity of figures and objects is visceral: the observer unconsciously becomes a participant in the scene, sharing in the feelings of torturer and victim. It would be possible to see this painting as a premonition of Hitler's Gestapo and concentration camps, but it is actually a heightened remembrance, and surely an attempt at exorcism, of Beckmann's wartime experience.

He was among the most patriotic of the painters who went off to war. By September 14, 1914, he was a volunteer orderly in a field hospital. At first he was thrilled by the fellowship among the troops and doctors, by the German victories and the sights and sounds of war. His duties— even the continual contact with the dead—were not trying; he had not, he said, lived so intensely or experienced so much in years. Having happened upon Hindenburg and the General Staff, he wrote his wife: "I myself yelled 'Hurrah!' before this remarkably strong fierce face with sharp eyes," and wished she could have been there to share in his joy "that Germany still produces men like Hindenburg."[23] When he witnessed a battle on the Eastern front in October, 1914, it was his esthetic sense that responded: he was thrilled by its musical and visual qualities. "Outside there was the wonderfully grand noise of battle," he wrote.

I went out, among crowds of wounded and exhausted soldiers coming from the battlefield, and heard this strangely awful, grand music. It is as though the

gates to eternity are being torn asunder when such a great salvo rings above. Everything suggests space, distance, timelessness. I would like to, I could paint this noise. *Ach*, these broad and uncannily beautiful depths! Crowds of people and "soldiers" moved all the while toward the center of this melody, toward the decisive moment of their lives.

Transferred to Flanders early in 1915, he reflected: "It is impressive to see what our country is accomplishing, how it is spreading itself out with elemental power, like a river which overflows its banks." A month later he experienced his first doubts. He began to suffer from "the loss of my individuality" and to miss his prewar freedom. He threw himself more and more desperately into painting, which he was able to continue at the front, as a deliverance from and a justification of the war. After the death of his friend and brother-in-law Martin Tube in March he became more and more nervous and found it increasingly difficult to justify the war. "What would we poor men do," he wrote in May, "if we didn't always create for ourselves ideas of fatherland, love, art, and religion, with which we can again and again cover up the black, dark hole a little?" The corpses and the wounded began to haunt him, and he expressed the desire to store up mentally all these "black human countenances staring out of the grave and the silent dead that come to meet me," for later translation to canvas. He had a recurrent dream of the destruction of the world. In June, 1915, suffering from nervous prostration, he was discharged from the service. He spent the rest of the war in Frankfurt, working in solitude to relearn the painter's craft—for he now considered his old style inadequate to the material he wanted to convey.

Between 1916 and 1919 he worked on a large canvas, "Auferstehung" ("Resurrection," Fig. 40) which remained unfinished and which marks his stylistic turning point. Here he put the sketches he had made in hospitals and morgues to use in attempting a cosmic depiction of suffering. This chaotic and partially indecipherable canvas is the opposite of the traditional joyful scene of release and transfiguration. The corpses rising from their graves all seem damned, though there are no demons to torment them. Gaunt figures with flaccid bodies and cadaverous faces, some hiding their eyes, rise and stretch their angular limbs before the deserted remains of a city and a sky with two suns, one enormous and one small and intense, neither of which casts much light. Below, in the foreground, are portraits

of Beckmann, his family, and some Frankfurt friends, wide-eyed but not entirely absorbed witnesses to the scene, as if watching from a theater box. In this work Beckmann brought into being the personages of his subsequent paintings, the contorted, bandaged sufferers and executioners with whom he was forever afterward obsessed.[24]

Others were also psychically disturbed by the war. The members of the now disbanded Brücke were all similarly shaken, though in different degrees. Like Beckmann, they viewed its horror in religious terms. Nolde, already forty-five years old, was able to continue his serene life in Schleswig throughout the war, with some sojourns in Berlin. He remained calm. Away from the battlefields and more patriotic than most others, he commiserated over lost battles and periodically expressed his faith in Germany's valor and cause. "Out of the distance we hear the din from the battlefield up here," he wrote in October, 1914. "The news gets through to us here also, and we live all day with the soldiers in East and West, at times in fearful anxiety, and then we rejoice when the news of victory arrives."[25] But even he began to be war-weary by 1918, and he later found a scapegoat in the international financiers, who, he felt, had profited from the war while his peasant neighbors' sons and others like them were butchered. "The backers and brokers remained under cover," he recalled in 1936. "And the money which moved between them was the grease of the entire murderous military machine. The stockholders of the steel works, of the oil and poison gas companies, all celebrated dark, infernal triumphs"[26]—a familiar tune, once sounded by the prewar Left and now echoed by the *völkisch* movement, notably the Nazis, with whom Nolde by this time sympathized.

Kirchner was inducted early in 1915. He was, he later said, "an involuntary volunteer and went into an artillery regiment as a driver. Military life was not for me. To be sure, I learned riding and the care of horses, but I had nothing left for the cannons. Service became too difficult for me and thus I became thinner and thinner."[27] In October, 1915, he was released as unfit for service after suffering a physical and mental breakdown. A month or so later he painted himself in uniform, with a green stump for a right arm (Fig. 41). A canvas stands indistinctly in the background of the painting, and a nude model stands distinctly behind his left shoulder. Beyond a loathing for war and a castration anxiety, Kirchner has expressed here his insecurity about his artistic future. The model is at his disposal, but without a right hand he can no longer paint.

Kept nervous by a recurrent fear of being redrafted, he tried to live in Berlin but repeatedly had to enter sanatoria. "The pressure of the war and the increasingly prevailing superficiality weigh more heavily than everything else," he wrote in 1916. "One feels that crisis is in the air. . . . Turgidly one vacillates, whether to work, where any work is surely to no purpose. . . . Nevertheless I am still trying to bring order into my thoughts and to create from the confusion a picture of the times, which is after all my task."[28] He did manage to work—until he was struck by an automobile in 1917 and, making the prophecy of his self-portrait come true, broadened the pain in his "skinned" painting arm into a partial paralysis of his arms and legs. Later that year he settled in Switzerland, near Davos, and pestered his various doctors with repeated requests for attestation to his illness.[29] He remained—his disclaimer notwithstanding[30]—psychosomatically ill until the end of the war, strenuously and compulsively battling the paralysis and pain in order to wield a paintbrush or a wood knife. Increasingly moody and querulous, he behaved oddly and shunned human contacts more and more. His friends carefully avoided mentioning the war in his presence, though he himself would compulsively broach the subject. Even in Switzerland, during a brief outing with Helene Spengler, the wife of one of his doctors and mother-in-law of his friend and patron Eberhard Grisebach, head of the Jena Kunstverein, "every uniform brought him up short, and in Davos there are 1,300 uniform-wearers now."[31] He rejoiced at war's end, hoping that the general disruption would facilitate a rebuilding of culture along the lines of brotherhood rather than nationalism. And his paralysis slowly vanished, though it took him a few years more to discontinue all the pain-killing drugs he had been using. About the German revolution he remained skeptical, seeing little action and too much idealistic talk.* He refused to make a poster in honor of the war dead. "So long as the dependents and invalids run around uncared for and, begging in the streets, show their mutilated members," he told Nele van de Velde, again exhibiting his preoccupation with his own unmutilated member, "one cannot make such artistic monuments. They only instigate new wars and

*"The way I hear it, matters over there are not very pretty. The great act of liberation of the Revolution seems to be turning, as always, into petty squabbling. The popularizing of art seems to be aiming at turning it into a surrogate for music-hall stuff. . . . The good gentlemen want to do everything, thus they do nothing and in the end they are still only will-less tools of Berlin cliques. It is unhealthy and artificial, this so-called spiritual revival." (Letter to Grisebach, May 9, 1919.)

battles anyway. To that I will not lend my art."[32] Not until 1925 did he consent to revisit Germany; and he made an artistic and personal virtue of remaining in neutral Switzerland for the rest of his life.

Pechstein, Heckel, and Schmidt-Rottluff spent most of the war years in military service. Pechstein and his wife, blissfully settled in Palau, heard about the war only in October, 1914; soon after, the Japanese, allied to the Entente, began an invasion and they were warned to leave. Uncertain about the fate of his family and his atelier, Pechstein decided to return to Germany, arriving late in 1915, only after internment by the Japanese, rescue through the good offices of an American diplomat who liked his work, a trip across the Pacific and the United States, and a hazardous crossing of the North Atlantic on a neutral ship. During this last voyage Pechstein worked as a stoker, concealing his German nationality with the help of false papers.[33] Upon arrival in Germany he was immediately drafted; after participating—much against his will—in the battle of the Somme, he was given a desk job and finally managed to obtain a discharge and return to Berlin. When the revolution came he was one of its staunchest supporters.

Heckel was a volunteer nurse in Flanders. Like so many others, he found new and interesting sensations in the war, but more and more came to resent the discipline and his inability to paint. "I have seen a lot in the military hospital in Berlin, and out here," he wrote Max Sauerlandt, then also in the army, but soon to become the director of the Hamburg Museum für Kunst und Gewerbe. "For over eight months we were in Ostend. Landscape, sea, sailors—an inexhaustible goldmine. . . . If only it were possible to be nothing but a painter, instead of nurse, comrade, German—all of which make it all but impossible to get around to work."[34] He did produce some graphics during the war, including a mystical Madonna soaring over Ostend (Fig. 42) at Christmas, 1915 (the original version was painted on tarpaulin as a Christmas decoration for the wounded), and woodcuts depicting the wounded, prisoners of war, and male nurses.

In service on the Eastern front, Schmidt-Rottluff was less phlegmatic than Heckel but was nevertheless entranced by the scenery. Already in August, 1915, he complained to Julia Feininger about the length of the war: "Unfortunately I am already falling into great apathy with respect to everything."[35] The poet Richard Dehmel unsuccessfully petitioned the German Chancellor for Schmidt-Rottluff's release, stressing his importance to the art world and the future need for such artists to meet the anticipated

postwar cultural demands. The disturbing break in the output of such artists, Dehmel claimed, could have serious effects on Germany's artistic development.[36] When Schmidt-Rottluff tried to paint in 1916 he found that his nerves were shaky. Two months later he wrote Feininger that he had given up trying: "Either you are a painter and you shit on the whole caboodle or you join in and kiss painting goodbye. . . ." Though he and Heckel both made it through the war, they both were left nervous and unable to work for quite some time. As late as 1920, Schmidt-Rottluff wrote Feininger: "With respect to work, this summer was unfortunately a very lazy season; it was for the most part because my body is on strike. I believe it is the memories of the war that are now showing themselves—it was a sure thing they would come. . . . Things will soon be different again."[37] The same year, inspired by a Central African statue, he sculpted "Arbeiter mit Ballonmütze" ("Worker with Balloon Cap," Fig. 43): unlike the African original, his version displayed the amputated legs and beggar's posture common by then among demobilized soliders.[38] Otto Mueller was left physically impaired after two lung hemorrhages suffered while on duty. He was to die of a lung ailment in 1930.

Other painters were similarly unable to cope mentally with the war. Alfred Kubin, opposed to war from the beginning and neurasthenic for years before, had difficulty working and suffered from a nervous eye disorder. Though patently unfit for service he was called up four times for medical examination. In 1916 he went through a mental crisis—". . . for days I have experienced extraordinary spiritual happenings," he told Feininger—after which he turned to Buddhism for release.

Oskar Kokoschka, whimsical as ever, at first treated the war as a game. Before leaving for the Eastern front as a volunteer cavalryman he painted a fan with war scenes for Alma Mahler, Gustav Mahler's widow and his mistress at the time. One of the images on the fan he enlarged into a painting, "Knight Errant" (Fig. 44), in which he depicted himself as a wounded knight in armor visited by a tiny, maliciously grinning angel of death. Late in 1915 he was seriously wounded (shot in the head; then stabbed in the chest by a Russian bayonet). In serious condition, he was put on a train as a prisoner of war. He bribed Russian soldiers to put him off the train at a station where, together with his Russian guards, he was retaken by the Germans.[39] He recovered in Vienna and went off once again to the Italian front as a military observer, this time to suffer shell shock and

be furloughed subject to reexamination. He was now saved by a doctor who took pity on war-weary intellectuals, admitting them to his Dresden sanatorium. There Kokoschka stayed through 1918, except for a trip to consult a doctor in Stockholm.

Still other painters were affected ideologically rather than mentally by their war experiences. Before the war Käthe Kollwitz had been a leftist without specific affiliation, a humanist who denounced inhumanity and class privilege. After the death of one of her sons in the war she became politically involved and developed a more direct, emphatic style. She began to lend her talent to the socialists, and then, after the Socialist Party split over Germany's postwar policies, to the Spartacists and their successors, the Communists. She drew posters and leaflets for worthy causes. Her mothers grieving over dead children or trying to feed and protect living ones began to take on her own features and become ever more simple and noble. Clearly somewhat obsessed, she worked for the next fifteen years on a huge monument to her son and other dead soldiers. Finally erected in a Belgian military cemetery in 1932, it consists of a pair of kneeling, grieving parents—Karl Kollwitz and herself.

George Grosz typifies a younger generation of Expressionists who came to maturity during the war and, while or after serving in the military, became confirmed antimilitarists and leftists. Before the war Grosz was an art student, illustrator, and cabaret entertainer, unpolitical but already possessed of great satirical talent and a misanthropic view of Berlin society, especially of the middle class. Despite his clear-sightedness in depicting the chaos and irrationality of the war enthusiasm in August, 1914 (Fig. 45), Grosz volunteered in November and entered a grenadier guard regiment.[40] Almost immediately taken seriously ill with a sinus infection, he was released from the army after a few weeks in a hospital, subject to possible recall, without having reached the front. His hospital stay alone was enough to turn him against the war; he spent the next two years in Berlin, producing ever more biting drawings and poems, with antimilitarism an important, but not predominant, theme.[41] He formed a lasting friendship with the brothers John Heartfield and Wieland Herzfelde which was to lead to journalistic, Dadaistic, and communistic collaboration. A second period of military service began in January, 1917, and ended a few months later much like the first: immediately stricken with his sinus condition, Grosz remained in military hospitals. He later hinted at incidents of deser-

tion, front duty, and dismissal on grounds of insanity, so judged on the basis of drawings he did while hospitalized—but these seem to be displacements of various friends' experiences onto himself.* By war's end he was a determined nihilist of German art and society—a perfect convert to Dadaism when it reached Berlin. So was Otto Dix, who served throughout the war on both the Eastern and Western fronts, part of the time as a machine gunner: in "Selbstbildnis als Mars" ("Self-Portrait as Mars," 1915), he first used black humor, as well as a cubist technique, to satirize militarism. For the next thirty-five years he would continually return to this theme, using ever stronger means to convey his rejection of war and of war-mongering governments. In Hanover, Kurt Schwitters, too, though less politicized and a noncombatant, attributed his turn to Dadaism and the development of his "Merz" pictures, made out of paper scraps, to his antiwar feelings. He was later proudly to state: "During the war I preserved myself for the fatherland and the history of art by bravery behind the lines."[42]

Two wartime publications which featured drawings and caricatures make it possible to date the changes in the views of some German painters. Published by Paul Cassirer, *Kriegszeit: Künstlerflugblätter (Wartime: Artists' Leaflets)* began on August 31, 1914, on a patriotic note: the prestigious art historian Julius Meier-Graefe urged German artists to fall in with the *Burgfrieden*, the official political truce, and contribute in their unique way to the war effort. During the nearly two years of its existence, the review printed patriotic cartoons and untendentious sketches by such artists as Max Liebermann, Ernst Barlach, and Käthe Kollwitz. Of the three, Liebermann (who had signed the manifesto of the 93 intellectuals) proved most patriotic. Barlach wavered between observations of the Eastern Front, allegories, and an occasional political cartoon, while Kollwitz typically portrayed an anxious war wife or mother. *Kriegszeit* was followed in April, 1916, by *Der Bildermann (The Picture Man)*. By now Cassirer was a pacifist and living in Switzerland; the contributors to his new review, published there, were all of like mind. Kollwitz and Barlach continued, and they were joined by Heckel, Kirchner, Kokoschka, and others in condemning the war and empathizing with its victims.

*His friend Oskar Maria Graf feigned insanity and spent a year in an asylum. (*Wir sind Gefangene* [Berlin: Verlag der Büchergilde Gutenberg, 1928], pp. 105–119.) According to Lewis, *George Grosz*, p. 52, Herzfelde was imprisoned for striking an officer; Heartfield spent much of the war in mental sanatoria.

Why were German painters so wrenched by the experience of the war, while the French, no less enthusiastic at first and disenchanted later, remained untouched, at least psychically? To answer this question fully would demand a thorough exploration of each nation's cultural development, for great temperamental differences are apparent in virtually all French and German art and literature produced since the late Middle Ages. Our French painters tended all along to be reserved and analytical, putting, for instance, the insights gained from the contact with primitive art to formal use in their own works. Even as Expressionists, in Fauvism, the French kept their emotions in check, distorting shapes and denaturalizing colors only to a degree. (It is interesting that the two most extreme Fauves, Van Dongen and Vlaminck, were respectively of Dutch and Flemish descent, and that the most "expressionistic" painter working in France, Chaim Soutine, was a Lithuanian Jew.) The Germans, on the other hand, tended to employ the same influences or experiences in expressing their innermost emotions, perceptions, and disturbances. They had always tended toward the grotesque and the distorted; they had always taken their surroundings and experiences to heart and tried to find religious or philosophical significance in them.

Given this pre-existing tendency to overreaction on the part of German painters, there were nevertheless three immediate causes for the difference in the response of the French and German artist-soldiers of 1914–18. One is the simple fact that many French painters had done military service as young men and thus were half-ready for war, whereas most Germans had escaped conscription. While the French army of that period was larger and more "democratic," and thus a truer cross-section of the population, the German army was smaller and more carefully trained, with more draftees released from service as unfit. Along with workers and Social Democrats, many young German painters must have been spared in this way, for there are virtually no indications in their diaries, letters, or memoirs that they served.* The second cause is connected with the first. When the war came, most French painters went to the front as conscripts, some being

*The only exceptions I have been able to find are Franz Marc, August Macke, and Alfred Kubin, who was released after brief service. Marc served with the militia, not the regular army. (On the comparative recruitment policies, see Eckart Kehr, "Zur Soziologie der Reichswehr," *Der Primat der Innenpolitik* [Berlin: Walter de Gruyter & Co., 1965], p. 237; and "Klassenkämpfe und Rüstungspolitik im kaiserlichen Deutschland," *ibid.*, pp. 100–2.)

transferred to the camouflage corps at a later date. Conversely, many Germans *volunteered*, and volunteered for hospital duty, where they were personally safe and yet had the worst of the carnage constantly before their eyes, the grisly wreckage of the battles without the thrill of the fight. The third cause, probably the most important, is conjectural, something not clearly indicated in their writings: the fact that the entire war, both in the East and the West, was fought outside Germany. The Germans were thus patently the aggressors, however they might argue that they were fighting a war of self-defense not initiated by them. As the conflict wore on, this fact might well have induced intense guilt in at least some Germans; whereas the French, actually defending their own territory, could retain their commitment even without chauvinism and keep on fighting to the end.

IV

Despite the growing discontent and anguish of painters and intellectuals, antimilitaristic manifestations were rare during the war. All but a few painters, however traumatized, continued in their roles of soldiers and citizens. As the initial enthusiasm of left-wing politicians waned in France and Germany, and they realized that parliamentary government had all but ceased to function, they increasingly reasserted themselves, criticizing the conduct of the war and eventually the war itself. But this criticism began only in 1916. Thereafter it slowly gained momentum in Germany, but in France it was quelled after the appointment of Georges Clemenceau as Premier in mid-1917.

Most painters kept their protests private or artistic, but a few particularly *engagé* leftists, among them such members of the generation of the 1890s as Signac and Frantz Jourdain, would not remain silent. They openly sympathized with Romain Rolland;[43] and, about 1916, Signac, Jean Grave, and others wrote a manifesto which denied the culpability of any one nation, emphasizing class, not national differences.[44] A young Belgian illustrator, Frans Masereel, who remained in Switzerland while his government repeatedly sought to conscript him, became noted for stark woodcuts with pacifist and leftist themes, published in new, pacifist Swiss journals such as *La Feuille* in Geneva, to which Rolland also contributed.

By the end of 1915, those artists and intellectuals who had chosen to

emigrate rather than fight were becoming restive. Forming several colonies in the large cities of neutral countries—Amsterdam, Barcelona, Lisbon, New York, Geneva, Zurich—they were aware of and somehow kept in touch with each other as well as with their friends and families in the belligerent countries. Switzerland was the meeting ground for exiles of all sorts—the safe, though scarcely calm, eye of the hurricane. Here, amidst pacifists, agitators, and exiles of all persuasions, a new generation of writers and painters discovered a new way of protesting the war. Dada, to some extent the child of the Italian Futurists and of such artists as Duchamp and Picabia, came into being in Zurich early in 1916.

Like most other modern art movements, Dada began with friendships—in this case between a German Expressionist writer, Hugo Ball, born in 1886, and a group of younger artists and writers: the Alsatian Hans Arp, the Rumanians Tristan Tzara and Marcel Janco, the German physician and poet Richard Huelsenbeck. The two Rumanians were studying in Zurich when the war broke out—Tzara philosophy and Janco architecture—and decided to remain there; the others left their native countries to avoid conscription or escape the chauvinistic atmosphere. Dada was the most international art movement to date—and, in *Cabaret Voltaire* (1916), the first Dadaist publication, Ball pointedly renounced his German nationality in order to prevent any "nationalist interpretation" of the group's activities. At first these young artists, displaced and in generally disastrous financial straits, came together in an attempt to keep the arts functioning and to continue to publicize and practice avant-gardism. *Cabaret Voltaire* and *Dada* (Nos. 1–3, 1917–18) testify to their continuing interest in painters and poets now recognized as masters: they published Kandinsky, Picasso, Apollinaire, Marinetti and several others.[45] The Cabaret Voltaire, where Dada began, was started by Ball and his mistress, Emmy Hennings, as a means of livelihood. It was a night spot where intellectuals could meet, recite their poetry, and ventilate their enthusiasms and gripes. Located in the Spiegelgasse in Zurich's old city—the same street in which Lenin and Krupskaya lived at the time—the Cabaret Voltaire developed into something still more scandalous and audacious than those prewar "happenings," the Futurist *serate*.

The catalyst was undoubtedly the war, and above all the discovery, made easy by the manifesto of the 93 German intellectuals and similar gestures, that in the present conflict not even the so-called guardians of truth were immune to parochialism and hatred. The young Dadaists

sensed acutely the irrationality then reigning in Europe. They began—progressively and unprogrammatically—to mirror and satirize the situation by turning art into chaos and declaring the irrational as valid artistically as the rational. Ball wrote in a diary of 1916: "Since the bankruptcy of ideas has stripped the concept of humanity down to its innermost core, the instincts and underpinnings are coming forth in a pathological way. Since neither art nor politics nor religious faith seems to be up to dealing with this break in the dam, there remains only the jest and the bloody posture (*blutige Pose*)."* What emerged was a sample of the nonviolent uses to which human aggression could be put: a harmless yet extremely shocking discharge of youthful high spirits, disgust with current politics, and desire for artistic innovation. The name, found by chance in a dictionary by Tzara or Huelsenbeck (its "authorship" is disputed), means "hobby-horse" in some languages; but it was chosen for its childish and musical sound, and its followers often asserted its meaninglessness. The Dadaists operated by calling everything into question, continuing the standard attacks on the bourgeoisie and the Academy, but now also maligning political leaders of every stripe, the avant-garde, and even—themselves. A group of Dadaists ended a manifesto of 1918: "To be against this manifesto is to be a Dadaist!"[46] Nor, for all the politicism of their antimilitarist and anticapitalist stance, did the Zurich Dadaists favor the left: they ignored Bolsheviks such as Lenin and pacifists such as Romain Rolland, or else ridiculed them; they mocked revolutionaries for assuming that people were capable of reason and worthy of salvation. All they were willing to concede was the absurdity of life. "Educational and artistic ideals as vaudeville program: that is our sort of *Candide* against the times," Ball asserted. "One acts as if nothing had happened. . . . One tries to make the impossible possible and to fake the betrayal of man, the wasteful exploitation of peoples' bodies and souls, this civilized butchery into a triumph of European intelligence."[47]

The Dadaist methods developed gradually and, for the most part, indi-

*In the same entry (June 12, 1916), Ball continues: "The Dadaist fights against the death agony and ecstasy of our time. Opposed to all sensible reserve, he tends to the curiosity of those who still get amusement and joy out of the most questionable sort of contrariness (*Fronde*). He knows that the world of systems is going to pieces, and that the age that demands payment in hard coin has started a rummage sale of dethroned philosophies. Where fright and a bad conscience begin for the shopkeeper, there begin for the Dadaist bright laughter and mild contentment." (Quoted from Ball's *Die Flucht aus der Zeit* by Huelsenbeck, *Dada. Eine literarische Dokumentation*, p. 154.)

vidually. At the Cabaret Voltaire and in a subsequent series of Dada evenings in Zurich, poetry readings, lectures, and singing tended always to greater absurdity or automatism. Some wrote nonsense poems, sometimes by picking words out of a hat; Ball composed "sound poems" in which he did his best to avoid anything that sounded like any word in any language; and groups of Dadaists spoke and chanted simultaneous poems, each speaking a different language or saying different words. They were particularly interested in automatism (what the French later called "automatic writing") and composition by pure chance. Another favorite technique in those days of hourly war bulletins was the fake news release, in which true information about the far-flung members of the avant-garde was mixed with absurd or apocryphal reports. Their manifestos sported drawings and calligraphic elements as well as words, with the words spaced out eccentrically, often upside-down.

The public, as expected, was stunned, alarmed, and angry. Huelsenbeck has given a colorful description of a Dada soirée in July, 1916. "It was a fantastic affair, and I still cannot figure out today how we were not murdered by the excited crowd," he wrote.

> We said, sang, and shouted just about everything one would have needed at this time, considering the extant post-Victorian culture and in view of the war that was flaming all around Switzerland, in order to commit literary, civil, and personal suicide. I read a Dadaist manifesto in which I declared Dada to be nonsense and bade the people to make themselves conversant with nonsense as a way of life. Tzara, Janco, and I delivered a simultaneous poem; we stood with our text at the edge of the podium like singers and screamed at the top of our lungs, only to be out-screamed by the public. They called for the police, the alienist, and the surgeon's satchel. They threatened, hissed, and cried, women passed out, and old men whistled blasts on keys and wooden pipes. I discovered the gymnastic poem. Tzara and I did deep knee-bends and read verses in-between [48]

They throve on contradiction, provocation, and, above all, the accidental and immediate. Huelsenbeck brought Dada to Germany in 1917, where it was immediately taken up by Grosz, Herzfelde, and others and became more ideological. During a Berlin soirée that year Huelsenbeck declared that not enough people had been murdered yet. "The police wanted to step in, children cried, men trampled one another," he reminisced. "Grosz urinated on the paintings in the exhibit." And a few months later Johannes Baader, dubbed "Oberdada" by the Berlin group, interrupted a service in

the Berlin Cathedral with the question, "What is Christ to the common man?" As no one answered, he shouted his own response: "He's crap to him" ("*Er ist ihm wurst*").

At war's end, the Zurich group dispersed and Dada won a following everywhere, joining forces with pre-Dadaists who had influenced it. Picabia, who spent part of 1917 in Zurich, fitting in with the general mood because of his protosurrealistic poems and mocking machine images on sexual themes, carried the Dada spirit on to Paris and back to New York, where Duchamp, a Dadaist in all but name for years, was living. Journals sprang up everywhere, and Dada came to mean different things in different countries, adapted, like so many prewar art forms, to the mentality of the natives. Zurich had had enough; there the nihilistic impulse and its tangible stimulus had wound down and artists turned to the positive—to a further elaboration of abstract art.

V

Thus it did not take the German defeat to turn German painters against the war, nor did it take the hard line of the French at Versailles to raise doubts in the minds of French painters about the purpose of the war and the virtue of the victors; nor can the swelling protest among intellectuals be attributed to the Russian Revolution, for it had begun long before, both in Germany and among the exiles in Switzerland and the United States. The Russian Revolution did, however, furnish an example of action. In particular the Bolshevik October Revolution showed that something could be done to stop the war machine and that a capitalist economic and political system was neither inevitable nor indispensable.

Even as Lenin, recent neighbor of the Cabaret Voltaire, and Trotsky, who had rubbed elbows with artistic émigrés in Spain and en route to New York, were returning to Russia, Western European artists began to respond to the February Revolution, the "bourgeois" one brought on by starvation and war-weariness that replaced autocracy with parliamentary government. In its May, 1917, issue, *Zeit-Echo*, a literary and artistic review published in Switzerland, announced a change in its outlook and content. Its editor, Ludwig Rubiner, welcomed the Russian Revolution and committed his review to humanism and opposition to the war. He urged intellectuals to drop their hermetic estheticism, made meaningless by the war, to devote

themselves to mankind, and henceforth to expound the ideas of brotherhood and peace as clearly as Dürer had expounded those of the Reformation. Rubiner was seconded by Hans Richter, an early convert to Zurich Dadaism who later went on to lead in experimentation with abstract films. In an article entitled "Ein Maler spricht zu den Malern" ("A Painter Speaks to Painters"), Richter likewise urged painters to drop their apolitical stance and join the fight against war and injustice, to use their talent to persuade and convince. He made *"Volksblätter,"* black-and-white drawings devoted to the ideals of the Russian Revolution. In "Der heilige Mitmensch: Widmungsblatt an die russische Freiheit" ("The Sacred Fellow-Man: Dedication Sheet to Russian Freedom") he depicted an embracing couple, symbolic of the new humanity, soaring above the ruins of the old order—a soldier on his knees with a broken sword, a gallows, a graveyard. In 1919 Richter founded and headed a short-lived artistic and political organization in Zurich, the Association of Revolutionary Artists.

A painter whose life was immediately—and irrevocably—affected by the Russian Revolution was Heinrich Vogeler. One of the founders of the turn-of-the-century artists' colony in Worpswede, Vogeler was well-known for his Jugendstil and Symbolist paintings and book illustrations. He had always shown humanitarian leanings (at the turn of the century he had planned, but not carried out, a utopian workers' settlement), but he was unpolitical before the war. In 1914, already forty-two years old, he volunteered, in part because of the recent breakup of his marriage, and served on the Eastern Front.[49] The news of the Russian Revolution converted him to pacifism and to what in later pamphlets he called "the new love of mankind"—an obvious sublimation of his love for the wife he had lost to a young schoolmaster. Already on March 22, 1917, while on leave from the front, he wrote, but did not send, a petition to a General von Gerock, urging him to take advantage of the change of government in Russia as a means to peace, and condemning the official mendacity and censorship engendered by the war. Now that the need for a defensive war had passed, he told the General, the offensive war should be ended immediately. "I know that this letter bears two [potential] consequences within it: the kindling of a spark [of understanding] that would lead the entire German people in the person of Your Excellency to put out the conflagration; and, on the other hand, the continued power of untruthfulness that probably will find its expression in my imprisonment and, possibly, execution. Either can only be a release for me. On April 4 I must go

back to my unit."[50] A year later he *did* send a letter to the Kaiser in the form of a legend protesting the harsh Treaty of Brest-Litovsk imposed on the new Soviet regime. This letter resulted in his confinement in an insane asylum for the remainder of the war. He painted "Die Kriegsfurie" ("Fury of War"), a scene not unlike Friesz's "War" and reminiscent of medieval renditions of the Last Judgment, in which a seminude woman reigns amid death and destruction, personified by nude, contorted bodies, dead and living. Vogeler's conversion to Bolshevism proved permanent; he supported the Spartacists in Germany, made several trips to the Soviet Union during the twenties, and finally emigrated in 1931, at the invitation of the Soviet government. He became an adviser on Russian provincial building and other projects and produced propaganda for the Soviet regime until World War II.*

Other painters reacted vaguely; it is on the whole impossible to determine the precise effect of the Russian Revolution on their thinking. But, particularly among a younger generation of artists, the tone of their ruminations became more ideological; they began to talk of a changed postwar world, one no longer ruled by the philistines (capitalists) who had corrupted art as they had corrupted politics. Their faith in the ruling powers long since shaken, painters became increasingly convinced—partly on the basis of the fellowship they had experienced in the trenches—that the future lay with the masses. And with this conviction came another: that their art would finally find its appreciative public, the very public (some even came to think) for which it had been created. Not that all of the avant-garde was ready to accept Rubiner's or Richter's injunction to paint *for* the people. Many believed, rather, that after becoming educated, the people would recognize the relationship between the clean, simple lines of modern art and the sane and sound lives they would lead under socialism. Already in 1916, Heckel had written optimistically from Flanders that the need for art was reawakening precisely "where the deed has eaten up everything contemplative," and described the openness to his art among both officers and common soldiers, who were ready to accept it once it was explained to them. "Here the higher ranks take pains with the common sailors," he wrote, "that they should [learn to] accept what is painted as a

*He is now an art hero of the East Germans; his Soviet works hang in the National Gallery in East Berlin. (*See* Deutsche Akademie der Künste, *Heinrich Vogeler: Werke seiner letzten Jahre* [(East) Berlin: 1955].) He died in 1942, in "protective" exile in Siberia together with many other non-Soviet citizens.

given, take pleasure in its color, liveliness, allow themselves to be taught and to enter into the work. Only the 'educated' citizen intervenes even here with a loaded question, full of self-conscious presuppositions, demanding the actual forms within his experience. And he is in the majority."[51] Other artists, too, noted the friendliness and receptivity to their art of proletarians and peasants.* Gustav Pauli, enthused over a 1917 exhibition of Berlin Expressionists, justified his opinion to the board of directors of the Hamburg Kunsthalle, of which he was director, by a sociological analysis. "Artistic individuals seem to be once more longing for the anonymity of organized production," he wrote.

> . . . We would then have once again, as in earlier centuries, an art of the people (that is, of the artistically educated commonwealth), for the people. In fact it is also very instructive to try to visualize, for once, whom this young expressionist art is actually there for, who its ideal public would be, into what surroundings it best fits. Impressionism was an art for connoisseurs, for sensitive epicures The new expressionist art seems to me rather an art of the aspiring, struggling popular classes. The works of these artists would go better in a sober laborer's home than in a salon with silken wallpaper. This is proletarian art, and I mean this without any unfriendly second thoughts and in no way with a belittling intention.†

Few painters had a clear idea of what they wanted, but many now instinctively felt that they must throw in their lot with the lower classes in the fight for brotherhood and human freedom against militarism and capitalism. It was with optimism and joy that many painters now looked forward to a brave new postwar world. The late Franz Marc had written back in 1914:

*Juan Gris, *Letters, passim*. Kirchner, who had painted sets for a local theater in Switzerland, wrote in 1920: "One sees once again that art is more easily understood by the so-called simple man than one would have thought." (Letter to Helene Spengler, April 9, 1920, *Maler des Expressionismus im Briefwechsel mit Eberhard Grisebach*, p. 124.)

†Gustav Pauli, "Reiseberichte," Hamburg Kunsthalle, Archiv 119a, July 9, 1917. Cf. Harry Graf Kessler, *Tagebücher, 1918–1937* (Frankfurt a. M.: Insel, 1961), January 4, 1919, p. 91: In a conversation between important politicians and a museum director over dinner, ". . . much talk about art, general agreement that in German art a transformation from the bourgeois to the popular already preceded the Revolution. Transformation from Impressionism, which offers intimate, middle class art in easel paintings, to Expressionism, which desires publicity, large rooms, monumental projects, effect on broad masses of people, pathos and rhetoric. A difference akin to that between a *causerie* in a Paris salon and a speech to the people of East Berlin or Schwabing." This, of course, was written during the revolutionary period in Germany, but it matches Pauli's earlier insight almost exactly. Cf. further Nolde's statement quoted above, p. 100, about his South Seas pictures being unacceptable in "perfumed salons."

In the last few years we have declared much of art and life to be decayed and done for and have pointed the way to new things.

No one wanted them.

We did not know that the Great War, far above the power of words, would come like lightning to break up the decay, cast off the dead weight and turn the coming into actuality.[52]

Now it was time for the people to act. And art, many pledged, would be on their side.

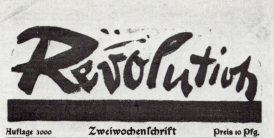

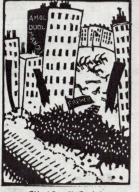

Fig. 28. RICHARD SEEWALD,
cover for *Revolution*, 1913.

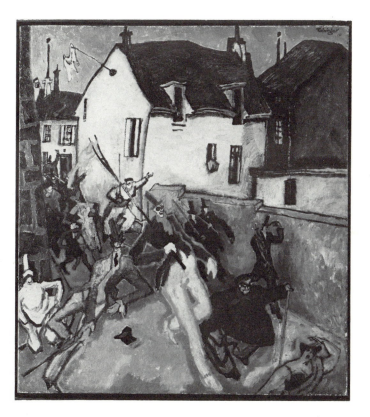

Fig. 29. LYONEL FEININGER,
Uprising, 1910. New York,
Museum of Modern Art.

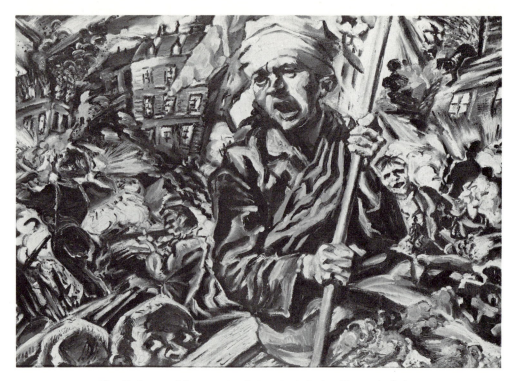

Fig. 30. LUDWIG MEIDNER, *Revolution*, 1913. Berlin, Nationalgalerie.

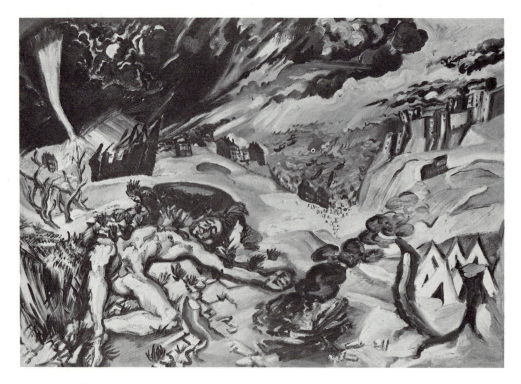

Fig. 31. LUDWIG MEIDNER, *Apocalyptic Landscape* (reverse of *Revolution*), 1913. Berlin, Nationalgalerie.

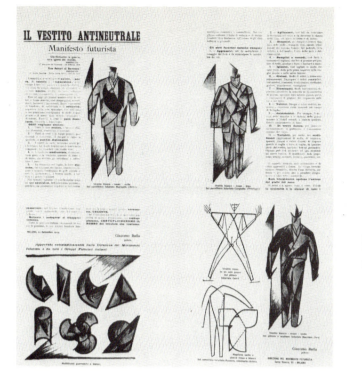

Fig. 32. GIACOMO BALLA,
The Antineutral Suit,
manifesto, late 1914.

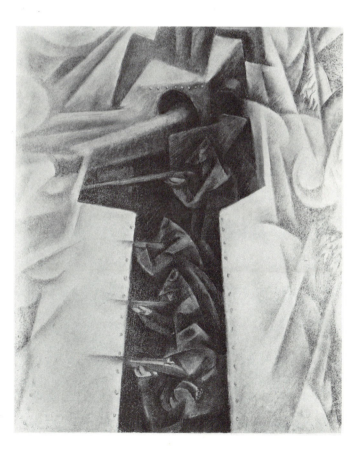

Fig. 33. GINO SEVERINI,
sketch for *Armored Train,* 1915.
New York, Museum of Modern Art.

Fig. 34. RAOUL DUFY,
The End of the Great War, 1915.
Paris, Musée des Deux Guerres Mondiales.

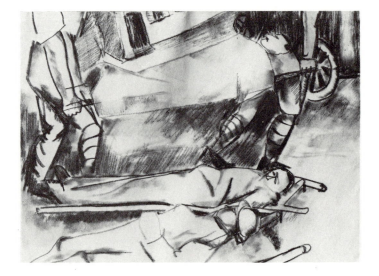

Fig. 35. OSSIP ZADKINE, *Stretcher-Bearers Carrying the Wounded*, ca. 1915. Paris, Musée des Deux Guerres Mondiales.

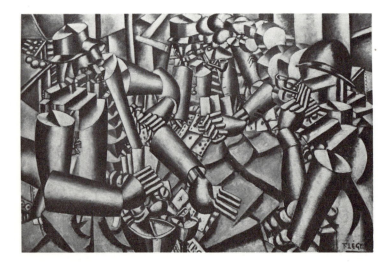

Fig. 36. FERNAND LÉGER,
The Card Game, 1917.
Otterlo, Rijksmuseum
Kröller-Müller.

170

Fig. 37. JACQUES VILLON,
The Shell Hole, Champagne, 1915.
Paris, Musée des Deux Guerres Mondiales.

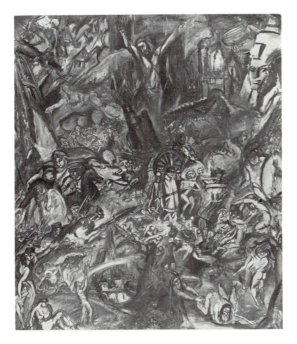

Fig. 38. OTHON FRIESZ, *War*, 1915.
Grenoble, Musée des Beaux-Arts.

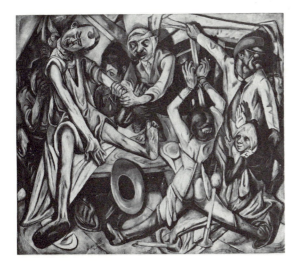

Fig. 39. MAX BECKMANN, *The Night*, 1918–19.
Düsseldorf, Kunstsammlung Nordrhein-Westfalen.

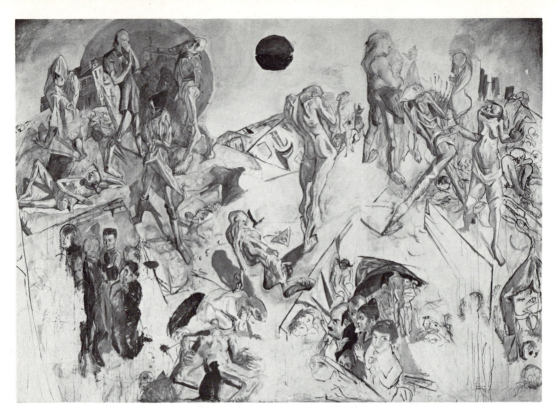

Fig. 40. Max Beckmann, *Resurrection*, 1916–18. Stuttgart, Staatsgalerie.

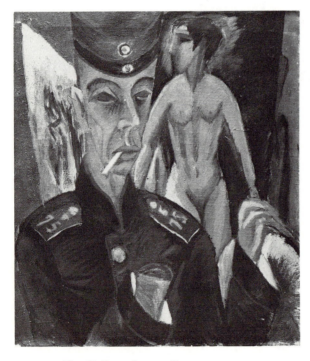

Fig. 41. Ernst Ludwig Kirchner,
Self-Portrait as a Soldier, 1915.
Oberlin, Allen Memorial Art Museum.

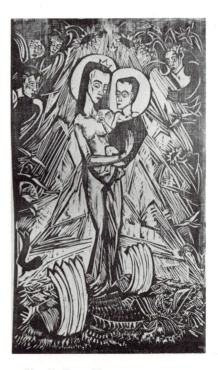

Fig. 42. Erich Heckel,
Madonna of Ostend, woodcut, 1915.
Berlin, Brücke Museum.

Art and Revolution: Practice, 1918–1921

Let the social republic give us its confidence, we already have freedom, and soon out of the dry soil flowers will bloom to its glory.

MAX PECHSTEIN, 1919[1]

On December 28, 1918, Count Harry Kessler, the liberal aristocrat, patron of avant-garde art, and observer of the international political and cultural scene, beheld the recently plundered royal apartments in Berlin. Germany had capitulated seven weeks before; the Kaiser had fled to Holland; the country, ruled now by a provisional government of moderate Socialists, was torn by their struggle to contain the Independent Socialists to their left and, at the extreme, the Spartacists, inspired with revolutionary ardor by the new Bolshevik regime in Russia. To Kessler, the costly but tasteless objects now in ruins and scattered about the palace were a symbol of the decadence and irresponsibility of the regime which had made the war and which now had justly perished. "The private rooms, furniture, useful objects and the remaining mementos and art objects of the Empress and Emperor are so drab and tasteless in the philistine manner," he wrote in his diary,

> that one can hardly cry out against the plunderers, but rather one can only be astonished that these poor, timorous, unimaginative beings who made this revolution come about, living out their futile lives among lackeys and shadowy flunkies, could have played a role on the stage of world history. Out of these surroundings came the World War, or at least that responsibility that is the Kaiser's: out of this kitsch-filled, narrow-minded world of appearances, betraying him and others with its flagrantly false values, came his judgments, plans,

schemes, and decisions. A sickly taste directing a pathological excitement of the all too well-oiled machine of state! Now this empty soul is scattered around here in all these meaningless goods. I experience no compassion, but only, when I think about it, horror and the feeling of having been an accessory because this world was not destroyed long since, but still lingers on everywhere in somewhat changed form.[2]

Kessler's conclusion was shared by many painters who now greeted the war's end, the apparent victory of socialism in Germany and the founding of communist parties in Europe with enthusiasm and with the desire to become involved in building a new society and new values. They felt that a critical turning point in history had arrived, a time of destruction and questioning in which man was being given the chance to begin life anew. They would—artistically and by other means as well—help free the people from their age-old economic and political tutelage; just as turn-of-the-century kitsch was the pendant to imperialism, authoritarianism, and cutthroat capitalism, so modern art, long since directed against the rule of the bourgeoisie, would now represent a new set of values: internationalism, simplicity, and fraternity.

In the wave of enthusiasm and unrest that swept Europe during the fall and winter of 1918, intellectuals and artists, united as never before, promptly set about founding organizations and reviews* through which their new goal, a free, triumphant art within a free society, could be propagated. The first and most widespread expression of the new spirit was an orgy of fraternization, accomplished, in a Europe still rife with suspicion and torn by national enmities, through manifestos and the reopening of the extensive lines of communication between the various national contingents of the avant-garde. Most painters had not entirely betrayed their prewar cosmopolitanism even while loyally serving their countries; now they joined more closely even than before the war in opposing the rebuilding of political and intellectual barriers between the nations. French artists wrote to Herwarth Walden, inquiring as to the state of the arts in Ger-

*An enormous number of (mostly short-lived) literary and artistic reviews were founded between 1918 and 1920. To mention only the most important: *Action, Clarté, Bulletin communiste, Éclair* in Paris; *Menschen* and *Neue Blätter für Kunst und Dichtung* in Dresden; *Der Ararat* and *Genius* in Munich; *Der Einzige* and *Der Gegner* in Berlin; *Die Erde* in Breslau; *Der Zweemann* in Hannover; *Die rote Erde* in Hamburg. (For a more extensive listing of the German periodicals, *see* Paul Raabe, *Die Zeitschriften und Sammlungen des literarischen Expressionismus. Repertorium der Zeitschriften, Jahrbücher, Anthologien, Sammelwerke, Schriftenreihen und Almanache 1910–1921* [Stuttgart: J. B. Metzlersche Verlagsbuchhandlung, 1964].)

many, thanking him for his heroic wartime support and loyalty, and proposing new international exhibitions.* Fernand Léger, now a member of the governing committee of the Salon des Indépendants, told Walden he wanted German artists included in the "sensational reopening" of the Salon planned for the spring of 1920. "I have spoken very seriously with the President, Signac, about the question of foreigners," he added. "I said that if a few advanced painters were accepting appointments to the Committee it was on the *absolute* condition that there would be no restrictions on foreigners, *whoever they may be*. We came to an agreement on this subject, and as I am a veteran I won't become suspect if I defend my opinions energetically."[3] Initiatives were taken to develop artists' and intellectuals' organizations which would match the international solidarity of the proletariat with that of "intellectual workers." A short-lived "Union of International Progressive Artists" was founded in Düsseldorf in 1922; its founders' manifesto, signed by major avant-garde groups and individuals, concluded: "The unfortunate exclusivity of minds must finally come to an end. Art needs the association of men, in whom it inheres. Beyond all questions of state and without the slightest political *arrière-pensée* or self-serving secondary aim, our slogan also must be: 'Artists of the world unite!'"[4] The wartime pacifists Romain Rolland, Henri Barbusse, and Henri Guilbeaux—"the first generation of Europeans," as Kasimir Edschmid, the influential art critic, called them—were now lionized as prophets, and—after bouts of breast beating—intellectuals called upon the entire scholarly and artistic community to lead the quest for unity among nations and "love . . . not hatred, construction, not dissension. Settlement, not revenge."[5] They had the good fortune and the great responsibility to be living at a crucial moment, they were told; they must work for all humanity, taking no account of national or class distinctions. "We do not recognize individual peoples," the "Declaration of Independence of the Spirit" stated. "We know only *the* people, one and all-encompassing, the people that suffers and struggles, falls and picks itself up again and strides forward ever again on its hard way, in blood and sweat. This people of all men, who all, all are our brothers."

*In his foreword to a 1921 Sturm exhibition, the French critic Waldemar George wrote: "We, the French artists who have also remained faithful to our ideal of international faith, want to thank at this hour our German friends for welcoming us to their hospitable country and thus giving us an example of immediate application of the principles of solidarity." ("Vorwort zur 93. Sturm-Ausstellung," *Der Sturm*, XII, No. 1 [January, 1921], 1–3.)

Putting art to work for internationalism and the proletariat would prove more complicated and demanding than most painters supposed. But, everywhere except Italy, many painters accepted the task with optimism and hope.

I

The model for socialist society and the artist's place within it was furnished by the new Soviet Russia, whose avant-garde was not only accepted but also given an important role in the development of Bolshevik institutions and the socialization of the masses. By 1917, Russia had a vigorous and sizable avant-garde, made up of Futurists, influenced ideologically by the Italian Futurists' irreverence for the past, and stylistically by the Italians, Cubism, and to some extent Expressionism; Suprematists, led by Casimir Malevich, whose nonobjective paintings were reduced to the most restricted geometrical elements; and a few unaffiliated painters such as Kandinsky and Chagall. Many had spent the prewar years in Paris or elsewhere in Western Europe. Of the entire Russian art world, only the avant-garde reacted enthusiastically to the Revolution and immediately volunteered their talents. While they remained aloof from Bolshevism until late 1918, they nevertheless took control of artistic affairs by participating energetically in propaganda, education, and commemorative projects. Leaving the closed world of the studio, they went out into the streets, making decorations for revolutionary celebrations and pageants, designing monuments to revolutionary heroes in response to a call from Lenin at the beginning of 1918,* and helping spread the revolutionary message to the people by designing propaganda posters and painting futuristic and topical designs on "agit-prop" (agitation and propaganda) trains and ships that were sent into the civil-war zones to inform and persuade the masses. "We do not need a dead mausoleum of art where dead works are worshipped," Vladimir Mayakovsky, the Futurist poet, orated, "but a living factory of the human spirit—in the streets, in the tramways, in the factories, workshops and worker's home."[6]

At first artists were left to their own devices: the revolutionary leaders

*To be sure, Lenin elicited widespread response from traditional artists. The monuments—to Courbet and Cézanne as well as more predictable "heroes of the Revolution"—were mostly realistic; mobs destroyed many of the futuristic ones. (Camilla Gray, *The Russian Experiment in Art, 1863–1922* [London: Thames and Hudson, 1962], p. 224.)

had too many other, more vital, problems to think about and were gener-
ally not interested in art in any case. But education could not wait, and a
Commissariat of Enlightenment (or Education: the Russian word can mean
either one) (Narkompros) was set up to deal with both education and
culture, headed by Anatole Lunacharsky.[7] Lunacharsky was no politician,
and his allegiance to Bolshevism was of suspiciously recent origin, but he
had a wide knowledge of philosophy and art and was the Bolsheviks'
unanimously accepted expert on education. (Although he was to head
Narkompros until 1929, he never became a member of the Central Commit-
tee of the Party.) He believed that enlightenment of the masses was essen-
tial to the success of the revolution, but also that art and science could be
creative only if allowed total freedom: they would then automatically
benefit the people and the state. He felt the proletariat, once given access
to all points of view and to all artistic and scientific tradition, would then
select the elements of its own culture, obviating the necessity for censor-
ship or suppression. Thus he insisted upon freedom for all artists, of what-
ever tendency—protecting even the traditionalists who were elitist in out-
look, suspicious of the revolution, and vehemently anti-Bolshevik. Al-
though no avant-gardist, he prided himself on understanding modern art.
But his liberality and broadmindedness had the practical result of benefit-
ting the avant-garde, for only they were willing to assume leadership of the
artistic organizations, and only they had firm ideas about the artist's re-
sponsibility to the new society and society's responsibility to the artist.

To head the graphic-arts division (IZO) of Narkompros, Lunacharsky
appointed David Petrovich Shterenberg (1881–1948), a progressive painter
who had spent the last prewar years in Paris, at the Ruche. On its govern-
ing board sat Kandinsky, Malevich, Vladimir Tatlin, the advocate of
monumental public architecture, and various Futurists. Kandinsky became
a professor at the Moscow "Higher Technical-Artistic Studios" (Vhu-
temas), that replaced the art academy, and was entrusted with developing
teaching methods and by-laws for artistic organizations. This Kandinsky
did, but his plans were eventually shelved or rejected by more radical
avant-gardists who seized control around 1921; this occasioned his depar-
ture for Germany and the Bauhaus the same year.[8] Chagall became direc-
tor of the art school in his home town, Vitebsk, and offered a professorship
to Malevich—who accepted, and soon after ousted Chagall from the school
in the cause of greater stylistic radicalism. After a short period of work for
the Jewish Kamerny Theater in Moscow, Chagall too returned to the West.

Between 1918 and 1921, IZO set up 36 museums all over the country, 13

of which, "Museums of Artistic Culture," were devoted to furnishing art education to the proletariat. Works were purchased from artists of all persuasions, but especially from the avant-garde, which had been totally ignored before the Revolution.

The Futurists, unlike Lunacharsky, insisted that they alone could produce art for the proletariat. The Petrograd branch of IZO informed more traditional artists: "Let only those who break and destroy forms in order to create new ones be with us, because they and we have a single thought: Revolution."[9] Although there was much disagreement—and more and more yet to come—about the role of the artist in developing a new proletarian culture and the methods that should be employed in educating the proletariat, most Futurists were agreed in rejecting easel painting and concentrated on producing works of a practical or theoretical nature which could have a direct impact on the lives and perceptions of the masses. Many of the early projects were utopian and impracticable. When IZO commissioned Tatlin in 1919 to design a monument to the Third International for the center of Moscow, he produced plans for a "union of purely artistic forms (painting, sculpture and architecture) for a utilitarian purpose"—a structure of glass and iron twice the height of the Empire State Building, with spherical, cylindrical, and pyramidal parts constantly turning at different rates, and with rooms for communal activities and an information center. Even when practicable, many projects could not be built for lack of resources. But Tatlin contributed practical designs, for work clothes that would be inexpensive, comfortable, and attractive, and for a stove that—in this period of acute scarcity—would produce a maximum of heat from a minimum of fuel; and Alexander Rodchenko designed workers' clubs, from the posters on the walls to the furniture. The Futurists, with their readiness to work with the people, influenced Proletkult, the organization founded soon after the February Revolution to develop an inherently proletarian culture. But they were also frequently rebuffed by Proletkultists who felt this culture had to be created *ex nihilo*, untainted by the ideas of bourgeois intellectuals out of touch with proletarian reality.

The West was kept well informed of the progress of the arts in Russia. In a manifesto dated November 30, 1918, and directed at "progressive" German artists, Shterenberg called for intellectual exchanges among artists of the two nations and an eventual supranational organization of artists. He asserted that the Russian government had entrusted leadership in artistic matters to "the new tendencies," for only "the new creations that came into being shortly before the world upheaval can be in step with the

rhythm of the new life being created."[10] Western intellectuals replied to this manifesto with expressions of solidarity with Russian artists and the Russian people; many spoke out against the Allied anti-Bolshevik intervention in the Civil War in late 1918 and 1919.[11] Lunacharsky's writings were translated and exhibitions organized. Various Russian painters exhibited at the Sturm Gallery and elsewhere in the West, and in 1922 a Berlin gallery sponsored a large exhibition of Russian art since the 1890s.

What impressed the Western avant-garde was the seeming liberality and openness of the Bolsheviks to the new art. In the "Free Artistic Studios" (Svomas and Vhutemas) that replaced the Petrograd and Moscow academies, artists were treated as workers producing useful and important products and given studios and professorships. Since the students were now permitted to study under whomever they wished, progressive artists were much in demand. A great many exhibitions were organized all over Russia, and the response of the proletariat seemed favorable.[12] (Like the Russian Futurists, many Western artists were in favor of collaborating with industry and bridging the gulf between art and craft.) Lunacharsky reported that the government was taking pains to conserve artistic and historical monuments, a project dear to his heart, of which the Futurists, however, disapproved strongly. Even the former art patron and multimillionaire Ivan Morosov, who had employed 15,000 workers before the war, seemed satisfied with the treatment accorded him and his collection. In an interview of 1919, the "Assistant Curator" of the "Second Museum of Western Art" (the "First Museum" consisted of Sergei Shchukin's collection) described the care with which his former collection was being preserved and exhibited. Whereas he had thrown it open to the public once a week, now modern French art was constantly available for public viewing. Still permitted to occupy part of his house, he was being called upon to lecture and to catalogue the collection. His interviewer concluded, "For the first time in history, a government is treating artists otherwise than as expendables."[13]

II

In France there was a prerevolutionary movement—or so it seemed to many at the time—which culminated in the founding of the Communist Party and its adherence to the Third International in 1920. But despite the destruction of much of the north and east of the country and the ubiquitous

human consequences of the war, the numerous cripples and the obvious surplus of women over men, France did not appear much changed. The political leaders remained mostly the same; the government of Clemenceau continued to triumph for a while, pressing for and obtaining a harsh peace treaty at Versailles. In general, the French were so relieved and eager to return to "business as usual" that the Left was unable to do any more than threaten.

The painters, likewise, were not greatly changed; among them equanimity reigned now as it had before and during the war. Their chief desire, at least as expressed in letters to Herwarth Walden, was to return to work and forget their wartime experiences and privations. Accepted now and beginning to prosper, some of them began to exchange their Bohemian ways and even their libertarian ideals for bourgeois respectability. Van Dongen, former anarchist, accepted large fees for portraits of the political and social lions and lionesses of the 1920s; Picasso kept an elegant apartment as well as his disorderly studio and soon bought a car; Sonia Delaunay designed a set of elegant (albeit simultaneist) dresses; the antisocial and usually boorish Soutine prospered. Segonzac wrote to John Quinn in 1922: "Life in Paris is still rather drab, and most of the places where we used to have a good time seem a bit like waiting rooms. People have lost their sense of fantasy. . . . I have also often been invited to the Princess Bassiano's. . . . She is a friend of painters and receives them in a charming and very simple manner. I found Derain . . . Dufy, Vuillard and others there."[14]

Few of the works produced in this period have any overt social content. Perhaps the strongest representation of the misery caused by the war was a colorful gouache by a former combatant, not-quite-progressive painter and later novelist, Jean Galtier-Boissière (Fig. 46). Here he depicted a 1919 procession of war cripples, armless, legless, blind, and bandaged, on the Champs-Elysées, watched by a dense but faceless crowd. Disturbing as the painting is, it cannot match the horror of the contemporary productions of a handful of German painters. Georges Rouault mingled references to the Passion and the war in a series of 58 engravings, collectively titled "Miserere," that he based on drawings made from 1914 through the 1920s. While not above satirizing the Kaiser or alluding to the German destruction of Rheims, he emphasized the Christlike suffering and perseverance of the ordinary man and expressed his hope for a better future world (Fig. 47).

Most painters continued with abstraction: Cubism and simultaneity

were taken up again, and a new formalist style, Purism, was developed by two younger newcomers, Amedée Ozenfant and Édouard Jeanneret-Gris, the latter soon to become known as Le Corbusier. Léger sympathized with the Purists' espousal of machine images; now he, too, concentrated on abstracting industrial imagery in the depiction of popular, everyday subjects. Like many Russians and Germans, he wished to unite art and technology in a form that could speak to the masses.[15] In 1927 he donated an abstract painting of 1918 to the State Museum of Modern Western Art in Moscow. He was to turn more and more to large figurative pictures meant for display in public places—including factories, or so he hoped, though this was never realized. Some painters, feeling perhaps like Robert Delaunay that the prewar artistic destructiveness and the war were not unconnected,* sought the stability of classicism instead of further avant-gardist experimentation. Cubism, represented now chiefly by Picasso, Gris, Braque, and Gino Severini, was more representational and colorful than before; and Picasso alternated his Cubism with drawings and paintings that declared him the spiritual heir of Ingres.

Not all intellectuals chose to return to isolation. Two movements, both artistically and politically leftist, developed and opposed one another during the immediate postwar era. One was the Parisian version of Dada, which clung to anarchism and the techniques of irrationality and absurdity developed in Zurich; the other was Clarté, the organization and periodical founded in 1919 by Henri Barbusse to promote pacifism and a nondifferentiated leftist activism and to develop an "International of Thought" on Rollandist lines which would prevent European intellectuals from ever again having to abdicate their freedom of speech and opinion as they had in 1914.[16]

Uncommitted at first, Clarté moved ever closer to Bolshevism, much against the wishes of Barbusse (and Rolland, who never joined); by 1921,

*In a letter of 1917, published by a Catalan journal, he declared: "One sensed already [immediately before the war] the catastrophe, the present transformation; it was *anxious*, symptomatically so. Art is certainly the medium which gives the most intense representation of an era, and that is why I say, on the subject of those who seek to restore old means of the craft (successive drawings), that it is insufficient and superficial. . . . If one was conscious of this destruction, and *one always is, more or less* [italics mine], one cannot once again employ the same means as before." This is, of course, an argument for continued experimentation; but others drew the opposite conclusions from a similar insight. (*Vell i Nou*, III, No. 57 [December 15, 1917], 677.) Delaunay remained preoccupied with this idea, as his later autobiographical and theoretical writings show: *Du cubisme à l'art abstrait*, Pierre Francastel (ed). (Paris: S.E.V.P.E.N., 1957), *passim*.

with the inauguration of the second series of the journal, its Communist direction was fixed. But in the beginning it came out for the avant-garde, for internationalism, and for human liberation. Most painters were unwilling to participate actively in the movement. But Picasso, Matisse, Léger, and Chagall, among others, permitted the publication of their works in the review, and articles about modern art were part of its regular offerings. The supporters of Clarté among artists were the anarchists Steinlen and Signac, and also former members of the Abbaye de Créteil, most prominently, Albert Gleizes. He had rejoiced over the Russian Revolution and now embraced its ideals, denouncing artistic individualism as bourgeois.

True to his earlier communism of the Abbaye, Gleizes asserted that a new collective form of art was arising, haphazardly at first, but eventually in an organized and principled way. A Cartesian as well as a collectivist, Gleizes wanted both a truly proletarian-oriented art (to be produced, however, by trained specialists particularly sensitive to the zeitgeist—the avant-garde, of course) and one simultaneously based on order and centuries of tradition. Airing his idea in numerous essays written in the early twenties and published in *Clarté* and elsewhere,[17] he never made clear what this art would look like, beyond its being based on the avant-garde discoveries of the prewar era, but he was adamant in rejecting anything that smacked of individualism and anarchy. Utilizing ideas old to him but new and equally inspiring to many other artists at the time, he denounced the consumer society that had engendered fierce competition even among artists, and asserted that the collaboration between artist-experts and people would be akin to that which had made the Gothic cathedrals possible. Here the avant-garde's prewar rejection of post-Renaissance art became explicitly political: for Gleizes, only once before, in high-medieval France, had there been that unification of spiritual, social, artistic, and scientific realms that now again would come into being under collectivism.

While Gleizes rejected Dadaism as the last gasp of a decadent bourgeoisie,[18] the Dadaists, convinced they had broken all class ties, were busy with their work of destruction, which even came to include attacks on the lower classes and their cultural leaders. The French Dadaists—Picabia, Tzara, Georges Ribemont-Dessaignes (a painter turned poet and playwright) and such future Surrealists as André Breton, Louis Aragon, and Philippe Soupault—remained firmly iconoclastic, accepting no idea, no program, no creed as worthy of belief or devotion. They continued the by now standard, hilarious soirées, more customary in Paris than

elsewhere; they attacked the cultural fetishism of intellectuals and the middle class by conducting a "guided tour" of Saint Julien-le-Pauvre, a place, they said, "that has no reason for existing," and by putting the nationalist novelist Maurice Barrès on mock trial, both in 1921; and they reached even the workers with their thrusts by including Lenin among those they attacked in a session at the popular university of the lower-class Faubourg Saint Antoine.* In a 1920 manifesto published in his review *Cannibale*, Picabia wrote: "Messrs. Revolutionaries, your ideas are as narrow as those of a petty bourgeois from Besançon."

As the years wore on, Dada became stultifying; the Parisian group, never really united anyway, fell apart, some opting for a return to artistic experimentation with abstraction and others going on to found Surrealism and embrace Communism. Gleizes deserted Communism and Clarté and went on to find religion and found his arts-and-crafts colony of Moly-Sabata, while the Surrealists joined Clarté (around 1925) and tried to reconcile an extremely individualistic art based on Freudian psychology with political activism. All in all, it amounted to a renewal of faith, communistic, religious, or artistic; and when faith came, French Dada died.

III

In a letter of 1922 to Trotsky, who incorporated it into his *Literature and Revolution*, the Italian Communist Antonio Gramsci regretfully reported the decline of Futurism. He had still admired the Futurists a year before for the destructive ardor they directed against the bourgeoisie, and which had won them worker support. But since then, he said, they had gone Fascist and lost their cohesion as a movement. Only one, the talented writer Aldo Palazzeschi, had broken with the group over intervention in the war; now he had stopped writing, and the others, Gramsci implied, were unlikely to produce anything valuable. The workers, for their part, were occupied with Proletkult, which was superseding nihilistic Futurism and building a new culture.[19]

Gramsci's report was quite accurate. At the end of the war, Marinetti

*The workers, said Ribemont-Dessaignes, had been friendly up to that point, for anything that attacked the bourgeoisie was all right with them. (*Déjà jadis*, p. 68.)

and a few remaining Futurists, still possessed of their nationalist bellicosity and joined now by a younger generation, helped found the paramilitary groups of dissatisfied, demobilized soldiers that were to coalesce in Mussolini's Fasci di Combattimento and stage the March on Rome in 1922.[20] Gabriele D'Annunzio's seizure of Fiume in 1919 was warmly applauded by Marinetti, who, together with Mussolini's Fasci and Mario Carli's Arditi, was already demonstrating against Bolshevism, against the peace terms imposed on Italy, and for Italian expansionism. The methods used by Mussolini in the initial stage of Fascism—the bombast and threats, the street brawling, the disregard for truth and legality—were, indeed, Futurist and had been learned directly from Marinetti in the course of the interventionist manifestations of 1915 and thereafter.

Marinetti was elected to the Central Committee of the Fasci at their first national congress. In 1919, Fascists and Futurists fought side by side against leftists in the Piazza Mercanti in Milan. But after the elections of November, 1919, when the Marinettist campaign staged by the Fascists ended in a rout, with the arrest of Mussolini, Marinetti, and others for attempts against the security of the state, Mussolini tempered his style. Futurism was left behind little by little, though the March on Rome still had something of the Marinetti stamp. Marinetti himself, while never again influential, was honored by the Fascist state and remained its faithful and enthusiastic servant until his death in 1944. Pitifully, this tireless *frondeur* and bitter foe of institutions ended as a member of the Italian Academy and Secretary of the Fascist Writers' Union.

In an essay written during 21 days he spent in prison in 1919, "Al di là del comunismo" ("Beyond Communism"), Marinetti outlined his postwar philosophy. Essentially it resembled his prewar ideas of movement, violence, and *Italianità*, with one addition: even more than against the *passatisti*, Futurism was now directed against Communism, an "expression of the bureaucratic cancer that has always eaten away at mankind," and a proponent of equality, that most uncreative concept. The essential conflict, he felt, was not the one between proletariat and bourgeoisie, but the same one the Futurists had described long ago between *passatisti* and *futuristi*. In an article of 1922, written—oddly—in French, he intoned:

> Down with Equality!
> Down with Justice!
> Down with Fraternity!
> They are whores, O Liberty,
> Leave them and climb with me!

Down with democracy!
Down with universal suffrage!
Down with quantity!
They are whores, O Liberty,
Leave them and climb with me![21]

What he favored was an uncompromising anarchism and idealism, which Fascism, with its myriad, highly bureaucratized institutions, ultimately would not condone any more than capitalism had done. He demanded a new Italy free of the papacy, the monarchy, marriage, parliament, the army, law courts, and jails, in order "that our race of geniuses may develop as many free, strong, industrious, original, swift individuals as possible." This would be achieved by what amounted to utopian socialism: "The proletariat of geniuses, collaborating in the development of industrial technology, will achieve that maximum of wages and minimum of manual labor that, without diminishing production, will liberate intelligence to think, create, and enjoy artistically."[22] His dreams dashed, Marinetti had to make do with the seeming fulfillment of one Futurist objective: the transformation of Italy into a world power.

Of the original group of painters, only Balla and Russolo remained true to Futurism after the war; and the younger adherents contributed no major innovations. Boccioni was dead; Severini remained in Paris and returned to Cubism; Carrà joined Giorgio de Chirico in the development of "metaphysical painting" and henceforth turned his back on politics and social themes: within a few years he left the avant-garde and turned to painting landscapes and peasant scenes in a classicist style. Balla's art remained primarily nonobjective. He now turned to the design of Futurist furniture and continued painting. Russolo henceforth was more interested in his musical inventions, the "*Intonarumori*," than in painting. Both signed manifestos and even participated in the early Futuro-Fascist organizations, but they were not strongly interested in politics. Their grandest gesture, in collaboration with Marinetti and others, was to urge the Fascist government to protect and publicize young Italian artists. In a manifesto of 1923 they declared their adherence to the new regime and asked it to support them by favoring the exhibition and diffusion of Italian art, abolishing academies, appointing young artists to design festivals, conducting competitions to give exposure to young artists, and creating an artists' credit institution which would accept paintings as security for loans or in exchange for stipends.[23] Needless to say, none of this came to pass, and the Futurists finished their careers in semiobscurity.

IV

In Germany the immediate postwar period was one of social crisis, severe economic strain, and civil strife over the future of the new democratic regime. For several months after the armistice, daily life was severely disrupted as, in conditions of mass starvation and rapidly accelerating inflation, a resurgent Right waged a deadly struggle against a disunited Left. The majority Socialists who led the postwar government proved more fearful of the Independents and Spartacists, later Communists, to their left than of the Junkers and industrialists, the disgruntled veterans, the nostalgic officials and hard-pressed shopkeepers to the right of center.

In a letter of September, 1919, to an American friend with whom he had lost touch because of the war, Lyonel Feininger, newly appointed master at the Bauhaus, described the Germans' hardships and their attitudes. The mark, he said, had dropped to 14 per cent of its prewar value, and prices of the few available commodities were fearfully high. He and his family, while better off than most, had been "living on muck not fit for decently kept swine, for 3 1/2 years." The sparse wartime diet would, he felt, affect people's health for years to come. The general mentality was also unhealthy, he suggested. "You can't get anyone to do anything except 'strike,' everyone lacks zeal for work here. 'It's all for the victors anyway,' they say. But that is the big mistake all round. The victors themselves are half dead with exhaustion. . . ."[24]

In this defeated, crisis-ridden country, as in the Soviet Union, artists became highly politicized. Their immediate impulse was to found organizations to disseminate their art and train proletarian eyes to appreciate it. They embraced the Left, determined to have some say in the rebuilding of German society. Joined now by a more deeply politicized generation that first came of age around 1914, the Expressionists lent their pens and brushes, and sometimes even their bodies, to the defense of human liberty.

Everyone seemed to have turned Red overnight. Herwarth Walden, denounced in January, 1919, by the young Max Ernst, head of a revolutionary Society of the Arts in Cologne, as a capitalist art-dictator,[25] just then began printing Marxist articles about the artists' responsibility to support the revolution[26] and sponsoring soirées attended by leftist political figures as well as art cognoscenti. His conversion proved so complete that, just before the Nazis took power, he emigrated to the Soviet Union, where he died during World War II. Pfemfert turned *Die Aktion* back into a politi-

cal organ, supporting the Spartacists and printing political drawings by Masereel (Fig. 48), Otto Freundlich, and younger Expressionists; after 1933 he joined the colony of leftist exiles in Mexico. In a spate of manifestos, painters and writers proclaimed their adherence to the proletariat, and then to the Spartacists, as the government brought in the counter-revolutionary Freikorps to crush them. In one such manifesto, Ludwig Meidner, in his typically apocalyptic tone, called upon artists to recognize their economic and spiritual kinship with the masses and, warning of a white terror, urged them—with a mixture of leftism and religiosity common to many Expressionists—to join the fight against the bourgeoisie:

> What use are riches and opulent, parasitical revelries to us?! Haven't they been the ruin of each and every talent? How you painters gobbled and boozed before the war, and brainlessly wasted your strength!! Free yourselves as much as you can from the pharisaical bourgeoisie. And no longer bow and cringe in the salons and wag your tails before rich flunkies. Be poor with the poor! The main thing is that the soup- and paint-pot is at stake.
>
> Now it must be: emancipation of the working class. But also: emancipation of the artists and poets. We no longer want to play the buffoon to ensure the good digestion of rich fools, snobs, and trumpeters!
>
> Up, up to the podium! To the bastions of future mankind: for human dignity, human love, equality, and justice. Yes, we are *all equal*. We are sent forth from *the same* source. Who would raise himself above his brother?! . . .
>
> With body and soul, with our hands we must participate. For it is a question of socialism: that is, *God's order in the world*.[27]

Meidner's manifesto and others were published in a 1919 pamphlet entitled *An alle Künstler*! (*To All Artists!*), in which major Expressionists and Socialists affirmed their solidarity and pledged to work for their common cause. Illustrated by avant-garde painters, including Feininger and the second-generation Expressionists César Klein and Georg Tappert, the pamphlet bore a cover drawing by Max Pechstein depicting a worker with a flaming red heart rising above the city, his right arm raised in a victorious and perhaps also imploring gesture (Fig. 49). The artists' demands for freedom and recognition were echoed by Kurt Eisner, head of the Bavarian Republic, in a speech reprinted in the pamphlet. He pledged his socialist regime to artistic freedom and suggested new ways of recognizing and supporting artists.

Some painters published political articles, theorizing about the configuration of the new society and taking stands on specific issues and events. In

a series of articles, the Berlin Dadaist Raoul Hausmann denounced sexual prudery and the exploitation of women as symptomatic and egregious evils of capitalism;[28] and, apart from composing dithyrambs in praise of "the new love in communist society," Heinrich Vogeler theorized about communist elementary education—and went on to found a school for workers' children in his Worpswede house.[29] He emphasized the need to raise independent and imaginative citizens for the new society, and suggested that children devote part of their time to practical work and learn by dealing with community problems. Otto Freundlich wrote numerous political articles and, between late 1918 and 1919, produced a large mosaic, "Geburt des Menschen" ("The Birth of Man," Fig. 50), in which, by placing a compass in the hand of newborn man, he suggested that man, not God, would now rebuild the world.

Other, less activist painters spoke up in moments of crisis or on behalf of worthy causes. When the Spartacist leaders Karl Liebknecht and Rosa Luxemburg were murdered in January, 1919, artists immediately expressed their horror at the tactics of the "forces of law and order" and their solidarity with the Spartacists. Drawings of Liebknecht proliferated; there was not only the famous one of him on his bier by Käthe Kollwitz, but another by Lovis Corinth, previously not always so well-disposed toward the Left, and portraits of both Liebknecht and Luxemburg by Karl Jacob Hirsch, a younger Expressionist. Ludwig Meidner rhapsodized, "Brother, light the torch; in the wind outside it stinks of death and betrayal," and then vowed to continue the fight for justice and humanity:

Alas, the way of mankind is long and full of trouble. Hatred, violence and hills of corpses are its milestones. Let us stride around it quickly. Become Communists like me! I want nothing, for I have everything in me—take my whole being to yourselves.
 Take everything else too: my pictures, books, poems—my chairs, cupboards, utensils are for you—all my enthusiasm, my spiritual force, what is deepest within me, my heart for you. Everything, everything is for you![30]

More practically, artists responded to economic crisis and social injustice with manifestos and posters and by donating works, as Kollwitz did, for instance, to aid famine victims in Russia and Vienna in 1921. Kollwitz in particular was always ready to produce posters attacking hunger, cramped living conditions, war, or injustice to children. An article of 1919, signed K. K. and written either by her or her husband, Karl, demonstrated statisti-

cally the exorbitant price workers were paying in infant and child mortality and urged mothers to join socialist women's groups to combat this result of exploitation.[31] Max Pechstein too produced several posters throughout the twenties in support of socialist and, later, communist causes; both he and César Klein designed posters urging Germans of all classes and persuasions to support the Nationalversammlung, the constituent assembly which met in Weimar to frame a republican constitution for Germany.

Both the central government and some local governments were eager at first to support the arts, and many socialist and liberal leaders even favored the avant-garde. In general, the parliamentary leadership wanted artistic freedom and democratic institutions which would go beyond supporting the artistic traditionalists dear to the Hohenzollerns. In a series of Reichstag debates in 1922 the leftists proposed government aid to destitute artists to counter the galloping inflation. The radical leftists, who either did not seize power or did not hold it for long, were more divided. Some had neither knowledge of nor interest in art, considering it of minor importance compared to social and economic problems; others, for instance the Bavarian leaders with literary credentials and anarchist leanings, Kurt Eisner and Gustav Landauer, favored artistic freedom and comprehensive state support;* and still others, the founders of Communism, for example, demanded committed, proletarian art—if not outright propaganda. Whereas Eisner affirmed that the socialist state could demand no more of the artist than "that he follow his innermost instincts freely and independently," and that art was inherently anarchistic, the Communist Klara Zetkin demanded "art works which lend soul and voice to the socialist world view," suggested that such an art could come only from the proletariat, and affirmed that the art of a free society would itself necessarily be free.[32]

The immediate result for artists of the change of regime was a liberalization in the museum leadership, either through new appointments or through the volte-face of directors. Ludwig Justi, for example, who had replaced Tschudi at the Berlin National Gallery and had managed to mollify the Kaiser until the war, now solidly supported modern art. Ultimately it was on the local level—above all in the city of Weimar—that public treatment of the arts changed most and the avant-garde received the

*Landauer's cultural program was closely akin to that of the avant-garde: erection of monuments and public buildings; painting and sculpture to be integrated with architecture; state acquisition of works; founding of new museums and support of traveling exhibits. (Fidelis, "Gustav Landauers Kulturprogramm," *Das Forum*, IV, No. 8 (May, 1920), 582–83.)

greatest—albeit still extremely meager—public support and recognition. But the central government also tried to help artists, and succeeded minimally by establishing the office of Reichskunstwart (Art Commissioner of the Reich), whose incumbent, the museum director and art historian Edwin Redslob, was expected to oversee the esthetic quality of new currency, stamps, flags, military uniforms and the like, and was empowered to commission designs for such articles from artists. This did not provide much support, but artists responded. In the mid-twenties, Karl Schmidt-Rottluff submitted a design for the German eagle.[33]

Numerous artists participated in organizations that were set up in the excitement of the Armistice and revolutionary movement and that aimed to unite artists and intellectuals in support of the proletariat. Two of these that originated in Berlin during the crisis of November, 1918, were to play a leading role in the German artistic life of the early twenties: the Arbeitsrat für Kunst (Works Council for Art), patterned at its inception on the revolutionary workers' and soldiers' councils, and the Novembergruppe.* While their membership and aims were nearly identical, the two groups never coalesced. The Novembergruppe, functioning as an organization of avant-garde artists, lasted until 1932, while the Arbeitsrat, presuming to be a quasiofficial organ dealing with artistic questions, barely survived the revolutionary period. Their membership included the leading lights of the prewar avant-garde and younger artists who soon changed the direction of Expressionism (toward the *neue Sachlichkeit*, or "new objectivity") and developed the major school of functional architecture.†

The aims of both groups were similar: to give artists the sense of community which would enable them to collaborate on large projects; to bring art to the people through exhibitions and educational initiatives; to brighten and improve the lives of workers through housing which would

*Others, mostly assimilated into these two, were a "Rat Geistiger Arbeiter," headed by Kurt Hiller, which was basically a literary organ; the Sezession "Gruppe 19" in Dresden, to which Conrad Felixmüller, Otto Dix, and others belonged; a "Künstlergruppe" in Halle; a "Vereinigung für neue Kunst und Literatur" in Magdeburg; the "Gruppe Rih" in Karlsruhe. ("Zehn Jahre Novembergruppe," *Kunst der Zeit: Organ der Künstler-Selbsthilfe*, III, No. 1–3 [1928], 22–24.)

A 1919 list of members and supporters of the Arbeitsrat reads like a Who's Who of the German art world, with the conspicuous exception of the German Dadaists, some of whom later joined. The early list included the painters Heinrich Campendonk, Feininger, Fuendlich, Heckel, Karl Jacob Hirsch, César Klein, Meidner, Mueller, Nolde, Pechstein, Christian Rohlfs, Schmidt-Rottluff; architects Walter Gropius, Erich Mendelsohn, Hans Poelzig, Bruno Taut, Max Taut; and art dealers, museum directors, and critics Adolf Behne, Paul Cassirer, Paul Erich Küppers, Karl Ernst Osthaus. (*Ja! Stimmen des Arbeitsrates für Kunst in Berlin* [Berlin-Charlottenburg; Photographische Gesellschaft, 1919], p. 115.)

incorporate the best available architecture and planning; to replace the country's backward and discriminatory art institutions (academies, museums, exhibitions) with more democratic ones corresponding to new social needs—and now giving the avant-garde the upper hand. It was assumed that art, revolutionary long before the November revolution, should play a central role in the social transformation taking place. The means adopted to gain adherents and fulfill this program were exhibitions, publications, and entertainments, many of them limited by their subjects to adepts of art but others aimed at the working class. There were balls and musical evenings; the Novembergruppe exhibited yearly as a group in the regular Large Berlin Exhibition; the Arbeitsrat sponsored an exhibition of "unknown architects" in 1919, and another of members' works for the proletariat of eastern Berlin during the winter of 1919–20.

"*Art and people must form a unity,*" intoned an Arbeitsrat flyer of 1919. "*Art should no longer be an enjoyment for the few, but rather the life and joy of the masses. The unification of the arts under the wing of a great architecture is the goal.*" Architecture was indeed at the heart of all these programs, and architects the most radical of all artists, since their profession demanded attention to social utility as well as esthetics. The answers to an Arbeitsrat questionnaire, sent to members early in 1919 with a view to determining a clear direction for the organization's future activities, are instructive, both in their unanimity and in the drastic changes—as much backward-looking as forward-looking—they propose.[34] Painters, architects, and scholars—Adolf Behne, Walter Gropius, César Klein, Gerhard Marcks, Karl Schmidt-Rottluff, Bruno and Max Taut—suggested the abolition of all art academies and the substitution of simple workshops in which the young would be trained as craftsmen, allowed to develop their talents freely with only observation and supervision by the teachers (i.e., master craftsmen), and encouraged to collaborate on actual projects even before they had proven their mastery of the craft. Now as before the war, their model was the medieval guild; their object lesson, the Gothic cathedral. Masters, journeymen, and apprentices, architects, painters and sculptors, artists and ordinary citizens, would come together in communal works for communal use. Museums and exhibitions, products of an alienated society that no longer made art an integral and indispensable part of daily life, would eventually become unnecessary as all the arts were united within the womb of architecture and cities again became organically related to human needs. Convinced that a socialist society was being born in Germany, the respondents stressed the necessity of tearing down the boundary between

pure and applied art, and eradicating the feeling of superiority of the "fine" artist: the painter or sculptor would henceforth be a craftsman first, earn his living with his hands, and not be averse to painting a wall or building it out of bricks rather than merely decorating it. "The artist must be a fellowman," wrote the architect Max Taut in his reply. "He has no right to claim 'special rights.' From his fellowmen he must obtain his rights like anyone else; he may neither exploit nor be exploited." The government, or individual localities, would be called upon to provide commissions but denied any say in the actual projects and above all prevented from instituting bureaucratic organs to administer the arts. Artists, not engineers, would supervise the constructions and assure their esthetic value.

These principles were embodied in the Staatliches Bauhaus, founded while the revolutionary spirit was strong in Weimar, the former capital of the Grand Duchy of Saxony-Weimar-Eisenach, seat of the National Constituent Assembly in 1919, and, after 1920, the capital of a newly created province of Thuringia. The Bauhaus superseded both the traditionalistic Academy of Fine Arts and the Grand Ducal School of Arts and Crafts, which, already progressive before the war under Henry van de Velde's direction, had been closed during the war. When appointed to the Bauhaus directorship, the architect Walter Gropius had to accept the participation of the professors of the former Academy; but he was intent on innovation, both in the learning process and in the design and production of objects and buildings, and the academics soon seceded. Gropius's founding manifesto contained a section of his response to the Arbeitsrat questionnaire and a woodcut, "Die Kathedrale des Sozialismus" ("The Cathedral of Socialism," Fig. 51), by Lyonel Feininger, one of his first appointees to a professorship.[35] Both the statement and the woodcut attested to the artists' hope of recapturing the intimacy and educational philosophy of the guild and the social integration of art manifested by the Gothic cathedral.

Under Gropius's direction the Bauhaus was organized like a guild. The students were called apprentices and journeymen, the professors, masters. Advancement was dependent upon the satisfactory completion of examinations; a Bauhaus diploma conferred mastership on its holder, and several Bauhaus graduates joined the instructors' ranks, beginning with Josef Albers. The instruction sought to combine esthetics with practicality: there was a series of workshops, each of which had a "Master of Form," a "fine" artist such as Feininger, Kandinsky, Klee, or Oskar Schlemmer, and a "Master of Craft," an artisan skilled in typography, cabinet-making,

locksmithing, and the like. Thus the student was taught to make a thing properly, and simultaneously to make it beautiful. He was trained in manual labor and also in what formerly went by the name of "fine arts." The layman was also expected to benefit, for Bauhaus-trained masters were to design and, Gropius also intended, produce beautiful objects at moderate cost. Gropius wanted the Bauhaus to become self-supporting through the sale of designs or the actual production of commodities, but this aim was achieved only to an extremely limited degree.

The Bauhaus was destined to play a leading role in the functionalist transformation of Western architecture and design. But it was also enmeshed in insoluble problems from its inception, in basic differences of outlook that were never resolved. The Masters of Form and Masters of Craft never did see eye to eye over the curriculum; some Masters of Form—Klee, Kandinsky, and Johannes Itten, who established the basic system of art education, among others—never renounced easel painting and insisted on the importance of disinterested, nonpractical formal study for the understanding and appreciation of beauty. In aiming at the production of commodities that would be both attractive and inexpensive, the Bauhaus members, like so many malcontented artists before them, first looked to the past: to the hand-made, painstaking productions of the preindustrial age. Influenced by Gottfried Semper, William Morris, and the prewar crafts movements of Weimar and Vienna, they sought to re-establish the intimate relation between artist and materials—at a time when few in Germany had enough to eat, let alone spare change for the purchase of beautiful objects, and when increasing concentration and rationalization of industry were considered essential for economic recovery. By 1923, Gropius, having become cognizant of the problem, changed his stance. Under the slogan "Art and Technology: A New Unity," he called for the artistic improvement of industrial products and Bauhaus design of assembly-line goods. But now some Masters of Form objected, fearing a decline in the quality of the product, and the step was never quite taken.

More advanced than even its socialist and liberal supporters were prepared to countenance, the Bauhaus was plagued by political problems almost from the beginning. State appropriations were never generous enough for the workshops to be properly equipped, and the manufacture of designs and products never attained the intended momentum or drew the anticipated financial backing. Beginning as early as 1919, Gropius was calumniated by the resurgent Right for his radically simplified, boxlike architecture, for moral turpitude, for Bolshevism; a series of lawsuits against

his scurrilous attackers lasted as long as the Bauhaus.* The "Cathedral of Socialism" image turned out to have been misguided with respect to German postwar politics and cost the Bauhaus dearly. The fact that Gropius had designed a monument to the freedom fighters of 1848 was the ground for repeated attacks, and Gropius was continually at pains to rebut charges about his relationship with socialism—disingenuously in the event. In 1925, after the Right won elections and took over the Thuringian government, the Bauhaus was ordered closed; it was saved by the liberal mayor of the small industrial city of Dessau (in Anhalt), who invited it to transfer its operations, secured financial backing from the city against great opposition, and managed to protect it until 1930. Then another move became necessary, this time to Berlin, where the Bauhaus lasted until the advent of the rabidly antimodernist Nazis.

To a left-wing French intellectual surveying the arts in Germany in the early twenties, everything seemed morbid and unrelieved by any touch of gaiety. "Torment, suffering, fatigued daring, above all ugliness, sadness, a neurotic psychology," he wrote. The best artists—he named Barlach, Kokoschka, and Kollwitz among others—and the mediocre ones had in common a total "ignorance of joy." "Is this man, this deformed reject that you find on all the canvases and sketches? Is this grimacing mask, contorted, black and ugly, the face of a man?" he asked himself. "Yes," he replied, "*Ecce homo*! It is exactly thus that the decadent art of the end of a civilization represents man: defeated, mutilated. Degenerated."[36]

The revolution was played out on canvas and paper as well as on the barricades. And not only the leftist side of it: the Berlin painter Arthur Kampf, long despised by the avant-garde as a reactionary, designed a flyer protesting Bolshevism, "*Berliner, schützt Euch und Eure Familie*" ("Berliners, Protect Yourselves and Your Family"), on which he depicted a bourgeois with a smoking rifle protecting his wife and child from a Bolshevik armed with a knife.[37]

*The first attack, late in 1919, was a so-called "citizens' protest," stemming from the right-wing Nationalist Party and accusing Bauhaus members of Spartacism. Many more followed, most notoriously the "Yellow Pamphlet" of 1924, instigated by a Master of Craft who had been fired and by a former Bauhaus accountant. In all these attacks minor offenses and discrepancies were exaggerated and erroneous political implications drawn. (And *see* Lane, *Architecture and Politics in Germany, 1918–1945*, pp. 69–86.)

In the hands of a younger generation, more *engagé* than their elders, Expressionism now became outright social criticism. Besides Käthe Kollwitz, such young painters as Conrad Felixmüller, George Grosz, Otto Griebel, Otto Dix, and Heinrich Ehmsen, all but Ehmsen born in the 1890s, now devoted themselves, often in the pages of *Die Aktion*, to sympathetic renderings of the proletariat, scathing attacks on the bourgeoisie and the government, and ghastly reminiscences of the war. Felixmüller visited Ruhr coal mines in 1919 and drew the forbidding black industrial landscape and its struggling workers. In a stark woodcut he depicted a woman carrying a puny child past a row of identical houses fronting factory buildings, their chimneys belching smoke. In the same setting he showed workers at their daily activities, or striking, or finding romance. Most effective was his illustration of a fallen leftist ("Gefallener Freiheitskämpfer," Fig. 52), his prone body and the flag he had carried fitted into a small square of cobblestones. Harking back to the French Revolution, now that the German one had been suppressed, he even had the temerity to suggest, on a 1926 cover for *Die Aktion*, a return to the Terror of 1793—in modern dress. Griebel, a Communist who defended Dresden during the Kapp Putsch in 1920, likewise drew touching portraits of beggars, satirical ones of the bourgeoisie like Grosz's more famous ones, and stirring depictions of proletarian solidarity.

Heinrich Ehmsen, witness to the Munich revolution and the 1919 Soviet dictatorship and its repression, was horrified yet fascinated by the vigilante justice of the streets. In several versions he depicted executions of revolutionaries in a manner reminiscent of Goya's "May 3rd, 1808". One of these renditions, monumental in scale, was based on an actual event, the shooting of the sailor Rudolf Egelhofer, a Kiel mutineer who, at age twenty-six, became commander-in-chief of the Red Army under the Munich Soviet regime. Ehmsen worked on the painting (Fig. 53) from 1919 to 1933. It is patterned on a medieval triptych, with a large, central panel on which the heroic, bigger-than-life sailor, towering above a scene of streetfighting and a soldier about to shoot him with a rifle, looks on benignly, and side panels depicting the now repressive socialist forces of order and the representatives of the future, the workers, symbolized by a robust couple with a child. On the left are caricatures of members of the Socialist national government, now scarcely distinguishable from those of the empire (a general with an old-style peaked helmet, a clergyman, a deputy and, clearly recognizable, Friedrich Ebert, the newly elected President of

the Republic, clutching a Bible to his breast), surrounded by their Freikorps soldiers poised for action. The new tricolor flags of black, red and gold fly from the buildings. In contradistinction, the right-hand panel depicts a large contingent of disciplined Communists marching behind red flags with hammers and sickles, pouring in endless succession from the streets beneath the monumental family group.

Stylistically more advanced, and equally committed, were the early works of George Grosz and Otto Dix, who were to play a major role in the avant-garde of the twenties. Grosz, with his hundreds of wartime line drawings, was already a past master of caricature. Now in ever more scathing drawings published in periodicals and in a series of portfolios through the 1920s, and in large paintings, he demonstrated the religious, political, and moral hypocrisy of the bourgeoisie, their gluttony, licentiousness, and lust for power. The women, their curves maximized, walk through the streets with their petticoats showing, or more often with transparent dresses that reveal their bloomers (a device used by Dix and Griebel as well). Whores flaunt their nakedness; the landscape is peppered with brothels and bars. The men are fixated on wine, women, and song—but also on food, Iron Crosses, and, above all, money.

In the hands of Grosz and other young painters, Cubist and Futurist techniques were used to stress the collapse of capitalist society and values. Fragmented houses seem to topple over onto the whores, cripples, and finer folk who people the streets. Grosz's wartime "Leichenbegängnis" ("Funeral Procession," Fig. 54), dedicated to Oskar Panizza, a noted satiric and fantastic poet who had gone insane in 1904, was related stylistically to Futurist paintings of crowds in the Galleria and also to Carrà's "Funeral of the Anarchist Galli" (Fig. 21). It presents a phantasmagoria of grotesque figures, symbolizing the institutions and personae of modern city life. Everything is topsy-turvy: the skyscrapers lean at incompatible angles, a mass of tightly packed figures conveys the claustrophobia produced by a rioting or celebrating crowd; unremarked by the multitude, who are too busy preaching religion, rattling sabers or chasing women, the skeleton sits atop his coffin guzzling wine.

In a series of 50 engravings published in 1924 as *Krieg* (*War*), Otto Dix, who had fought throughout the war with increasing revulsion, turned his reminiscences and war drawings into ghastly, graphic depictions of death and destruction. His expressionistic treatment of the direct and indirect carnage of war is more horrifying than a realistic one could have been. He depicted the dehumanized shapes of men in gas masks; the ugly flotsam

left by a battle; the fright of a man at the moment he is wounded (Fig. 55). He also depicted the ordeal of civilians: one of the engravings shows the inhabitants of a town fleeing a plane about to bomb them; another shows a cadaverous, deranged woman offering her breast to her dead baby.

Along with other German painters and writers, Dix turned to merciless social satire, taking the ugliest aspects of contemporary reality and uglifying them even more for shock effect. In 1920 he painted a legless, armless, blind matchbook-seller, still wearing his soldier's cap, crying "Matches, genuine Swedish matches . . ." as pairs of well-clad legs rush past him and a malicious-looking dachshund urinates on one of his stumps. The prose pendant to this typical example of the black humor of the time was a short dissertation by the Dadaist Raoul Hausmann on the advantages of artificial limbs, so common in these first postwar years. "Every child knows what a prosthesis is. As necessary today for the ordinary man as Berliner *Weissbier* used to be. A proletarian arm or leg works beautifully once a prosthesis is attached."[38]

The prewar Expressionists were far less willing to allow their newfound concerns to permeate their painting, even though their sympathies were with the far Left, as their (albeit brief) participation in the Arbeitsrat and Novembergruppe indicates. Their earlier concern with unfortunates and social outcasts remained evident in their painting, but, despite their avowals of community spirit in their answers to the Arbeitsrat questionnaire, they tried to keep art and politics separate.

The German Dadaists—Huelsenbeck, Hausmann, Hannah Höch, Grosz, Dix, and others—reacting to the revolutionary crisis and with a sharp eye for the chinks in Germany's philosophical armor, supported the Spartacists and constituted themselves propagandists of the social revolution. Although their pronouncements still were full of nonsense and nihilism, and—in line with the Dadaist creed—deliberately inconsistent, negating even their own affirmative stands and reserving the right to change their minds instantly and without explanation, they clearly affirmed their radical materialism and their intention of working for the proletariat. A manifesto issued by the "Revolutionary Dadaist Central Council," that is, by Hausmann and Huelsenbeck, entitled *"Was ist der Dadaïsmus und was will er in Deutschland?"* (*"What is Dadaism and What Does It Want in Germany?"*), called for the nationalization of property, socialist construction projects, the increase of leisure time through mechanization, artists' adherence to communism, and the following, more typically Dadaistic enactments:

a) Daily meals at public expense for all creative and intellectual men and women on the Potsdamer Platz (Berlin);

b) Compulsory adherence of all clergymen and teachers to the Dadaist articles of faith;

c) The most brutal struggle against everything the so-called "intellectual workers" stand for . . . against their concealed bourgeoisism, against expressionism and postclassical education as advocated by the Sturm group;

d) The immediate erection of a state art center, elimination of the concept of property from the new art (expressionism); the concept of property is entirely excluded from the superindividual movement of Dadaism, which liberates all mankind;

e) Introduction of the simultaneist poem as a Communist state prayer;

f) Requisition of churches for the performance of bruitism, simultaneist and Dadaist poems;

g) Establishment of a Dadaist advisory council for the remodelling of life in every city of over 50,000 inhabitants;

h) Immediate organization of a large-scale Dadaist propaganda campaign with 150 circuses for the enlightenment of the proletariat;

i) Submission of all laws and decrees to the Dadaist central council for approval;

j) Immediate regulation of all sexual relations according to the views of international Dadaism through establishment of a Dadaist sexual center.[39]

They held demonstrations akin to contemporary Dadaistic ones elsewhere. Huelsenbeck, the "Dadasopher" Hausmann, and the "Ober-Dada" Baader made a riotous "Dada-Tour" to Leipzig, Prague, and other cities in February, 1920, and there was a series of Berlin evening performances much like those at the Cabaret Voltaire. At the "First International Dada Fair" in 1920, bourgeois taste and mythology were trampled upon in the usual way, but the satire was more politically oriented than outside Germany, with a stuffed sailor hanging from the ceiling and with Grosz's vehement attack on the Prussian military caste, "Gott mit uns" ("God Be With Us"), a series of drawings named after the motto stamped on Krupp's cannons, on the walls. "If drawings could kill," said Kurt Tucholsky, no mean satirist himself, "the Prussian military would surely be dead."[40]

Grosz and his cronies, John Heartfield and Wieland Herzfelde, along with the other Dadaists, publicized their quixotic communism, attacking Expressionism, abstraction, and German idealism as well as militarism in a series of periodicals repeatedly confiscated by the police. Joining together already in 1916 in the editorship of *Neue Jugend*, a rather conservative literary review that they took over in order to avoid censorship, the three were to face prosecutions and attacks from the resurgent Right throughout

the twenties over the output of their Malik Verlag, founded in 1917 and the major publisher of leftist literature after the war.* With pungent political-satirical articles by Herzfelde and Grosz, Grosz's by then well-known caricatures, and Heartfield's propagandistic photomontages, an invention which influenced Soviet propaganda design, the Malik Verlag unremittingly opposed the repression of the revolution by the ruling Socialists, publicized the development of Soviet Communism, and produced an endless stream of invective against the nascent democracy and renascent militarism.

In so doing, it again and again ran up against the "forces of order," while simultaneously gaining widespread adherence among the far Left and the lower classes. Although street vendors declined to handle his publications for ideological reasons or out of fear of reprisals, Wieland Herzfelde could boast to Count Harry Kessler in April, 1919, that he was printing four to five thousand copies of the low-priced *Die Pleite*; a month later, the number had climbed to ten or twelve thousand.[41] Sentenced to two weeks in jail for publishing, in *Jedermann sein eigner Fussball*, a call to arms from the Bavarian soldiers' councils against the expected white terror, Herzfelde emerged with horrifying tales of the mistreatment of prisoners and reprisals against activists by the government soldiers and guards. Recounted as *Schutzhaft (Protective Custody)* and sold as an issue of *Die Pleite*, Herzfelde's indictment created a stir among liberals and radicals.† In conversations with Kessler, Herzfelde likened his intentions in *Jedermann sein eigner Fussball* to those of Aristophanes. He wanted, Kessler reported, "'to drag through the mud everything that was previously dear to the Germans,' that is, all outworn 'ideals,'"—even those of the Left if they were

*Named after the Hebraic hero of an Else Lasker-Schüler poem, the press became notorious for periodicals such as *Der Gegner (The Adversary)*, *Die Pleite (Bankruptcy)*, *Jedermann sein eigner Fussball (Everyone His Own Football)*, and the writings of such leftists as Upton Sinclair, Maxim Gorki, Ilya Ehrenburg, and Vladimir Mayakovsky, suitably—and ostentatiously—jacketed with photomontages by Heartfield. (For a complete list of its publications, see Deutsche Akademie der Künste zu Berlin [East], *Der Malik-Verlag, 1916–1947*, exhibition, December 1966–January 1967.) Herzfelde told Harry Kessler in January, 1919, that all the artists and writers connected with the Malik Verlag had "Spartacist-Bolshevik" leanings. (Kessler, *Tagebücher*, p. 109.)

†*Schutzhaft: Erlebnisse vom 7. bis 20. März 1919 bei der Berliner Ordnungstruppe* (Berlin: Malik Verlag, March 1919). The cover was by Grosz. Said Kessler (March 12, 1919, p. 159): "His description of the jails is so terrible that I felt ill with disgust and indignation. Dostoevsky's 'House of the Dead' is outdone. The mishandling of prisoners, from spitting in their faces to putting their backs to the wall and murdering them, is so common, the torturing in the presence of officers so much a matter of course, that Wieland's belief in deliberate lynching, with instruction sessions during which it is taught, seems almost reasonable. . . . The vision

useless clichés—"in order to break a new path and find fresh air." Grosz, meanwhile, aimed at being the "German Hogarth," according to Kessler, "deliberately representational and moralistic"; he wanted "to preach, improve, reform." His "Deutschland, ein Wintermärchen" ("Germany, A Winter's Tale"), taking its title from Heinrich Heine's satirical poem, filled this bill. Depicting the previous ruling class as the support of a listless, gluttonous bourgeoisie, it was meant as an object lesson—intended for classroom walls, Grosz informed the Count.

Less dogmatic, the other Dadaists nevertheless also tended to moralize. They did so by preaching communism and the death of art to the individualistic-minded avant-garde that wished to continue painting abstract or expressionistic pictures or writing expressionistic poetry and prose. To the communists they opposed their own brand of individualism and chameleon changeability—though not very forcefully. Their most cutting blows, of course, were aimed at the middle class and went straight to the heart. They used a variety of techniques to demoralize and simultaneously outmoralize the sober citizens. They posed as upright protectors of the people, rejecting Zurich Dadaism's stance of antiart for antiart's sake, Huelsenbeck said, in favor of the belief that it was important "for people to possess well-fitting shoes and spotless suits."[42] Recognizing that a "phenomenon of German history" was taking place, the fact "that Germany becomes the land of poets and thinkers whenever it begins to realize that it is done for as the land of judges and lynchers," they launched an all-out attack on the new government's attempt (by having its constituent assembly meet in Weimar, the city of Goethe and Schiller) to relate the establishment of German democracy to Goethe's and Schiller's classicism, in contradistinction to the now discredited martial spirit of Potsdam and Frederick the Great. Trumpeting their antipathy to the "Weimar conception of life," they blamed German idealism and the emphasis of the Weimar thinkers on spiritual over material matters for Germany's crisis and its military, economic, social, and moral bankruptcy.[43] For all their contrariness, the German Dadaists were believers as well as haters, and they were to prove themselves the most profoundly politicized of the Western avant-garde.

one gets is of a completely dehumanized soldiery that elicits from the other side an equally inhuman thirst for blood." When Kessler raised the question in official circles, Gustav Stresemann and others promised to bring it up at a session of the Nationalversammlung in Weimar. (*Ibid.*, March 23, 1919, pp. 161–162.)

Art and Revolution:
Theory and Practice

That man is a wretch who wants his ability with a brush recognized as a mission inspired by the deity—today, when a Red soldier's cleaning of his gun is more important than the entire metaphysical work of all the painters. . . .
 The term "Art" is an annulment of human equality.

GEORGE GROSZ AND JOHN HEARTFIELD[1]

Art is a spiritual function of man, the purpose of which is to free him from the chaos of life (tragedy). Art is free in the use of its means but subject to its own laws. . . . However trivial this may sound, there is no real difference between painting an imperial army headed by Napoleon and a Red army headed by Trotsky!

HANS ARP, THEO VAN DOESBURG, KURT SCHWITTERS, TRISTAN TZARA, *et al.*, "Manifest Proletkunst," 1923[2]

No sooner had most of the avant-garde joined, or at least tacitly endorsed, the revolutionary movements in Russia, Germany, and elsewhere, than ideological differences became apparent which were to split the avant-garde and decide most painters against further political involvement. Long before the Soviet regime and the Communist parties of the Third International began to dictate style and subject matter to artists, a tense and factious dialogue began among Western artists over the role of art in a revolutionized society, and that of the avant-garde under collectivism. In the few years following the armistice, moved more by their disappointment over the proletariat's lack of interest in their art than by the resurgence of the Right, painters progressively abjured direct participation in politics and forged a myth of their eternal apoliticism. Their struggles over acceptance of a nonindividualistic political order and ideology exemplify the political dilemma of the twentieth-century artist.

I

In the spring of 1920, during the fighting between socialists and reac-
tionaries brought about by the right-wing Kapp Putsch, Oskar Kokoschka,
then a professor at the Dresden Academy of Fine Arts, wrote a manifesto
which was posted all over the city and reprinted in myriad journals.
Noting that a Rubens painting in the Zwinger, the state art gallery, had been
pierced by a bullet, the buoyant Kokoschka ironically urged "all those
who intend in future to argue over their political theories, whether left-
wing, right-wing, or centrist, with shooting matches . . . no longer to hold
such military exercises in front of the Zwinger Art Gallery, but perhaps
at the rifle-ranges on the heath, where human culture won't be en-
dangered." By destroying public monuments and works of art, the
combatants were, he asserted, robbing "the poor people of the future of
their most sacred goods"; in years to come the German people would
"derive more happiness and meaning from seeing the preserved pictures
than from any possible views of the politicking Germans of today."[3] As in
ancient times, he said, political differences ought to be settled by
hand-to-hand combat between leaders in the arena, not by street battles.

Kokoschka's manifesto met with a fierce reaction from some members
of the avant-garde. Perhaps in reply to it, and certainly with reference to
the Kapp Putsch, Otto Dix, then also in Dresden, painted a scene of bar-
ricade fighting in which the barricade was made of signs, a piano, objets
d'art, jewels, and laces, and a cartload of old master paintings (Fig. 56). The
Malik Verlag set was especially piqued; taking Kokoschka's words at face
value, Grosz and Heartfield accused him of wanting to sacrifice workers'
lives to save bourgeois culture and the individualism that had fostered it
and that it in turn had fostered. Asserting that the proletariat would even-
tually create its own culture as easily as it had improvised organizations to
promote the class struggle, they suggested the sale of all these "mis-
treated" paintings to the Entente in exchange for food for starving children.
(Kokoschka had suggested that these works might be punitively
confiscated by an Entente raid.) To their minds, art and culture were the
contemporary opium of the people, utilized by exploiters to draw attention
away from pressing economic problems. Another commentator on

Kokoschka concluded: "It is impossible to destroy enough 'culture' for the sake of culture."[4]

This exchange raised in their most extreme form issues that were then plaguing the avant-garde as a whole and on which artists felt compelled to take sides. Kokoschka has since said that the shooting of the Rubens was unimportant to him at the time, and that he had seized on the incident as a means of drawing attention to an intolerable situation, the inhumanity he had witnessed in the Dresden streets, where vigilante justice was being meted out by both workers and reactionaries to their presumed enemies.[5] But he did demand the preservation of landmarks and assert the importance of tradition, while to his opponents everything produced in the past was expendable now the millennium had come.

Artists began to debate questions that only leftists had previously alluded to—and then half-heartedly. Granted, they would henceforth work for and with the proletariat; but what would be the artist's role in the new society? Were all previous artistic styles now meaningless, even the avant-garde's? Who would decide what art was right for the new age? Could the artist still expect creative freedom *and* improved economic conditions? But first of all, ought he to continue producing art when so many practical jobs remained to be done?

Although these questions were debated in nonrevolutionary countries such as France as well, they came to a head in Germany and Russia. In Germany the most coherent—and extreme—position was elaborated by the Malik Verlag group, Berlin Dadaists, and younger Expressionists. According to these staunch communists, the Revolution had created a breach between past and future economic systems which art could cross no more than any other human activity. The prerevolutionary avant-garde might have been progressive, alienated from the economic hierarchy, and even harbingers of revolution; but their art, in its disregard for reality and its esotericism, was indissolubly linked to capitalist individualism. What was needed now was community spirit and engagement, not ivory-tower estheticism; communism would inevitably elicit a new art, "sullied by no past,"[6] despite the avant-garde's possible refusal to break with the Old Regime. Young Conrad Felixmüller told the tale of an artist, the son of proletarians, who deserts his class in pursuit of avant-gardism and then rediscovers his class under the impact of revolution. At first he rejects his profession as meaningless in a time of critical economic and political needs.

But in the end he takes up his brush again in the service of the masses: " '. . . just because you are a proletarian,' he said to himself, 'a proletarian first and an artist only second, as an artist you may only be a proletarian. The fine phrase "free, unpolitical art" is not meant for you.' "[7]

The first duty of the artist now was to support the Revolution by all available means; he was exhorted by some to defer his professional work until the fate of the masses was assured and meanwhile to join the workers and soldiers in the streets. "Artistic freedom" was seen as a byword of the capitalist era that was no longer valid: art had always supported some religion or ideology, and only the morally impoverished bourgeoisie, unable to look beyond materiality, had "freed" it. Thus even the most adamantly antibourgeois artist was held to be in complicity with the regime he claimed to destroy, for a refusal to adopt an ideology constitutes an acceptance of the status quo, or so said George Grosz and Wieland Herzfelde. According to Raoul Hausmann, artists, in their rootlessness, were helping "in the continued building of the pyramid of blood, sweat, lies, and filth they call civilization."[8] George Grosz offered the artist two choices: either to become an engineer—a technician—or a creator of the new art of the masses, integrating "himself, as a propagandist and representative of the revolutionary idea and its adherents, into the army of the suppressed, who struggle for their rightful share of the world's goods and for a meaningful social organization of life." In either case he must renounce "pure art."[9] Art must join in the struggle to free every individual from exploitation and then help develop that unity of effort and purpose without which socialism would fail. Some communists recognized the role the prewar avant-garde had played in laying the groundwork for revolution—their spiritual anarchy that had torn apart the complacent bourgeois world view. But now anarchy was no longer permissible, and artists no longer had the right to be Cubists, Expressionists, or Futurists, to paint abstract pictures which only a highly educated elite could understand. Goya, Hogarth, and Daumier were the fitting models for the proletarian artist.

Opinions varied as to how artists of various persuasions would be brought around to supporting and working for the proletariat. It was generally assumed that they would defect spontaneously; if not, they should be deterred from publicizing their ideas. Wieland Herzfelde, however, in a series of well-reasoned and unusually sensitive articles in *Der Gegner* in 1920–21 entitled "*Gesellschaft, Künstler and Kommunismus*" ("Society, Artists, and Communism"), demonstrated the complexity of the situation. Not even proletarians, he said, could be expected to drop overnight the ideas and

social roles inculcated under capitalism; even less could artists be expected immediately to retool, to forget the deceptive creative freedom they had enjoyed. They had been exploited under capitalism, but in a special way. They were not, like workers, alienated from the product of their labor; and they eventually shared in the profits of the art dealers who exploited them. Moreover, their solitary and individual method of work reinforced their anarchist tendencies, as did their personal relationships, for their "comrades" were rivals and competitors for the scanty market as well as being friends. Thus their very life style and aspirations were tied to the capitalist economic system, and they could not be expected to want to emancipate themselves from it. Asserting that the participation of artists was essential to the speedy success of a revolution, Herzfelde, unlike most other revolutionaries, gave the problem of their economic security and position within the new system high priority. Ideally, he said, their theoretical relationship with communism should be elaborated and publicized well before the Revolution; once it came, they should promptly be unionized and given financial support, for their economic problems would be even greater than before. In line with Lunacharsky's philosophy, Herzfelde suggested that the government allow artists of all persuasions, avant- and arrière-garde, considerable latitude at first, even at the risk of their publishing and exhibiting things out of tune with the new regime. It should, in effect, demonstrate to the artists that the masses are neither uninterested nor ungrateful, and that their economic well-being would henceforth be assured: they would be brought around to a socialist ideology only by discovering for themselves its practical superiority—by being shown with the greatest delicacy on which side their bread would henceforth be buttered. Only in this way could they be induced to drop their individualism, both in artistic style and life style, and to create a new art in the likeness of the new man.

This demand for the artist's total reorientation was compatible with that of the Russian Proletkult for an inherently proletarian culture, then making headway against Lunacharsky's liberalism and beginning to influence other government leaders. It was the view also of a large number of Russian Futurists, who took control of IZO and the art schools in 1921, and, still practicing and championing extreme avant-gardism, nevertheless joined Proletkult and sought to replace hermetic studio work with practical projects and with theorizing which would have practicality as its ultimate aim. The Constructivists, as they now called themselves, were still a puzzle to the masses—and ultimately unacceptable to the pedestrian-minded

Soviet leadership, though they were to be tolerated for several years more. They were concerned almost exclusively with construction projects, propaganda, typography, and design, and with laying the theoretical groundwork for a gradual reorientation away from painting to three-dimensional and utilitarian forms of art. It soon became apparent, both in Germany and Russia, that the workers were not responding as anticipated. Despite all the assertions that workers had a natural artistic bent, a need for creative expression and the ability to recognize and accept the clean lines of functionalist design, not enough of them lined up to be educated, nor did they reject traditional realism in favor of more revolutionary forms.

Most artists disagreed with this ideological approach to their former and future social roles and the projected development of the arts. Such artists as Heinrich Vogeler and Otto Freundlich, although both communists, upheld artistic freedom and stressed the seminal role of the pre-war avant-garde. They and many others agreed that a mass art was now needed to correspond to the mass public, and that craftsmanship should form the base of the new art, with architecture its organizing center;[10] but they denied that the proletariat could take the lead or dictate the direction this art would take. Freundlich warned of the danger of growing bureaucratization and accused communist intellectuals of trying to pour new wine into old—academic—bottles.[11] It would be necessary to devise new forms for the new content and not revert to the realism engendered by capitalist materialism, which, Vogeler said, made men into chasers after trends (*Konjunkturenjäger*) instead of creators (*Gestalter*). Many artists tacitly and somewhat naively assumed that, since art had been revolutionary before the Revolution, avant-garde artists would intuitively understand what was now needed and respond to the new economic and social situation. In the area of culture the artists should be the teachers and the people should have the humility and willingness to learn. (It was clear to Vogeler and Freundlich that the *creatio ex nihilo* demanded by Proletkultists was an impossibility if art were ever to progress beyond folk art; but, enamored of the Proletkult idea, they did not state their point this flatly.) Contributors to *Clarté* roughly shared this view. Even Henri Barbusse, who had founded the movement and review to propagate "the great fundamental ideas" and spread the revolutionary spirit, castigated French leftists for their reactionary artistic conceptions. "The newest tendencies in art are . . . in complete harmony with the organization of collective modern life that communism is working to establish," he asserted.[12] Albert Gleizes stressed the irony that recent revolutionary styles had been accepted only "in the circles

most opposed to [their] spirit"—by "certain personalities in the reactionary political parties."[13] Thus it was realism that was bourgeois and had to be overcome, and the avant-garde had long since escaped the bourgeoisie.

It was clear almost from the first that most painters were even less willing than these to sacrifice their autonomy to the ideological needs of the moment, and to abandon individualism or those other "isms" which were now beginning to gain them recognition. For the former Fauves, the Cubists, and the older Expressionists, art had already demonstrated its revolutionary character as the vanguard of all the transformations brought on by the war and its aftermath. The art of the new era already existed, and the claim that its creators should produce for mass society denoted a return to philistinism that they would not countenance. They accepted neither the Marxist doctrine of the primacy of economic relationships over ideas nor the attempts of leftists to bring them into the fold. From the Revolution they expected only artistic freedom and easier economic circumstances; they would give the most to the new society by continuing to produce the modernist works they were convinced were the best contribution art could make in the twentieth century. Because they persisted in setting themselves, intellectually at least, above the proletariat, and because they refused to give their undivided attention to the first order of business, i.e., assuring and consolidating the Revolution, leftist activists within and without their ranks accused them of bad faith.

The artists emphasized their expectations from socialism, the socialists theirs from art. Even so convinced a revolutionary as Max Pechstein, who continued to work for communism throughout the twenties, stressed the importance of a liberated artistic community, assuming rather vaguely that only it would generate an "art for the people." "The revolution has brought us the freedom," he wrote,

> to express and realize age-old desires. Our sense of duty teaches us that we also must do our own work for ourselves. We desire it and do it also without self-seeking, our eyes clearly fixed on the ideal time [ahead]: "the transformation of our feeling for our time into a weltanschauung." Thus the cry "Art for the People!" is no empty call. Our will is immaculate, not being founded on any personal will to power.[14]

Most artists rejected the exhortations to engagement without producing supportive arguments; they merely dropped out, returning to the isolation of their studios and to the styles elaborated before the war. The revolutionary art organizations founded in the first flush of enthusiasm did not

achieve their aims. Increasingly bureaucratic, disrupted by sharp antagonisms among factions and by attacks from the Right and the Left, they became ever less effective.* Soon all the prominent artists had deserted them and they were left in the hands of second-raters or of youngsters who had yet to make their mark—and who were to be prevented from doing so by the rise of Nazism.

Revolutionary fervor certainly was largely dampened by the rapid resurgence of the Right in all of Western Europe, and especially in Germany, where the "Revolution" proved chimerical and even the moderate parliamentary Socialists were edged out of power. One could therefore argue that artists and proletariat never had a chance to get together, for the society never actually was revolutionized. Thus, the art of the proletarian era remained undiscovered.

It seems quite clear, however, from the experience at the Bauhaus and in Russia and from the arguments just cited that most artists had already made their choice between art and revolution before governments began to meddle in their affairs or communism opted for philistinism and repression. The Russian avant-garde enfeebled itself through controversies before the government began to place restrictions upon it, and years before the 1932 proclamation of "socialist realism" as the only officially accepted art form. At the Bauhaus, despite the consensus on the need for the composite work of art with a social aim, two divergent educational philosophies were at odds almost from the first and never became reconciled. The painters among the Masters of Form—Johannes Itten, Klee, Kandinsky, and, to some extent, Oskar Schlemmer—resisted from the first Gropius' pragmatic drive for full-scale production and his later espousal of technological methods. They were never willing to tear down their ivory towers, for they believed in the creative primacy of the idea over its realization and made theoretical formulation, not practical adaptation, the keystone of their educational philosophy. (Even such a Constructivist as El Lissitsky produced highly abstruse formulations, claiming that they were leading to something practical.) In a 1923 letter to Katherine Dreier, written at the height of the runaway inflation in Germany, Kandinsky expressed pessimism over the current triumph of reaction and preoccupation with material goods as well as his firm preference for spirituality:

*Leftists accused the groups of trying to shelter artists from political life and of setting up a new elite in place of the old. (Otto Freundlich, "Absage," *Die Erde,* I, No. 24 [December 15, 1919], 686–87; Otto Dix, George Grosz, *et al.,* "Offener Brief an die Novembergruppe," *Der Gegner,* II, No. 8–9 [1920–21], 297–301.)

Our nouveaux riches are bad, and the immediate future is in their hands, whatever the government calls itself. Thus intellectual workers are being repressed. Spirit, art, science, religion, morality are to be "superseded" and humanity is going once again to start haggling over belly-stuffing goods until it either becomes idiotic or begins to despair. The materialistic soup will have to be gulped down to the last drop. . . . But through repeated hard knocks and despair the way to the spirit will be found. . . .[15]

In the West, artists could continue to evolve freely and in isolation, and most henceforth made a virtue of doing so. Some continued to opt for realistic, socially critical imagery, but most denied their social responsibility and rejected realism once more. In the end, only a small minority of the avant-garde joined the Communist Party between 1918 and the late 1920s (Grosz, Dix, Heartfield, Freundlich, Hausmann, and some second-generation Expressionists, ex-Dadaists, and Surrealists). Only they remained activistic after the initial two or three postwar years, and even some of them began to separate their art and their politics, attempting, and believing themselves, to be both good communists and good avant-gardists.

II

By 1925 Europe was pacified, and the art world with it. It was a relatively cheerful time: the memory of the war was dimming, Germany's runaway inflation was over, and the next war did not yet loom on the horizon.

For most painters, whatever their ideological vicissitudes, the period of war and revolution had been decisive. Few could pick up their brushes just where they had left them in 1914, and virtuosi like Picasso, who could always invent a new style while continuing to work in the old one, were all but nonexistent. (Picasso, besides, had not experienced war and revolution as had others.) Some were now too old or tired to find new sources of invention: Carrà, de Chirico, Derain, Metzinger, and later Balla turned back toward a traditional classicism; Russolo stopped painting permanently and Münter for several years. Some continued their old styles, often with less verve than before: the former Brücke members continued a colorful, if somewhat subdued, Expressionism; Balla (until around 1930) his nonrepresentational brand of Futurism; Severini, Braque, Marcoussis, Villon, and others, a synthetic Cubism; Van Dongen, Dufy, Friesz, Marquet, Vlaminck, and others, a watered-down Fauvism; Kokoschka a subdued, almost Impressionist handling of landscape. Others—Gris, Feininger,

Matisse, Nolde, Soutine—changed not at all or only moderately, but continued producing works of the first rank. Relatively few—Arp, Beckmann, Jawlensky, Kandinsky, Klee, Léger, Malevich, Mondrian—began anew or came into their own after the war.

A few painters—the older radicals Kollwitz, Signac, and Vogeler, Max Pechstein (until the late 1920s), and the now thirty-odd-year-old Grosz, Hausmann, and younger Expressionists—continued to adhere individually, no longer within organizations, to the communist faith or propaganda; but they formed only a small minority. For most, *artistic* avant-gardism was still what counted, and capitalist society was now providing, as it had done since a hundred years before, the liberal conditions they required: creative freedom, the possibility of earning a modest—and now, for some, even a sumptuous—living, and the hope or achievement of fame. For a few painters—Gleizes, Severini, and Rouault among others—religion became a substitute for socialism. They, too, were a small minority. Most retired to cultivate their gardens and claimed ever after to be, and always to have been, apolitical.

They were replaced on the artistic and political barricades by two new movements, some of whose leaders came from among them: Surrealism in France and *"die neue Sachlichkeit"* (The New Objectivity) in Germany. While Surrealism, in its attempt to plumb the unconscious, emphasizing irrationality and immediacy, was patently apolitical, and *die neue Sachlichkeit*, with its social satire and obsessive concentration on unappealing human foibles, was patently political, adherents of both movements joined their respective communist parties and, during the late twenties and the thirties, repeated to a large extent the public quarrels and mental qualms of the older generation. Only now the political situation had altered drastically in all Western countries: everywhere there were governments or parties demanding ideological subordination from artists, and with the power to enforce that demand. In France, the Surrealists, generally Trotskyist in orientation, soon became disenchanted with cell meetings in which workers criticized them as elitist and bourgeois and their works as unreal, and dropped out of the Party within a few years.[16] Of the movement's leaders only the writer Louis Aragon went along with Stalinism, renouncing Surrealism in order to do so. In Germany, the Nazi takeover forestalled any similar confrontation between artists and communists, but Verists such as Dix and Grosz, retaining their commitment to revolution, nevertheless stood aloof from Party activities for the most part, and Beckmann stood aloof from the Party.

The Left would not credit the revolutionism of the avant-garde; the Right would not credit its apoliticism. As Stalinism hardened ideologically, gaining control of the Western parties, artists were castigated for believing they could liberate themselves as individuals, or could liberate society by means of ideas, and were told to become realists if they wished to remain Communists. For the Right, on the other hand, modern art had irrevocably stamped itself as leftist during the war and immediate postwar years. Long before it was put out of business by the Nazis, the Bauhaus had been wasting away under the attacks of a variety of rightists. It did not take Hitler to end the cooperation between the avant-garde and the German state, or even to imbue most Germans with a preference for traditional art. It was not Hitler who began the racist and nationalist attacks on Expressionism and functional architecture that characterized them as the work of foreigners, Jews, or mental defectives.*

It was Hitler, however, and to a lesser extent other fascist leaders, who once more politicized some avant-gardists. Under the threat or the actuality of war and repression, a few (very few painters as opposed to writers) supported the Popular Front movements in France and elsewhere, registered their protest against the insurgent forces in Spain (though none joined the International Brigades), and resisted, though usually passively, the Nazi occupation of most of Europe. The response of avant-garde painters, compared with that of other intellectuals, was extremely meager, however. Picasso's "Guernica" (1937), a horrified outcry against the first recorded all-out bombing of civilians, and his engraved "Dream and Lie of Franco"; Beckmann's "Departure" triptych and other treatments of torturers (who were not necessarily Nazis, since these subjects predated them) and their victims; Dix's savage, allegorical anti-Nazi works: a pretty small output when compared to the works dealing with World War I or even with the effusive celebrations of brotherhood around 1919–21. Many more painters protested verbally but, understandably, from exile—in Holland, Scandinavia, England, and the United States.

In Germany, the Expressionists, Verists, and former Bauhaus members either went into exile or remained and retreated into obscurity as Hitler, the former academic painter (and academic reject), took his revenge on the

*For example, Paul Schultze-Naumburg, a turn-of-the-century modernist architect of country houses, compared Expressionist works with photos of people with elephantiasis and other deforming diseases. (*Kunst und Rasse* [Munich: 1928]. *See also* Barbara Miller Lane, *Architecture and Politics in Germany 1918–1945* [Cambridge, Mass.: Harvard University Press, 1968], pp. 125–67.)

avant-garde, declaring it "degenerate" and "cultural Bolshevist" and, starting in 1933, placed its members under severe legal restrictions, removing them from honorary and teaching posts and barring them from exhibiting, selling, or, by 1937, sometimes even painting.* To enforce these restrictions, the Gestapo was ordered to inspect certain painters' studios periodically—sometimes the Gestapo officers even felt brushes for dampness. With the cooperation of such embittered, conservative men of the art world as the architect Paul Schultze-Naumburg, the Munich painter Adolf Ziegler, and the racist critic Wolfgang Willrich, the Nazis destroyed murals and public monuments, removed thousands of modernist works from German museums, and staged a massive show of "degenerate art" in Munich in 1937, where modern paintings and sculptures were shown through slogans painted on the walls to be depictions of (and simultaneously the work of) physical and mental defectives, self-revelations by Jews, incitements to class war, attempts at the demoralization of the German people, and attempts to set up Blacks and South Sea Islanders as a racial ideal.† The public came in droves—it was the most heavily attended art exhibition recorded up to then, with 42,000 spectators on the peak day—though not all came to read the slogans and laugh: the guards were instructed to make sure the visitors were not dawdling in front of the paintings.[17] In 1939, the most valuable avant-garde works were traded off for foreign currency in an auction held in Lucerne; thousands of others ended on a huge bonfire lit by the Berlin Fire Department.

The German avant-garde had always been concerned with the problem of German-ness. While accepting French and primitive influences and asserting the cosmopolitanism of modern art, they had contradictorily been at pains to rediscover their national character (in the works of Dürer, Cranach, Grünewald, and others) and to produce works that were modern, superlative—yet unmistakably German. Nolde, a member of the Danish Nazi Party (he was then a Danish citizen), protested to Goebbels his inclusion in the "degenerate art" show: "My art is German, strong, austere and sincere."[18] Hitler thought otherwise: his taste ran to the sweet, sentimental, and erotic; his political ambition called for the pseudo-classical and monumental. Distrusting the modernists' prewar and Weimar internationalism, he was convinced that art had to become German—that

*See Appendix B for the specific actions against individuals.
†Willrich penned a racist, patriotic blast against the avant-garde and progressive museum directors: *Säuberung des Kunsttempels* (Munich: 1937). Ziegler, aside from being a favorite painter of Hitler's, was head of the Chamber of Fine Arts and instrumental in arranging the Munich exhibition. And *see* the guide to that exhibition, which is profusely illustrated, with an Otto Freundlich stone sculpture on its cover.

is, to portray the new, vigorous, joyous Germans under National Socialism—before it could become good. In his speech at the opening of the Munich Haus der Kunst in 1937, where an exhibit of approved art was meant to point the way of the Third Reich against the "degenerate art" then on view, he stated: ". . . our modern German state that I with my associates have created has alone brought into existence the conditions for a new, vigorous flowering of art." To the avant-garde he offered two possibilities:

> . . . either these so-called artists really see things this way and therefore believe in what they depict; then we would have to examine their distorted eyesight to see if it is the product of a mechanical failure or of inheritance. . . . [Or], on the other hand, they themselves do not believe in the reality of such impressions but try to harass the nation with this humbug for other reasons, then such an attempt falls within the jurisdiction of the penal law.[19]

The artists who remained in Germany sat it out, worked clandestinely (Nolde's wartime "unpainted pictures" are among his finest), sometimes (as with Dix, Ehmsen, and Felixmüller) were conscripted as casualties mounted, and watched as their studios were destroyed by bombs. In the occupied countries, avant-gardists fled into exile or to safer ground (the south of France), or remained and, as with Picasso, capitalized on their international fame to offer passive resistance. (When a German officer pointed to a reproduction of "Guernica" and asked Picasso, "Did you do that?" he reputedly replied, "No, you,"[20]) One lamentable group—Derain, Van Dongen, Dunoyer de Segonzac, Friesz, and Vlaminck—now grown worldly, accepted an invitation from Arno Breker, Hitler's favorite sculptor, and visited Berlin for eight days in 1941, thereby gaining a reputation for collaborationism that was hard to eradicate after the war.* Though many of the painters survived, living to be eighty and more and to enjoy fame and wealth after the war, European avant-gardism had been damaged beyond repair by 1945—by Stalinism as well as fascism. With the inspiration and sometime participation of the many émigrés—most notably, Duchamp, Beckmann, Feininger, Ernst, Mondrian, Léger (who, however, returned to France in 1945), Gropius, and Mies van der Rohe—the banner of artistic innovation passed to the United States, where three generations of avant-gardists (the Abstract Expressionists, the Pop artists, and the more varied present group—the Concept artists, Photorealists, and

*Information on this is scarce; although it is mentioned by the various painters' biographers, they prefer not to dwell on it. Vlaminck was jailed for forty-eight hours after the liberation but never brought to trial.

others) have held forth. Postwar European avant-gardists, such as they are—there are no indigenous movements, only individuals—have taken their stylistic directions mostly from New York. And their politics, humanitarian and indeterminately leftist as before, have been mainly reactive to Washington, especially since Indochina became an American affair.

Of Europe's pre-1914 avant-garde, two became Communists around 1945: Léger and Picasso. Léger had supported the Popular Front in the late 1930s, joining the Front's Maison de la Culture along with Masereel, André Lhote, Marcel Gromaire, and other artists; both he and Picasso were now enthusiastic over the Party's triumphant organization of the antifascist Resistance. Both were delegates to the World Peace Conference that met in Wroclaw, Poland, in 1948 to protest Western rearmament. Both produced works celebrating postwar heroes and events: portraits of Henri Martin, a sailor who protested the French government's refusal to compromise with Ho Chi Minh in Indochina, and of Party leaders; Léger's "Homage to the Rosenbergs"; Picasso's peace dove and his "Massacre in Korea." But both also refused to toe the Stalinist line and, maintaining up to their deaths that they were good Communists, went their own stylistic ways, oblivious to cell meetings and to the Party's obvious displeasure with their art. In 1947, Maurice Thorez, the head of the French Communist Party, denounced nonrepresentational painting; in 1953 Party members attacked a Picasso sketch of Stalin for its lighthearted, youthful interpretation of the dead hero. Picasso remained silent then; and in 1956, he contented himself with a verbal protest against the Soviet intervention in Hungary. The Party tolerated him and Léger because of their international prestige; they in turn tolerated the Party because of the same humanism and optimistic trust in the workers that had characterized the twentieth-century avant-garde all along. Now as before, Léger and Picasso trusted in education to show the workers—eventually—their fraternal bond with modern artists. Meanwhile, the Party had no right to meddle in matters that did not concern it. As Picasso put it in 1945 to a young American Communist and amateur painter who admired his work: "I am a Communist and my painting is Communist painting. . . . But if I were a shoemaker, Royalist or Communist or anything else, I would not necessarily hammer my shoes in a special way to show my politics."[21] The belief that there is no essential difference between an anonymous shoemaker's hammering of his leather and a world-famous painter's brushing of his canvas: here, in a nutshell, lies the avant-garde's warm humanism and its disastrous naïveté.

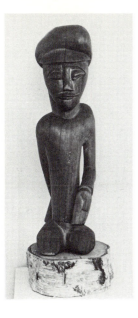

Fig. 43. *(left)* Karl Schmidt-Rottluff,
Worker with Balloon Cap, 1920.
Berlin, Brücke Museum.

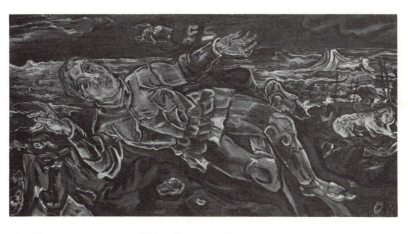

Fig. 44. Oskar Kokoschka, *Knight Errant,* 1915.
New York, The Solomon R. Guggenheim Museum.

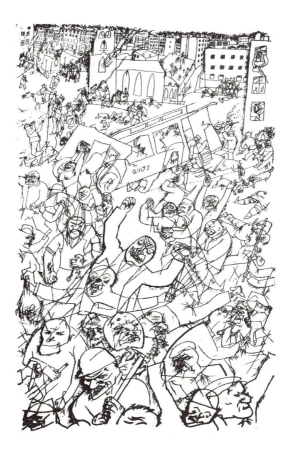

Fig. 45. George Grosz,
Pandemonium, August, 1914.

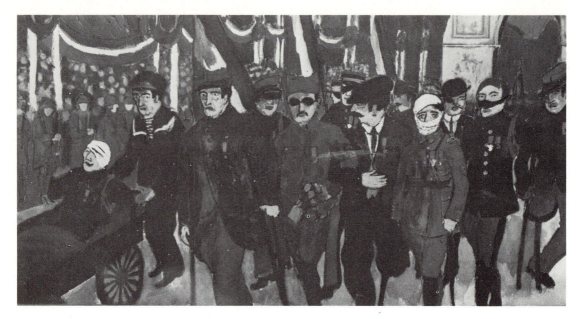

Fig. 46. JEAN GALTIER-BOISSIÈRE, *Procession of Cripples, 14 July 1919*.
Paris, Musée des Deux Guerres Mondiales.

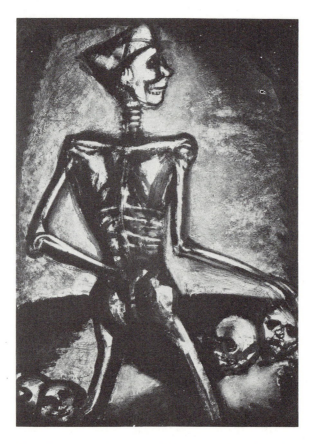

Fig. 47. GEORGES ROUAULT, "Man is a Wolf to Man,"
from *Miserere*, 1926. New York, Museum of Modern Art.

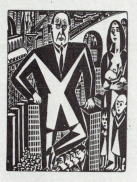

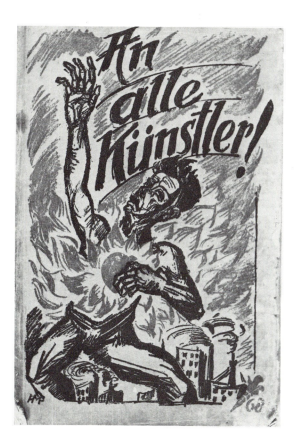

Fig. 48. Frans Masereel, "The Modern Slaver," cover for *Die Aktion,* 1922.

Fig. 49. Max Pechstein, *To All Artists!,* 1919.

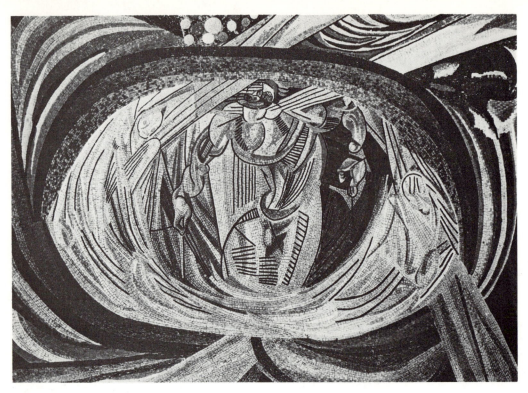

Fig. 50. Otto Freundlich, *The Birth of Man,* mosaic, 1918–19.

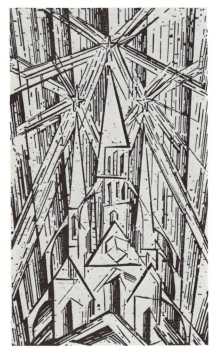

Fig. 51. Lyonel Feininger,
The Cathedral of Socialism, 1919.

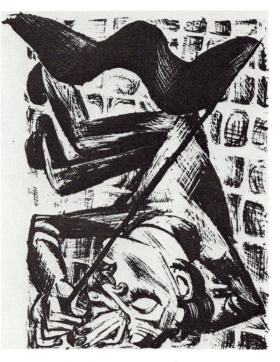

Fig. 52. Conrad Felixmüller,
"Fallen Freedom Fighter,"
from *Das Kestnerbuch,* 1919.

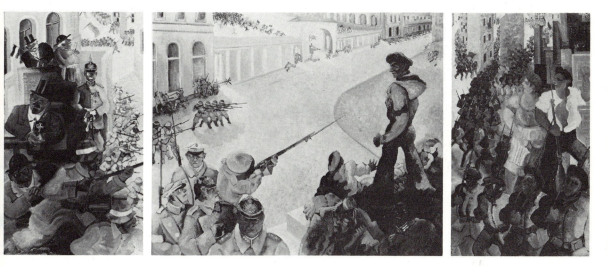

Fig. 53. HEINRICH EHMSEN, *The Shooting of the Sailor Egelhofer*, 1919–33. Moscow, Army Museum.

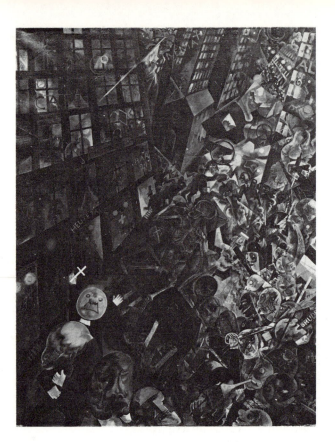

Fig. 54. George Grosz, *Funeral Procession (Homage to Oscar Panizza),* 1917–18. Stuttgart, Staatsgalerie.

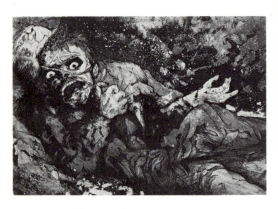

Fig. 55. Otto Dix, "Wounded Man," from *Der Krieg,* 1924. New York, Museum of Modern Art.

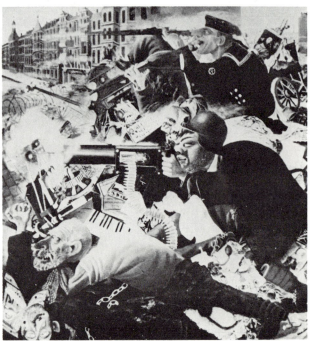

Fig. 56. Otto Dix, *The Barricade,* ca. 1920.

Conclusion: The Politics of the Avant-Garde

A poet who wants to exert an influence in the political sphere must dedicate himself to a party, and as soon as he does this he is lost as a poet; he must say farewell to his freedom of spirit, his candor of vision and pull instead the cap of blind hate and narrow prejudice over his ears.

GOETHE to ECKERMANN, 1832[1]

In many respects, the avant-garde of the early twentieth century was politically like its nineteenth-century forerunner: both were predominantly, though not exclusively, leftist in their sympathies, favoring those political philosophies which were humanitarian and democratic and which held an idealistic view of man's potential.[2] Conversely, in their approach to their art, they were (as by its very nature an avant-garde must be) highly exclusive, elitist, and antidemocratic, stressing uniqueness, talent, and vision, qualities given to few. In our period, some painters stressed one and some another of these two aspects of avant-gardism. Kandinsky, for example, celebrated his unique vision above any sympathy he might have had for suffering humanity, while Grosz came to consider himself the servant of that humanity, and his vision contingent on social needs. But almost all the painters had impulses in both directions; and whether they stressed artistic or political revolution, they sought in their art to subvert the accepted conceptual and representational modes.

Their most characteristic quality as artists was a feeling, to some extent self-imposed, of isolation and alienation from society at large. As social radicals, most of them conversely demonstrated a longing for reintegration with mankind in some future world that would right social wrongs. Many of them sought to reach that world by a return to the human relationships of preindustrial eras rather than by any further evolution of contemporary

institutions. These conflicting tendencies—the artist's need for isolation and love for the extraordinary as against the humanist's desire for social harmony—made ordinary political participation almost impossible. Before 1918 we rarely find an avant-gardist as an active member of an organized political party, not even so radical a one as the Socialist Party at the turn of the century. The one political creed to which they gravitated was that of anarchism, and that because it was the one political philosophy that sought to unite social justice and individualism, to allow the artist to return to the mainstream of society and yet retain his creative independence and integrity. (It is not surprising that, conversely, anarchists saw in the artist a model of self-reliance, creativity, and nonalienation.) With the exceptional complicity of the ruling class, the artists were already living anarchistically within their professional community. They were only the more susceptible to the vision of a world in which all men would live together amicably, respectfully, and creatively, without recourse to government. Thousands of seemingly hard-nosed workers and sharp-witted intellectuals in the movements of the Left were equally blind at that time to the impracticality of the anarchist vision.

What separates twentieth-century avant-garde artists from their predecessors is not so much the content of their social attitudes and political opinions as the stage on which history determined they should act them out. In the world crisis of 1914–19 they had the opportunity of trying to change the world to suit their ideals and economic interests. Indeed, they were enjoined to drop painting for politics, to exchange their palettes for guns and pickaxes or to use them propagandistically—steps that most were unwilling to take.

From the point of view of political activism it is possible to accuse all but a few determined communists among them of a lack of commitment and, nothwithstanding their radical talk, of an elitism which attached them to the established order and which they ultimately refused to shed. All this is true: clearly, most painters' were sincere in their theoretical humanitarianism but unwilling to become directly or professionally involved in bringing about social change. They were weak-willed and inconstant; they raised the proletariat's hopes with fine talk and idealistic theorizing, but when the "moment of truth" arrived they refused to assume leadership or integrate themselves into the rank and file, valuing continued artistic innovation above social justice. But were not almost all the prewar anarchists and socialists equally at a loss at the "moment of

truth," even if we disregard their almost universal capitulation to nationalist sentiment in 1914? In the countries that experienced revolution between 1917 and 1919, most socialist leaders allowed insecurity about the common man to replace their vision of a classless, nonexploitative future and brutally suppressed extreme revolutionists or assumed dictatorial or quasidictatorial powers.

Like the painters, the majority of prewar socialists and anarchists were inconsistent and idealistic, quick to attack the ruling powers with virulent phrases and violent prophecies, but untrained in leadership and unprepared for power. The avant-garde was unready for participation in mass political parties, and by its very nature unwilling to take direction from those untutored in art. But thousands of prewar activists were equally recalcitrant, especially the anarchists, whose philosophy was as much negated by the mass parties as was that of the artists. Some anarcho-syndicalists, socialists, and avant-gardists (Marinetti, Balla, Nolde, Vlaminck) went over to the Right at this juncture and accepted ideologies that were not unlike prewar anarchism in their violence and their opposition to the Establishment, but that sought to organize mankind under a strong elite and in the name of nationalism. And something similar happened de facto in the Soviet Union.

If avant-garde artists had a revolutionary theory at all, it was one diametrically opposed to dialectical materialism. The politicians of the far Left believed that what was needed was political and economic revolution: from this all the components of human liberation—social, institutional, creative—would automatically flow. The avant-garde artists and intellectuals tended to believe that similar aims—the total liberation and resensitization of all men—could be achieved only with the help of art, by a cultural revolution. An esthetic attitude to the world—a new openness to and appreciation of beauty—would alter human consciousness, making exploitation, human misery, ugliness, and facile rationalizations for the status quo henceforth intolerable. Thus, to reintroduce the esthetic into daily life was a profoundly revolutionary act: by altering their experience of and expectations from the world, it would prepare the masses for social, political, and economic revolution—a utopian concept, never clearly formulated, but one which still holds a powerful attraction for artist-innovators today.[3] (And is it any less convincing than the classical Marxist assurance that the transfer of control over production will automatically liberate men from their entrenched bureaucratic, social, educational, and cultural systems?)

Once revolutionary socialism came to power in Russia, and briefly in Germany, the differences between the political and artistic avant-gardes became apparent, and the incompatibility of the two forms of activism blatant. For those who remained politically committed, everything, including their personal well-being and their art, had to be sacrificed to the achievement of social justice. But however strong their commitment to the cause of social justice, most avant-gardists refused to make that sacrifice. Tied, in the end, more to their status as an avant-garde than to any desire to end bourgeois supremacy, they refused to put themselves in the hands of the workingman, to trust in that good sense and innate artistic feeling with which they had long credited him—and which they now discovered he lacked. In the last resort, human individuality and creative freedom were indispensable to them, whatever the social cost. They continued to consider equality a desirable condition for everyone else.

Again and again, during this century, avant-gardists have tried to subvert the artistic establishment by presenting works so devoid of polish and elegance, so detached from all traditional esthetic notions, so prosaic and "democratic" in content, as to bring down accusations of anarchism and lunacy on their heads. Yet these works have only temporarily succeeded in alienating the art-viewing and art-buying public, and they have neither dented the capitalist system of production and consumption nor deepened the artistic sensibilities of the masses. Try as they may to antagonize collectors, dealers, and critics by using ever more humble materials and ever more crude techniques, avant-garde artists continue to work for a small public that has proved always willing to try to understand them, though unwilling to share their social aspirations. And the larger public that might share the artists' democratic and humanitarian aspirations is now no less than ever put off by their individualism and the estheticism that still shines through the crudeness.

The major problem faced by the modern artist is not his social alienation but rather the threat that that alienation might end, removing the need for the continued existence of a vanguard and ending the tension between "Bohemian and bourgeois" that has made Western art so volatile and exciting. Despair as it may, and go looking into past societies for a better relationship to the public and of its product to daily social life, the avant-garde survives only by its freedom to be unconventional, antisocial, and capricious.

If a liberal political climate, up to now provided only by enlightened

despotism in its last years and by middle-class liberalism, but certainly theoretically possible under socialism, were no longer to exist, the avant-garde would not exist either, just as it did not before 1750. Understandably, it is difficult to imagine a world without an avant-garde, that is, a world which does not set the artist apart from ordinary men, recognize his gifts as unusual and his mission as one of leadership, and leave him alone to do his valuable work. Not that art would cease to be produced or treasured without an avant-garde—but it would necessarily be a different sort of art, produced by different men for a different public.

It was no avant-garde that built the Gothic cathedrals, but rather men who were in the mainstream of society and subscribed so fully to its values that they were able to synthesize and epitomize them in stone. This consensus has been lacking in modern society, and modern art epitomizes that *lack* of consensus. That we regret the passing of a sense of wholeness is evident in our abundant art and literature of despair and in the avant-garde's everlasting nostalgia for past societies. The Soviet commissars have tried to create a new consensus by propaganda and censorship, whereas new beliefs, and a fitting new art, must arise from the society itself to be vital and credible. If the doctrine of socialist realism has even succeeded in integrating the artist into society, it has killed his creativity by imposing on him a nineteenth-century form of expression, a product of the capitalist era just like abstraction. Folk art may, as the early twentieth-century avant-garde thought, be the starting point for some art of the future; but folk art must come spontaneously and directly from the folk, not by fiat from above. Naïveté cannot be produced to order.

The avant-garde came into existence at least partly as a result of political revolution and social ferment; it went on to alter European culture profoundly. If the time ever comes when men are once again so unified in adhering to a world view and set of moral values as no longer to need a cultural elite, then the avant-garde will give way to some unalienated body of artists. Until that time the avant-garde will be with us, above or below ground, and we cannot expect its politics to be far different from what they have been—humane and antirepressive, but also averse to deserting artistic for social action. In our society, the avant-garde will, as before, be most truly political not when its members man the barricades, literally or in their art, but rather when they get on with their historic task of trying the untried, questioning the unquestioned, and refusing the accepted order of things.

Appendixes
Notes
Bibliography

A P P E N D I X A

Avant-Garde Participation in the Paris Salons and International Exhibitions, 1903-1920

NAME	1903	'04	'05	'06	'07	'08	'09	–	'10	–		'11	–	'12				'13		'19	'20
	IA	IA	A	A	IA	IA	IA	NKVM 1	IA	Sbd 1	NKVM 2	IA	BR 1	IA	BR 2	Sbd 2	IA	EDH	NYAS	A	A
Arp														X				X			
Balla														X				X			
Beckmann																	X				
Boccioni														X							
Braque					XX	X	X							X	X			X		X	
Campendonk											X							X		X	
Carrà														X				X			
Chagall													XX				X				
De Chirico															XX		X	X			
Delaunay	XX			X	XX		X					X		X	X			X	X		
Delaunay-Terk														X	XX			X			
Derain		X	X		XX				X		X	X				X			X		
Van Dongen	XX	X	X	XX	XX			XX	X	X	XX	XX	X	XX		X		X		X	X
Duchamp					X	XX	X		XX			XX		XX					X	X	X
Dufy	X		X	XX	X				X			X			X			X	X		
Dunoyer de Segonzac					X	X			XX			XX		XX				X	X	X	X
Ehmsen																	X				
Ernst																	X				

KEY: I = Salon des Indépendants; A = Salon d'Automne; NKVM = Neue Künstlervereinigung München (winter 1909–1910, winter 1910–1911); Sbd = Sonderbund (1910 in Düsseldorf, 1912 in Cologne); BR = Blaue Reiter (winter 1911–1912, summer 1912); EDH = Erster Deutscher Herbstsalon; NYAS = New York Armory Show.

SOURCES: Available exhibition catalogues (see Bibliography, section IV). Catalogues for the 1905 and 1906 Salon des Indépendants were unobtainable.

NAME	1903	'04	'05	'06	'07	'08	'09	—	'10		—	'11	—		'12			'13		'19	'20
	IA	IA	A	A	IA	IA	IA	NKVM[1]	IA	Sbd	NKVM[2]	IA	BR[1]	IA	BR[2]	Sbd	IA	EDH	NYAS	A	A
Feininger																		X			
Freundlich													X							X	X
Friesz	X	XX	X		X	XX	X		XX			X		X			X	X		X	X
Gleizes	X		X						XX			XX		XX			XX	X	X	X	X
Goncharova														X				X			
Gris														X			X				
Heckel										X						X		X			
Hofer								X		X						X		X			
Jawlensky			X					X		X	X										
Kandinsky			X	X	XX	XX	XX	X		X	X		X	X	X	X	X	X	X		
Kirchner																X			X		
Klee																		X			
Klein															X						
Kokoschka																X		X			
Kollwitz															X						
Kubin								X					X					X			
Kupka				X	X							XX		X			XX	X		X	X
La Fresnaye									XX			XX		X			XX	X	X		
Larionov														X				X			
Le Fauconnier	X								XX			XX		X			X	X	X		
Léger									XX			XX		X				X	X		
Macke													X		X	X		X			
Malevich															X	X					
Marc													X		X	X		X			
Marcoussis			X											X			X	X			

230

NAME	1903 IA	'04 IA	'05 A	'06 A	'07 IA	'08 IA	'09 IA	– NKVM-1	'10 IA	'10 Sbd	– NKVM-2	'11 IA	'11 BR-1	– IA	– BR-2	'12 BR	'12 Sbd	IA	EDH	'13 NYAS	'19 A	'20 A
Marquet	X				X	X	X		X											X		
Matisse	XX	XX	X	X	XX	XX	X		XX	X		XX	X			X	X			X	X	X
Metzinger	X	XX		X	XX	XX	XX		XX			X				XX	XX	XX	X	X	X	X
Modigliani					X	X			X			X						X			X	
Mondrian												X				X	X	X	X			
Mueller												X				X	X					
Münter					XX	XX	X	X	X		X	X	X			X	X		X			
Nolde						X	X						X			X	X					
Pascin							X		XX			X			X	X	X			X		
Pechstein												XX				X	X			X	X	X
Picabia	XX	X	X	X					X			XX	XX			XX	X	XX	X	X	X	X
Picasso		X						X			X	XX	X			X	X			X	X	X
Rouault	X	X	X	XX	XX	XX	X	X	X		XX	XX	X	X		X		X		X		
Rousseau	X	X	X	XX	XX	XX	X	X	X		X	X		X	X	X		X	X	X	X	X
Russolo																X	X		X			
Schiele																	X					
Schmidt-Rottluff									X													
Schwitters																						
Severini						X	X		X										X			
Soutine																						
Tappert												X										
Utrillo							X											X			X	X
Villon	X	X	X	XX	X	X	X		XX			X	X		X	X	X	X		X	X	X
Vlaminck		X	X	XX	XX	XX	XX	X	XX		X	XX	X		X	XX	X	X		X	X	X
Werefkina								X			X	X							X			

Biographical Sketches of the Principal Avant-Garde Painters

List of Abbreviations

AfK Arbeitsrat für Kunst, 1918-?
BR Blaue Reiter, 1911-1914
EDH Erster Deutscher Herbstsalon, 1913
NG Novembergruppe, 1918-1932
NKVM Neue Künstlervereinigung München, 1909-1911
NYAS New York Armory Show, 1913
SA Salon d'Automne, 1903-
Sbd(D) Düsseldorf Sonderbund Exhibition, 1910
Sbd(C) Cologne Sonderbund Exhibition, 1912
SI Salon des Indépendants, 1886-

ARP, HANS (JEAN). Alsatian, born 1886 in Strasbourg; died 1966 in Basel. Arp's father was North German, his mother Alsatian, and he was bilingual. He was early interested in poetry the German Romantics and Rimbuad. While visitng relatives in Paris in 1904 he was attracted to modern art; he enrolled in the Strasbourg School of Decorative Arts the same year and published his first poems in *Das neue Magazin*, edited by René Schickele. From 1905 to 1907 he studied under Ludwig von Hofmann at the Weimar School of Applied Art, directed by Henry van de Velde. He was influenced by Aristide Maillol. In 1908, he studied at the Académie Julian in Paris. In 1911, living with his family in Switzerland, he cofounded an artists' organization, Der Moderne Bund, which sponsored an exhibition in Lucerne in which Matisse, Picasso, Friesz, and Ferdinand Hodler participated; the same year he traveled to Munich, where he met Kandinsky. He participated in the second BR exhibition in Munich, in a second Moderne Bund exhibition and in the EDH. He met Robert Delaunay. In 1914-15 he met Picasso, Modigliani, and others in Paris. In 1915 he was in Zurich, making collages and tapestries. He met Sophie Taeuber and they collaborated on embroidery, tapestries and collages. Between 1916 and 1919 he participated in the Zurich Dada movement. In 1917 he made his first abstract wood relief, initiating his characteristic style. In 1919–20, he joined Max Ernst in the Cologne Dada movement and visited Berlin, participating in the Erste Internationale Dada-Messe. In 1922, he and Taeuber were married. He participated in further Dadaist activities and exhibitions, remaining especially close to Ernst, Kurt Schwitters, and the Dutch architect Theo van Doesburg. In 1925, he moved to Paris and participated in the first Surrealist Exhibition. He settled in Meudon, outside Paris. With Taeuber and van Doesburg he decorated L'Aubette, a Strasbourg nightclub, in 1926–28. His most characteristic works were reliefs and sculptures in metal,

wood, or stone, composed of irregular, undulating, abstract forms without decoration. He belonged to the "Abstraction-Création" group in Paris in 1931–32. During World War II he spent some time in Grasse with Sonia Delaunay and then took refuge in Switzerland. Sophie Taeuber was killed accidentally in 1943. In 1946 he returned to Meudon. He traveled widely and received major commissions in France and abroad, including one for a monumental relief for the UNESCO building in Paris. In 1959 he married Marguerite Hagenbach, a Swiss collector. In 1960 he was made Chevalier of the Legion of Honor. He grew ever more famous, exhibiting widely and receiving many prizes.

BALLA, GIACOMO. Italian, born in Turin, 1871; died in Rome, 1958. The son of a chemist, Balla studied violin as a child and, ca. 1878–95, studied painting nights while working in a lithographic laboratory. In 1900 he discovered Divisionism during a trip to Paris. After 1895 he supported himself in Rome by teaching and drawing caricatures. He was influenced by Naturalism and Postimpressionism up to 1910, when he joined the Futurist movement, signing the first manifesto of the Futurist painters and many subsequent ones. Then his works progressively became more abstract, first in the "*compenetrazioni iridescenti*" ("iridescent interpenetrations") of 1912, sketches for decorations in the Löwenstein house in Düsseldorf. Married in 1904, he had two daughters. He participated in building the "Pavilion of the Roman Countryside" for a 1911 exhibition celebrating the 50th anniversary of Italian unification. He participated in Futurist exhibitions in London and Paris (1912) and in Berlin (1913), and in the EDH. His Futurist works demonstrate an interest in the movement of machines and animals; he also began before World War I to design utilitarian objects (clothes, furniture, toys, etc.) in a Futurist style. He joined the Futurist interventionist demonstrations in 1914–15, though he was over age for military service. He designed an "antineutral suit" that was worn at demonstrations. In 1917 he designed sets for Stravinsky's *Feux d'Artifice*. After 1918 he exhibited frequently. He continued Futurism, though most of his works until 1935 were nonrepresentational. Thereafter he returned to traditional realism. He sympathized with Fascism, collaborating artistically on Party journals, but he did not participate in politics.

BECKMANN, MAX. German, born in Leipzig in 1884; died 1950 in New York. The youngest of three children of a prosperous Leipzig flour merchant, Beckmann was raised largely in Braunschweig, among millers and farmers. There he was early attracted to the works of Rembrandt. He disliked school and left the Braunschweig Gymnasium in 1900, and studied art at the Weimar Academy until 1903. The art critic Julius Meier-Graefe, impressed with his work, raised 3,000 marks to send him to Paris for a few months, where he was influenced by Postimpressionism and by late medieval French primitives. He then settled in Berlin and painted in an Impressionist style. In 1905 he won the Villa Romana Prize, which entitled him to a six-month stay in Rome. In 1906 he married Minna Tube, an art student and later opera singer; a son was born in 1908. Influenced by Munch and Delacroix, Beckmann painted some simple portraits and large-scale mythological scenes. In

1910 he served on the executive board of the Berlin Sezession. In 1913 Paul Cassirer showed a large retrospective of his work. A volunteer medical corpsman in 1914, Beckmann at first exulted over the new experiences of the war and then grew progressively disturbed. He had a nervous breakdown and was discharged; he moved to Frankfurt and developed a new, Expressionistic style by dealing with his observations of the war. Ever afterward he was largely concerned with scenes of violence and atrocities. His later style was much influenced by early German painters such as Grünewald. In 1925 he participated in the *Neue Sachlichkeit* (New Objectivity) exhibition in Mannheim, whose artists, earlier Expressionists, all emphasized a heightened depiction of reality; he was appointed to a professorship at the Städelsche Kunstinstitut in Frankfurt; he divorced Minna Tube and married Mathilde von Kaulbach, a young violinist and daughter of the noted Munich painter Friedrich August von Kaulbach. When the Nazis came to power he was declared "degenerate" and dismissed from his post. He moved to Berlin to live in seclusion. Five hundred nine of his works were removed from German museums, and 10 were in the "Degenerate Art" exhibition in Munich in 1937. The Beckmanns left Germany immediately after the opening of his exhibition and lived in Amsterdam during World War II. In 1947 they moved to the U.S., where Beckmann taught in St. Louis and New York and exhibited frequently.

BOCCIONI, UMBERTO. Italian, born in Reggio Calabria in 1882; died on active duty in 1916. The son of a minor civil servant, Boccioni spent his childhood in Genoa, Padua, and Catania. He received a diploma from the Catania Technical School in 1897. Desiring to become an artist against his father's wishes, Boccioni studied with a poster painter in Rome ca. 1901, and later with Giacomo Balla (1902–3) and at the Free School of the Nude at the Rome Academy. He worked as a commercial artist for the Italian Touring Club and for various periodicals. After 1907 he lived chiefly in Milan. Previously influenced by Impressionism, Divisionism, and Postimpressionism in turn, he joined the Futurist movement in 1910, signing the "Manifesto of the Futurist Painters." His capital works, "The City Rises" and "States of Mind," soon followed, between 1910 and 1911, and in 1912 he began making Futurist sculptures. In 1914 he published a theoretical treatise, *Pittura Scultura Futuriste*. He traveled to Paris and Russia in 1906, and again to Paris in 1911 and 1912. He participated in Futurist exhibitions in London and Paris (1912) and Berlin (1913), in the EDH, and sent works to the Panama Pacific International Exhibition in San Francisco in 1915. He participated in interventionist demonstrations (1914–15), being arrested in Milan in September, 1914. He volunteered in May, 1915, and served in the Lombard Cyclist Volunteers, then in the Alpini. Furloughed late in 1915, he returned to the front in July, 1916, and was killed soon after by a fall from his horse. A retrospective exhibition was held at the Milan Galleria Centrale d'Arte in 1916.

BRAQUE, GEORGES. French, born 1882 in Argenteuil-sur-Seine; died 1963 in Varengeville, Normandy. The son of a house painter, Braque grew up in Argenteuil and Le Havre, where he attended the lycée until 1897. In 1899 he was apprenticed to a house painter, finishing his training in Paris. In 1901–2 he did military service

near Le Havre. He began painting lessons at the Le Havre École des Beaux-Arts in 1897, and simultaneously studied music with a brother of Raoul Dufy. Between 1900 and 1903 he attended various art schools in Paris, spending two months at the École des Beaux-Arts under Léon Bonnat, then studying further on his own in museums and galleries. He became a Fauve in 1906, exhibiting brightly colored landscapes and seascapes at the 1906 SI. In 1907 Guillaume Apollinaire introduced him to Picasso and soon after they began collaborating, developing analytic Cubism by 1909. Braque used imitation wood and marble in the first *papier collé* (collage) in 1912, and, around then, began "synthetic" Cubism, more colorful and less cerebral than the previous phase. He married Marcelle Lapré in 1912. Mobilized in August, 1914, he sustained a head wound in 1915 and was discharged in 1917. In 1922 he moved from Montmartre, where he had lived since 1903, to Montparnasse, then (in 1925) to a house designed for him by Auguste Perret near the Parc Montsouris. He never entirely abandoned Cubism, using its techniques in series of still-lifes after 1918, in several "billiard tables" in 1944. After 1956, highly abstracted birds became his predominant theme. He began sculpting in 1920 and more extensively after 1939. In 1952–53 he decorated the ceiling of the Salle Henri II in the Louvre, and in 1953–54 he designed stained-glass windows for the church in Varengeville, where he lived after the Second World War.

CAMPENDONK, HEINRICH. German, born 1889 in Krefeld; died 1957 in Amsterdam. The son of a dry goods merchant, Campendonk spent his early years in Krefeld, attending the School of Decorative Arts between 1905 and 1909, working in the studio of Jan Thorn-Prikker. Under the influence of Postimpressionism, folk art, and the BR, which he joined when he moved in 1911 to Sindelsdorf (Upper Bavaria), he painted naïve, colorful works, mostly landscapes with animals and peasants. Though he participated in the first BR exhibition, the EDH, and other exhibitions at the Sturm Gallery, he became better known as a decorative artist. He executed numerous frescoes and designed stained glass windows in the 1920s and 1930s. He served in World War I until discharged in 1916. During the 1920s he taught at the Essen School of Decorative Art and then the Düsseldorf Academy. He became friendly with Katherine Dreier and served as a director of the Société Anonyme in New York after 1923 and as Vice President in 1944. In 1933 he was removed from his post by the Nazi government. He emigrated, to Belgium and later to Amsterdam, where he taught at the National Academy of Fine Arts. At the Paris World's Fair of 1937 he received the Grand Prize for a stained glass window.

CARRÀ, CARLO. Italian, born in Quargnento, near Alessandria, in 1881; died 1966 in Milan. The fifth child of a poor artisan with a love for Machiavelli and other philosophers, Carrà began to draw during a severe illness in 1888. Since his family could not provide for his education, he was apprenticed to a decorator at the age of 12. In 1895 he moved to Milan, where he worked at menial tasks, lived among the poor, and discovered the museums. In 1899–1900 he worked on the Universal Exposition buildings in Paris, and then spent some months in London, where he frequented anarchist circles. Back in Milan, he continued to work as a decorator

after 1901, to read philosophy and political theory, and to attend art schools. In 1905 an uncle provided a small income, and Carrà attended the Milan Academy of Fine Arts. From 1906 to 1908 he studied at the Brera Museum and painted briefly in a Divisionist manner. In 1910 he became a Futurist. In 1911 he traveled with Russolo and Boccioni to Paris and was influenced by Cubism. In 1912 he again visited Paris and participated in the Futurist exhibition at the Galerie Bernheim-Jeune. In 1914 he began making collages under Cubist influence. In 1917 he was drafted; after a short time in the infantry he was given a desk job due to poor health and then treated in a Ferrara military hospital, where he met Giorgio de Chirico and the two developed "Metaphysical Painting." He became interested also in the Tuscan artists of the quattrocento. Demobilized in 1919, he returned to Milan and married; a son was born in 1922. He collaborated in the "Vallori Plastici" movement and turned back toward realism. To support his family he became an art critic for the Milan daily, *L'Ambrosiano*. His remaining works were largely landscapes. In 1934 he designed sets for a production of *La Bohème* in The Hague. He traveled widely during the 1930s. In 1938 he completed two frescoes in the Milan Palace of Justice; these were covered over by order of the Fascist government in 1942. After the bombing of Milan in 1943, Carrà took refuge near Lake Como for the remainder of the war. After the war, he illustrated editions of the *Odyssey*, Mallarmé's "Un Coup de dés" and "L'Après-midi d'un faune," and Rimbaud's "Une Saison en enfer." He continued writing and painting until a month before his death.

CHAGALL, MARC. Russian, born in Vitebsk in 1889; lives in Saint Paul-de-Vence. One of nine children of a poor Jewish family, Chagall studied in a Vitebsk art school (ca. 1906) and then in St. Petersburg (1907–10). Through his teacher, Léon Bakst, he became acquainted with Impressionism and Postimpressionism. In 1910 he moved to Paris, where he soon became acquainted with Blaise Cendrars, Max Jacob, Apollinaire, Léger, and Modigliani. He exhibited his brightly colored, proto-Surrealist canvases at the SA and SI and in the EDH. Herwarth Walden bought (but presumably never paid for) several paintings for his private collection and repeatedly exhibited Chagall's work, even during World War I. Chagall was in Russia when the war broke out and was forced to remain there. He married Bella Rosenfeld in 1915; a daughter was born in 1916. He participated in the "Jack of Diamonds" exhibition of the Russian Futurists in 1916. In 1918 he was appointed Commissar of Fine Arts for Vitebsk; he founded and directed an art academy there, inviting El Lissitzky, Ivan Puni, and Casimir Malevich as instructors. In 1919 he participated in the "First Official Exhibition of Revolutionary Art" in the Winter Palace in Petrograd; the Soviet government bought twelve of his works. The Suprematists, led by Malevich, ousted him from the Vitebsk Academy as insufficiently radical. From 1919 to 1921 he worked for the Jewish Kamerny Theater in Moscow and taught at a colony for war orphans. He began to write his autobiography. In 1923 he returned to Paris. He illustrated Gogol's *Dead Souls*; many other book illustrations followed, including some for the Bible. In 1933 his works were burned in Mannheim by the Nazis. He received the Carnegie Prize in 1939. In 1940 he took refuge in southern France; from 1941 to 1947 he lived in New York. In 1947 he returned to France. He

exhibited widely and received many commissions. Bella Chagall had died in 1944, and he remarried in 1953. He made ceramics and sculptures for the first time, and, in 1960–61, designed 12 stained glass windows for the synagogue of the Hadassah clinic in Jerusalem. In 1963 he decorated the ceiling of the Paris Opera. In 1973 he visited the Soviet Union for the first time in fifty years, to inaugurate an exhibition of his work.

DE CHIRICO, GIORGIO. Italian, born 1888 in Volo, Greece; lives in Rome. The son of a Sicilian railway engineer and a Genovese noblewoman, de Chirico was raised in Greece until 1905, and then lived in Munich (until 1909), Milan (1909), and Florence (1910). The middle child of three, he was sickly and early discovered an artistic vocation, taking drawing lessons from a Greek painter before 1900. He studied drawing and painting at the Athens Polytechnic Institute (1900–2) and at the Munich Academy (1906–8). In Munich he came under the influences of Schopenhauer, Nietzsche, Max Klinger, and, most strongly, the Swiss symbolist Arnold Böcklin. Beginning in 1910, he synthesized unconscious autobiographical matter and philosophical ideas in paintings of deserted city streets and squares which won him the admiration of Guillaume Apollinaire and, eventually, the reputation of a founder of Surrealism. In 1912 he settled in Paris, remaining until he was called up in 1915. He was assigned to an infantry regiment in Ferrara. Early in 1917 he met Carlo Carrà in a military hospital and the two, both war-weary, collaborated in the development of "Metaphysical Painting." Around 1925 he abandoned this style and returned to a classical style. In 1929 he published *Hebdomeros*, an autobiographical novel and, in 1947, a volume of memoirs. He moved back and forth between Paris, Rome, and Florence during the interwar period. Since 1929 he has designed sets and costumes for several operas and ballets and has done extensive book illustrations.

DELAUNAY, ROBERT. French, born 1885 in Paris; died 1941 in Montpellier. An only child whose parents were divorced, Delaunay was raised by his art-loving mother in Paris and by an aunt and uncle near Bourges. A poor student who hated school, he quit the Lycée Michelet in Vanves at 17 and, from 1902 to 1904, served an apprenticeship in a studio that produced theatrical backdrops. He did military service in 1907. By then he was under the influence of the Nabis, of Postimpressionism, and more particularly of Cézanne, and was painting divisionist works. In 1910 he married Sonia Terk, a Russian painter. A son was born in 1911. Together the Delaunays developed a colorful Cubist style dubbed "Orphism" by Apollinaire. Delaunay decomposed the Cathedral of Laon, Saint Séverin, and the Eiffel Tower into intersecting planes with a combination of flat color and divisionism. He did several versions of the Cardiff soccer team and, chiefly after World War I, many nonrepresentational works with brightly colored disks. Before 1914 he exhibited at the SI and SA, at both BR shows, and at the EDH. Having earlier fulfilled his military obligations, he spent the war years in Spain and Portugal, returning to Paris in 1920. He participated in the Exposition Internationale des Arts Décoratifs in 1925 and, with Sonia, decorated the Railway Pavilion and the Palace of the Air for

the 1937 Paris World's Fair. After 1930 his works were almost entirely abstract. He left Paris in 1940 for the Auvergne and then further south.

DELAUNAY-TERK, SONIA. Russian, born 1885 in the Ukraine; lives in Paris. Raised after 1890 by an aunt and uncle in St. Petersburg who left her a large income, she was educated in St. Petersburg. She then studied drawing in Karlsruhe (1903–4) and in Paris (1905) at the Académie de la Palette. She was influenced by Van Gogh, Gauguin, and Fauvism. In 1909 she married Wilhelm Uhde, the German art critic and collector; she divorced him in 1910 and married Robert Delaunay, with whom she had a son in 1911. Until 1934 they kept a studio on the rue des Grands Augustins. She exhibited simultaneist works, quite similar to Robert's but tending more toward the abstract and decorative, at the EDH and the 1914 SI. She illustrated Blaise Cendrars' "Prose du Transsibérien et de la petite Jeanne de France," creating a publication that was revolutionary both in its format and in the close interlocking of the poem and her colored designs. The Delaunays spent the World War I years in Spain and Portugal, returning to Paris in 1920. Having lost her Russian income in 1917, she made a living through decorative art. She had experimented with simultaneist designs for fabrics, clothing, and bookbindings from 1912; now she became one of the major fabric designers of Art Déco. She created brightly colored, geometric costumes for Diaghilev's *Cleopatra* in 1918 and for Tristan Tzara's *Le Coeur à gaz* in 1923. She collaborated with the couturier Jacques Heim on a boutique for the 1925 Exposition Internationale des Arts Décoratifs. With her husband she designed the Railway Pavilion and the Palace of the Air for the 1937 Paris World's Fair. During World War II she accompanied Robert to southern France; after his death she joined the Arps in Grasse until 1944. She now lives in Paris, still producing simultaneous canvases and decorative objects, exhibiting frequently.

DERAIN, ANDRÉ. French, born 1880 in Chatou; died 1954 in Versailles. The son of a confectioner, Derain attended school in Le Vésinet and the Lycée Chaptal in Paris. He became interested in art about 1895 and took drawing lessons, but, due to parental disapproval, he enrolled in the Paris School of Mines in 1896, intending to prepare for the entrance examination to the École Polytechnique, which he never attended. He developed artistically on the side, becoming friendly with Vlaminck (ca. 1900) and Matisse. He and Vlaminck shared a studio on the Seine and produced similar landscapes and portraits. He did military service from 1901 to 1904; when he returned to Paris he devoted himself entirely to art, and he studied at the Académie Julian, and by copying old masters in the Louvre. He supported himself by caricaturing; he exhibited highly colored canvases as one of the "Fauves" in the 1905 and 1906 SI and SA. Interested in African art, he turned to more somber coloration and a more intellectual approach to form. He met Picasso in 1906; after marrying in 1907 he moved to Montmartre, becoming an intimate of the Cubist group. Though he never became a full-fledged Cubist, he participated in the early development of the movement with still-lifes and landscapes inspired partly by primitive art. In 1910 he moved to the Latin Quarter; he continued to exhibit at the Salons and had a series of exhibitions in various German cities in 1914. He served throughout World War I, in Champagne, the Somme, and Verdun. In 1919 he

turned to the classical style which he retained for the rest of his life. He did sets and costumes for a Ballets Russes production of *La Boutique fantasque* in 1919 and for Erik Satie's *Jack-in-the-Box* in 1926. In 1941, along with Vlaminck, Friesz, Van Dongen, *et al.*, he visited Berlin on the invitation of Arno Breker. This brought about ostracism from the official Salons at war's end.

DIX, OTTO. German, born 1891 in Untermhaus (Thuringia); lives in Hemmenhofen on Lake Constance. Dix was one of five children of a metal worker. His mother was an amateur poet. At the Untermhaus Volksschule he showed talent for drawing and was allowed to take lessons. He was apprenticed to a decorator and, from 1909 to 1914, attended the Dresden School of Decorative Art on a stipend from the Prince of Gera, to whom Dix had been recommended by his drawing teacher. Influenced by 15th-century German painters (Dürer and Cranach) and by Impressionism, he turned to Expressionism ca. 1912 under the influence of Van Gogh and German Expressionists. Inducted in 1914, he served throughout the war, on both fronts, and was wounded several times. He made hundreds of war drawings, which he later transformed into the gruesome paintings and graphics that are among his most characteristic works. Back in Dresden in 1919, he studied at the Art Academy, participated in the Dada movement there, joined the NG in Berlin, and became a founding member of the revolutionary Gruppe 1919 of the Dresden Sezession.
In 1920 he participated in the Erste Internationale Dada-Messe at the Burchart Gallery in Berlin. In 1920 he began painting in a verist style that came to be known as *"die neue Sachlichkeit"* (New Objectivity), finding his characteristic themes in morbidly satirical interpretations of German society, women, sex, and war. His portfolios of war engravings were published in 1923–24. In 1923 he married and moved to Düsseldorf, where he studied at the Academy until 1925. He had three children between 1924 and 1929. In 1927 he received a professorship at the Dresden Academy; in 1931 he became a member of the Prussian Akademie der Künste; he was removed from both posts by the Nazis in 1933. An activist with Communist leanings since 1918, he now painted allegorical anti-Nazi works. He was forbidden to exhibit and his Dresden studio was searched periodically. In 1937, 360 of his works were confiscated by the Nazis; many were destroyed and 8 were exhibited in the "Degenerate Art" exhibition in Munich. Imprisoned by the Gestapo in 1939 he was later allowed to serve in the militia. Taken prisoner by the French, he was recognized and put to work painting portraits of De Gaulle for propaganda posters. Since 1946 he has lived in Hemmenhofen and since 1955 has belonged to the West Berlin Academie der Künste, and since 1956 to the East Berlin Academy as well.

VAN DONGEN, KEES. Dutch, became a French national in 1929. Born in Delfshaven in 1877; died 1968 in Monte Carlo. The son of a brewery director and a pious Catholic woman, Van Dongen left school early against his parents' wishes, and briefly went to sea, and then was apprenticed in his father's business. In his early teens he became an atheist and took up painting, largely influenced by Rembrandt. He attended the Rotterdam Academy from 1892 to 1897, supporting himself by working in the brewery and caricaturing for several reviews. In 1899 he moved to Paris, settling in Montmartre. In 1901 he contracted the first of three marriages. A Fauve

with a predilection for portraits of entertainers, streetwalkers, and other social outcasts, he exhibited in the 1905 *"cage aux fauves"* at the SA and frequently, until World War I, in the SA, SI, and abroad. In 1913 he left Montmartre for Montparnasse. Remaining in Paris during World War I, he became widely known and began receiving commissions for portraits of social and political leaders. He was known as a society artist from the early 1920s. In 1941 he visited Berlin for eight days at the invitation of Arno Breker.

Duchamp, Marcel. French; naturalized American in 1954. Born 1887 in Blainville, Normandy; died in 1968 in Neuilly. The third of six children of a Rouen notary and the grandson (on his mother's side) of a noted engraver, Duchamp early showed an interest in music, art, and chess. Two of his brothers and one sister also became artists. After studying at the Rouen Lycée, and already painting landscapes, Duchamp studied at the Académie Julian in Paris (1904–5). Until 1910 he drew caricatures to earn a living. Having studied typography for that purpose, in 1905 he did the one-year military service required of printers. From 1906 to 1908 he lived in Montmartre; after 1909 he lived in Neuilly-sur-Seine, avoiding extensive contact with the art world by working for a meager living at the Bibliothèque Sainte Geneviève. His cubistic "Nude Descending a Staircase" (1912) caused a sensation in Paris and in New York, where it was exhibited in the NYAS. Soon after, Duchamp moved gradually away from painting. In 1914 came the first of many "ready-mades," manufactured articles that he chose, named, and signed, thereby satirically conferring the mantle of art on them. That same year he was declared unfit for military service due to a heart ailment; he left for New York in 1915, and in 1917, when the U.S. entered the war, went to Buenos Aires for the duration. From 1915 to 1923 he worked on the "large glass" ("The Bride Stripped Bare by Her Bachelors, Even"); though never completed, it is his capital work, satirizing male and female sexuality by a series of machine images. Universally recognized as a Dadaist *avant la lettre*, he participated in Dadaist activities in New York and Paris and later sympathized with, but did not join, the Surrealist movement, retaining the playful, nihilistic spirit of Dada throughout his life. He participated in Francis Picabia's ballet *Relâche* in 1924. He experimented with optical machines whose disks ("rotoreliefs"), painted with black and white spirals and puns, became "dematerialized" when rotated at the proper speed. Between the wars he lived alternately in New York and Paris, deserting art for chess-playing for many years. He collaborated with the American heiress Katherine Dreier in founding (in 1920) and running the Société Anonyme, an organization which sponsored exhibitions and collected modern works (now at Yale University Art Gallery). He was married briefly in 1927 to the daughter of a French automobile tycoon; he lived with an American, Mary Reynolds, between 1930 and 1950; and he remarried in 1954. Under his name or the pseudonym "Rrose Sélavy," he continued for the rest of his life to sign ready-mades or produce works with witty, punning titles, but he never again took his role as artist seriously or put brush to canvas.

Dufy, Raoul. French, born 1877 in Le Havre; died 1953 in Forcalquier (Basses-Alpes). Dufy was one of nine children of a poor family with musical interests; his

father managed a small business. At 14, Dufy left school to help support his family, working until 1898 as a clerk for a coffee importer, studying painting at night at the Le Havre Municipal Art School. He did a year of military service between 1898 and 1899. On a scholarship provided by the city of Le Havre, Dufy went to Paris in 1900, settling in Montmartre and studying at the École des Beaux-Arts. The influences of Impressionism and Toulouse-Lautrec led him to Fauvism, and he participated in the group exhibitions of the Fauves at the 1905 and 1906 SA and SI. His paintings combined a strong linear element with the impressionistic use of bright colors. Beginning in 1912 he designed fabrics for a Lyons silk firm, Bianchini-Férier, and for the couturier Paul Poiret. He also became noted for woodcuts influenced by popular art, which he often made as book illustrations. During the First World War he served in the army, producing patriotic prints and war drawings. After the war, he became noted for his fabric designs and ceramics as well as paintings. He designed tapestries for Poiret's barge-pavilions at the 1925 Exposition des Arts Décoratifs, and, with his brother Jean, a painter, he decorated the Palais de l'Electricité of the Paris World's Fair of 1937. During World War II he moved to the south of France, remaining there until his death.

DUNOYER DE SEGONZAC, ANDRÉ. French, born 1884 in Boussy Saint Antoine near Paris; lives in Paris. Raised in Paris in aristocratic surroundings, Dunoyer attended the Lycée Henri IV, the Lycée Louis-le-Grand, and the École des Langues Orientales, where he studied Sudanese dialects. In 1904 he did his year of military service. Between 1900 and 1908 he studied in various academies, failing the entrance examination to the École des Beaux-Arts. He lived in the Latin Quarter and exhibited Impressionist-inspired landscapes at the SA and SI. In 1910 he published an album of line drawings of Isadora Duncan, the modern dancer then the rage in Paris. In 1911 he designed sets for *Nebuchadnezzar*, performed at the Théâtre des Arts (Paul Poiret did the costumes). In 1914 he served on the Lorraine front in the infantry; in 1915 he was transferred to the first camouflage section set up by Guirand de Scevola; he then served in the Battle of the Somme. In 1917 he was given command of a camouflage section. He sent war drawings to various reviews. During the 1920s he illustrated several books about the war, in particular works by Roland Dorgelès. Never a thoroughgoing avant-gardist, he frequented fashionable Paris society and also artists and writers such as Jean Cocteau and André Derain. In 1941, with other artists, he visited Berlin at the invitation of Arno Breker.

EHMSEN, HEINRICH. German, born 1886 in Kiel; died 1964 in East Berlin. The son of a basketmaker, Ehmsen attended public school in Kiel and was apprenticed to a decorator from 1901 to 1906. He attended the Dresden School of Decorative Art until 1909, studying with Peter Behrens and Jan Thorn-Prikker. In 1909 and 1910 he studied in Paris, becoming acquainted with the Italian Futurists, Picasso, Vlaminck, Matisse, *et al.*, and settled in Munich until 1928. During World War I he served in France and Rumania. Back in Munich in 1918, he sympathized with the revolutionaries, glorifying the Leftist forces in his capital painting, "The Shooting of the Sailor Egelhofer," which he worked on from 1919 to 1933. In 1932 he spent nine months in the U.S.S.R. In 1933 he was imprisoned by the Gestapo. His works were

removed from fifteen German museums and he was unable to exhibit again until 1945. Serving in the army during World War II and given responsibility for prop-agandizing French artists, he was disciplined for "Francophile attitudes." Many of his works were destroyed in an air raid. After the war, he settled in East Berlin. He is perhaps best known for 30 engravings he made in 1927 as illustrations for Gerhart Hauptmann's *Der Narr in Christo—Emanuel Quint*.

ERNST, MAX. German; naturalized French in 1958. Born 1891 in Brühl near Cologne; died in 1976 in Paris. The son of a teacher and painter, Ernst attended the Brühl Gymnasium and studied art history and philosophy at the University of Bonn. He decided to become an artist very early, but had no formal training. He was friendly with Macke, and he met Delaunay and Apollinaire in 1913 in Paris. He exhibited in the EDH. He served in the German army during World War I. In 1919 he founded a Dadaist group in Cologne with Hans Arp and Johannes Baargeld and published a review, *Die Schammade*. Between 1922 and 1938 he lived in Paris, where he was a cofounder of Surrealism. He was married four times, most notoriously to Peggy Guggenheim between 1941 and 1943. In 1938 he left Paris and Surrealism for the south of France, where he was interned as an enemy alien between 1939 and 1940. He then went to New York until 1945, spent some years in Arizona, 1949–53 in Paris, and thereafter lived largely in the south of France. He never abandoned a surrealist style; he is most known for *"frottages"* made in the twenties and for collaged novels made of fragments from old prints.

FEININGER, LYONEL. American, born 1871 in New York; died there in 1956. The son of two eminent German musicians, Feininger had two younger sisters. He was raised partially in New York and, because the parents were often away on concert tours, partially by a farmer's family in Sharon, Connecticut. His later subject matter would be a mixture of city and country motifs. Taught the violin by his father from the age of five, Feininger played in concerts as a child and retained a love of music. His preference for art displeased his father, who nevertheless allowed him to have drawing lessons and to attend the Hamburg School of Decorative Art from 1887 to 1888 and the Berlin Academy in 1889. In 1890–91 he was sent to the Collège Saint Servais in Liège, perhaps to lure him away from art. Back in Berlin, he continued to study at the Academy until 1892 and then for a year attended the Académie Colarossi in Paris. Between 1892 and 1909 he made his living as a caricaturist for Berlin and Paris reviews and the *Chicago Sunday Tribune*. He had two daughters from a first marriage to a painter's daughter and gifted pianist (1901–5), and three sons with Julia Lilienfeld, a painter he married in 1908. They spent 1906–8 in Paris and then settled in Berlin. Feininger's paintings, caricaturelike, dealt with social subjects and the urban scene until, as the result of a 1911 visit to Paris, he discovered Cubism and developed a unique approach to architecture and landscape. For the rest of his life he devoted himself to the cubistic depiction of landscapes, seascapes, churches, and public buildings, often those of Thuringia and other areas of eastern Germany. He participated in the EDH. After World War I, which he spent in Germany, undisturbed despite his American citizenship, he joined the AfK and the NG, became friendly with Walter Gropius, and was appointed to a mastership at the

Bauhaus in 1919, taking charge of the graphic workshop. His woodcut "The Cathedral of Socialism" was the frontispiece to the first Bauhaus manifesto. In 1924 he cofounded the Blue Four, a revival of the BR, with Kandinsky, Klee, and Jawlensky. When the Bauhaus was closed down by the Nazis, he remained in Berlin. In 1937, 378 of his works were confiscated from German museums and some of them were sold in Switzerland. He then left Germany and settled in New York. He produced murals for the 1938 New York World's Fair. During his last years he remained friendly with other Bauhaus émigrés (Gropius, Albers, *et al.*), and with young American artists, including Mark Tobey.

FELIXMÜLLER, CONRAD. German, born 1897 in Dresden; lives in West Berlin. The son of an ironworker, Felixmüller received musical training; in 1911, he attended the Dresden School of Decorative Art and, from 1912 to 1915, the Dresden Academy. Starting in 1915 he contributed Expressionist graphics to *Der Sturm* and *Die Aktion*. During and immediately after World War I he traveled to the Rhineland, the Ruhr, and Westphalia. His impressions of the Ruhr coal mining district were set down in drawings and woodcuts of miners that are among his most characteristic works. He is also known for portraits of workers. A leftist of strong convictions, he joined the NG and the "Gruppe 1919" of the Dresden Sezession. In 1931 he received the Saxon State Prize for painting. In 1937, 151 of his works were confiscated from German museums by the Nazi government. In 1940 his Berlin studio was destroyed. He served in the German army from 1944 and was taken prisoner in 1945. After the war he settled in East Germany, where he held a professorship at the Martin Luther University in Halle after 1949. In 1961 he moved to East Berlin and in 1967 to West Berlin. He is married and has two sons.

FREUNDLICH, OTTO. German, born in Stolp (Pomerania) in 1878; died 1943 in Poland. The son of a well-to-do Jewish merchant, Freundlich worked briefly for a wood dealer and then, against his father's wishes, studied art history in Berlin and Munich (1903–4). During a stay in Florence (1905–6) he began to paint and sculpt, and studied painting in Berlin in 1907–8. In 1909 he moved to Paris, living at the Bateau Lavoir, where he became acquainted with the Cubists. Between 1910 and 1913 he exhibited at the Paris Salons and in the Berlin Neue Sezession, the Sbd(C) and the EDH. From 1914 to 1924 he lived in Cologne. He served as a medical orderly during World War I. After the war he collaborated on *Die Aktion* with woodcuts and articles on revolutionary themes. He made a mosaic, "The Birth of Man," in 1918–19. He belonged to the AfK and the NG. He was twice married and divorced. In 1924 he returned to Paris; his paintings and black-and-white woodcuts now became nonrepresentational. From 1930 he lived with a sculptress, Jeanne Kosnick-Kloss. In the 1930s he belonged to the "Abstraction-Création" group and collaborated on the revolutionary Cologne review *a-z*. He was declared "degenerate" by the Nazi government; one of his sculptures was reproduced on the cover of the catalogue for the "Degenerate Art" exhibition in Munich. At the outbreak of World War II he was interned by the French and released in February, 1940. He fled to the Pyrenees when the Germans invaded France. In 1943 he was imprisoned and deported to Poland.

FRIESZ, OTHON. French, born 1879 in Le Havre; died 1949 in Paris. An only child, Friesz was the son of a sea captain and of a musician who had studied with Liszt. Both families had long histories in commerce and trading. Friesz hated school and left the Le Havre lycée in 1896 after an abortive attempt to stow away on a ship. His parents discouraged his seafaring bent and, having early acquired a love of drawing, he entered the Le Havre Academy, studying there until 1899, becoming friendly with Raoul Dufy, a fellow-student. On a scholarship from the *département* he attended the Paris École des Beaux-Arts, studying with Léon Bonnat until 1904. Despite his professor's traditionalism, he was influenced by Impressionism and Postimpressionism. Exhibiting with the Fauves at the 1905 and 1906 SA and SI, he became known for brightly colored landscapes and seascapes, many painted along the Seine and the Channel coast. He lived in the Latin Quarter and later in Montparnasse, moving frequently. He married the niece of an admiral. Mobilized in August, 1914, he served at first with a territorial regiment; then, after having been wounded, he did topographical work at the front; and finally he worked on airplane camouflage. During a leave in 1915 he painted an apocalyptic work, "War." After the war, and for the rest of his life, he painted mainly landscapes in a style that had become unprogressive. He won the Carnegie Prize in 1925 and was made Chevalier of the Legion of Honor in 1926 (Officer in 1933; Commander in 1939). He remained in Paris during World War II, and along with other artists went to Berlin in 1941 at the invitation of the sculptor Arno Breker.

GLEIZES, ALBERT. French, born in Paris, 1881; died in Paris, 1953. The son of an industrial designer and a Flemish woman, Gleizes studied at the Collège Chaptal and in his father's atelier. He early displayed an interest in art. About 1900 he was influenced by realism and later by Impressionism. He exhibited at the Salon of the Société Nationale des Beaux-Arts (the more liberal of the two academic Salons) and, after 1903, at the SA and the SI. Around 1904–5 he was a cofounder of the Association Ernest Renan and a volunteer teacher at other popular universities. From 1906–7 he was a founding member of the Abbaye de Créteil. After the failure of the Abbaye he met Metzinger and Le Fauconnier and painted some classical landscapes, afterward (ca. 1910) turning to Cubism, which became his characteristic style. He participated in the Cubist group exhibition at the 1911 SI and in the Section d'Or in 1912. With Metzinger he wrote the major theoretical work on Cubism, *Du "Cubsime,"* in 1912. At the beginning of World War I he was mobilized, then released after a few months. He then married Juliette Roche, the daughter of a former government minister, and left for the U.S., spending the remainder of the war in New York, which he depicted in a monumental Cubist style. In 1918 he underwent a religious conversion and turned to the art of the Middle Ages. He retained his early utopian socialism, wrote extensively about art, society, and religion, supporting left-wing and humanitarian causes. During the 1920s he painted several religious subjects. In 1927 he founded Moly-Sabata, an agricultural and crafts colony on the Rhône that survived until World War II. Thereafter he lived mostly in Paris, continuing to write and to paint murals that featured brightly colored arcs. In 1951 he was named Chevalier of the Legion of Honor.

GONCHAROVA, NATHALIA SERGEYEVNA. Russian; acquired French nationality in 1938. Born 1881 in Netchaevo near Tula; died 1962 in Paris. The daughter of an architect and niece of Pushkin's wife, Goncharova was raised on her grandmother's estate at Ladyjino, near Tolstoy's estate of Yasnaya Poliana. In 1891 she entered a Moscow Gymnasium and between 1896 and 1898 studied botany, zoology, and history in Moscow. In 1898 she entered the Moscow School of Painting, Sculpture and Architecture. There she met Mikhail Larionov, who was to become her lifelong companion. Residing in Moscow until 1914, she participated in the exhibition of Russian art organized by Diaghilev at the 1906 SA. She was influenced by icons and Russian folk art, by Fauvism and, from 1909, by Cubism. While she painted many Cubist-inspired works, she is best known for the theatrical decors for the Ballets Russes she made beginning in 1909 and extending through the 1920s. She was a style-setter, inventing the comfortable shirtdress and wearing body make-up applied by her artist friends. In 1910 she participated in the "Jack of Diamonds" exhibition in Moscow; in 1912 in the "Donkey's Tail" exhibition in Moscow, along with Larionov, Malevich, and Tatlin; and in the second BR exhibition. In 1914 she signed Larionov's "Manifesto of Rayonnism." In 1915 she left Russia with Larionov, reaching the West via Sweden and Norway, joining Diaghilev in Switzerland. The year 1916 was spent on theatrical work in Spain and Italy; 1917 in Rome and Paris. After 1918 she lived mostly in Paris. Despite important exhibitions and considerable acclaim for her theatrical work she died penniless: a painting paid for her funeral.

GRIEBEL, OTTO. German, born 1895 in Meerane (Saxony); died 1972 in Dresden. The son of a paperhanger, Griebel studied at the Dresden Royal School of Drawing and the School of Decorative Art from 1909. He served in World War I. He returned to Dresden as a staunch leftist and joined several radical and Communist groups, including the NG, the "Gruppe 1919" of the Dresden Sezession, the Rote Gruppe, Young Rhineland, etc. From 1919 to 1921 he studied at the Dresden Academy, simultaneously participating in the Dresden Dada movement. His paintings were similar in their biting social satire to Grosz's and Dix's. A contributor to Communist newspapers and reviews such as *Die rote Fahne*, he joined the German Communist Party in 1918 and participated in revolutionary battles, notably in putting down the Kapp Putsch in Dresden. He was briefly imprisoned after the Nazi takeover in 1933; then he was forbidden to exhibit and his house and studio were frequently searched, and antifascist and antimilitarist works were confiscated. Two studios in succession were bombed during World War II and virtually all his works lost. Those which have survived, now in Dresden, East Berlin, Zwickau, and Moscow museums, are dadaistic or *neue Sachlichkeit* satires of capitalist society or realistic depictions of proletarian solidarity. He was married and the father of three sons.

GRIS, JUAN (JOSE VICTORIANO GONZALEZ). Spanish, born in Madrid in 1887; died 1927 in Boulogne-sur-Seine. Gris was the thirteenth of 14 children (many died in infancy) of a well-to-do merchant who later had financial troubles. Gris, raised in luxury, early showed an interest in art. He attended the Madrid School of Arts and Manu-

factures and submitted caricatures to various reviews. Against his parents' opposition he left school ca. 1904 to devote himself entirely to painting, briefly studying with an academic painter. In 1906 he moved to Paris, lived in the Bateau Lavoir, and supported himself by drawing for *L'Assiette au beurre*, *Le Cri de Paris*, and other reviews. He was early influenced by Art Nouveau and, ca. 1910, by naturalism. He was married briefly; a son was born in 1909. In 1911 he produced his first oil paintings, selling some to "Père" Clovis Sagot. In 1912 he began to paint in the Cubist style and to make collages. He exhibited at the SI and the Section d'Or (1912) and signed an exclusive contract with D. H. Kahnweiler. He began a liaison with "Josette" which lasted until his death. During World War I, desperately poor, he lived alternately in Paris and the south of France. In 1916 he began painting architecture as well as portraits and still-lifes; since Kahnweiler was outside France for the duration of the war, he signed an exclusive contract with Léonce Rosenberg. After the war Gris had more opportunities to exhibit. He participated in the second Section d'Or in 1920 and resumed business relations with Kahnweiler. Beginning in 1922 Gris did sets and costumes for several Diaghilev ballets. After 1922 he lived in Boulogne-sur-Seine, spending much time also in the South. Ill frequently since 1920, he began to be successful just as his health worsened.

Grosz, Georg(e). German, citizenship revoked by Germany in 1938; naturalized American. Born 1893 in Berlin; died 1959 in Berlin. The child of an innkeeper and a cook, Grosz spent part of his childhood in Stølp (Pomerania). He studied at the Dresden Academy from 1909 to 1912 and at the Berlin School of Decorative Art from 1912 to 1916. In 1910 he published his first caricatures in *Ulk*. After 1912 he lived in Berlin; he spent part of 1913 in Paris. During World War I he was inducted into the infantry, but released in 1916 after a series of illnesses. Reinducted in 1917, he was soon released again without ever having seen combat. During the war he became friendly with Wieland Herzfeld(e) and his brother Helmut (John Heartfield) and collaborated on their review, *Neue Jugend*, which became increasingly antimilitaristic and hostile to the government. From simple, untendentious line drawings of Berlin streets and society, Grosz proceeded to savage, highly complex attacks on German society in all its manifestations, from capitalism, politics, and war to private life. At war's end he supported Spartacism, joining the Communist Party in 1918. He also became a cofounder of the Berlin Dadaist movement and the moving spirit behind the Erste Internationale Dada-Messe of 1920. With the Herzfeld brothers he edited and illustrated several ephemeral reviews and worked for their Malik Verlag, which published major leftist writings throughout the 1920s. Opposed to abstraction, which he considered lacking in social conscience, he became a major member of the verist *neue Sachlichkeit* movement. He married in 1920 and had two sons. He was periodically brought to trial and fined for sacrilege and offending public morality. When the Nazis came to power, he emigrated to the U.S., living in New York, teaching at the Art Students' League. In 1937 the German government confiscated 285 of his works from public collections, destroying most of them. After World War II he twice visited Germany and moved back there just before his death.

HAUSMANN, RAOUL. Alsatian, born 1886 in Vienna; lives in Limoges, France. The son of an Alsatian academic painter and an Italian woman, Hausmann lived in Vienna, attending a parochial school there until 1900. He then moved to Berlin, where he studied painting and sculpture for several years and worked on an illustrated weekly. He was influenced by Cubism in 1912. The same year he began publishing critical articles in *Der Sturm*. Remaining in Berlin during World War I, he collaborated on *Die Aktion* and with the leftist Franz Jung on *Die freie Strasse*, which he edited in 1918–19. He was a cofounder of Berlin Dada in 1917 and became noted for his phonetic poems and "photomontages," collages made of photographs, typography, and magazine illustrations. Between 1918 and 1920 he edited *Der Dada* and participated in Dadaist demonstrations in Berlin, Dresden, Leipzig, Prague, etc. In 1920 he began painting in a constructivist style and collaborating with the Dutch De Stijl group. In 1923 he abandoned painting for optical experiments and invented the "Optophone." From the end of World War I through the early 1930s he published numerous, extreme leftist, political articles in various journals, including *Die Aktion*, *Die Erde*, *a-z*, a left-wing art review published in Cologne in the late twenties, and a new series of *Der Gegner* that he and Jung edited ca. 1930–32. He was a member of the NG from 1918 to 1924. In 1933 he left Berlin and settled in Paris, traveling repeatedly to Spain, Zurich, and Prague. He spent World War II teaching languages in Payrac (Lot).

HEARTFIELD, JOHN (HELMUT HERZFELD). German, born 1891 in Berlin-Schmargendorf; died 1968 in East Berlin. Heartfield was one of four children (among them, Wieland Herzfelde) of a Socialist worker and sometime poet (pseud. Franz Held) and of a textile worker. Orphaned ca. 1899, he was raised by foster parents. He was a recalcitrant student, but loved books and art; he studied drawing with a Dutch seascapist. About 1910 he studied at the Royal School of Decorative Arts in Munich and supported himself with commercial art. In 1913 he settled in Berlin and was introduced to the Sturm and Aktion groups by Else Lasker-Schüler. He served on the Western front from November 1914 to January 1915, when he was discharged. In opposition to the war and the Junkers, he translated his name into English and kept this pseudonym ever after. Recalled by the army in October, 1915, he feigned insanity: he was hospitalized for a while and then allowed to return to Berlin. He and Herzfelde became friendly with George Grosz and the three took over publication of a review, *Neue Jugend*, in protest against the war; they later founded the Malik Verlag to publish their own and other leftists' works. To confound the censors Heartfield devised a technique of photomontage which became his trademark. In 1917, through Harry Kessler, he was employed by the military photographic agency (forerunner of UFA) to work on special effects for war films. He continually found pretexts to avoid finishing propaganda films. Enthusiastic over the revolutionary events in Germany, he embraced Spartacism and joined the Communist Party immediately after its formation. He participated in the Erste Internationale Dada-Messe in 1920. During the interwar period he became a noted propagandist of the Left; his photomontages, made entirely of photographs, influenced the propaganda and commercial art of the Soviet Union. He designed sets for

Erwin Piscator's "political theater" and collaborated with Max Reinhardt on films. In 1933 he fled Germany for Prague and from 1938 to 1950 lived in England. He then moved to East Berlin.

HECKEL, ERICH. German; born 1883 in Döbeln an der Mulde (Saxony); died 1970 in Hemmenhofen on Lake Constance. The son of an engineer in railway construction who was often transferred, Heckel spent his childhood in various small towns in Saxony and the Erzgebirge. He entered the Realgymnasium in Freiberg and graduated in Chemnitz, in 1904, where he became friendly with Karl Schmidt-Rottluff. He studied architecture at the Dresden Technische Hochschule from 1904 to 1905 and worked for an architect as a draftsman. More interested in painting and decoration, he was a cofounder of the Brücke in 1905. Like his fellow members, he was influenced by German primitives, Postimpressionism, and African art. Together with the other Brücke members he moved to Berlin in 1911 and spent summers painting in the country, in Moritzburg near Dresden, and then in Dangast on the North Sea coast. With Kirchner and the prominent decorator Jan Thorn-Prikker, he designed a chapel for the Sbd(C); and he designed some rooms for the 1914 Werkbund exhibition, also in Cologne. At the beginning of World War I he volunteered for the Red Cross and in 1915 was sent as an orderly to Flanders, where he spent the remainder of the war, managing to draw and paint with the permission of a superior who was an art historian. For a sailors' Christmas party in 1915 he painted a mystical "Madonna of Ostend," and decorated a room in the Ostend railway station that was used as temporary quarters for sick and wounded soldiers. After the war he returned to Berlin and continued painting in his prewar Expressionist style. He traveled frequently. In 1937, 729 of his works were confiscated from German museums and he was forbidden to exhibit. When his Berlin studio and home were destroyed, he moved to Hemmenhofen. From 1949 to 1955 he was a professor at the Karlsruhe Academy.

HIRSCH, KARL JACOB. German, born 1892 in Hanover; died 1952 in Germany. The son of a Jewish doctor, Hirsch disliked school but showed a strong interest in music. When a serious illness at age twelve ruined his chances of being a first-rate performer, he turned to art. He studied in Munich with Debschitz from 1911 to 1912; then in Worpswede; and in Paris in 1914. In Berlin in 1915, he contributed drawings to *Die Aktion*. From 1916 to 1918 he served with an armored regiment and then did clerical work in a Berlin garrison. Radicalized by the war, he became a cofounder of the AfK and the NG and contributed expressionistic graphics and poetic and political writings to various leftist reviews. During the 1920s he gave up painting for writing. His books were burned by the Nazis and he emigrated in 1933, reaching the U.S. via Denmark and Switzerland. In 1945 he returned to Germany.

HÖCH, HANNAH. German, born 1889 in Gotha; lives in West Berlin. The eldest of five children of an insurance executive and an educated woman with musical and artistic interests, Höch spent her entire childhood in Gotha. To dissuade her from becoming an artist, her father made her spend the year 1911 working for his firm as a bookkeeper. She, however, persisted in her ambitions and attended the Berlin

School of Decorative Arts between 1912 and 1914 and then studied with Emil Orlik at Berlin's Museum of Decorative Arts. From the beginning of World War I through 1915 she served as a volunteer with the Gotha Red Cross. Upon returning to her studies in Berlin she met Raoul Hausmann, with whom she lived until 1922. Until 1926 she supported herself by working part-time for a Berlin publisher. She participated in the Berlin Dadaist movement, exhibiting in the Erste Internationale Dada-Messe in 1920 and in the Dadaist speaking tour to Dresden, Prague, and other cities. She became friendly with Schwitters and the Arps. She was one of the first artists to make "photomontages," collages made of fragments of magazine illustrations, typography, and other materials. She used lace and paper dress patterns in some of these, and she made a series of Dadaistic dolls. In 1922 and 1925 she decorated "grottoes" in Schwitters' *Merzbau*. Between 1926 and 1929 she lived in Holland, collaborating with the De Stijl group and moving over stylistically to Surrealism. She became friendly with a Dutch poet, Til Brugman, and the two lived together until 1935. Returning to Berlin in 1929, Höch continued to paint surrealistically. Her works were declared degenerate by the Nazis in 1933; an exhibit of her work at the Dessau Bauhaus planned for 1932 had been canceled when the newly elected Nazi government of Saxony closed that institution. In 1938 she married a man to protect him from Nazi persecution; the marriage was unsuccessful and they were divorced. She lived through World War II in obscurity; since the war she has produced both surrealistic and abstract paintings.

HOFER, KARL. German; born 1878 in Karlsruhe; died 1955 in Berlin. Hofer's father, a musician, died soon after his birth; his mother, penniless, worked as a housekeeper. He was raised by a great-aunt and, after 1888, in the Karlsruhe orphanage. Between 1892 and 1896 he was apprentice and journeyman with a bookbinder. He then attended the Karlsruhe Academy until 1901, and the Stuttgart Academy, 1901–02. He lived in Rome from 1903 to 1908 and in Paris, 1908–14. Earlier influenced by the German painter Hans von Marées, he fell under a Cézannian influence in Paris. While clearly an Expressionist, he never was as bold with form and color as most other Germans. He was interned by the French as an enemy alien in 1914 and in 1917 allowed to go to Switzerland. The war had a great effect on his style, leading him to use earthy colors and paint hard outlines. After 1918 he lived in Berlin, teaching at the Academy in Charlottenburg from 1920 to 1933. He became a member of the Prussian Academy of Art in 1923 and won the Carnegie Prize in 1934. In that year he was discharged from his teaching post, in 1938 from the Academy, and he was forbidden to paint or exhibit by the Nazi government; 313 of his works were confiscated from German museums. He remained in Berlin throughout World War II, however. In 1943 his studio was bombed; in 1944 the Nazis put him in a sanatorium, presumably to silence him. After the war he received a professorship at the Hochschule für Bildende Künste and became president of the West Berlin Academy of Art.

JAWLENSKY, ALEXEI. Russian, born 1864 in Tver, near Moscow; died 1941 in Wiesbaden. The son of an aristocrat and army colonel, Jawlensky was destined for a military career. He attended the Alexander Military Academy in Moscow in 1882—

commissioned lieutenant in 1884. Having decided to dedicate himself to art, he resigned his commission in 1896 (then a captain) and moved to Munich, where he entered the private art school of Anton Azbé, where he met Kandinsky. He had already studied art part-time for years in Moscow and had been influenced by Ilya Repin and other Russian realists. He met Marianne Werefkina in Repin's studio; the two lived together until about 1918. In 1907 he worked in Matisse's studio in Paris, a contact which perhaps influenced his predilection for strong, vibrant color. A cofounder of the NKVM in 1908, he exhibited with the NKVM and at the Sbd(C) and the EDH. He became preoccupied almost exclusively with portraits; the faces would become more and more abstracted and masklike in the 1920s. With Werefkina he lived mostly in Murnau, near Kandinsky and Münter. At the outbreak of World War I, fearing internment as an enemy alien, he immediately departed for Switzerland. He lived first in Zurich and then in Ascona, returning to Germany in 1920, and settling in Wiesbaden in 1922. In 1924 he cofounded the Blue Four with Kandinsky, Klee, and Feininger. In 1933 he was forbidden to exhibit by the Nazis and in 1937, 72 of his works were confiscated from German museums. After 1929 he suffered from crippling arthritis which necessitated repeated hospitalization and progressively restricted his ability to work.

KANDINSKY, WASSILY. Russian; naturalized German in 1928. Born in Moscow in 1866; died in Paris in 1944. The son of the prosperous manager of a tea firm, Kandinsky was raised in Moscow and, after 1871, in Odessa. He remained attached to Moscow, with its ancient churches and palaces; he later connected his highly colorful style and some of his imagery to memories of that city. He was early impressed with Russian and German fairy tales. Since one grandmother was a German-speaking Balt, he spoke German from childhood. His father, tolerant and understanding, arranged for Kandinsky to study drawing while still a child. His parents were divorced during his childhood; his mother had two daughters in a subsequent marriage and Kandinsky remained close to them, though living with his father's family. While studying at the Odessa Gymnasium he also continued to paint and took piano and cello lessons. At nineteen he returned to Moscow to study economics and law. In 1889 he was sent by the Society for Natural Science, Ethnography, and Anthropology to Vologda in the North to report on peasant law and survivals of primitive customs among the local tribes. He studied peasant architecture and decoration as well. He passed the law examination in 1892 and became an instructor at Moscow University in 1893; in 1896 he was offered a professorship at the University of Dorpat; he declined, moved to Munich, and devoted himself to painting. By this time, he had been influenced by the Impressionists, especially Monet. He had married a cousin, Ania Chimiakin, in 1892; the marriage was unhappy and they were divorced in 1911. From 1897 to 1899 he studied at the private art school of Anton Azbé, there meeting Jawlensky and Werefkina, and later studied at the Munich Academy under Franz von Stuck. He was influenced by Jugendstil and adopted a decorative style, frequently, until 1907, depicting scenes from fairy tales. In 1902 he founded the Phalanx Group, which sponsored exhibitions of progressive art (including Impressionism, Neoimpressionism, etc.), but it had no criti-

cal success and was dissolved in 1904. It also had a school where Kandinsky taught painting until 1903. Among his students was Gabriele Münter, with whom he lived until World War I. Through another Phalanx student he was introduced to theosophy and then to Rudolf Steiner's anthroposophy, which confirmed his already spiritual and mystical attitudes to form and color. From 1904 to 1908 he and Münter traveled throughout Europe. Spending a year in Sèvres, outside Paris, eight months in Berlin, and becoming acquainted with European art and artists, including Matisse and the Fauves, they repeatedly exhibited at the SI, SA, and the Berlin Sezession. In 1908 they settled in Munich; in 1909 Münter bought a house in Murnau and they spent much time in the country. Kandinsky's style changed abruptly under the influence of Fauvism and Berlin Expressionism, and in the following years his colorful depictions of Murnau and the Bavarian countryside became more and more abstract until the object was all but eliminated. The transitional paintings feature mountain scenery with horses and riders—distant reminiscences of the fairy tales. In 1909 he joined with Jawlensky, Werefkina, Kubin, *et al*, to found a new artists' association, the NKVM, which exhibited works of the international avant-garde. He explained his esthetic theories in *Concerning the Spiritual in Art*, written in 1910 but not published until 1912. In 1911 he, Münter, and others resigned from the NKVM and formed a new organization, the BR, which exhibited as a group in Munich galleries in 1911 and 1912 and published an almanac in 1912. Kandinsky had a one-man show at the Sturm Gallery in 1912 and participated in the EDH the following year. When World War I began he left Germany for Switzerland, fearing internment as an enemy alien. He spent the war years in Russia, then in Stockholm, where he saw Münter for the last time (1916), then again in Russia. In 1917 he married Nina Andreevskaya, the daughter of a Russian general. With the Russian Revolution he received government posts. From 1918 he taught in the Higher Technical-Artistic Studios (Vhutemas) in Moscow; in 1919 he participated in the founding committee for Museums of Artistic Culture throughout Russia; in 1920 he received a professorship at the University of Moscow. In 1921, rendered ineffectual by the more radical Constructivists, he accepted a mastership at the Bauhaus, remaining there until it was closed by the Nazi government in 1933. After ca. 1917, under the influence of Malevich's Suprematism, Kandinsky evolved his emotional prewar style into a cooler, more geometrical one that still employed bright colors and forms similar to the immediate prewar ones. In 1924 he cofounded the Blue Four with Jawlensky, Klee, and Feininger, and he was associated with Katherine Dreier's Société Anonyme in New York. In 1928 he designed sets and costumes for a stage version of Mussorgsky's *Pictures at an Exhibition* at the Bauhaus. In 1931 he produced a ceramic mural for a Berlin architectural show. In 1933 he moved to Paris, settling in Neuilly-sur-Seine. He was declared degenerate by the Nazis, and in 1937, 57 of his works were confiscated from German museums and sold. His last paintings were extremely colorful, softer and less geometric than the middle ones, though not as lyrical as the early nonrepresentational ones.

KIRCHNER, ERNST LUDWIG. German, born 1880 in Aschaffenberg, near Frankfurt–am–Main; committed suicide in 1938 in Frauenkirch, Switzerland. The eldest of

three sons of a chemical engineer in charge of paper factories who was often transferred from place to place, and of a woman from a merchant family, Kirchner grew up in Frankfurt, Perlen, and Chemnitz, a frightened, overly sensitive child. He was given drawing lessons from childhood and made his first woodcuts at fifteen. He graduated from the Gymnasium in Chemnitz in 1901, and, since his parents objected to his becoming an artist, he enrolled at the Dresden Technische Hochschule to study architecture, receiving his degree with honors in 1905. By then he was also a full-fledged painter, having studied in 1903–4 in Munich under Debschitz at the Kunsthochschule and the Lehr- und Versuchsatelier für Angewandte und Freie Kunst. He was influenced by German fifteenth-century painting, by Jugendstil and Postimpressionism, especially by the work of Van Gogh and Munch, and by primitive art. He was a cofounder of the Brücke in 1905. His highly colored, often distorted works dealt with both landscape and the modern urban environment—city streets, dance halls, circuses, etc. He lived in Berlin from 1911 to 1917. He exhibited with the Brücke until 1913, in the Berlin Neue Sezession (1910–12) and Freie Sezession (1914), in the second BR exhibition, in the Sbd(C), and the NYAS. He lived with two women in turn. The second, Erna Schilling, was his almost constant companion from 1912 until his death. In 1915 he was trained as an artillery regiment driver, but was released from service after a nervous breakdown. After several stays in sanatoria he moved to Switzerland in 1917 and suffered from a psychosomatic paralysis until after the end of the war. He settled in a mountain cabin near Davos and correspondingly his work was devoted to the surrounding mountain scenery and peasant life. During the 1920s he had frequent exhibitions in Germany, but did not visit Germany until 1926. Under a pseudonym, L. de Marsalle, he wrote several articles about his work. Between 1927 and 1935 he turned toward abstraction but never rejected the object entirely. He influenced a group of young Basel artists, called the "Red-Blue" group. He was deemed degenerate by the Nazis and in 1937 all his works in German museums were confiscated. Depressed by these attacks and by the rumors of war, he shot himself on June 15, 1938.

KLEE, PAUL. Swiss, born 1879 in Münchenbuchsee near Bern; died 1940 in Muralto-Locarno. The son of a music teacher and a singer, the younger of two children, Klee studied music and attended the Bern Progymnasium and Literarschule, studying Greek and the classics. About 1891 he decided on a career in art rather than music, and attended the Munich Academy for some years. Between 1902 and 1906 he continued his studies in Bern and played in the civic orchestra and with a string quartet. He married the pianist Lily Stumpf in 1906; they had one son (born 1907). Returning to Munich in 1906, Klee was influenced by Postimpressionism. His drawings and etchings, which were previously symbolic and related to Jugendstil, now became lighter, more humorous, and more abstract. Having become acquainted with Kandinsky, he joined the Blaue Reiter in 1911. During a trip to Paris in 1912 he became acquainted with Delaunay, who had considerable influence on his use of color. A trip in 1914 to Tunis with Macke and Louis Moilliet was similarly influential. He began producing his characteristically

witty, delicately colored watercolors and paintings, usually on a small scale, only just before World War I. He participated in the second BR exhibition, the Sbd(C), and the EDH. From 1916 he served in the German army, escorting military transports and painting airplanes. In 1918 he returned to Munich; from 1921 to 1931 he served as a master at the Bauhaus, first taking charge of bookbinding, then glass painting, then weaving. He was a cofounder of the Blue Four along with Kandinsky, Jawlensky, and Feininger in 1924. From 1931 he taught at the Düsseldorf Academy, until he was dismissed by the Nazi government in 1933. He then emigrated to Bern. In 1937 the German government confiscated 102 of his works from German museums and sold them at auction. Many were bought by Swiss museums, where they are now. After 1935 Klee's health deteriorated rapidly.

KLEIN, CÉSAR. German, born 1876 in Hamburg; died 1954 in Pansdorf near Lübeck. Klein's father, opposed to his desire to become an artist, apprenticed him to a Hamburg paint firm until 1894. Klein then attended the Hamburg School of Applied Art until 1897 and the Düsseldorf Academy and Berlin Museum of Arts and Crafts until 1903. He became noted for mosaics and interior decoration, working on the administrative reception room at the Siemens factory in Berlin in 1913 and the Marmorhaus on the Kurfürstendamm in 1914. He was less known for his paintings. Influenced by such Germans as Hans von Marées, Hans Thoma, the Swiss Arnold Böcklin, and the Postimpressionists, he was first an Expressionist and later, in the 1920s, a Surrealist. He married in 1901. In 1919 he was a cofounder of the NG, and he expressed his sympathy with the German revolution and the new democratic government in illustrations for reviews and in posters. He was offered a Bauhaus post in 1919 but declined in favor of a professorship at the Berlin Museum of Decorative Arts, which he held until 1933, when he was put on leave of absence by the Nazi government (dismissed in 1937). After 1937 he lived quietly in Pansdorf.

KOKOSCHKA, OSKAR. Austrian, naturalized British in 1947. Born 1886 in Pöchlarn on the Danube; lives in Villeneuve, near Lausanne, Switzerland. The son of a Czech goldsmith, Kokoschka was raised in Vienna, completing the Realschule there in 1904. On a scholarship, he studied at the Vienna School of Decorative Art from 1904 to 1909 and worked at the Wiener Werkstätte, the pioneering, Jugendstil studio of design, after 1907. He was befriended by the architect Adolf Loos, who fostered his career. In 1910 and 1911 he was in Berlin, collaborating closely with Herwarth Walden on *Der Sturm*; the first of a series of Expressionist portraits of German and Austrian intellectuals date from that period. Moving between Vienna and Berlin, he lived with Alma Mahler, the widow of the composer Gustav Mahler, from 1912 to 1914. "Die Windsbraut" ("Bride of the Wind," 1914), perhaps his capital work, pictures him and Alma. He taught evening classes at the Vienna School of Decorative Art. He also wrote Expressionist plays, such as *Mörder, Hoffnung der Frauen* (*Murder, Hope of Women*, 1910). In 1914 he volunteered into the Austrian cavalry and was critically wounded in 1915. After his convalescence he returned to the Italian front as an observer, but suffered shell shock. He was given leave, and until 1918

remained mostly in a Dresden sanatorium. From 1919 to 1924 he taught at the Dresden Academy. From 1924 to 1930 he traveled throughout Europe, painting cityscapes in an Expressionist manner highly influenced by Impressionism. When the Nazis came to power in Germany he went to Vienna, then to Prague, and, during the 1938 Munich crisis, to London, where he remained during World War II. After the war he settled in Switzerland. For many years he taught a summer "School of Seeing" in Salzburg.

KOLLWITZ, KÄTHE. German, born 1867 in Königsberg; died 1945 in Moritzburg, near Dresden. Kollwitz (née Schmidt) was the daughter of a mason and contractor, a Social Democrat who was a lecturer in the Königsberg "Freie Gemeinde." Her brother became editor of *Vorwärts,* the Socialist newspaper. She studied drawing under Karl Stauffer-Bern at the Berlin Verein der Künstlerinnen in 1885–86, and in Munich from 1887 to 1889. Influenced by the naturalist engraver Max Klinger, she decided to devote herself to drawing and graphics. She married Karl Kollwitz, a doctor and Socialist, in 1891 and moved to the lower-class neighborhood of northern Berlin. They had two sons. Between 1894 and 1898 a series of engravings to Gerhart Hauptmann's naturalist play *The Weavers* established her reputation. She followed this with illustrations of the German Peasant War of the sixteenth century (1905–8). Thereafter she consistently dealt in a left-wing, humanitarian way with social themes, concentrating especially on proletarian mothers and children. In 1904 she studied sculpture in Paris; in 1907 she won the Villa Romana Prize, which enabled her to spend a year in Rome. After one of her sons was killed in Flanders during World War I she began a large monument, depicting mourning parents, that was set up in a Belgian cemetery in 1932. A Socialist long before, she became an activist as a result of the war, contributing posters and graphics to humanitarian causes throughout the 1920s. In 1920 she became a professor and member of the Prussian Academy. In 1933 she signed an antifascist appeal; forced by the Nazi government to resign from the Academy, she was forbidden to sell or exhibit. When her Berlin studio was bombed in 1943, she moved to Saxony.

KUBIN, ALFRED. Austrian, born 1877 in Leitmeritz (Bohemia); died 1959. Kubin was the son of an officer turned government surveyor, who was often away from home, and of a woman with musical talent who died of consumption when the son was ten years old. He had two younger sisters; his father remarried twice, first to his mother's sister who soon died, then to a woman who showed little interest in the children. From youth Kubin suffered from neurasthenia and convulsions (possibly epilepsy). Though he disliked school, he attended the Salzburg Gymnasium, failing in his second year. He was then sent to a Salzburg trade school (1889–91) and subsequently apprenticed to an uncle in Klagenfurt, a landscape photographer. Military service in 1897 ended after three months when Kubin had a nervous collapse. During his apprenticeship, Kubin had discovered his artistic bent; in 1898, with a small inheritance, he moved to Munich and enrolled in the private art school of Ludwig Schmidt-Reutte. After 1900 he studied at the Munich Academy. Already fascinated with mysticism and spiritualism, Kubin was drawn to the work of vision-

ary artists such as Breughel, Goya, Rops, Munch, Ensor, and Redon. (He was also influenced by Schopenhauer.) Around 1900 he made his first characteristic black-and-white grotesque drawings. He married in 1904 but, his wife also being sickly, they had no children. In 1906 they moved from Munich to Zwickledt-am-Inn in the Austrian Tyrol. In 1908–9, during twelve weeks, he wrote his visionary novel *The Other Side*; thereafter he gave up color entirely in his drawings. He concentrated on depicting his dreams and fantasies. He illustrated the first of many books, including, notably, those of Edgar Allan Poe, E. T. A. Hoffmann, and Dostoevsky. He participated in both NKVM exhibitions, the second BR exhibition, and the EDH. Antimilitaristic from the start of World War I, he was four times called for military examinations and finally dismissed as unfit for service. In 1916, after reading a book on Buddhism, he withdrew temporarily into solitude. This strengthened him and he resumed his activities. During the interwar period he continued to illustrate books and to become known, offsetting the loss of his assets during the 1923 inflation through frequent sales and commissions. He was staunchly anti-Nazi; in 1937, 63 of his works were confiscated from German museums. He remained in Zwickledt throughout World War II.

Kᴜᴘᴋᴀ, Fʀᴀɴᴛɪsᴇᴋ (Fʀᴀɴᴋ). Czech, born 1871 in Opočno, in eastern Bohemia; died 1957 in Puteaux, near Paris. Kupka was the eldest of six children of a notarial clerk of modest means. Various members of the family painted, and Kupka was interested in art from an early age. He was high-strung, often ill, and he quarreled with his stepmother, who disapproved of his drawing. He was apprenticed to the village saddle maker; his master and the local mayor recognized his talent and sent him to the School for Crafts in Jaroměř. From there he went on to the Prague School of Fine Arts (1887–91) and the Vienna Academy (1891–93). He was influenced by Nietzsche, Schopenhauer, Dante, and by spiritualism. (He became a medium around 1890.) He moved to Paris ca. 1898, settling in Montmartre until 1906 and thereafter in Puteaux, where he became an intimate of Jacques Villon and Raymond Duchamp-Villon. He supported himself by caricaturing for several publications (particularly anarchist and socialist ones) and by illustrating books. Influenced at first by Symbolism and Art Nouveau, he underwent a Cubist influence and then turned to pure abstraction ca. 1911, becoming one of the first to produce nonobjective works. He exhibited in the SA and SI. He married twice (his first wife died) but had no children. He fought in the Foreign Legion during World War I until he was wounded on the Somme. He then worked with Tomas Masaryk and Edvard Beneš to organize Czech military units in France. He designed uniforms, banners, and medals; he fought in a Czech legion in the Argonne campaign under Foch. At war's end he was officially labeled a traitor in Austria and awarded the Legion of Honor in France. In 1918 he returned to Czechoslovakia to work in the Ministry of Defense. In 1919 he became a professor at the Prague School of Fine Arts, but he returned to Paris on a leave of absence which was renewed yearly from then on. He was paid a meager salary to supervise Czech students in Paris. Poor and forgotten, he became ever more bitter, finding painting difficult. He was alcoholic and frequently ill, recovering somewhat after 1934. During World War II he worked again

for Czechoslovakia. Threatened by the Gestapo, he left Paris for the South. After the liberation he found new energy and worked strenuously until his death. He had several exhibitions during the last few years when he began to be recognized.

DE LA FRESNAYE, ROGER. French, born 1885 in Le Mans; died 1925 in Grasse. The son of an aristocrat, La Fresnaye was educated privately by a tutor and then attended school in Paris. He studied painting at the Académie Julian (1903), the École des Beaux-Arts (1904–5, 1906–8) and the Académie Ranson (1908); sculpture with Aristide Maillol (1910). In 1905–6 he did military service, being released, however, after an attack of pleurisy. He was influenced by Cubism in 1911, and in 1912 collaborated with André Mare and the Puteaux group (Villon, Duchamp-Villon, Gleizes, *et al.*) on a "cubist house" for the 1912 SA. He exhibited in the Section d'Or (1912), at the SA and SI, and in the second BR exhibition and the NYAS. At the beginning of World War I he enlisted in the army, earned two citations, and became a sergeant. In 1918 he suffered lung hemorrhages in the trenches and he was discharged. He never recovered and spent the remaining seven years of his life in and out of sanatoria.

LARIONOV, MIKHAIL FYODOROVICH. Russian; naturalized French in 1938. Born 1881 in Tiraspol, Bessarabia; died 1964 in Fontenay-aux-Roses. The son of a military doctor from Archangel and a woman who was of mixed Polish, Russian, and Greek ancestry, Larionov attended secondary school in Moscow and then the Moscow School of Painting, Sculpture, and Architecture between 1898 and 1908. He lived with Nathalia Goncharova beginning ca. 1900; together they visited Paris and London in 1906. He was influenced by Impressionism and Pointillism, then (ca. 1908) by Expressionism. He had a particular interest in primitive and folk art, basing many early works on popular images and lower-class customs. During his military service in 1908–9 he did many paintings of soldiers. In 1913 he began "Rayonnism," a synthesis of Cubism, Futurism, and Orphism that analyzed objects into rays of reflected light. A Rayonnist manifesto of 1913 was signed by eleven artists. He participated in Diaghilev's exhibition of Russian art at the 1906 SA; in 1908 he organized the "Golden Fleece" exhibition in Moscow which featured 282 French works. In 1910 he organized the "Jack of Diamonds" in Moscow, which showed the Cubists, Malevich, and Kandinsky; in 1912 he participated in the "Donkey's Tail" with Malevich, Tatlin, *et al*; and in 1913 he participated in the EDH. He served in the Russian army between late 1914 and early 1915, and was released from further service after suffering a concussion and an attack of nephritis; in June he left Russia, not to return, working with the Ballets Russes in Switzerland, Spain, and Italy during the war and then settling in Paris, in the Latin Quarter. From then on he concentrated on theatrical work. He was partially paralyzed after 1946.

LÉGER, FERNAND. French, born 1881 in Argentan; died 1955 in Gif-sur-Yvette. Léger's father, a livestock breeder, was often querulous and always in financial difficulties; his mother was extremely pious. After studying at *collèges* in Argentan and Tinchebray he was apprenticed to an architect from 1897 to 1899. From 1900 to 1902

he worked as a draftsman in a Paris architect's office; he then did military service in Versailles until 1903 and again worked for an architect until 1904 and later for a photographer. In 1903 he was refused admission to the École des Beaux-Arts but accepted at the École des Arts Décoratifs and also studied at the Académie Julian. He settled on the Left Bank, living at the Ruche between 1908 and 1910. He was influenced by Impressionism, by the Fauves and, in 1907, by Cézanne. Discovering Cubism in 1910, he began fragmenting his images into forms that suggested machinery, a style dubbed "Tubism" by a critic. He exhibited at the SA and SI, at Kahnweiler's gallery, and in the EDH and NYAS. In August, 1914, he was mobilized as a sapper in the Engineering Corps. He was gassed in 1917; while convalescing, he painted "The Card Game," a major work in which his fragmented, mechanistic imagery takes on new color in contact with his reminiscences of life in the trenches. In the early 1920s he collaborated with the "Purists," Amédée Ozenfant and Charles-Édouard Jeanneret (Le Corbusier), turning toward simpler geometric forms and friezelike canvases. He made a short experimental film, *Ballet mécanique,* in which objects move around and people's movements are shown to be mechanical. He married in 1919 and, after the death of his wife, again in 1952. He began a school during the 1930s. He designed murals for Le Corbusier's Pavillon de l'Esprit Nouveau at the Exposition des Arts Décoratifs in 1925; he decorated the Palais de la Découverte for the 1937 Paris World's Fair. In 1940 he fled Paris for Normandy, Bordeaux, Marseille, and, finally, the U.S., where he taught during the war. Returning to France in 1945, he joined the Communist Party and embarked on a series of large paintings depicting workers and circus performers, meant to hang in factories. He bought a country house to which he retired in 1952.

MACKE, AUGUST. German, born in Meschede (Westphalia) in 1887; died in the Battle of the Marne, 1914. The only son of a mining engineer and contractor with an interest in antiquities but little business sense, Macke was raised in Cologne and, after 1900, in Bonn. His mother came from a family of farmers and artisans. Macke had five older sisters; three died in childhood. His mother turned their home into a boardinghouse to support the family. Interested in painting from his early teens, Macke was an adequate but not outstanding student at the Bonn Realgymnasium. He left school before graduating, having decided, against his father's wishes, to become an artist. With the financial aid of the father of a school friend, he attended the Düsseldorf Academy from 1904 to 1906 and also the Düsseldorf School of Decorative Art which was less rigid in its methods. Influenced by Beardsley and Japanese prints, he earned his living painting theater sets. During a 1907 trip to Paris he was strongly influenced by Impressionism. The same year he studied in Berlin under Lovis Corinth and was influenced by French and German Postimpressionism. In 1908 he volunteered for a year of military service; after being released in 1909 he married Elisabeth Gerhardt, a prosperous Bonn merchant's daughter whom he had known since school days. They had two sons. They were relatively comfortable financially, as Elisabeth had a small income, and her uncle, Bernhard Koehler, a wealthy Berlin manufacturer, bought Macke's paintings and those of other avant-gardists. At this time Macke evolved his characteristic style, depicting

city scenes in a brightly colored but gentle manner, more like Fauvism than German Expressionism. During a year in Tegernsee in Bavaria (1909–10) Macke became friendly with Franz Marc. After returning to Bonn in 1911 he remained in close contact with Marc and became a member of the BR, participating in its two exhibitions and also in the Sbd(C) and the EDH. He was influenced by Cubism and by Delaunay's Orphism, ca. 1912. In 1914 Macke traveled to Tunisia with Paul Klee and Louis Moilliet and subsequently incorporated the North African color and imagery into his works. He participated in the German invasion of France. He received the Iron Cross before his death in September, 1914.

MALEVICH, CASIMIR. Russian, born 1878 in Kiev; died 1935 in Leningrad. The son of a sugar refinery executive, Malevich was raised in Kiev. From 1898 to 1901 he lived in Kursk, where he exhibited paintings of local street life. He was employed in an office, saving money to attend art school. In 1902 his father died and he moved to Moscow, attended art schools there, and was influenced by the Impressionist, Postimpressionist and Fauvist works in Shchukin's and Morosov's collections. In 1907 he took part, along with Kandinsky, Larionov, David Burliuk, *et al*, in an exhibition arranged by the Moscow Artists' Association. In 1909 his first marriage was dissolved; he married again (twice) and had one child. From 1906 he painted Fauvist works and was influenced by Cubism in 1912; he took part in major manifestations of the Russian Futurists, such as the "Jack of Diamonds" exhibition in 1910–11 and the "Donkey's Tail" of 1912 (in which he, along with Larionov, Goncharova, and Tatlin presented primitivist peasant pictures). He participated in the second BR exhibition. In 1913 he designed scenery and costumes for an opera, *Victory Over the Sun*, with music by Matyushin, which created a scandal at its première. During World War I he began painting nonobjective pictures, launching Suprematism at the exhibition "0.10." His works featured geometric forms in two or three colors; in 1918 he painted the famous "White on White," consisting of only one white square within another of a slightly different tone. He published a theoretical treatise on Suprematism in 1920. Late in 1917 he was named instructor at the Moscow Academy of Fine Arts and he designed costumes and scenery for Mayakovsky's revolutionary play *Mystery-Bouffe*, produced by Meyerhold. In 1920 Lunacharsky appointed him to the State Art Commission along with Kandinsky and Tatlin. In 1918 he was instructor at the Vitebsk Academy by invitation of Marc Chagall; he ousted Chagall soon after, considering him too conservative. In Vitebsk he organized an artistic group, Unovis ("affirmation of new art"), which operated like a political party with uniforms and slogans and which decorated the town with circles, squares, and triangles for the anniversary of the Revolution. In 1921 the Unovis were ousted from the Vitebsk school; in 1922 Malevich left for Petrograd with five pupils to join the newly formed Institute for Artistic Culture (INKCHUK). After 1923 he concerned himself almost entirely with applied art. In 1927 he was permitted to take many of his works to an exhibition in Berlin. He visited the Bauhaus and became acquainted with Gropius, Le Corbusier, and various other painters and architects. The works and some manuscripts remained in the West after his return to Russia, and are now in the Stedelijk Museum in Amsterdam. INKCHUK was dissolved in 1927; as the avant-garde came into disrepute, Malevich suffered increasing harassment, in-

cluding a brief arrest in 1930 because of his continuing contacts with Germany. In 1933 he was violently attacked for his "formalism." Suffering from cancer, he was finally left alone, and died in extreme poverty.

MARC, FRANZ. German, born 1880 in Munich; died 1916 near Verdun. Little is known about Marc's early years. He completed the Abitur and, rejecting a previous interest in theology, enrolled at the University of Munich to study philosophy. He did military service in an artillery regiment ca. 1898. Around 1900 he decided on a career in art and enrolled at the Munich Academy until 1903. From 1907 to 1910 he taught anatomy in Munich. He visited Paris in 1903, 1907, and 1912, the last time visiting Robert Delaunay with August Macke. He lived in Munich until 1909, then moved definitively to the Bavarian countryside, first to Sindelsdorf, and in 1914 to Ried. He was early influenced by Impressionism and Munich Jugendstil. After 1910 he developed a highly colored Expressionist style, influenced by Cubism from 1912 and tending ever more toward abstraction; however, he never abandoned his subjects, which consisted mostly of landscape and animals. In 1912 he coedited (with Kandinsky) the Blaue Reiter almanac. He participated in both BR exhibitions and in the Sbd(C) and the EDH. He was married twice, happily the second time to an art student, Maria Franck (from 1911). He was mobilized at the beginning of World War I and served almost continuously to his death in the Battle of Verdun.

MARCOUSSIS, LOUIS (LUDWIG CASIMIR LADISLAS MARKOUS). Polish, born 1878 in Warsaw; died 1941 in Cusset, France. The second of four children of the Jewish director of a Warsaw carpet factory, Marcoussis was raised in comfort. He was educated first by a French governess and then at the Gymnasium. He attended law school, but soon left to study painting. His father wanted him to become a decorative artist and work for the family business; he refused, they quarreled, and Marcoussis left Warsaw. He studied at the Cracow Academy (1901–2), supporting himself by doing caricatures. With a small income provided by his father, now convinced of his talent, he settled in Paris in 1903. He attended the Académie Julian for a few months and then worked on his own. He was influenced by Impressionism, then by Postimpressionism and Cézanne, and by primitive and popular art. He painted in a Fauvist style and supported himself by caricaturing for L'Assiette au beurre and other publications. From 1907 to 1910 he lived with Marcelle Humbert, later Picasso's "Eva." He became a Cubist in 1910 and became well-known for his cubist still-lifes, portraits, and, in the 1920s, paintings on glass. He produced some rare Cubist graphics. He exhibited intermittently at the SA, and participated in the Section d'Or and the EDH. In 1913 he married Alice Halicka, a Polish painter; they had a daughter in 1922. He volunteered in 1914 and served in an artillery regiment, and subsequently as a second lieutenant with the Franco-Polish mission in Paris. In 1917 he returned to the front, serving in Champagne, Lorraine, and at Verdun. He was decorated with the Croix de Guerre and promoted to first lieutenant. After the war he returned to Paris, made several trips to Poland, and became increasingly recognized for his paintings and illustrations. He exhibited widely between the wars. In 1940 he left Paris for Cusset near Vichy. He died of lung cancer in 1941.

Marquet, Albert. French, born 1875 in Bordeaux; died 1947 in Paris. Marquet's mother was a peasant and the family poor; in 1890 she bought a shop in Paris in order to help support the family and allow him to study art. Beginning in 1900 he studied at the École des Arts Décoratifs and later at the École des Beaux-Arts, for a while under Gustave Moreau, meeting Matisse and Rouault in Moreau's studio. With them and others, he exhibited Fauvist canvases at the 1905 and 1906 SA and SI. He concentrated on landscapes and views of Paris. In 1908 he settled in a studio on the quai Saint Michel, remaining there for years and traveling widely to paint landscapes. He exhibited frequently at the SI and participated in the Sbd(C) and the NYAS. He spent World War I in the south of France—not mobilized. After the war he continued traveling and painting landscapes in a somewhat subdued style. He married in 1923.

Matisse, Henri. French, born 1869 in Cateau-Cambrésis; died 1954 in Nice. The elder of two sons of well-to-do-shopkeepers, Matisse attended the Lycée in Saint Quentin and studied law in Paris from 1887 to 1888, passing the *capacité*. He then worked as a law clerk in Saint Quentin, studying drawing on the side. While convalescing from an appendectomy in 1890, he decided to become an artist. He studied in Paris at the Académie Julian under Bouguereau in 1891 and then under Gustave Moreau at the École des Beaux-Arts, in the evening at the École des Arts Décoratifs, and again at the Beaux-Arts in 1899, when Moreau's successor, Cormon, asked him to leave the school. He was influenced by Impressionism and by J. M. W. Turner's seascapes, and later by Cézanne, Van Gogh, Gauguin, and Neoimpressionism. He settled in the Latin Quarter and, in 1898, married a woman from Toulouse; they had three children. In 1905 and 1906 Matisse exhibited with the Fauves at the SA and SI, painting his well-known, highly colored landscapes with figures, "Luxe, calme et volupté" and "La joie de vivre," and becoming acquainted with the Michael Steins. At the urging of Sarah Stein and the German painter Hans Purrmann, Matisse ran an art school from 1907 to 1911 in the former Convent of the Sacred Heart on the boulevard des Invalides. In 1909 he was able to buy a small property in Issy-les-Moulineaux outside Paris; he settled there until the end of World War I. In 1909 he produced two important works: the large paintings of "Music" and "Dance" for the Russian entrepreneur Sergei Shchukin. He traveled to Germany in 1908 and 1910, to Moscow in 1911, and to Morocco in 1912 and 1913. He exhibited at the SA and SI almost yearly and in the Sonderbund exhibitions and NYAS. When World War I began, he tried unsuccessfully to volunteer (he was 45), then spent much of the war painting the Mediterranean scenery and a series of interior scenes of Nice hotels. After 1922 he spent half of each year in Paris and half in Nice, captivated by the southern light. His works, now subdued in color though they continued to depict the female figure with sensuality, were more classical in inspiration. Increasingly famous, Matisse exhibited widely. He remained in the South during World War II; in 1944 his wife was arrested and his daughter deported for acts of resistance to the Nazis. After a serious intestinal operation in 1941, Matisse remained partially bedridden. When he could no longer paint he began to make large collages of brightly colored paper, in which human and vegetal forms

are combined with abstract ones. After 1943 he lived in a villa in Vence. Between 1948 and 1951 he decorated a Rosary Chapel for a Dominican convent in Vence.

MEIDNER, LUDWIG. German, born in Bernstadt, Silesia, in 1884; died in Darmstadt in 1966. The child of a Jewish textile merchant, Meidner had a younger sister. He disliked school and, in 1901, was apprenticed to a mason. Having a love of art from childhood, he left home in 1903 to study at the Breslau Royal Art School. In 1905–6 he lived in Berlin, earning 100 marks monthly as a fashion illustrator. In 1906–7 he attended the Académie Julian in Paris; subsequently he lived in Berlin until the war, often in dire poverty. In 1912 he was a cofounder of "Die Pathetiker," a painters' club. He exhibited at the Sturm Gallery in 1912. His highly emotive style was greatly influenced by that of Van Gogh; influenced also by socialism, he repeatedly depicted revolutionary subjects. Between 1916 and 1918 he served in the infantry and as an interpreter in a prison camp. After the war he settled in Berlin, teaching at the Studienatelier für Malerei und Plastik in Charlottenburg. He married a painter, Else Meyer, in 1927, and had a son in 1929. In 1935 he was declared "degenerate" by the Nazi government and, as a Jew, forbidden to work or exhibit. From 1935 to 1939 he lived in Cologne and taught drawing in a Jewish school. His works increasingly dealt with biblical subjects. In 1939 he fled to England. Interned on the Isle of Man in 1940–41, he remained in England until 1953. He spent the rest of his life in Germany, first in a Jewish old-age home in Frankfurt, then in the Taunus, and finally in Darmstadt.

METZINGER, JEAN. French, born 1883 in Nantes; died 1956 in Paris. Metzinger is known mainly as a Cubist, the cotheoretician of Cubism with Albert Gleizes (*Du "Cubisme,"* 1912). Little is known about his life. He settled in Paris about 1903, living in Montmartre. He was influenced by Cubism beginning in 1909. Unlike most other Cubists, who concentrated on still-lifes and interiors, Metzinger painted landscapes and urban scenes. He exhibited with the Cubists in Room 41 of the 1911 SI, at the Section d'Or in 1912, and in the EDH. During World War I he served in the army until released in 1915. After 1921 he returned to figurative art, later alternating between figurative and abstract works.

MODERSOHN-BECKER, PAULA. German, born 1876 in Dresden; died 1907 in Worpswede near Bremen. Paula Becker was the third child of a civil-service engineer and of the daughter of a titled colonel. In 1888 the family moved to Bremen, where she received her first art instruction. In 1892 she spent a year studying art in London. Her father disapproved of her vocation, however, and insisted that she become a teacher. After two years of teacher-training (1893–95) she attended the art school of the Verein Berliner Künstlerinnen (where Kollwitz had previously studied) from 1896 to 1898. She discovered the recently founded artist colony of Worpswede in 1897 and settled there in 1898 to continue her education. She traveled to Norway in 1898, to Switzerland in 1899, and to Paris for six months in 1900 with Clara Westhoff, the Worpswede sculptress who married Rainer Maria

Rilke. In Paris Becker studied at the Académie Colarossi and the École des Beaux-Arts and was influenced by Rodin, Degas, and Cézanne. She became friendly with Emil Nolde. In 1901 she married the Worpswede painter Otto Modersohn, many years her senior, and settled in Worpswede, where she produced primitive paintings of the local peasants and children plus several self-portraits. In 1905 she again studied in Paris, at the Académie Julian. Unhappy in her marriage, she went to Paris in February, 1906, and studied at the École des Beaux-Arts until March, 1907. Her husband joined her there and they returned to Worpswede together. In November, 1907, she gave birth to a daughter and died three weeks later of an embolism.

MODIGLIANI, AMADEO. Italian, born in Leghorn in 1881; died 1920 in Paris. Modigliani was the youngest of four children of a Jewish wood and coal dealer. After his father went bankrupt, his mother, Eugenia Garsin, opened a school and later wrote novels and translated. An aunt, Laura Garsin, wrote essays on philosophy and social questions, and Modigliani's eldest brother, Emmanuele, was a lawyer and Socialist deputy. Modigliani, a sickly child, received a classical education until 1898. After recovering from typhus he began drawing lessons with Guglielmo Micheli, a student of the *Macchiaiolo* Giovanni Fattori. He was early influenced by the *Macchiaioli* and the Pre-Raphaelites. In 1901, on a trip to the South with his mother for his health, he was greatly influenced by the Mannerist sculptor Tino di Camaino. From this time dates his lifelong interest in sculpture; poverty and ill health, however, prevented him from working in this medium as much as he would have wished. In 1902 he attended Fattori's Free School of the Nude in Florence and the Institute of Fine Arts in Venice in 1903–4. In 1906 he moved to Paris, where he lived for the rest of his life, visiting Italy in 1909 and around 1912. He studied for a while at the Académie Colarossi, and he moved frequently between Montmartre and Montparnasse, living briefly at the Bateau Lavoir and the Ruche and frequenting both the Cubists and the German and Russian colonies. His life was disordered and dissolute: he drank, took drugs, and lived in extreme poverty. Transforming the influences of Mannerism and Tuscan Renaissance and realist art that he had brought from Italy, and adding those of primitve art and Postimpressionism, he developed his distinctive static, highly simplified style. His sculptures and paintings depicted nudes and portraits exclusively. He had several liaisons, but two were influential or lasting: with Beatrice Hastings, a British poet, from 1914 to 1916; and with Jeanne Hèbuterne, a young Parisian art student, from 1917 to his death. In 1916 he met the Polish art dealer Leopold Zborowski, who provided him with a small monthly income. The last four years of Modigliani's life, during which he suffered from tuberculosis, were also his most productive. He became well-known, though never financially successful. He died of tuberculosis and was buried in Père Lachaise. The day after his death, Jeanne, who had had a daughter in 1919 and was expecting another child, jumped to her death from a sixth-story window.

MONDRIAN, PIET. Dutch, born 1872 in Amersfoort; died 1944 in New York. The child of a large, devoutly Calvinist family, Mondrian was raised in the small Dutch town

of Winterswijk, where his father directed a Calvinist primary school and painted as a hobby. He was taught to draw and paint by his father and an uncle. He himself taught drawing in Dutch schools from 1889 to 1894. He then studied at the Amsterdam Academy until 1896. He remained in Amsterdam until 1911, progressively distancing himself from his father's realism through contact with the art of Van Gogh and the Impressionists. In 1909 he joined a theosophical organization in Amsterdam. In 1912 he moved to Paris, settling in Montparnasse, and by 1914 his depictions of landscape, especially of trees, were becoming ever more abstract under the influence of Cubism. He exhibited widely in Holland and in the SI (1911–13), the Sbd(C), and the EDH. He developed his characteristic nonobjective style, eventually consisting of juxtaposed quadrilinear areas of primary colors, in some "plus and minus paintings" produced during World War I in Holland, where he lived mainly in an artists' colony in Laren. He met the Dutch architect Theo van Doesburg in 1915 and the two cofounded the De Stijl group in 1916–17, which sponsored exhibitions and published one of the most influential reviews of modern art. Mondrian published numerous theoretical articles in *De Stijl* until 1925, when he withdrew from the group in protest over Doesburg's reintroduction of the diagonal into architecture. In 1919 Mondrian settled again in Montparnasse, remaining there until 1938, when he moved to London. In 1940 he emigrated to New York. Two of his last paintings, produced there, are among his most famous: "Broadway Boogie Woogie" and "Victory Boogie Woogie." During the interwar period he exhibited widely in Paris and abroad. He participated in the large international exhibition of the Société Anonyme at the Brooklyn Museum in 1926, was a member of the "Abstraction-Création" group founded in Paris in 1931, and contributed to *Circle* in 1937.

MUELLER, OTTO. German, born 1874 in Liebau, Silesia; died 1930 in Breslau. Mueller was the eldest of six surviving children of a civil servant who had wanted to be a sculptor and a Bohemian woman who was partly deaf and paid little attention to her children. He grew up in various Silesian towns, attending the Gymnasium in Görlitz. He suffered an attack of rheumatic fever when he was thirteen. He discovered his artistic vocation early; his father was opposed, but finally agreed to apprentice him to a lithographer, and later, on the advice of the lithographer and of Gerhart Hauptmann, to finance his studies at the Dresden Academy (1894–96). After studying under Franz von Stuck in Munich, he worked on his own, influenced by Böcklin and Hans von Marées. Settling in Berlin in 1908, he joined the Brücke in 1910. He was particularly interested in depicting the nude in nature. Impressed by Egyptian frescoes, he developed lime watercolors to reproduce their color and texture. He exhibited with the Brücke, at the 1910 Neue Sezession, the second BR show and the Sbd(C). He was married to a Prague milliner from 1905 to 1921 and then twice more during the 1920s; he had one son. Not liable for military service due to poor health, he nevertheless volunteered in 1916 and served in an armored corps until 1918, being treated in 1917 for lung hemorrhages. In 1919 he settled in Breslau, becoming a professor at the Academy there. Always attracted by gypsies, he made several trips to Hungary, Rumania, and Bulgaria during the

1920s, and he depicted gypsy life almost exclusively. In 1927 he published a portfolio of lithographs of gypsies. After years of increasing debility he died of a lung disease in 1930.

MÜNTER, GABRIELE. German, born 1877 in Berlin; died 1962 in Frieden. The younger of two daughters of a well-to-do merchant family, Münter grew up in the Rhineland and then, after her mother's death in 1897, spent a few years with relatives in Arkansas and Texas. Before his marriage her father had spent ten years in the U.S. She had studied art in Düsseldorf before leaving Germany; she returned in 1901 and enrolled in Kandinsky's Phalanx School in Munich. She lived with Kandinsky from 1903 until 1916. The two settled in Munich, traveled widely between 1904 and 1907, spending much time in Paris, then returned to Munich. In 1909 Münter bought a small house in Murnau, where they stayed most of the time until the war. Influenced by Postimpressionism and somewhat by Kandinsky, though she did not follow him into nonrepresentational painting, Münter produced highly colored landscapes and still-lifes, based on the Bavarian alpine landscape and the intimate atmosphere of the Blaue Reiter artists' houses. She exhibited at the SA and SI between 1907 and 1912, in both NKVM exhibitions, both BR exhibitions, and the EDH. When World War I began she accompanied Kandinsky to Switzerland. When he returned to Russia she traveled, settling in Stockholm, where she saw him for the last time in 1916, and then in Copenhagen until 1919. Unable to paint for the next ten years, she lived in Munich and Murnau until 1924, in Berlin from 1924 to 1930, where she married Johannes Eichner, a philosopher, and then in Murnau for the rest of her life. In 1937 an exhibition of her work at the Munich Kunstverein was closed by the Nazi government and the same year she was included in the exhibition of "degenerate art."

NOLDE, EMIL. German; naturalized Danish. Born Emil Hansen in 1867 near Nolde, Schleswig; died 1956 in Seebüll, Schleswig. The son of a peasant farmer, Nolde was apprenticed in a furniture factory between 1884 and 1888 and then worked as an artisan until the late 1890s and taught at the Museum for Industrial Arts in St. Gall, Switzerland. He studied drawing part-time, but he produced his first painting only in 1896, at the age of twenty-nine. In 1898–99 he studied art in Munich and in 1900 at the Académie Julian in Paris. Living mainly in small Schleswig localities, he settled briefly in Berlin in 1902 and again after 1910. Having developed independently a highly colored Expressionism, he joined the Brücke in 1906, leaving the group the next year. Emotional in style, he was eclectic in his choice of subjects, treating landscape, still-life, domestic scenes, and religious subjects with bright colors, a thick application of paint and much distortion of form. He exhibited at the Berlin Sezession until 1910 and then with the Neue Sezession, and in the second BR exhibition and the Sbd(C). In 1902 he married a Dane, Ada Vilstrup, who died in 1946; he remarried thereafter. In 1913–14 he and Ada traveled to the South Seas via Siberia, Korea, China, and Japan. He spent much of World War I in Schleswig. From 1916 to 1940 he spent his winters in Berlin, lived primarily in Schleswig or in nearby Denmark. Despite his membership in the Danish Nazi Party and his lifelong

espousal of nationalism and German *völkisch* ideology, Nolde was declared "degenerate" in 1933 and, in 1937, 1052 of his works were confiscated from German museums. In 1941 he was forbidden to work; a series of "unpainted pictures," small watercolors for the most part, were the result. He never lost his love of bright, startling color or of the flat northern landscape.

OPPENHEIMER, MAX. Austrian, born in 1885 in Vienna; died 1954 in New York. Habitually signed his works "MOPP." An Expressionist who was greatly influenced by Klimt, Schiele, and Kokoschka, Oppenheimer studied at the Vienna and Prague Academies. He moved between Vienna and Berlin and contributed to *Die Aktion* and other Expressionist reviews. He was known especially for his posters. He spent much of World War I in Zurich and then lived mainly in Vienna and Berlin, emigrating to New York in 1939. In 1937 the Nazi government confiscated nine of his works from German museums.

PASCIN (JULIUS MORDECAI PINCAS). Bulgarian; naturalized American in 1920. Born 1885 in Vidin, Bulgaria; committed suicide in 1930 in Paris. The son of a wealthy Jewish grain merchant of Spanish origin, Pascin was a younger child in a large family (some biographers speak of eight children, others of eleven). He attended primary school in Bucharest, secondary school in Vienna (1895–1901), and then worked for a while in his father's firm. Between 1902 and 1905 he attended art schools in Munich and other cities and began publishing humoristic drawings. In 1905 he signed an exclusive contract with *Simplizissimus* in Munich, drawing for the review regularly for some years. In 1905 he moved to Paris, settling in Montparnasse. He attended various Parisian art schools. Never a member of a movement, Pascin was influenced by Impressionism, Expressionism, and, briefly, by Cubism. He painted above all nude models and prostitutes, using a sinuous line and delicate coloring. He had two mistresses, one of whom he married in 1920. He exhibited at the SA between 1908 and 1912 and participated in the Sbd(C) and the NYAS. At the beginning of World War I he went to London and then New York to avoid being drafted into the Bulgarian Army. He traveled in the U.S. and acquired American citizenship. He then returned to Paris, settling in Montmartre and then Montparnasse. During the 1920s he exhibited frequently and traveled widely, visiting North Africa several times. He became an intimate of the American Lost Generation in Paris. In June, 1930, he hanged himself.

PECHSTEIN, (HERMANN) MAX. German, born 1881 in Zwickau; died 1955 (in Berlin?). One of six children of a textile worker, Pechstein grew up in poverty. While still a child he learned to draw from an uncle. He left school in 1896 and was apprenticed to a decorator in Zwickau. In 1900 he attended the Dresden School of Decorative Art. A ceiling he painted for the 1906 Kunstgewerbeausstellung in Dresden brought him to the attention of the Saxon government, which awarded him a prize the next year, and of Erich Heckel. He joined the Brücke soon after. He spent part of 1907 in Paris and became acquainted with Kees Van Dongen and other painters. In 1908 he settled in Berlin, exhibiting at the Sezession there and, in 1910, cofounding the

Neue Sezession. In 1911 he, with Kirchner, began the "MUIM-Institut," an art school. He left the Brücke in 1912. He exhibited in the second BR show and the Sbd(C). In 1913–14 he and his wife emigrated to the South Seas, settling in the Palau Islands. They were forced to leave when the Japanese invaded the islands and with difficulty made their way back to Europe via the U.S. Pechstein then served in the German army in 1916 and 1917. He did a series of engravings based on the Battle of the Somme. In 1918 he was a cofounder of the NG, and contributed to Socialist causes throughout the 1920s. In 1923 he became a member of the Prussian Academy and a professor at the art school in Berlin-Charlottenburg. He was dismissed from his post in 1933 and from the Academy in 1937; 326 of his works were confiscated from German museums and he was forbidden to exhibit and refused permission to leave Germany. Between 1933 and 1945 he lived in Leba (Pomerania); in 1945 his Berlin studio was bombed and many works destroyed. After 1945 he was made a professor at the Hochschule für bildende Künste in Charlottenburg.

PICABIA, FRANCIS. Spanish and French, born 1878 in Paris; died 1953 in Paris. A wealthy aristocrat, Picabia had among his forbears a Cuban planter and railroad magnate, a wealthy Parisian businessman and amateur photographer, and an art collector. A rebellious but talented student, he was enrolled at the Collège Stanislas and the Lycée Monge (1888–95). He then attended the École des Arts Décoratifs and first exhibited at the academic Salons. He was influenced by Impressionism (ca. 1900), then by Neoimpressionism and Fauvism (ca. 1908–9), and by Cubism (ca. 1909–10). He exhibited with the Cubists and "Orphists" at the Section d'Or in 1912, in the SA and SI (1911–12), the EDH and the NYAS. He was particularly friendly with Marcel Duchamp; the two later produced works that differ radically in appearance but share the same "proto-Dadaist" spirit. Picabia was known for his love of women, racing cars, drugs, and alcohol. He married three times, first a music student, Gabrielle Buffet (1909–31), and he had several children. In 1915, while on a mission for the French Army to buy supplies in the Caribbean he met Duchamp in New York, deserted and failed to return to France, traveling between the U.S., Barcelona, and Switzerland for the remainder of the war. Participating in Dadaist activities in these places, he founded a Dadaist review, *391*, in Barcelona and maintained communications between the various Dadaist groups. He now developed his most distinctive paintings, in which machinery stands for human relationships and sexual activity. Like Duchamp, he was an incorrigible punster. Returning to Paris in 1919, he participated in its Dadaist movement and later in Surrealism. For the Ballets Suédois, in 1924, he wrote *Relâche* and directed a short film shown during the ballet, *Entr'acte*. Duchamp, Erik Satie, and Man Ray participated in the film and the ballet. Picabia settled in a chateau he built in Mougins. He was awarded the Legion of Honor in 1933. During World War II he lived in the south of France; afterward he returned to Paris.

PICASSO, PABLO. Spanish, born 1881 in Malaga; died 1973 near Cannes. The older of two children of a painter and art teacher, Picasso was already a skilled academic painter at the age of twelve. He learned at first from his father and then at the Da

Guarda School of Arts and Industries in La Coruña, where his father taught, the School of Fine Arts in Barcelona (1895–97) and the San Fernando Academy in Madrid (1897–99). He published drawings in various periodicals and, in 1901, served as art editor and illustrator for *Arte Joven* in Madrid. He was early influenced by Naturalism and by leftist ideologies. While living in Barcelona, he visited Paris repeatedly between 1900 and 1903 and was influenced there by Postimpressionism, especially Toulouse-Lautrec and the illustrator Théophile Steinlen. He moved to Paris in 1904, settling in Montmartre until 1912 and spending summers in Spain or in the French countryside. His Expressionistic "Blue Period" (1901–4) was succeeded by the more gentle "Rose Period" (1905–6); thereafter came the experiments, influenced by archaic Spanish and primitive art, that led to Cubism. He lived with Fernande Olivier from 1906 to 1911, most of that time in the Bateau Lavoir, and became friendly with Max Jacob, Guillaume Apollinaire, Henri Rousseau, Georges Braque, Gertrude Stein, *et al*. In 1907, when D. H. Kahnweiler became his dealer, he ceased exhibiting elsewhere on a regular basis, though he did participate in the second NKVM exhibition, the second BR exhibition, the Sbd(C), and the NYAS. His companion after 1911 was "Eva" (Marcelle Humbert), who had left Louis Marcoussis for him. During World War I he remained in France. His Cubist works became more colorful and less abstract and, before the end of the war, he began a series of portrait line drawings inspired by classical models, especially by Ingres. While working with the Ballets Russes in Rome on the ballet *Parade* in 1917 (with Jean Cocteau and Erik Satie), he met Olga Koklova, a ballerina, and married her in 1918. She had the first of his four children, Paolo, in 1921. During the early 1920s he alternated between Cubist and more traditional, classicist works, and then began painting in a Surrealist style as well. He participated in the first Surrealist exhibition in Paris in 1925. He produced sculptures as well as paintings, and eventually ceramics also. He worked for the Ballets Russes, designing sets for de Falla's *Three Cornered Hat* (1919), Stravinsky's *Pulcinella* (1920), Satie's *Mercure* (1924), etc. He lived in Paris and in various châteaux he bought, the first one in the Eure and later others on the Côte d'Azur. He was an implacable foe of fascism and mixed his Surrealist works of the 1930s with Expressionistic, antifascist ones, such as "The Dream and Lie of Franco" and "Guernica," the latter produced within two months in 1937 in his Paris studio to protest the bombing by the Insurgents of a small Spanish town. He had a series of wives and mistresses, each of whom had some influence on his style: Dora Maar, Marie Thérèse Walter, Françoise Gilot, with whom he had two children, and Jacqueline Roque, whom he married in 1961 and who survives him. He spent most of World War II in Paris, sometimes harassed but never harmed by the Nazis. In 1944 he joined the French Communist Party, which had led the antifascist resistance. After the war he settled in the south of France, in Vallauris and Cannes. He continued to produce prolifically in several media and a variety of styles. The outstanding postwar works are series of "recapitulations" of old master paintings, such as Velasquez' "Las Meninas" and Delacroix's "Femmes d'Alger," and bright, childlike line drawings and paintings.

PUNI, IVAN (JEAN POUGNY). Russian; naturalized French in 1946. Born 1894 in Konokkala, Finland; died 1956 in Paris. The son of a cellist of Italian ancestry and of

a Russian woman, Puni, destined for a military career, was educated in the Russian Cadet Corps. With the encouragement of the noted Russian Realist Ilya Repin, he chose to study painting instead, and attended the Académie Julian in Paris ca. 1910–12. He spent 1913 and 1914 in Paris, exhibiting at the SI, and World War I in Russia, where, along with Malevich and Tatlin, he participated in avant-garde exhibitions such as "Tramway V" and "0.10." He signed Malevich's Manifesto of Suprematism. In 1917 he was named professor at the Petrograd Academy, and he and his wife, Xenia Boguslavskaya, taught at the Vitebsk Academy under Chagall. In 1920 he left Russia for Berlin, where he exhibited at the Sturm Gallery in 1921. He worked extensively for the theater. In 1923 he settled in Paris and became friendly with Léger, Amédée Ozenfant, Severini, and Marcoussis. He was not greatly influenced by Suprematism, preferring for the most part to paint in a synthetic Cubist style not unlike that of Severini of the early 1920s. He spent World War II in the south of France and in 1947 he was awarded the Legion of Honor. In 1958 a large posthumous retrospective of his work was held at the Musée National d'Art Moderne in Paris.

ROUAULT, GEORGES. French, born in Paris in 1871 (in the last days of the Commune); died 1958 in Paris. His father was a cabinetmaker from Brittany. From 1885 to 1890, apprenticed to a stained-glass painter, he worked on the restoration of medieval windows. He attended evening classes at the École des Arts Décoratifs. In 1890 he enrolled at the École des Beaux-Arts, studying first with Élie Delaunay and then Gustave Moreau, in whose studio he met Matisse and Marquet. He was early attracted to religious subjects, and his style was greatly influenced by his work with stained glass. In 1903 he was appointed curator of the newly founded Musée Gustave Moreau (comprised of works willed to the government by Moreau). Rouault was a cofounder of the Salon d'Automne in 1903; for a few years he exhibited somber paintings of prostitutes and circus performers. He was a member of the *"cage aux fauves"* at the 1905 SA. He married in 1908 and had four children. In 1908 he painted a series of "Judges and Tribunals" based on observation. In 1911 he moved to Versailles, where he became friendly with Jacques Maritain. From 1913 he was represented by Ambroise Vollard. Between 1917 and 1927 Vollard commissioned several series of illustrations, including "Miserere," based on World War I. It was published only in 1948, after Vollard's death. Beginning in 1918 Rouault turned increasingly to religious subjects, especially the Passion. His works became more colorful, and he labored over many of them for years, building up layer after layer of paint. In 1929 he designed sets and costumes for Diaghilev's production of *The Prodigal Son* (music by Prokofiev and choreography by Balanchine). In 1937 he had a retrospective at the Petit Palais. After a lawsuit against Vollard's heirs in 1947 for return of hundreds of his paintings, he burned 315 canvases. A ceramicist since before World War I, he began producing enamel work in 1949. He was given a state funeral at Saint-Germain-des-Prés.

ROUSSEAU, HENRI. French, born in Laval (Mayenne) in 1844; died 1910 in Paris. Rousseau was the fourth of five children of a tinsmith. He attended the Laval

Lycée, winning prizes for drawing and singing. In 1863 he worked for a lawyer; then, after being sentenced to one month in prison for petty larceny, he volunteered for a seven-year army stint. In 1868 his father died; he left the army, obtaining a discharge as sole support of his mother. In 1869 he married Clémence Boitard and settled in Paris. They had nine children, all of whom, except for a daughter, Julia, died in infancy. He entered the Paris toll service as second-class clerk, a position he held until his retirement. In 1884 he began copying paintings in the national museums; in 1886 he exhibited for the first time at the SI—he would exhibit there every year thereafter except 1899 and 1900. In 1888 his wife died. In 1892 he received a silver medal in a painting competition held by the Municipality of Paris. In 1893 he retired from the toll service and devoted himself henceforth wholly to painting, living in Montparnasse. By this time he had evolved his highly personal, primitive style, painting views of Paris and its suburbs and portraits of his friends. More and more he began to depict exotic scenes as well, particularly jungles. ''The Sleeping Gypsy,'' perhaps his most famous work, was painted in 1897. In 1899 he married Josephine Noury, who died in 1903. In 1900 he began to give violin and painting lessons; he played in the orchestra of the Amicale of the Fifth Arrondissement. In 1908 Picasso organized a party in his honor in the Bateau Lavoir. He began holding ''musical and family evenings'' at his apartment in Montparnasse. In 1909 he was tried for fraud, given a suspended sentence, and fined 100 francs. His paintings began to sell and Wilhelm Uhde, one of his first admirers who dealt in his work, arranged a one-man show at a furniture shop on the rue Notre-Dame-des-Champs. He died alone the next year at the Hôpital Necker. He was buried in a pauper's grave, but his remains were removed a year later to a plot by Delaunay and other friends. In 1947 his remains were again removed, to Laval.

RUSSOLO, LUIGI. Italian, born in Portogruaro (Veneto) in 1885; died 1947 in Ceno Lago Maggiore. One of five children of a watchmaker who was also a church organist, Russolo was a brilliant student. He studied piano and violin and retained his interest in music after deciding to become a painter. He had no academic training; having taught himself to draw, he gained experience in Milan by working on restoration of Leonardo's ''Last Supper'' and the Castello Sforzesco. He signed the first Futurist manifesto in 1910. His paintings, on the typical Futurist themes of modern life, were abstract in style. In the same period he was experimenting with new musical instruments. He invented ''noise instruments'' called *intonarumori* and wrote a manifesto on the art of noise (*bruitism*). In 1915 he volunteered for the Lombard Cyclist Battalion along with Marinetti and Boccioni. He received a head wound and was decorated for bravery. After the war he ceased painting and devoted himself entirely to his musical experiments.

SCHIELE, EGON. Austrian, born 1890 in Tulln an der Donau; died 1918 in Vienna. The son of a railroad traffic controller, Schiele had three sisters. The family lived at the Tulln railroad station, and the young Schiele began to draw the trains seen out of his window. His parents wanted him to become an engineer; they disapproved of his artistic inclinations and burned his drawings. He attended school in Tulln and,

from 1900 to 1906, the Gymnasium in Krems and then in Klosterneuburg. After his father's death in 1905, his mother moved to Vienna; Schiele came with her. He studied from 1906 to 1909 at the Vienna Academy and was influenced by Klimt. In 1912 he was imprisoned for twenty-four days for corrupting minors with his drawings of nudes. Less decorative and more tense than Klimt's, his works display a tortured and extremely idiosyncratic use of line. Though he did landscapes and buildings, his major subject matter was women and children. He participated in the Sbd(C) and contributed drawings to *Die Aktion* and other Expressionist reviews. He was accepted for military service in 1915 after having been declared unfit to serve twice previously. An enthusiastic soldier, he was nevertheless found unfit for front duty and eventually given sentry duty near Vienna, where he could paint and spend time with his wife, Edith Harms, whom he had married in 1915. He was also able to travel within Austria and to exhibit—in Zurich, at the Berlin and Munich Sezessions, and in Scandinavia. In October, 1918, both he and his pregnant wife died of influenza.

SCHLEMMER, OSKAR. German, born 1888 in Stuttgart; died 1943 in Baden-Baden. Schlemmer's parents died when he was a child. From 1903 to 1905 he served an apprenticeship in an intarsia workshop. In 1905 he attended the Stuttgart School of Applied Arts, and from 1906 to 1910 the Stuttgart Academy, where he became friendly with Willy Baumeister, later a noted abstractionist. Schlemmer again studied at the Stuttgart Academy in 1912, under Adolf Hoeltzel, and again in 1918–19. In 1914 he made three wall paintings for the Cologne Werkbund exhibition. He served in the German army during World War I. In 1916 the first part of his *Triadic Ballet*, for which he had done both choreography and costumes, was performed. In 1919 he returned to Stuttgart and, as a member of a revolutionary student council, tried unsuccessfully to reform the Academy. With other students he founded the "Uecht-Group" of avant-garde artists. In 1920 he married Helene Tutein ("Tut"), who survives him. The same year he exhibited at the Sturm Gallery and was appointed to the Bauhaus, where he served as Master of wall painting (1920–22), of wood and stone sculpture, and of metal work (1923–30). He produced highly polished metal sculptures as well as paintings. In both, influenced by Cubism, he represented the human figure by means of regular, curvilinear forms, much like those the Purists were then using in Paris. He continued his ballet work, enlarging and improving the *Triadic Ballet* and planning an experimental theater. In 1923 he and his students painted murals in the Bauhaus workshop building in Weimar. In 1928–30 he painted nine murals for the Folkwang Museum in Essen. In 1930 he accepted a professorship at the Breslau Academy; in 1932 he moved to the Vereinigte Staatsschulen für Kunst in Berlin-Charlottenburg. He was dismissed in 1933 and an exhibition planned for the Stuttgart Kunstverein was canceled by the government. Back in 1930 Thuringian Nazis had destroyed the Weimar murals; in 1934 those in the Folkwang Museum were removed. In 1937, 51 of his works were removed from German museums. From 1938 to 1940 he worked for a camouflage firms in Stuttgart; from 1940 until he became ill in 1942 he worked for a Wuppertal varnish factory.

SCHMIDT-ROTTLUFF, KARL. German, born Karl Schmidt in 1884 in Rottluff, near Chemnitz. The son of a miller, Schmidt-Rottluff finished secondary school in Chemnitz and, in 1905, he entered the Technische Hochschule in Dresden to study architecture. Already acquainted with Heckel in Chemnitz, he now met Kirchner and Bleyl, and the four founded the Brücke in 1905. Like the other Brücke members, he lived in Dresden until 1911, spending summers in the North German countryside painting landscapes, and then settled in Berlin. He exhibited with the Brücke, at the Berlin Neue Sezession in 1910, and at the Sbd(D). From 1915 to 1918 he served on the eastern front, together with the poet Richard Dehmel and the novelist Arnold Zweig. He produced some woodcuts on religious themes and a "War Portfolio" at the end of the war. When back in Berlin, he joined the AfK and the NG. He married in 1919. During the 1920s he worked with the Reichskunstwart, designing printed matter and an emblematic eagle for the Weimar Republic. He became a member of the Prussian Academy in 1931 but was forced to resign by the Nazi government in 1933. In 1937, 608 of his works were removed from German museums, 51 of these being shown in the "Degenerate Art" exhibition in Munich. In 1941 he was dismissed from the Artists' Council (*Kunstkammer*) and forbidden to work and exhibit. In 1943 his house and studio were bombed and he moved to Rottluff for the remainder of the war. He now lives in Berlin.

SCHRIMPF, GEORG. German, born 1889 in Munich; died 1938 in Berlin. The son of a businessman who died before he was born, Schrimpf and several siblings were raised by his brutal stepfather, a baker. After attending elementary school he was apprenticed to a confectioner at the age of 13, even though he wanted to be a decorative artist. Before World War I he worked in Munich and Ascona as a confectioner, became an anarchist, and taught himself to paint. He served briefly at the beginning of the war but was released due to a rheumatic illness. He moved to Berlin in 1915, worked in a chocolate factory, began to contribute to *Der Sturm* and *Die Aktion*, and married a painter, Maria Uhden, who died in 1918. His most characteristic works were figure paintings executed in a naïve style. In 1918 he joined the Novembergruppe and returned to Munich. He spent much time after 1922 in Italy, where his work influenced that of Carrà and of the "Valori Plastici" group. From 1926 to 1933 he taught at the Städtische Westenrieder Gewerbeschule in Munich and from 1933 to 1938 at the Staatliche Kunstschule in Berlin-Schöneberg. Thirty-three of his works were confiscated from German museums in 1937 and he was dismissed from his teaching post in 1938.

SCHWITTERS, KURT. German, born 1887 in Hanover; died 1948 in Kendal, near Ambleside, England. The only child of a seamstress and a middling merchant of ladies' wear, Schwitters lived most of his life in Hanover. He was an epileptic from childhood and frequently ill. After completing the Maturität at the Hanover Realgymnasium in 1908, he studied at the Hanover Kunstgewerbeschule in 1908 and 1909. As interested in music and poetry as in painting, he wrote poetry throughout his life. He spent 1909–14 at the Dresden Academy and studied briefly

in Berlin. He was early influenced by Expressionism, and he discovered his own, novel style only during World War I. He did office work in the army during 1917, having been found unfit for service at the front; for the remainder of the war he worked as a mechanical illustrator in an iron factory. He married a distant cousin in 1915 and had one son, born in 1918. Antimilitaristic during the war, he was enthusiastic over the revolutionary events and quit his job. He returned to Hanover, supported his family by working as an advertising designer and consultant (opening his own firm), evolved his abstract "Merz" (from *Kommerz*, commerce) style, which featured rubber stamps and bits of old paper and trash picked up on the street, and began the *"Merzbau"* ("Merz construction"), turning rooms of his house into cavelike spaces and grottoes made of scraps of wood and decorations. His friends decorated some of the grottoes. He collaborated on *Der Sturm*, participated in some activities of the Berlin Dadaists, including the lecture tour to Prague, Dresden, and other cities in 1921, contributed to *De Stijl* during the 1920s, and began his own review, *Merz* (1923–32). In the 1930s he became a member of the "Abstraction-Création" group in Paris. He emigrated to Norway in 1937, beginning a new *Merzbau* there, and then to England in 1940. In 1937 many of his works were removed from German museums and shown in the Munich "Degenerate Art" exhibition. The *Merzbau* in Hanover was destroyed in 1943; he began a third one in England after 1945.

SEVERINI, GINO. Italian, born 1883 in Cortona (Umbria); died 1966 in Paris. The son of a dressmaker and an usher in a law court, Severini was largely raised by his equally poor grandparents. He was expelled from school at fifteen for stealing examination questions and thereafter moved with his parents to various small towns. In 1899 he moved with his mother to Rome: she resumed her trade to help him become a painter, and he worked at menial jobs, studying drawing on the side. A priest from Cortona subsidized his studies between 1900 and 1902; he met Boccioni and Balla during this period and studied philosophy and social thought. He was influenced by Impressionism and Neoimpressionism. In 1905 he moved to Paris, settling in Montparnasse and later Montmartre. He was influenced by Cubism around 1910 and joined the Italian Futurists in 1912, though living mainly in Paris. An habitué of Paris dancehalls, he frequently painted the night life in a fragmented, cubistic fashion. In 1913 he married Jeanne Fort, daughter of the poet Paul Fort, and spent the next year in Italy. He was ill when the war broke out and was not drafted. He and Jeanne had two children. Returning to Paris late in 1914, he painted several works on war themes and then returned to a Cubist style until 1921. He became increasingly interested in classical proportions, applying these in his Cubist works. In 1923 he underwent a religious conversion and decorated three Swiss churches during the 1920s. During the 1930s he received commissions for frescoes and mosaics for public buildings in Italy. He wrote extensively, publishing art theories, views on art and society, and an autobiography. During the last twenty years of his life he increasingly received commissions, participated in exhibitions, and won prizes, though his innovative work had been done before 1914.

SOUTINE, CHAIM. Lithuanian, born 1893 in Smilovitchi, near Minsk; died in Paris in 1943. The tenth of eleven children of a poor Jewish tailor, Soutine grew up in extreme poverty, in the cheerless, provincial *shtetl* where he was born. Dedicated to drawing by the age of thirteen, he was frequently beaten by his father and older brothers for the sin of making images. Upon receiving a small compensation after having been beaten mercilessly by the sons of a pious Jew he had asked to pose for him, he left Smilovitchi for Minsk (ca. 1909), where he took drawing lessons. He subsequently studied at the Vilna School of Fine Arts (1910–13), and then under Cormon in Paris, where he lived at the Ruche (and occasionally at the Cité Falguière in Montparnasse) until 1919. He was befriended by Modigliani as well as several fellow East Europeans. Desperately poor, he worked part-time as a railway porter and, during the war, as a ditch digger. At this time, under the influences of El Greco and Van Gogh, he developed his characteristic Expressionist style, with its tortured, highly colored landscapes, still-lifes, and portraits. In his numerous paintings of cattle carcasses, fish, and fowl, he turned an obsession with sustenance, the result of his hard childhood in the *shtetl* and even harder youth, into art; in portraits of choirboys and servants, he insistently repeated his childhood acts of sacrilege. In Céret (Pyrenees) between 1919 and 1922, and then in Cagnes (on the Riviera) until 1925, he produced his finest landscapes; from 1923 to 1928 he depicted uniformed humans and dead animals. Although financially secure after 1923, he was nevertheless beset by complexes and phobias. After 1925 he lived mainly in Paris, spending summers in the South and, between 1931 and 1935, in Chartres. His paintings became calmer, more carefully composed, and lower-keyed. His only known lasting liaison, with "Mlle. Garde" (Gerda Groth), was from 1936 to 1939. Under the German occupation he took refuge in small towns outside Paris; he was frequently discovered and threatened by the Nazis. He died during an operation for a ruptured ulcer.

TAEUBER-ARP, SOPHIE. Swiss, born 1889 in Davos; died 1943 in Zurich. Taeuber studied decorative art at the École des Arts et Métiers in St. Gall (1908–10) and the Hamburg Schule für Kunst und Gewerbe (1912) and painting with von Debschitz in Munich (1911–13). She was a member of the Schweizerischer Werkbund from 1915 to 1932 and, from 1916 to 1929, Professor at the Zurich Schule für Kunst und Gewerbe. She participated in Dadaist activities in Zurich from 1916 to 1920. In 1922 she married Hans Arp. The Arps were active in Strasbourg, completing mural and window paintings on a private commission in 1926 and, with Theo van Doesburg, decorating a nightclub, L'Aubette, in 1927 and 1928. From 1928 to 1940 they lived in Meudon-Val-Fleury, outside Paris, in 1941 in Grasse, and then in Switzerland. In the 1930s they participated in the "Abstraction'Crátion" movement in Paris. In 1937 Taeuber founded an art review, *Plastique*, and directed it until 1939. Her death was accidental.

TAPPERT, GEORG. German, born 1880 and died 1957 in Berlin. An Expressionist who produced chiefly portraits and flower paintings, Tappert studied at the Karlsruhe Academy and, under the architect Paul Schultze-Naumburg, in Saaleck. He was

cofounder of an art school in Worpswede in 1909, the same year in which he became a professor at the Berlin Staatliche Kunstschule. In 1910 he was a cofounder of the Neue Sezession in Berlin. He exhibited in the second BR show. He was a cofounder of the NG in 1918 and, from then until 1933, Professor at the Hochschule für Kunsterziehung in Berlin. In 1933 he was dismissed by the Nazi government and barred from exhibiting. After 1945 he was a professor at the Hochschule für bildende Künste in Berlin.

TATLIN, VLADIMIR. Russian, born 1885 in Kharkov, in the Ukraine; died 1953 in Novodevichye. By 1910, Tatlin was in Moscow, studying at the Academy. He was early influenced by icons and by Cézanne; upon meeting Picasso in Paris in 1912, he turned to Cubism, making Cubist relief constructions out of wood, cardboard, metal, cement, and tar. He covered their surfaces with glazes on which he sprinkled powder or broken glass (1913–14). His works soon became nonfigurative. In 1915 he exhibited in "Tramway V" and "0.10" in St. Petersburg with Malevich, Puni, *et al.* After the November Revolution he was given a teaching post at the Higher Technical-Artistic Studios (Vhutemas) in Moscow. He led the "Productivists," who, in opposition to Malevich, advocated the application of art to utilitarian ends. In 1919 he made an 82-foot model for a "Monument to the Third International," which was to be 1,312 feet high and house a public information center and meeting halls. It was to be formed of a sphere, pyramid, and cube, each of which would rotate at a different rate. In 1922 Tatlin moved to Leningrad, teaching at the Research Institute for Artistic Culture (INKCHUK) and designing consumer goods. After 1927 he taught ceramics at the reorganized State Art Studios. More and more in disrepute, he spent his last years in poverty in a former monastery in Novodevichye which was run as a home for needy artists.

VILLON, JACQUES (GASTON DUCHAMP). French, born in Damville, near Rouen, in 1875; died in 1963 in Puteaux. An elder brother of Marcel Duchamp, Villon was one of six children of a Norman notary. He attended the Rouen lycée and then the law school there, until 1894, when he went to Paris to study art at Cormon's studio, drawing cartoons for a living. A cofounder of the SA in 1903, he participated in its subsequent exhibitions. After 1909, Villon began painting in the Cubist style. In the Puteaux studio of Villon and his sculptor brother, Raymond Duchamp-Villon, a group of artists, chiefly Cubists, gathered for weekly meetings, forming the Section d'Or in 1912 and exhibiting together at the Galerie La Boëtie. Villon participated in the NYAS. During World War I he served in the army and then in a camouflage section; he produced many realistic and Cubist war drawings. In 1921 he engraved a series of 34 "Architectures"; many of his postwar works were abstract. During World War II he stayed in Bernay (Eure), then in Brunié (Tarn). After the war he won increasing recognition, exhibited frequently, and received the Legion of Honor in 1953.

VLAMINCK, MAURICE. French, born 1876 in Paris; died 1958. The son of a Flemish violinist and a French pianist who were quite poor, Vlaminck and his four siblings

were raised at a grandmother's house in Le Vésinet, outside Paris. He received musical training and supported himself for years by giving music lessons and playing in orchestras. Though a good student, he disliked school. He learned drawing privately from a Vésinet harness-maker and an academic painter. He participated, with considerable financial success, in bicycle races from 1893 to 1896; from 1897 to 1900 he did military service and, radicalized by his experiences, participated in Parisian anarchist groups for a few years after his release. He married in the 1890s and had two daughters; he was to have two more in the 1920s with a second wife. He met André Derain in 1900 and the two set up a joint studio in Chatou on the Seine and began producing similarly expressionistic landscapes under the influence of Postimpressionism. Vlaminck also wrote, and Derain illustrated, a series of semipornographic novels between 1902 and 1907. He exhibited with the Fauves at the 1905 and 1906 SA, repeatedly thereafter at the SA and SI, at Vollard's gallery, at the second NKVM exhibition, the second BR exhibition, the Sbd(C), and the NYAS. Painted with large strokes and a thick impasto, his works were predominantly landscapes of the Seine Valley. He was mobilized in the infantry in 1914, but, antimilitaristic, was recalled to Paris through the intercession of relatives and worked as an industrial draftsman, then as a turner, in a factory. After the war he settled in the country near Paris. He grew increasingly well-known and exhibited frequently. Beginning in 1929 with *Tournant dangereux*, he published a series of memoirs. He spent World War II at his country house in the Eure-et-Loire; in 1941, along with Derain, Friesz, Dunoyer de Segonzac, Van Dongen, *et al.*, he visited Arno Breker in Berlin. Reputedly a Nazi sympathizer, he was arrested in August, 1944, but released after forty-eight hours.

VOGELER, HEINRICH. German, born 1872 in Bremen; died 1942 in the U.S.S.R. The son of a merchant, Vogeler attended the Düsseldorf Academy. He was early influenced by socialist ideas and by such leftist writers as Maxim Gorki. In 1894 he became one of the first artists to settle in Worpswede, near Bremen. He painted realistic scenes of peasant life and scenes from fairy tales in a Jugendstil manner, and later was influenced by Naturalism. He was married and had two daughters. His marriage failed just before World War I and he volunteered, though past military age, and served in Poland, Rumania, and France between 1914 and 1918. Under the influence of the Russian Revolution, he wrote a letter to Wilhelm II protesting the Treaty of Brest-Litovsk early in 1918; he was arrested and committed to an asylum for the remainder of the war. In 1918 he was a member of the Bremen Workers' and Soldiers' Council. He founded a utopian commune in his Worpswede home, Barkenhoff, and gave the home to the Communist Internationale Arbeiterhilfe in 1923 to be used as a children's home. He had painted revolutionary frescoes in the dining room, which he was forced to cover up in 1927. He joined the German Communist Party in 1926. He visited the Soviet Union several times beginning in 1923 and was invited to settle there in 1931. He traveled widely for the Soviet government, organizing architectural and agrarian projects, observing the peoples of various regions and producing propaganda posters in a cubistic style.

After the Soviet Union entered World War II he was evacuated to Kazakhstan, where he died.

WEREFKINA, MARIANNE VLADIMIROVNA. Russian, born 1860 in Tula; died 1938 in Ascona, Switzerland. An aristocrat and the daugher of a general who, after 1886, was governor of the Peter and Paul Fortress in St. Petersburg, Werefkina grew up in luxury. She received art lessons as a child and, after 1886, studied with Ilya Repin, the noted Russian Realist, in St. Petersburg. In his studio she met Alexei Jawlensky, with whom she lived from 1891 to 1918. She rejected Repin's Realism, preferring the then developing Russian symbolism; she was also influenced by Nietzsche and by the Rosicrucianism of "Sar" Peladan. In 1896 she, Jawlensky, and other Russian painters settled in Munich. She painted mainly landscapes and brightly colored still-lifes, in an expressionist manner. She was a cofounder of the NKVM, participating in its two exhibitions and in the EDH. At the outbreak of World War I, she and Jawlensky left for Switzerland to avoid internment as enemy aliens. She lived at first in St. Prex and Zurich and in 1918 settled in Ascona, remaining there for the rest of her life.

Notes

CHAPTER 1 (pp. 3–18)

1. Letter to the Minister of Fine Arts, refusing the Legion of Honor. Quoted in Charles Léger, *Courbet* (Paris: Crès, 1929), p. 155.
2. Irving Stone (ed.), *Dear Theo: The Autobiography of Vincent Van Gogh* (New York: New American Library, 1969), p. 327.
3. The best account of the development of art academies is Nikolaus Pevsner, *Academies of Art, Past and Present* (Cambridge: Cambridge University Press, 1940).
4. *Ibid.*, pp. 82–85. On seventeenth-century Italian academies, *see also* Francis Haskell, *Patrons and Painters* (New York: Alfred A. Knopf, 1963). A useful but not always accurate study of artists' personalities and social attitudes from the Renaissance to the French Revolution is Rudolph and Margot Wittkower, *Born Under Saturn* (New York: Norton, 1963).
5. On the early period of the French Academy, see Pevsner, *op. cit.*, pp. 82–106, and Harrison C. and Cynthia A. White, *Canvases and Careers: Institutional Change in the French Painting World* (New York, London, Sydney: John Wiley and Sons, 1965), pp. 5-12.
6. David L. Dowd, *Pageant-Master of the Republic: Jacques-Louis David and the French Revolution* (Lincoln: University of Nebraska, 1948), *passim;* Donald Drew Egbert, *Social Radicalism and the Arts: Western Europe* (New York: Alfred A. Knopf, 1970), p. 26.
7. White, *op. cit.*, p. 17. The most comprehensive study of the nineteenth-century Academy is Albert Boime, *The Academy and French Painting in the Nineteenth Century* (London: Phaidon, 1971).
8. Linda Nochlin, "The Invention of the Avant-Garde: France, 1830-80," in Thomas B. Hess and John Ashbery (eds.), *Avant-Garde Art* (New York: Collier, 1967), p. 21.
9. Egbert, *op. cit.*, p. 121; Renato Poggioli, *The Theory of the Avant-Garde* (New York: Harper and Row, 1971), pp. 8-12.
10. Frederick Antal, "Reflections on Classicism and Romanticism," *Classicism and Romanticism* (New York: Basic Books, 1966), p. 10.

11. *See* Dowd on the period up to 1794; and, more generally, Étienne Jean Delécluze, *Louis David: Son école et son temps* (Paris: Didier, 1855), Walter Friedlaender, *David to Delacroix* (New York: Schocken, 1968), pp. 12-35, and James A. Leith, *The Idea of Art as Propaganda in France, 1750-1799* (Toronto: University of Toronto Press, 1965).

12. Pierre Gaudibert, "Eugène Delacroix et le romantisme révolutionnaire," *Europe*, No. 41 (April, 1963), 4-21.

13. T. J. Clark, *The Absolute Bourgeois: Artists and Politics in France, 1848-1851* (London: Thames and Hudson, 1973), p. 131; Gaudibert, *op. cit.*, pp. 16-18.

14. Reprinted in French in Ramon Guthrie and George E. Diller, *French Literature and Thought Since the Revolution* (New York: Harcourt, Brace and Company, 1942), pp. 149-50.

15. *Du principe de l'art et de sa destination sociale* (Paris: Garnier Frères, 1865), pp. 369-76 and *passim*.

16. Charles Baudelaire, "De l'héroïsme de la vie moderne," *Salon de 1846, Oeuvres complètes* (Paris: Gallimard, 1961), pp. 949-52. On the relation of this theme to Realism, see Linda Nochlin, *Realism* (Harmondsworth, Baltimore and Victoria: Penguin, 1971), pp. 179-206.

17. See Nochlin, *Realism, passim,* and, on Germany, Richard Hamann and Jost Hermand, *Gründerzeit* ([East] Berlin: Akademie Verlag, 1965) and *Naturalismus* ([East] Berlin: Akademie Verlag, 1959). And on Italy, *see below*, pp. 38–39.

18. Robert L. Herbert, "City vs. Country: The Rural Image in French Painting from Millet to Gauguin," *Artforum*, VIII, No. 6 (February, 1970), 45-49.

19. Meyer Schapiro, "Courbet and Popular Imagery: An Essay on Realism and Naïveté," *Journal of the Warburg and Courtauld Institutes,* IV (1940), 164-91.

20. Quoted by Nikolaus Pevsner, *Pioneers of Modern Design* (Harmondsworth: Penguin Books, 1960), p. 22.

21. Siegfried Giedion, *Mechanization Takes Command: A Contribution to Anonymous History* (New York: Norton, 1948), pp. 347-48, 357-59; Egbert, *op. cit.*, pp. 597-99; Pevsner, *Pioneers . . .* , pp. 25-36.

22. Quoted from a letter of January, 1855, to Champfleury, in Benedict Nicolson, *Courbet: The Studio of the Painter* (New York: Viking, 1973), p. 60.

23. *See* Nochlin, *Realism,* pp. 118-19. The "wretched of the earth" were, and still are, celebrated in the *Internationale*, composed in 1871 by Eugène Pottier.

24. On anarchist theory, see James Joll, *The Anarchists* (London: Eyre and Spottiswoode, 1964); on theory and practice, see George Woodcock, *Anarchism: A History of Libertarian Ideas and Movements* (Cleveland and New York: World Publishing Company, 1962).

25. Their letters to Jean Grave, preserved at the Institut d'Histoire Sociale Contemporaine in Paris, testify to this. Some of these have been published by Robert L. and Eugenia W. Herbert in "Artists and Anarchism: Unpublished Letters of Pissarro, Signac and Others," *Burlington Magazine*, CII, Nos. 692, 693 (November and December, 1960), 473-82, 517-22. *See also* Eugenia Herbert's study of the left-wing French and Belgian artists and writers of the 1880s and '90s, *The Artist and Social Reform: France and Belgium, 1885-1898* (New Haven: Yale University Press, 1961).

26. "Impressionnistes et révolutionnaires," *La Révolte*, IV, No. 40 (June 13-19, 1891). Cf. Herbert, *The Artist and Social Reform,* pp. 189-90.

CHAPTER 2 (pp. 19–41)

1. Juan Gris, *Letters,* ed. and trans. by Douglas Cooper (London: privately printed, 1956), letter to D. H. Kahnweiler, November 27, 1921, p. 128.

2. Quoted by Charles Hotz, *L'Art et le peuple* (Marseille: Editions de la Société "Arts et Excursions," 1910), p. 29.
3. On the working-class movements at the turn of the century, *see* James Joll, *The Second International, 1889-1914* (New York: Harper and Row, 1966) and *The Anarchists* (London: Eyre and Spottiswoode, 1964), Jean Maitron, *Histoire du mouvement anarchiste en France, 1880-1914* (Paris: Société Universitaire d'Éditions de Librairie, 1951); on the Dreyfus Affair, Douglas Johnson, *France and the Dreyfus Affair* (New York: Walker and Company, 1966), Charles Péguy, *Notre jeunesse* (1910), and various treatments by novelists (especially Roger Martin du Gard's *Jean Barois*, 1913); on intellectuals' attitudes to Positivism and other timely issues, H. Stuart Hughes, *Consciousness and Society* (New York: Vintage Books, 1958); on Symbolism, Philippe Jullian, *The Symbolists* (London: Phaidon, 1973); on artists and radicalism in the 1880s and '90s, Eugenia W. Herbert, *The Artist and Social Reform* (New Haven: Yale University Press, 1961).
4. Stefan Zweig, *The World of Yesterday* (Lincoln: University of Nebraska Press, 1964), pp. 25-26.
5. Erich Mendelsohn, *Briefe eines Architekten* (Munich: Prestel Verlag, 1961), letter of September 17, 1914, p. 30.
6. An idea of what appealed to a typical late-nineteenth-century art patron can be had from Jean Paul Crespelle's *Les Maîtres de la belle époque* (Paris: Hachette, 1966). For an anarchist's analysis of the extent to which this art expresses and portrays middle-class society, see Francis Jourdain, "L'Art officiel de Jules Grévy à Albert Lebrun: Vingt ans de grand art ou la leçon de la niaiserie," *Le Point*, XXXVII (Mulhouse: April, 1949).
7. *Der Ararat*, I, No. 4 (January, 1920). The Kaiser continued, referring to the avant-garde: "As ruler I find it extremely unfortunate that art does not, through its masters, take a strong enough stand against such tendencies." Wilhelm and his Empress fought the modern school tooth and nail. See below, pp. 119–20.
8. "Irrweg der 'Abstrakten,'" *Die Welt*, Berlin, October 11, 1953.
9. He entered these lines twice within a fortnight: December 21, 1907, and January 2, 1908. Printed in Umberto Boccioni, *Gli Scritti editi e inediti*, ed. Zeno Birolli (Milan: Feltrinelli, 1971), pp. 271, 273.
10. Kees Van Dongen, *Van Dongen, raconte ici la vie de Rembrandt et parle, à ce propos, de la Hollande, des femmes et de l'art* (Paris: Flammarion, 1927), pp. 16-17.
11. Alfred Kubin, "Autobiography," in *The Other Side: A Fantastic Novel*, trans. Denver Lindley (New York: Crown Publishers, 1967), p. iv.
12. Maurice de Vlaminck, *Tournant dangereux: Souvenirs de ma vie* (Paris: Stock, 1929), p. 22.
13. Quoted by Donald E. Gordon, *Ernst Ludwig Kirchner* (Cambridge, Mass.: Harvard University Press, 1968), p. 14, from a letter to Dr. Carl Hagemann of June 30, 1937.
14. André Derain, *Lettres à Vlaminck* (Paris: Flammarion, 1955), p. 96.
15. Pierre Cabanne, *Entretiens avec Marcel Duchamp* (Paris: Pierre Belfond, 1967), p. 37.
16. Quoted in Lothar-Günther Buchheim, *Otto Mueller: Leben und Werk* (Feldafing: Buchheim Verlag, 1963), p. 32.
17. Hermann Bahr, *Tagebuch* (Berlin: Paul Cassirer, 1909) entry of December 26, [1905], p. 90.
18. Gordon, *op. cit.*, p. 18; "Aus den 'Erinnerungen' von Fritz Bleyl," *Bildnisse der Brücke-Künstler von einander* (Stuttgart: Reclam, 1961), p. 23.
19. Vlaminck, *Tournant dangereux*, pp. 45-74. Cf. Derain, *op. cit.*, pp. 19-143.
20. M. Wlaminck [*sic*], "L'Anniversaire," *Le Libertaire*, Ser. 3, VII, No. 56 (January 13-20, 1901), 5; "Le Chemin," *ibid.*, No. 73 (July 13-20, 1901), 2-3; "L'Entente," *ibid.*, VI, No. 55 (December 16-23, 1900), 2-3. He later said he had written for other journals and had problems with the police over his anarchist activities, but I have been unable to corrob-

orate this. *See* Derain, *op. cit.*, p. 59. According to Marcel Sauvage, *Vlaminck: Sa vie et son message* (Geneva: Pierre Cailler, 1956), p. 97, he collaborated on *Fin de siècle* and *L'Anarchie* between 1898 and 1899.

21. Vlaminck, *Portraits avant décès* (Paris: Flammarion, 1943), p. 110.

22. *Tournant dangereux*, pp. 93-94. Cf. Maurice Genevoix, *Vlaminck: I. L'Homme. II. L'Oeuvre* (Paris: Flammarion, 1954), p. 13.

23. Derain, *op. cit.*, pp. 122, 26.

24. Gino Severini, *Tutta la vita di un pittore* (Milan: Garzanti, 1946), pp. 13-14. In retrospect, he realized that they had difficulty reconciling Marx's materialism with their artistic aspirations and reverence for the art of the past. His mother was horrified at hearing his subversive ideas during a visit. His philosophy did not prevent him from requesting and accepting financial support from a prelate (*ibid.*, pp. 15, 19, 30).

25. Grave's extensive correspondence with artists at the Institut d'Histoire Sociale Contemporaine, Paris, documents this collaboration.

26. Quoted in Alvan Francis Sanborn, *Paris and the Social Revolution* (Boston: Small, Maynard and Co., 1905), pp. 383-84. In the first issue Willette explained the review's title: "... when the French people demand bread, they are generally told: 'Here's bread ... As for butter, you can go dig in your ears!'" *L'Assiette au beurre*, No. 1 (1901). The following noted anarchists and socialists collaborated on the journal: Jean Grave, Elisée Reclus, Jean Jaurès, Urbain Gohier, Gustave Hervé, Miguel Almereyda, Charles Malato. *See ibid.*, Nos. 222 (July 1, 1905), 263 (April 14, 1906), and 451 (November 20, 1909).

27. *L'Assiette au beurre*, No. 30 (October 26, 1901), "Petite histoire pour petits et grands nenfants [*sic*]." For other examples of Van Dongen's work, *see ibid.*, No. 12 (June 20, 1901), No. 18 (August 1, 1901) and *Les Temps nouveaux*, September 30, 1905 and July 28, 1906.

28. *L'Assiette au beurre*, No. 177 (July 20, 1904). Kupka's espousal of anarchism is documented in his correspondence with Jean Grave from ca. 1905 to 1908. (Paris, Institut d'Histoire Sociale Contemporaine.) For other Kupka drawings, see *Les Temps nouveaux*, August 26, 1905, July 14, 1906, December 8, 1906.

29. *L'Assiette au beurre*, No. 8 (May 23, 1901), "Pour Dieu, pour le Tsar, pour la Patrie."

30. *Ibid.*, No. 392 (October 3, 1908), "Bruits de guerre et bruits de paix," a response to tensions between Austria and Russia on the eve of Austria's annexation of Bosnia and Herzegovina. The cover of this issue shows the German Chancellor von Bülow saying: "Instead of shells we shall henceforth use only olive branches, which we'll let fall on the world. That is why we need so many cannons."

31. *Ibid.*, No. 438 (August 21, 1909). *See also ibid.*, No. 398 (November 14, 1908), No. 419 (April 10, 1909), No. 426 (May 29, 1909), No. 427 (June 3, 1909), No. 450 (November 13, 1909), No. 474 (April 30, 1910). Other contributors to *L'Assiette au beurre* were Louis Marcoussis [Markous] (No. 521, March 25, 1911, and No. 540, August 5, 1911), Ardengo Soffici (No. 25, September 19, 1901), and Alfred Kubin, who contributed to an international issue on war, No. 324 (June 15, 1907). André Derain allegedly also contributed cartoons to radical journals under the pseudonym "Bouzi," but I have been unable to find any of these. *See* his *Lettres à Vlaminck*, p. 84. In addition, André Salmon, poet and later intimate of the Cubists, wrote revolutionary poems for the review. *See L'Assiette au beurre*, No. 168 (June 18, 1904) and No. 181 (September 17, 1904).

32. *Simplizissimus*, XII, No. 12 (June 17, 1907), 195, No. 18 (July 29, 1907), 289, No. 35 (November 25, 1907), 557. *See also* XII, No. 33 (November 11, 1907), 527, No. 39 (December 23, 1907), 640, and XIII, No. 20 (August 17, 1908), 336.

33. *Ibid.*, XIV, No. 16 (July 19, 1909), 267. The "Bilder vom Elend" appeared in the following issues: XIV, Nos. 31, 33, 35, 38, 40, 43 (November 1, November 15, November 29, December 20, 1909; January 3, January 24, 1910), 515, 551, 587, 659, 695, 747. *See also* XIII, No. 39 (December 28, 1908), 669; XIII, No. 48 (March 1, 1909), 814; XIV, No. 6 (May 10, 1909), 89; XV, No. 28 (October 10, 1910), 457; XV, No. 42 (January 16, 1911), 721.

34. *Sciarpa nera*, No. 1 (1909), *La Rivolta*, II, No. 5 (May 10, 1911). *See also* his portrait of Nietzsche, *ibid.*, I, No. 31 (November 1, 1910).

35. On the major modern German graphic cycles, see Gerhard Pomerantz-Liedtke, *Der graphische Zyklus von Max Klinger bis zur Gegenwart* ([East] Berlin: Deutsche Akademie der Künste, 1956).

36. *See* Maurizio Fagiolo Dell'Arco. *Balla pre-futurista* (Rome: Mario Bulzoni, 1968), for a catalogue and numerous photographs of Balla's early works. The most noted predecessor for such subjects is, of course, Géricault, but his are static, psychological portraits which do not graphically depict the sitters' infirmities.

37. Umberto Boccioni, "Diario padovano," *Poesia e Critica*, IV, No. 8-9 (May, 1966), 14, entry of March 30, 1907.

38. A small illustration of this work is given in Will Grohmann, *Wassily Kandinsky: Life and Work* (New York: Abrams, n.d.). A narrower version (perhaps the same one?) is to be found in the Städtische Galerie im Lenbachhaus, Munich.

CHAPTER 3 (pp. 48–77)

1. Emil Nolde, *Briefe aus den Jahren 1894-1926* (Berlin: Furche-Kunstverlag, 1927), letter of October 9, 1926, to Max Sauerlandt, pp. 179-80.

2. *See*, for instance, correspondence between August Macke and Franz Marc (*Briefwechsel* [Cologne: M. DuMont Schauberg, 1964]); among the Italian Futurists in Maria Drudi Gambillo and Teresa Fiori (eds.), *Archivi del futurismo*, 2 vols. (Rome: De Luca, 1958, 1962); between Juan Gris and various friends (Gris, *Letters*, ed. Douglas Cooper [London: privately printed, 1956]).

3. *See*, for example, Kirchner's "Erich Heckel and Otto Mueller Playing Chess" (1913) and his group portrait of the Brücke, finished only in 1925, when he was at odds with the other members and at pains to minimize the group's importance. Both works are found in Donald E. Gordon, *Ernst Ludwig Kirchner* (Cambridge, Mass.: Harvard University Press, 1968).

4. *See* the catalogues of the two Balue Reiter exhibitions in Munich, 1911 and 1912, and Wassily Kandinsky and Franz Marc (eds.), *Der blaue Reiter*, reprint, ed. Klaus Lankheit (Munich: Piper, 1963), *passim*. After World War I, a new organization was begun by Feininger, Jawlensky, Klee, and Kandinsky under the name "Blue Four."

5. Georges Ribemont-Dessaignes, *Déjà jadis: Ou du mouvement Dada à l'espace abstrait* (Paris: Juillard, 1958), pp. 31-35. Marcel Duchamp participated less devotedly and regularly, and never lived in Puteaux. Pierre Cabanne, *Entretiens avec Marcel Duchamp* (Paris: Pierre Belfond, 1967), p. 53.

6. Interview of 1953 with Peter Selz, cited in Selz's *German Expressionist Painting* (Berkeley and Los Angeles: University of California Press, 1957), p. 78.

7. Olivier, *op. cit.*, pp. 78-83; André Salmon, *Souvenirs sans fin*, 3 vols. (Paris: Gallimard, 1955-61), II, 48-58; Roger Shattuck, *The Banquet Years* (Garden City: Anchor Books, 1961), pp. 69-72. The "classic" description of this event, on which all later ones are at least partly based, is Maurice Raynal's, "Le Banquet Rousseau," *Les Soirées de Paris*, No. 20 (January 15, 1914), 69-72.

8. Francis Carco, "De Montmartre au Quartier Latin," in *Mémoires d'une autre vie* (Geneva: Editions du Milieu du Monde, 1942), pp. 214-15.

9. *See* the conflicting accounts in Wilhelm Uhde, *Von Bismarck bis Picasso. Erinnerungen und Bekenntnisse* (Zurich: Oprecht, 1938), p. 191, and Otto Freundlich, "Erinnerungen an das Künstlerleben in Paris vor dem Kriege 1914," *Aus Briefen und Aufsätzen*, ed. Günter Aust (Cologne: Verlag Galerie der Spiegel, [ca. 1960]), n.p. Cf. André Salmon, *op. cit.*, II, 23-25. That Picasso—and even more Fernande Olivier—was upset over the incident is clear from a note he sent Gertrude and Leo Stein soon afterward. (Papers of Gertrude Stein, Beinecke Library, Yale University, letter of June [14], 1908. Olivier [*op. cit.*, pp. 56-57, 89] said the incident frightened the artists out of their experimentation with drugs.)

10. Olivier, *op. cit.*, p. 26; also quoted by Charles Douglas [pseud.], *Artist Quarter: Reminiscences of Montmartre and Montparnasse in the First Two Decades of the Twentieth Century* (London: Faber and Faber, 1941), p. 47. Cf. Salmon, *op. cit.*, I, 170.

11. [Pierre] [Brassaï, *Conversations avec Picasso* (Paris: Gallimard, 1964), p. 133.

12. Allan Mitchell, *Revolution in Bavaria, 1918-1919: The Eisner Regime and the Soviet Republic* (Princeton: Princeton University Press, 1965), pp. 22-23.

13. Wieland Herzfelde, *Immergrün: Merkwürdige Erlebnisse und Erfahrungen eines fröhlichen Waisenknaben* (Berlin: Aufbau-Verlag, 1949), p. 126. Grosz, however, lived by choice in the South End, far from the art world, in a miserable tenement with packing cases for furniture. He invited Herzfelde, who wrote: ". . . my host sat there like a prominent rich man visiting poor relatives" (*Ibid.*, p. 139).

14. Oskar Kokoschka, "Geschichte von der Tochter Virginia," *Spur im Treibsand* (Zurich: Atlantis Verlag, 1956), pp. 10-11.

15. Trust [Herwarth Walden], "Der Sumpf von Berlin. 'Spezialbericht': Café Grössenwahn," *Der Sturm*, II, No. 82 (October, 1911), 651-52.

16. Hermann Uhde-Bernays, *Im Lichte der Freiheit. Erinnerungen aus den Jahren 1880 bis 1914* (Frankfurt a. M.: Insel, 1947), pp. 356-57, 360.

17. Erich Mühsam, *Unpolitische Erinnerungen* ([East] Berlin: Verlag Volk und Welt, 1961), p. 173; Severini, *op. cit.*, p. 76.

18. Gordon, *op. cit.*, p. 22.

19. Umberto Boccioni, *Pittura Scultura Futuriste (dinamismo plastico)* (Milan: Edizioni futuriste di "Poesia", 1914), p. 165, on the composition of the first technical manifesto of April 11, 1910; *see also* introductory passage to Marinetti's "Foundation and Manifesto of Futurism," *Archivi del futurismo*, I, 15-16.

20. Alfred Kubin, "Autobiography," in *The Other Side*, trans. by Denver Lindley (New York: Crown Publishers, 1967), p. xlvi.

21. Ernst Ludwig Kirchner, *Briefe an Nele und Henry van de Velde* (Munich: Piper, 1961), Frauenkirch, July 5, 1919, p. 100. Yet he feared he would become *embourgeoisé* through life in Switzerland: *See* Lothar Grisebach (ed.), *Maler des Expressionismus im Briefwechsel mit Eberhard Grisebach* (Hamburg: Christian Wegner, 1962), letter from Helene Spengler to Grisebach, July 18, 1921, p. 133.

22. Macke and Marc, *Briefwechsel*, [December, 1910], pp. 25, 27.

23. The manifesto of 1906 and the statutes are reprinted in Christian Sénéchal, *L'Abbaye de Créteil* (Paris: André Delpeuch, 1930), pp. 138-48.

24. Unpublished memoir, quoted by Daniel Robbins, *Albert Gleizes: A Retrospective Exhibition* (New York: Solomon R. Guggenheim Museum, 1964), pp. 12-13.

25. Daniel Robbins, "From Symbolism to Cubism: The Abbaye of Créteil," *Art Journal*, XXIII, No. 2 (Winter, 1963-64), 112. This information has been confirmed to me by Juliette Roche Gleizes, the painter's widow, who claims that they conscientiously gave lectures every night.

26. Duhamel, *op. cit.*, p. 8. Back in 1905, Arcos had already published an attack on materialism in *La Vie. See* Sénéchal, pp. 16-18.

27. "Discours prononcé au banquet du 10 décembre [1906]" (Paris: "L'Abbaye" [Groupe fraternel d'artistes], 1907). Robbins asserts that the speech was given at a banquet for Rodin; the published version, however, states that it was given at a banquet in Adam's honor.

28. Eberhard Grisebach to Helene Spengler, Jena, February 13, 1914, *Maler des Expressionismus . . .* , p. 41.

29. Pierre Sichel, *Modigliani* (New York: E. P. Dutton, 1967), p. 77; and *see* Fritz Löffler, *Otto Dix* (Vienna and Munich: Anton Schnoll, 1967), p. 47, on Dix's elegant attire as of 1922—a time when his paintings dealt with revolutionary subjects and savagely criticized capitalist society.

30. Cabanne, *op. cit.*, p. 17.

31. Quoted in English translation by Gordon, *op. cit.*, p. 22, from a letter to Carl Hagemann of November 19, 1935.

32. Kasimir Edschmid (ed.), *Schöpferische Konfession*, vol. 13 of *Tribüne der Kunst und Zeit* (Berlin: Erich Reiss, 1920), pp. 19-20.

33. Max Beckmann, *Sichtbares und Unsichtbares*, ed. Peter Beckmann (Stuttgart: Christian Belser, 1965), p. 55; Chapiro, *op. cit.*, pp. 37-38; Georges Duhamel, *Biographie de mes fantômes*, vol. 2 of *Lumières sur ma vie*, pp. 148-56; Umberto Boccioni, *Gli Scritti editi e inediti* (Milan: Feltrinelli, 1971), letter of April 17, 1906, pp. 336-37; Severini, *op. cit.*, p. 12; Löffler, *op. cit.*, p. 11; Oskar Maria Graf, *Wir sind Gefangene. Ein Bekenntnis aus diesem Jahrzehnt* (Berlin: Verlag der Büchergilde Gutenberg, 1928), p. 34.

34. Franz Jetzinger, *Hitlers Jugend: Phantasien, Lügen—und die Wahrheit* (Vienna: Europa-Verlag, 1956), p. 262; Werner Maser, *Die Frühgeschichte der NSDAP* (Frankfurt a. M.: Atheneum, 1965), pp. 116-17.

35. Papers of Gertrude Stein, Beinecke Library, Yale University, postcard of [1910?].

36. Wages in the provinces were one-half to two-thirds these figures. By this time the worker had certain social security benefits which the painter, of course, did not have. Figures from Ministère du Travail et de la Prévoyance Sociale, *Annuaire statistique*, vol. 30 (1910), p. 241.

37. Sturm-Archiv, postcard of September 24, 1912, Carton 4. Since 1909 he had been asking 1,000 to 3,000 marks for oil paintings. On the other hand, he was willing to lower his prices considerably for a sincere but impecunious admirer.

38. Letter to Fritz Levedag, Berlin, Bauhaus-Archiv.

39. Sturm-Archiv, Carton 1, November 25, 1916.

40. *See* Gris, *op. cit.*, letter to Kahnweiler of November 15, 1919, p. 70. Cf. description of his wartime arrangements with Léonce Rosenberg, *ibid.*, letter of March 25, 1921, to Maurice Raynal, pp. 102-3. Gris was desperately poor during the war and was thus forced to accept an arrangement that most others managed to avoid.

41. Macke and Marc, *op. cit.*, letter of June 12, 1914, from Marc to Macke, p. 184. Cf. *ibid.*, letter of March 12, 1913, from Marc to Macke, pp. 152-53.

42. Umberto Boccioni, "Diario padovano," *Poesia e critica*, IV, No. 8-9 (May, 1966), 29, entry of August 12, 1907.

CHAPTER 4 (pp. 84-114)

1. Eric Mendelsohn, *Letters of an Architect*, ed. Oskar Beyer (London, New York, Toronto: Abelard-Schuman, 1967), Munich, November 11, 1913, pp. 27-28.

2. Georges Ribemont-Dessaignes, *Déjà jadis: Ou du mouvement Dada à l'espace abstrait* (Paris: Juillard, 1958), p. 14.

3. Felix Klee (ed.), *The Diaries of Paul Klee* (Berkeley and Los Angeles: University of California Press, 1964), No. 747, p. 194. While I have employed this translation here and throughout, I have continually checked it with the original German version (Paul Klee, *Tagebücher, 1898-1918* [Cologne: M. DuMont Schauberg, 1957] and have made extensive changes.

4. *The Diaries of Paul Klee*, No. 514, Summer, 1903, p. 144.

5. Feininger Papers, Houghton Library, Harvard University, transcripts, I (August, 1913), 246. "Is it not an immutable law that whoever wants to go 'before the public' (and that is the *raison d'être* of most artists) is all but corrupted already?" *Ibid.*

6. Letter of 1912 from Boccioni to Carrà, printed in Carrà's *La Mia Vita* (Milan: Rizzoli, 1943), pp. 162-65; reprinted in Maria Drudi Gambillo and Teresa Fiori (eds.), *Archivi del futurismo* (Rome: De Luca, 1958, 1962), I, 240.

7. *"Ça m'épate tout le temps à moi-même de savoir faire ça. Je n'en reviens pas car je croyais que c'était bien plus difficile."* Daniel-Henry Kahnweiler, *Juan Gris: Sa vie, son oeuvre, ses écrits* (Paris: Gallimard, 1946), Paris, September 7, 1915, pp. 31-32. English from Juan Gris, *Letters*, ed. and trans. Douglas Cooper (London: privately printed, 1956), p. 31. Picasso perennially delighted in satirizing the academic painter. See Brassaï's delightful description of one such occasion in 1944, including his photograph of the master "painting" an academic odalisque, while the actor Jean Marais poses. [Pierre] Brassaï, *Conversations avec Picasso* (Paris: Gallimard, 1964), pp. 150-51.

8. August Macke and Franz Marc, *Briefwechsel* (Cologne: M. DuMont Schauberg, 1964), letter to August Macke, August 9, 1910, p. 17.

9. *Im Kampf um die Kinst. Die Antwort auf den "Protest deutscher Künstler"* (Munich: Piper, 1911), p. 81.

10. Emil Nolde, *Briefe aus den Jahren 1894-1926*, ed. Max Sauerlandt (Berlin: Furche-Kunstverlag, 1927), p. 81. The letter was written on January 2, 1912, to the unknown author of a book entitled *"Verhältnis zur Kunst."* According to Gabriele Münter, Kandinsky's doctrine for the Blaue Reiter was "that it is not a question of modernity or of one particular form or tendency, but rather of the originality of the experience and the authenticity of its expression." Letter to Wilhelm Worringer of January 13, 1951, after a photocopy in the Worringer Nachlass, Germanisches Nationalmuseum, Nuremberg.

11. "Notes d'un peintre," *La Grande Revue*, XII (December 25, 1908), 744.

12. Catalogue of the Blaue Reiter, I. Ausstellung, bei Thannhäuser, Munich, 1911-12.

13. "Über die Formfrage," *Der Blaue Reiter*, ed. Wassily Kandinsky and Franz Marc, reprint by Klaus Lankheit (Munich: Piper, 1965), p. 142.

14. Letter to Katherine Dreier of March 14, 1927, Dreier Correspondence. Resistant even to the Blaue Reiter at first, Macke wrote Marc: "Must the children all have names?" *Briefwechsel*, February 5, 1912, p. 101.

15. "Das neue Programm," *Kunst und Künstler*, XII (1914), 299-314; reprinted in Diether Schmidt, *Manifeste Manifeste. 1905-1933. Schriften deutscher Künstler des zwanzigsten Jahrhunderts* (Dresden: Fundus-Bücher, 1964), p. 80.

16. *Ibid.*, p. 83.

17. Letter to Julia Feininger, July, 1916, Feininger Papers, transcripts, I.

18. For Marinetti, *see* below, pp. 106–10. Guillaume Apollinaire, *Les Peintres cubistes. Méditations esthétiques* (Paris: 1913) and *Chroniques d'art (1902-1918)*, ed. L.-C. Breunig (Paris: Gallimard, 1960); Herwarth Walden, *Gesammelte Schriften*, I (Berlin: Verlag der Sturm, 1916) and *Der Sturm, 1910-1918, passim.*

19. Hence the name "Bridge." Letter from Schmidt-Rottluff to Nolde, February 4, 1906, reprinted by Schmidt, *op. cit.*, p. 40.

20. "Gründungsaufruf KG Brücke," printed in *ibid.*, p. 39.
21. "Die 'Wilden' Deutschlands," *Der Blaue Reiter*, pp. 28-29.
22. "Les Origines de la peinture contemporaine et sa valeur représentative," *Montjoie!*, I, Nos. 8, 9-10 (1913), 7, 9-10 and *Der Sturm*, IV, No. 172-173 (August, 1913), 78.
23. Macke and Marc, *op. cit.*, January 14, 1911, p. 40.
24. Pierre Cabanne, *Entretiens avec Marcel Duchamp* (Paris: Pierre Belfond, 1967), p. 74. Speaking thus in 1966, Duchamp regretted that the twentieth century had failed to rectify Courbet's error. Cf. Wassily Kandinsky, *Concerning the Spiritual in Art* (New York: George Wittenborn, 1947), p. 24.
25. Albert Gleizes and Jean Metzinger, *Du "Cubisme"* (Paris: Eugène Figuière et Cie., 1912), p. 6: "We could hardly blame him, however, for it is to him we owe our own powerful and subtle joys today."
26. Franz Marc, "Die konstruktiven Ideen der neuen Malerei," *Pan*, II (October, 1911-March, 1912), 528.
27. Franz Marc, "Die neue Malerei," *Pan*, II (October, 1911-March, 1912), 469.
28. Gleizes, "Souvenirs: Le Cubisme, 1908-1914," p. 13.
29. Umberto Boccioni, "Diario padovano," *Poesia e Critica*, IV, No. 8-9 (May, 1966), 24-25, entry of June 15, 1907; 29, entry of July 12, 1907.
30. Kasimir Edschmid (ed.), *Schöpferische Konfession* (Berlin: Erich Reiss Verlag, 1920), p. 35. In his introduction to the catalogue of the Erster Deutscher Herbstsalon of 1913, which brought together the work of the European avant-garde in Berlin, Herwarth Walden stated: "Naturally one can't paint *Geist*, but to paint a body without it is no art at all. Art is the personal representation of a personal experience." Or *see* Franz Marc, "Die konstruktiven Ideen der neuen Malerei," 528.
31. Gris, *op. cit.*, pp. 104-5, letter of ca. March 25, 1921. He went on: "No glass manufacturer would ever be able to make any bottle or water-jug which I have painted, because they have not, nor can they have, any equivalent in a world of three dimensions. . . ." Cf. Gleizes and Metzinger, *op. cit.*, pp. 15-17.
32. Kandinsky, *Concerning the Spiritual in Art*, pp. 30-31; *Im Kampf um die Kunst*, pp. 73-75; "Malerei als reine Kunst," *Der Sturm*, IV, No. 178-79 (September, 1913), 99.
33. Matisse, *op. cit.*, 741.
34. Max Beckmann, *Sichtbares und Unsichtbares*, ed. Peter Beckmann (Stuttgart: Christian Belser, 1965), pp. 64-66.
35. "Vita moderna e arte popolare," *Lacerba* (June 1, 1914). Cf. his contemporaneous letter to Soffici: "This famous exhibition, if not a formidable affirmation of such works of art, was all the same by its popular character perfectly compatible with our contemporary spiritual attitude." *Archivi del futurismo*, I, 337.
36. Macke and Marc, *op. cit.*, Bonn, 2d. Day of Christmas, 1910, p. 32. Marc replied in the affirmative: "You're quite right. In such restful, simple things ultimately lies the quintessence of art; a bridge, a smoking chimney, a house mirrored in the water. . . ." *Ibid.*, December 29, 1910, p. 36.
37. *Ibid.*, April 12, 1911, p. 53.
38. Quoted in Robert Goldwater and Marco Treves (eds.), *Artists on Art* (New York: Pantheon Books, 1945), pp. 442-43. This statement, supposedly from Klee's diary, does not appear in the published version of the diary.
39. Umberto Boccioni, "Diario padovano," July 25, 1907, 30. "[Giovanni] Segantini was right in saying we should return to the humble daisy in the field, putting aside our airs of skillful master painters." Diary entry of March 14, 1907, *Archivi del futurismo*, I, 226.
40. *The Diaries of Paul Klee*, No. 905 (1912), p. 266.
41. Jean Laude, *La Peinture française (1905-1914) et "l'Art nègre"* (Paris: Klincksieck, 1968), pp. 243-395. The most comprehensive work to date on the extra-European influences on

Western art is the massive, profusely illustrated *Weltkulturen und moderne Kunst,* ed. by Siegfried Wichmann (Munich: Bruckmann, 1972). *See* especially pp. 456-85.

42. *Briefe an Nele und Henry van de Velde,* January 20, 1919, p. 14. For a photograph of the door, *see* Lothar Grisebach (ed.), *E. L. Kirchners Davoser Tagebuch* (Cologne: M. DuMont Schauberg, 1968), p. 301.

43. Max Pechstein, *Erinnerungen* (Munich: List Taschenbücher, 1963), pp. 59, 67, 83.

44. *See* Donald E. Gordon, *Ernst Ludwig Kirchner* (Cambridge, Mass.: Harvard University Press, 1968), p. 97, for a perceptive analysis of this painting, and compare it with the "Brooklyn Bridge" paintings of the American Futurist Joseph Stella, which are gay in tone and favorable to modernization.

45. Letter of June, 1914, to Julia Feininger, Feininger Papers, transcripts, I, 323.

46. "Das neue Programm," *Kunst und Künstler;* reprinted in Schmidt, *op. cit.,* p. 89.

47. Cabanne, *op. cit.,* p. 50.

48. "Les Origines de la peinture contemporaine et sa valeur représentative," *Der Sturm,* IV, No. 172-73 (August, 1913), 79. On the subject of specialization, cf. Umberto Boccioni, "Diario padovano," July 7 [1907], 28. And on Orphism, see Robert Delaunay, *Du cubisme à l'art abstrait,* ed. Pierre Francastel (Paris: S.E.V.P.E.N., 1957), *passim.*

49. The best descriptions of the Futurist movement are Raffaele Carrieri, *Futurism,* trans. Leslie van Rensselaer White (Milan: Edizioni del Milione, [1963]); Rosa Trillo Clough, *Futurism: The Story of a Modern Art Movement* (New York: Philosophical Library, 1961); Christa Baumgarth, *Geschichte des Futurismus* (Reinbeck bei Hamburg: Rowohlt Taschenbuch Verlag, 1966); Joshua C. Taylor, *Futurism* (New York: Museum of Modern Art, 1961). Baumgarth does a fine job of pointing out the philosophical and literary influences on Marinetti and the painters. Their insistence on the connection between esthetic, political, and social concerns was constant. See Boccioni, Carrà, Russolo, Balla, Severini, "Les Exposants au public," *Archivi del futurismo,* I, 105 (hereafter cited as *Archivi*): "If our paintings are futurist, that is because they are the result of ethical, esthetic, political, and social conceptions which are absolutely futurist."

50. "Fondazione e manifesto del Futurismo," *Archivi,* I, 17; Boccioni, Carrà, Russolo, Severini, Arnaldo Bonzagni and Romolo Romani, "Manifesto dei pittori futuristi," February 11, 1910, *ibid.,* 63.

51. "Manifesto dei pittori futuristi," *ibid. See also* Boccioni's diagnosis of Italy's malaise in the major theoretical treatise of Futurist figurative art, *Pittura Scultura Futuriste,* Part I: "Perché siamo futuristi," pp. 3–18. *See also* a diary he kept in 1907, cited in *Archivi,* I, 225. On March 14, 1911, Marinetti explained, in an interview in *Le Temps,* that Italy, unlike France, needed Futurism to lift the crushing weight of tradition.

52. The best study of Marinetti's politics is in James Joll, *Three Intellectuals in Politics* (New York: Harper and Row, 1965), pp. 133-78. For Marinetti's life *see* Walter Vaccari, *Vita e tumulte di F. T. Marinetti* (Milan: Editrice Omnia, 1959), and Marinetti's own *Marinetti e il Futurismo* (Rome and Milan: Edizioni "Augustea", 1929). Also instructive are Giovanni Papini's affectionate but critical sketch, "Il Prete poeta," in *Passato remoto, 1885-1914* (Florence: L'Arco, 1948), pp. 261-64, and Giovanni Calendoli's introduction to Marinetti, *Teatro,* I (Rome: Vito Bianco, 1960).

53. Vaccari, *op. cit.,* p. 133.

54. F. T. Marinetti, *Guerra sola igiene del mondo* (Milan: Edizioni futuriste di "Poesia", 1915), p. 5. James Joll cites a slogan of the Compagnons de l'Action d'Art which might have influenced Marinetti's tactics: "Long live violence against all that makes life ugly!" (*op. cit.,* p. 135).

55. André Gide, *Journal,* I, "feuillets 1911" (Paris: Gallimard, 1948), p. 348.

56. *Déjà jadis,* pp. 39-40.
57. Quoted in Carrieri, *op. cit.,* p. 43.
58. "La Pittura futurista. Manifesto tecnico," *Archivi,* I, 65.
59. Carrà, *La Mia Vita,* pp. 72-74.
60. Boccioni, Carrà, Russolo, Severini, "Presentazione alle opere esposte alla Sackville Gallery," *Archivi,* I, 111. Original in English.

CHAPTER 5 (pp. 115–131)

1. *Briefe an Nele und Henry van de Velde* (Munich: Piper, 1961), August 3, 1918, p. 88.
2. Gelett Burgess, "The Wild Men of Paris," *Architectural Record,* XXVII, No. 5 (May, 1910), 401.
3. France, Chambre des Députés, *Débats parlementaires*, December 3, 1912, p. 2,924. The only rebuttal came from a more prominent Socialist, Marcel Sembat, and then it did not raise the nationalist issue. "When a painting seems bad to you," he said, "you have an undeniable right: that is, of not looking at it, of going to see others; but one doesn't call the police!" (*Ibid.,* p. 2,926.) For a more detailed discussion of these and similar charges, see Theda Shapiro, *French Painters and Politics, 1900-1920,* unpublished Masters' Essay, Columbia University, 1965, pp. 29-48.
4. August Macke and Franz Marc, *Briefwechsel* (Cologne: M. DuMont Schauberg, 1964), letter of June 12, 1914, p. 184. Nationalistic statements were the exception. *See,* for example, one in Beckmann's 1904 diary, written long before he joined the avant-garde. (Peter Beckmann [ed.], *Sichtbares und Unsichtbares* [Stuttgart: Christian Belser, 1965], entry of April 14, 1904, p. 60.) Cf. statement by David and Wladimir Burliuk in the catalogue of the Neue Künstlervereinigung München, Second Exhibition, Moderne Galerie, Munich, 1910-11, pp. 5-6.
5. Hermann Uhde-Bernays, *Im Lichte der Freiheit. Erinnerungen aus den Jahren 1880 bis 1914* (Frankfurt a. M.: Insel, 1947), p. 404.
6. Karl Vinnen, *et al., Ein Protest deutscher Künstler* (Jena: Eugen Diederichs, 1911), pp. 12 and *passim.*
7. West Berlin, Westdeutsche Bibliothek, Sturm-Archiv, Carton 4, Kandinsky to Walden, February 16, 1913; *Der Sturm,* III, Nos. 150-151, 152-153 (March, 1913), 277-79, 288; IV, No. 154-155 (April, 1913), 3, 5.
8. The discussion which follows is largely based on the following: Siegfried, "L'Art révolutionnaire," *Les Temps nouveaux*, XVII, No. 51 (April 20, 1912); Charles Hotz, *L'Art et le peuple* (Marseille: Société "Arts et Excursions", 1910); Fernand Pelloutier, *L'Art et la révolte* (Paris: Bibliothèque de l'Art Social, 1897); Jean Jaurès, "Art et socialisme," reprint of a speech of 1900, *La Forge,* Nos. 5, 6 (January, March, 1918); Paul Adam, *L'Art et la Nation* (Paris: "L'Abbaye", 1907); Georges Sorel, *Reflections on Violence* (New York: Collier, 1961), originally published in 1906; L. de Saumanes, "Le Peuple et l'art," *Les Temps nouveaux,* XVII, Nos. 45, 46 (March 9, and March 16, 1912); [Jules Félix] Grandjouan, "L'Art et le peuple," *La Guerre sociale,* II, No. 15 (March 11-17, 1908); Joseph Paul-Boncour, *Art et démocratie* (Paris: Ollendorff, 1912); Maurice Robin, *L'Art et le peuple* (Paris: Bibliothèque des "Hommes du Jour", 1910); Jean Ajalbert, *Une Enquête sur les droits de l'artiste* (Paris: Stock, 1905).
9. Charles Hotz, *op. cit.,* p. 44.
10. Ajalbert, *op. cit.,* p. 56.
11. "Abwehr I," *Der Sturm,* III, No. 108 (May, 1912), p. 25.

12. Grandjouan, "L'Art et la misère," *La Guerre sociale,* II, No. 4 (January 8-14, 1908).
13. Michael Sadler, *Modern Art and Revolution* (London: Hogarth Press, 1932), pp. 18-19.
14. Quoted in English by Selz, *op. cit.,* p. 267.
15. See James Joll, *The Second International, 1889-1914* (New York: Harper and Row, 1966), pp. 126–43. In the novel *Les Thibault* ("Été 1914"), Roger Martin du Gard gives a good account of the influence of these ideas and of their rapid demise in July, 1914.
16. Sturm-Archiv, Carton 5, Kokoschka to Walden, postcard postmarked May 25, 19[11?].
17. Sturm-Archiv, Carton 2, Delaunay to Walden, October 2, 1919.
18. "Autobiography," in *The Other Side,* trans. Denver Lindley (New York: Crown, 1967), p. xliii.

CHAPTER 6 (pp. 132–166)

1. Franz Marc, *Briefe, Aufzeichnungen und Aphorismen,* I (Berlin: Paul Cassirer, 1920), p. 46.
2. Maria Drudi Gambillo and Teresa Fiori (eds.), *Archivi del Futurismo* (Rome: De Luca, 1958, 1962), I, August 6 [1914], 343. He soon decided the war would last at least ten years; Futurism simply had to collaborate "in the splendor of this conflagration . . ." Letter to Severini of November 20, 1914, *ibid.,* 349.
3. *Ibid.,* [Fall, 1914], I, 344-45.
4. Rome, Archivio Centrale dello Stato, P.S. (Dir. Gen. Pubblica Sicurezza—Min. Interno), A5G, Conflagrazione europea, 3B, telegrams of September 16 and 17, 1914. The "formless object" was an Austrian flag and the second Futurist with Marinetti was Boccioni, not Carrà. *See* letter from Boccioni to his family, [September 16, 1914], *Archivi,* I, 346, in which the painter reported the incident with obvious pleasure: "You will have read that I tore up an Austrian flag last night in a box at the Dal Verme during a gala performance, and Marinetti unfurled an Italian one. Tonight we begin again. Maybe they'll arrest us for a few hours. It's necessary. If you read this in the *Corriere* don't get alarmed. The functionaries, guards and carabinieri laugh under their breath and say, while making the arrests, 'we too are in agreement with you.' The point of making arrests is to show that the government is repressing the cry 'Down with Austria.' "
5. F. T. Marinetti, "In quest'anno futurista," *Der Mistral,* I, No. 2 (March 21, 1915). Cf. Carlo Carrà, *Guerrapittura* (Milan: Edizioni futuriste di "Poesia," 1915), *passim.*
6. Letter to Contessa V. Piccini, [September-October, 1915], *Archivi,* I, 366.
7. Letter to F. B. Pratella, [December 20, 1916?], *Archivi,* I, 374. *See also* his articles in *L'Italia futurista,* 1916-1918, *passim.*
8. Letter to Gertrude Stein, September 11, 1914. Papers of Gertrude Stein, Beinecke Library, Yale University. That he felt commitment to France is obvious. His positive feelings are indirectly corroborated by two later letters from his mistress, Eva [Marcelle Humbert] to Stein, in which she declared *"Vivent les alliés et à bas l'Allemagne!!"* (October 6, 1914) and later noted that she was knitting scarves for the soldiers (November 10, 1914).
9. See a photograph of Segonzac beside the "tree" in Château de Sceaux, Musée de l'Ile de France, *Donation André Dunoyer de Segonzac* (Sceaux: 1965), n.p.
10. Quoted in Brussels, Palais des Beaux-Arts, *Fernand Léger, 1881-1955,* exhibition of October-November, 1956, p. 30; cf. Dora Vallier, "La Vie fait l'oeuvre de Fernand Léger. Propos de l'artiste recueillis," *Cahiers d'art,* II (1954), 140.
11. Georges Duhamel, *Lumières sur ma vie,* vol. IV, *La Pesée des âmes* (Paris: Paul Hartmann, 1949), pp. 130-31.

12. Juan Gris, *Letters* (London: privately printed, 1956), letter of October 17, 1916, p. 42.

13. John Quinn Memorial Collection, New York Public Library, Duchamp-Villon to Quinn, April 8, 1916 (transcript); Segonzac to Quinn, August 10, 1917 (transcript).

14. Rouault to Quinn, [postmark November 26, 1918]; Dufy to Quinn, May 30, 1918 and February 4, 1919.

15. West Berlin, Westdeutsche Bibliothek, Sturm-Archiv, Carton 4, Kandinsky to Walden, August 2, 1914.

16. August Macke and Franz Marc, *Briefwechsel* (Cologne: M. DuMont Schauberg, 1964), Lisbeth Macke to Maria Marc, Bonn, September 5 and 29, 1914, pp. 190, 192.

17. Marc, *Briefe, Aufzeichnungen und Aphorismen,* November 11, 1914, p. 21: "I have long since felt this war to be not a German affair but a world happening."

18. "Das geheime Europa," *Das Forum,* I, No. 12 (March, 1915), 633-34. Cf. "Im Fegefeuer des Krieges," *Der Sturm,* VII, No. 1 (April, 1916), 2: "The future type of the European will be the German type; but first the German must become a good European. *That* he is not always and everywhere today."

19. "Das geheime Europa," 637-38.

20. Marc, *Briefe, Aufzeichnungen und Aphorismen,* p. 32.

21. Paul Klee, *Tagebücher, 1898-1918* (Cologne: M. DuMont Schauberg, 1957), No. 956, 1915, p. 325.

22. Max Pulver, *Erinnerungen an eine europäische Zeit* (Zurich: Orell Füssli Verlag, 1953), p. 47.

23. Max Beckmann, *Briefe im Kriege* (Berlin: Bruno Cassirer, 1916), p. 9.

24. *See* Peter Selz's fine analysis of Beckmann's paintings of this period, *Max Beckmann* (New York: Museum of Modern Art, n.d.), pp. 25-35.

25. Emil Nolde, *Briefe aus den Jahren 1894-1926,* ed. Max Sauerlandt (Berlin: Furche-Kunstverlag, 1927), October 15, 1914, p. 112.

26. Nolde, *Welt und Heimat. Die Südseereise, 1913-1918* (Cologne: M. DuMont Schauberg, 1965), p. 140.

27. Quoted in Donald E. Gordon, *Ernst Ludwig Kirchner* (Cambridge, Mass.: Harvard University Press, 1968), pp. 26-27, from an unpublished manuscript, "Die Arbeit E. L. Kirchners." All translations are Gordon's.

28. Quoted *ibid.,* p. 27.

29. Lothar Grisebach, *E. L. Kirchners Davoser Tagebuch. Eine Darstellung des Malers und eine Sammlung seiner Schriften* (Cologne: M. DuMont Schauberg, 1968), p. 275, note 126.

30. Kirchner to Helene and Luzius Spengler, November 28, 1918, *Maler des Expressionismus im Briefwechsel mit Eberhard Grisebach,* ed. Lothar Grisebach (Hamburg: Christian Wegner, 1962), p. 91.

31. Helene Spengler to Grisebach, February 5, 1917, *ibid.,* p. 61.

32. Kirchner to Nele van de Velde, February 20, 1921, *Briefe an Nele und Henry van de Velde* (Munich: Piper, 1961), p. 41. Cf. Kirchner to Grisebach, February 13, 1921, pp. 128-29, in which he voices the same sentiments, adding that the money should go to help war invalids: "For them to endure their lives and go on living is often more heroic than to happen to fall in action."

33. Max Pechstein, *Erinnerungen* (Munich: List Taschenbücher, 1963), pp. 97-108.

34. Hamburg, Staats- und Universitätsbibliothek, Max Sauerlandt Nachlass, Carton 5, Mappe 12, March 13, 1916. *See also* Heckel's wartime letter to the Feiningers, July 23, 1915, Feininger Papers, Houghton Library, Harvard University.

35. Feininger Papers, [postmark August 28, 1915]. Cf. Otto Mueller's reactions to Landsturm service, according to Lothar Günther Buchheim, *Otto Mueller: Leben und Werk* (Feldafing: Buchheim Verlag, 1963), p. 248. According to his biographer, Hans Hess, Feininger was

initially pro-German, then increasingly antimilitaristic. *Lyonel Feininger* (New York: Harry N. Abrams, [1959]), p. 72. He later attributed the development of his monumental, architectural style to "an aloofness . . . not to be obtained through any conscious effort of aspiring for an ideal—it was suffering and horror of the soul that made my visions so 'final.' " Letter from Dessau of May 14, 1928 to Alfred H. Barr, quoted by Hess, p. 76.

36. "Gesuch an Seine Exzellenz den Herrn Reichskanzler um Befreiung des Malers Karl Schmidt-Rottluff vom Heeresdienst," undated, mimeographed, unsigned. Nachlass Richard und Ida Dehmel, Hamburg, Staats- und Universitätsbibliothek.

37. Feininger Papers, August 27, 1920; *see* Heckel's letter of May 15, 1919, to Julia and Lyonel Feininger: "All the memories of the war years keep coming up strongly once again, but perhaps they are also losing their capacity to depress me."

38. Manfred Schneckenburger, "Bemerkungen zur 'Brücke' und zur 'primitiven' Kunst," *Weltkulturen und moderne Kunst,* ed. Siegfried Wichmann (Munich: Verlag Bruckmann, 1972), pp. 458, 464.

39. Sturm-Archiv, Carton 6, Adolf Loos to Walden, [postmark October 13, 1915]; Kokoschka to Walden, October 27, 1915, Carton 5: "I'm curious whether I'll be dead the next time."

40. Beth Irwin Lewis, *George Grosz: Art and Politics in the Weimar Republic* (Madison, Milwaukee and London: University of Wisconsin Press, 1971), pp. 19-22, 23.

41. *See* his drawings in *Neue Jugend,* and the *Kleine Grosz Mappe* (Berlin: Malik Verlag, 1917).

42. Quoted in translation in Werner Schmalenbach, *Kurt Schwitters* (New York: Harry N. Abrams, n.d.), pp. 31-33. And *see ibid.,* p. 46, 1923 statement from *Merz,* 2, No. i: "There are no values worth defending. Our enemies are just like us. It is not enemies we should fight but the faults in ourselves. The enemy has more right to live than we to kill him."

43. Romain Rolland, *Journal des années de guerre, 1914-1919* (Paris: Albin Michel, 1952), p. 188.

44. Paris, Archives Nationales, F⁷ 12911, *Propagande par tracts, affiches, placards, etc., 1912-1917.*

45. *See* these publications and the following memoirs of the early period of Dada: Richard Huelsenbeck, *En avant Dada. Die Geschichte des Dadaïsmus* (Hanover and Leipzig: Paul Steegemann Verlag, 1920); Hans Richter, *Dada—Kunst und Antikunst. Der Beitrag Dadas zur Kunst des 20. Jahrhunderts* (Cologne: M. DuMont Schauberg, 1964); Tristan Tzara, "Chronique zurichoise," *Dada Almanach,* ed. Richard Huelsenbeck (Berlin: Erich Reiss Verlag, 1920). The best secondary accounts are Georges Hugnet, *L'Aventure Dada* (Paris: Seghers, 1957, reissued 1971), and Michel Sanouillet, *Dada à Paris* (Paris: Jean-Jacques Pauvert, 1965). The most important documents can be found in Richard Huelsenbeck (ed.), *Dada. Eine literarische Dokumentation* (Hamburg: Rowohlt, 1964); Hugnet; Robert Motherwell (ed.), *The Dadaist Painters and Poets* (New York: Wittenborn, Schultz, 1951).

46. Tristan Tzara, Franz Jung, George Grosz, Marcel Janco, Richard Huelsenbeck, Raoul Hausmann, Hugo Ball, Hans Arp, Enrico Prampolini, *et al.,* "Dadaistisches Manifest," *Der Zweeman,* I, No. 3 (January, 1920), 16.

47. *Die Flucht aus der Zeit,* entry of June 16, 1916, reprinted in Huelsenbeck, *Dada. Eine literarische Dokumentation,* p. 155. Two months earlier he had noted: "Total skepticism also makes possible total freedom" (*ibid.,* April 8, 1916, p. 148). *See also* Tzara's 1918 Dadaist manifesto, printed in *Sept manifestes Dada.*

48. Huelsenbeck, *Dada. Eine literarische Dokumentation,* p. 18.

49. Letters, Vogeler-Archiv, Haus im Schluh, Worpswede bei Bremen. And *see* Vogeler, *Erinnerungen,* ed. Erich Weinert (Berlin: Rütten und Loening, 1952).

50. Handwritten petition in pencil. Hamburg, Staats- und Universitätsbibliothek.

51. Heckel to Max Sauerlandt, March 31, 1916, Sauerlandt Nachlass, Carton 5, Mappe 12.

52. "Im Fegefeuer des Krieges," *Der Sturm,* VII, No. 1 (April, 1916), 2.

CHAPTER 7 (pp. 173–200)

1. *An alle Künstler!* (Berlin: 1919), p. 22.
2. Harry Graf Kessler, *Tagebücher, 1918-1937* (Frankfurt a. M.: Insel, 1961), p. 86.
3. Sturm-Archiv, Carton 6, Léger to Walden, [1919].
4. "Kort Overzicht der Handelingen van het Internationale Kunstenaarscongres te Düsseldorf (29-31 Mai 1922)," *De Stijl,* V, No. 4 (1922), 50. Major signatories were the Dresden Sezession, Young Rhineland, the Novembergruppe, Oskar Kokoschka, Romain Rolland, Wassily Kandinsky.
5. "Aufruf an die revolutionäre französische geistige Jugend," *Das Tribunal,* I, No. 8-9 (August-September, 1919), 95. (Printed also as "Appel à la Jeunesse intellectuelle française," in *Clarté,* No. 5-6 [December 13, 1919]. The manifesto was endorsed by various German intellectuals, including Max Pechstein.) Also Romain Rolland's "Unabhängigkeits-Erklärung des Geistes" ("Declaration of Independence of the Spirit"!), *Das Forum,* III, No. 11 (August, 1919), 825-34, endorsed by Benedetto Croce, Albert Einstein, Hermann Hesse, Heinrich Mann, Ramsay MacDonald, Bertrand Russell, Paul Signac, Rabindadnath Tagore, and Henry van de Velde, among others. This manifesto, dated March, 1919, was printed also in German in *Die Sichel,* I, No. 4 (October, 1919), 59-60; and in French in Paul Colin's Belgian review *L'Art libre* (volume and date unobtainable) and *De Stijl,* II, No. 9 (July, 1919), 105-6.
6. Quoted in Gray, *op. cit.,* p. 219. Speech to the "working masses" in November, 1918.
7. On Lunacharsky's background, philosophy, and leadership of Narkompros, *see* Sheila Fitzpatrick, *The Commissariat of Enlightenment* (Cambridge: Cambridge University Press, 1970), pp. 4-10, 112-56, and *passim.*
8. *See* Kandinsky's account of his activities to Katherine Dreier, December 3, 1922, Dreier Correspondence, Beinecke Library, Yale University.
9. Quoted by Fitzpatrick, *op. cit.,* p. 124.
10. "Ein Aufruf der russischen Künstler," *1919. Neue Blätter für Kunst und Dichtung,* I (February, 1919), 213-14. Printed also in *Die Pleite,* I, No. 1 (March, 1919) and *Menschen,* II, No. 5 (March 1, 1919).
11. "Aufruf zur internationalen Solidarität," *Das Forum,* IV, No. 1 (October, 1919), 76-77, signed by Anatole France, Barbusse, Steinlen, Signac, Luce, Vlaminck, Frantz Jourdain, *et al.*
12. Alexandre Mercereau and Boris Sokoloff, "L'Art et le bolchévisme," *La Forge,* No. 17-18 (July-August, 1919), 37-38; Konstantin Umanski, "Neue Kunstrichtungen in Russland," *Der Ararat,* I, No. 4 (January, 1920), 13.
13. *De Stijl,* III, No. 9 (1920), 79-80. First published elsewhere. *See also* Jacques Mesnil, "L'Art dans la Russie des Soviets," *Bulletin communiste,* III, No. 9 (March 2, 1922), 171.
14. Segonzac to Quinn, August 6 [1922]. John Quinn Memorial Collection, New York Public Library.
15. *See* Léger's article of 1924, "The Machine Aesthetic, the Manufactured Object, the Artisan and the Artist," printed in translation in *Léger and Purist Paris,* The Tate Gallery, November 18, 1970-January 24, 1971 (London, [1971]), pp. 87-92.
16. The first series of the journal, from 1919 to 1921, is subtitled "Bulletin français de l'Internationale de la Pensée." The term comes from a manifesto of March 15, 1918, written by Romain Rolland. Nicole Racine, "The Clarté Movement in France, 1919-21," *Journal of Contemporary History,* II, No. 2 (April, 1967), 196. Despite its intentions, the movement remained almost entirely a French affair.
17. "Vers une époque de bâtisseurs," *Clarté,* Ser. 1, Nos. 13, 14, 15, 22, 32 (March 20, April 3,

April 17, June 26, September 11, 1920). And *see* his *Tradition et cubisme: Vers une conscience plastique* (Paris: Povolozky, 1927), a collection of articles he wrote between 1913 and 1924.

18. "L'Affaire Dada," *Action*, No. 3 (April, 1920), 26-32.

19. "Una lettera a Trotskij sul futurismo," reprinted in *Scritti politici*, ed. Paolo Spriano (Rome: Editori Riuniti, 1967), pp. 529-31; also, "Marinetti rivoluzionario?" *Ibid.*, p. 395.

20. The major sources for the relations of Futurism with Fascism are Marinetti's autobiographical writings, *Marinetti e il futurismo* (Rome and Milan: Edizioni "Augustea," 1929) and *Futurismo e Fascismo* (Foligno: Franco Campitelli, 1924). The best secondary account of Marinetti's career under Fascism is James Joll, *Three Intellectuals in Politics* (New York: Harper and Row, 1965). Renzo De Felice assesses Marinetti's influence on Mussolini in the first volume of his thorough biography, *Mussolini il rivoluzionario: 1883-1920* (Turin: Giulio Einaudi, 1965), especially pp. 474-82.

21. "A chacun, chaque jour, un métier différent (l'inégalisme)," "*Noi,*" Ser. 2, I, No. 1 (April, 1923), 2. Originally published in 1922.

22. "Al di là del comunismo," *Marinetti e il futurismo*, pp. 138-39, 143-44.

23. "I diritti artistici propugnati dai futuristi italiani. Manifesto al Governo fascista," "*Noi,*" Ser. 2, I, No. 1 (April, 1923), 1-2.

24. Feininger to Fred Werner, September 15, 1919. Feininger Papers, Houghton Library, Harvard University, transcripts, II, 57.

25. In a letter to John Schikowski, editor of *Vorwärts*, Sturm-Archiv, Carton 11. (The letter, erroneously dated January 7, 1918, was surely written on that day of 1919.) Ernst declared himself unwilling to support an organization "which directs itself once again to the bourgeoisie (certain from the outset with Walden's leadership)." His own organization was directed exclusively to the proletariat. "We work in cooperation with the trade unions and the Socialist party organizations."

26. For example, "Kunst und Leben," *Der Sturm*, X, No. 1 [April, 1919], 2-3; "Künstler, Volk und Kunst," *ibid.*, 10-13.

27. "An alle Künstler, Dichter, Musiker," *Der Anbruch*, II, No. 1 (January, 1919); a somewhat different version was printed in *Das Kunstblatt*, III, No. 1 (January, 1919), 29-30.

28. "Der Besitzbegriff in der Familie und das Recht auf den eigenen Körper," *Die Erde*, I, No. 8 (April 15, 1919), 242-45; "Zur Weltrevolution," *ibid.*, I, No. 12 (May 15, 1919), 368-71; "Zur Auflösung des bürgerlichen Frauentypus," *ibid.*, I, No. 14-15 (August 1, 1919), 461-65; "Schnitt durch die Zeit," *ibid.*, I, No. 18-19 (October 1, 1919), 539-47.

29. Heinrich Vogeler, *Das neue Leben. Ein kommunistisches Manifest* (Hanover: Paul Steegemann Verlag, 1919); "Über die kommunistische Schule," *Das Forum*, IV, No. 7 (April, 1920), 504-08, No. 9 (June, 1920), 660-64, V, No. 3-6 (December, 1920-March, 1921), 224-33; letter to a Herr Schumacher about the school, Bremen, Kunsthalle, Mappe "Künstlerbriefe."

30. "Brüder, zünd' die Fackel an. Zum Gedächtnis Carl Liebknechts und Rosa Luxemburgs," *Die Erde*, I, No. 4 (February 15, 1919), 115, 118.

31. "Mütter, werdende Mütter!" *Menschen*, Montagsblatt Nr. 11 (March 10, 1919), 2.

32. Eisner in *An alle Künstler!*, p. 27; Klara Zetkin, "Kunst und Proletariat," *Das Forum*, V, No. 2 (November, 1920), 114-21.

33. Deutsches Bundesarchiv, *Akten betreffend Kunstberatungsstelle im Reichsministerium des Inneren (Reichskunstwart)*, R 431/831. Band I, 8 December 1919–31 December 1930. Also Rudolf Blümner, "Die Aufgaben des Reichskunstwarts," *Der Sturm*, XI, No. 7–8 ([October] 1920), 116–17.

34. The questions and replies were published as a pamphlet, *Ja! Stimmen des Arbeitsrates für Kunst in Berlin*. The frontispiece was a Feininger woodcut, "Rathaus."

35. The best source of information on the Bauhaus is Hans M. Wingler, *The Bauhaus: Weimar Dessau Berlin Chicago* (Cambridge, Mass. and London: M.I.T., 1969), which consists almost entirely of documents and illustrations. And *see* Barbara Miller Lane's fine study, *Architecture and Politics in Germany, 1918-1945* (Cambridge, Mass.: Harvard University Press, 1968).

36. R. Albert, "Les Riches contre la culture," *Clarté*, III, No. 18 (December 1, 1923), 459.

37. *Der Sturm*, X, No. 3 ([June, 1919]), 39; Wolfgang Hütt, "Materialien zur Darstellung der Novemberrevolution in der bildenden Kunst in Deutschland," *Wissenschaftliche Zeitschrift der Martin-Luther-Universität Halle-Wittenberg*, VIII (1958-59), 161.

38. Raoul Hausmann, "Prothesenwirtschaft (Gedanken eines Kapp-Offiziers)," *Die Aktion*, X, No. 47-48 (November 27, 1920), 669-70.

39. Richard Huelsenbeck, *En avant Dada. Die Geschichte des Dadaïsmus*, vol. 50-51 of *Die Silbergäule* (Hanover, Leipzig: Paul Steegemann Verlag, 1920), pp. 30-31. English translation from Robert Motherwell (ed.), *The Dada Painters and Poets* (New York: Wittenborn, Schultz, 1951), pp. 41-42.

40. Peter Panter [Kurt Tucholsky], "Dada," clipping of 1920 from a Berlin newspaper in Grosz file, Kurt Wolff Archive, Beinecke Library, Yale University.

41. Kessler, *op. cit.*, April 12, 1919, p. 173; May 3, 1919, p. 183. It was a policy of the press to make these reviews cheap and accessible to the public. *Die Pleite* sold for 50 pfennigs.

42. Huelsenbeck, *En avant Dada*, p. 20.

43. Raoul Hausmann, "Pamphlet gegen die Weimarische Lebensauffassung," April, 1919. Quoted in Huelsenbeck (ed.), *Dada. Eine literarische Dokumentation* (Hamburg: Rowohlt, 1964), p. 34. *See also* Hausmann's French version in *Courrier Dada* (Paris: Le Terrain Vague, 1958), p. 34.

CHAPTER 8 (pp. 201–214)

1. "Der Kunstlump," *Die Aktion*, X, No. 23-24 (June 12, 1920), 331; reprinted from *Der Gegner*, I, No. 10-12 ([early 1920]), 48-56.

2. *Merz*, 2, No. i (1923), quoted in English in Werner Schmalenbach, *Kurt Schwitters* (New York: Harry N. Abrams, n.d.), p. 46.

3. Reprinted in "Der Kunstlump," 330.

4. F. W. Seiwert, "Das Loch in Rubens Schinken," *Die Aktion*, X, No. 29-30 (July 24, 1920), 418. Also Kurt Hiller, "Zum Fall Kokoschka," *Der Gegner*, II, No. 1-2 (1920-21), 45, and *Die Aktion*, X, No. 35-36 (September 4, 1920), 487-88. A year earlier, though, Walter Hasenclever had pointed out, apropos of an exhibition in Berlin, that Kokoschka had been the greatest prewar "terror of the burghers." "Oskar Kokoschka," *Menschen*, Montagsblatt No. 3 (January 19, 1919), p. 3.

5. Oskar Kokoschka, *Mein Leben* (Munich: Bruckmann, 1917), pp. 182–83; earlier stated to me in a 1968 interview. Kokoschka chose the Rubens issue because "with yammering about the fact that the lives of guiltless people, women and children, were being endangered on the streets, I couldn't even have made a cat come out of a hot oven." *Mein Leben*, p. 183.

6. Raoul Hausmann, "Die neue Kunst," *Die Aktion*, XI, No. 19-20 (May 14, 1921), 284; "PRÉsentismus gegen den Puffkeïsmus der teutschen Seele," *De Stijl*, IV, No. 9 (1921), 138-39; "Die Kunst und die Zeit," *Veröffentlichung der November-Gruppe*, Heft 1 (Hanover: Paul Steegemann Verlag, May, 1921), 3, 5.

7. Conrad Felixmüller, "Der Prolet (Pönnecke)," *Die Aktion*, X, No. 23-24 (June 12, 1920), 336.

8. George Grosz and Wieland Herzfelde, *Die Kunst ist in Gefahr* (Berlin: Malik-Verlag, 1925), pp. 24-26. Raoul Hausmann, "Intellektualismus, Gesellschaft und Gemeinschaft," *Die Aktion*, XIII, No. 25-26 (July 15, 1923), 351.

9. Grosz and Herzfelde, *op. cit.*, p. 32; Harry Graf Kessler, *Tagebücher, 1918-1937* (Frankfurt a. M.: Insel, 1961), March 16, 1919, p. 158; Herzfelde, "Gesellschaft, Künstler und Kommunismus," *Der Gegner*, II, No. 8-9 (1920-21), 305.

10. Heinrich Vogeler, *Proletkult. Kunst und Kultur in der kommunistischen Gesellschaft* (Hanover: Steegemann, 1920), 5-7, 12.

11. "Die schöpferische Macht im Kommunismus," *Die Aktion*, XI, No. 39-40 (October 1, 1920), 551; "Bekenntnis eines Intellektuellen," *Die Aktion*, XIV, No. 1-2 (January 20, 1924), 32.

12. Quoted in André Gybal, "Les Tendances de l'art moderne," *Clarté*, Ser. 2, I, No. 2 (December 3, 1921), 30.

13. Albert Gleizes, "Vers une époque de bâtisseurs," *Clarté*, Ser. 1, No. 13 (March, 20, 1920). And *see* Gybal, *op. cit.*, 30.

14. "Was wir wollen," *An alle Künstler!* (Berlin: 1919), pp. 21-22.

15. September 13, 1923, Dreier Correspondence, Beinecke Library, Yale University.

16. *See* their periodical, *Le Surréalisme au service de la Révolution*, published between 1930 and 1933. By 1925, *Clarté*, to which they then began to contribute, had become Trotskyist as well. And *see* André Breton's "Second Manifesto of Surrealism," 1930, which explains their disaffection. Reprinted in English in André Breton, *Manifestoes of Surrealism*, trans. Richard Seaver and Helen R. Lane (Ann Arbor: University of Michigan Press, 1972), pp. 119-87. An excellent analysis of the Surrealists' relations with Communism is Robert S. Short, "The Politics of Surrealism, 1920-36," in Walter Laqueur and George L. Mosse (eds.), *The Left-Wing Intellectuals Between the Wars, 1919–1939* (New York: Harper Torchbooks, 1966), pp. 3-25.

17. Ian Dunlop, *The Shock of the New: Seven Historic Exhibitions of Modern Art* (New York, St. Louis, San Francisco: American Heritage Press, 1972), p. 255. Dunlop's account is the most recent and succinct summary of the relations between the German avant-garde and Nazism. Two German works contain many documents: Hildegard Brenner, *Die Kunstpolitik des Nationalsozialismus* (Hamburg: Rowohlt, 1963) and Joseph Wulf, *Die bildenden Künste im dritten Reich* (Gütersloh: Sigbert Mohn Verlag, 1963).

18. Quoted in English in Dunlop, *op. cit.*, p. 253.

19. *Ibid.*, p. 246.

20. Quoted in English by Dore Ashton (ed.), *Picasso on Art: A Selection of Views* (New York: Viking, 1972), p. 149, from Simone Téry, "Picasso n'est pas officier dans l'armée française," *Les Lettres françaises*, March 24, 1945.

21. Jerome Seckler, "Picasso Explains," *New Masses*, (March 13, 1945), pp. 4-7; reprinted in Ashton, *op. cit.*, p. 140.

CHAPTER 9 (pp. 221–225)

1. Johann Peter Eckermann, *Conversations with Goethe*, trans. Gisela O. O'Brien (New York: Frederick Ungar Publication Co., 1964), p. 227.

2. Renato Poggioli, *The Theory of the Avant-Garde* (New York, Evanston, San Francisco, London: Harper and Row, 1971), presents a fine overall view of the entire literary and artistic avant-garde in relation to nineteenth and twentieth century society.

3. One need only read the writings and sayings of the current "Concept Artists," especially those of Joseph Beuys. *See,* for example, Lucy Lippard, *Six Years: The Dematerialization of the Art Object from 1966 to 1972* (New York: Praeger, 1973), pp. 121-22 and *passim.* And compare the political attitudes of various Surrealists in the 1920s and '30s: Robert S. Short, "The Politics of Surrealism, 1920-36," in Walter Laqueur and George L. Mosse (eds.), *The Left-Wing Intellectuals Between the Wars, 1919-1939* (New York: Harper Torchbooks, 1966), pp. 3-25.

Bibliography

SOURCES

I. UNPUBLISHED MATERIALS

Berlin. Akademie der Künste. *Akten, Preussische Akademie der Künste: Personal-nachrichten*.

Berlin. Bauhaus-Archiv. Letters from Lily Klee to Fritz Levedag, 1931.

Berlin. Brücke-Museum. *Mitgliederverzeichnis der Brücke*, 1909.

Berlin. Staatsbibliothek Preussischer Kulturbesitz. *Sturm-Archiv*. Letters to Herwarth Walden; guest book from the Walden Collection, 1913–20; Nell Walden's scrapbook.

Bremen. Kunsthalle. *Künstlerbriefe*, Vol. I, letters from various artists to Gustav Pauli.

Bremen. Staatsbibliothek. Letters of Max Liebermann, Otto Modersohn, Hans am Ende, Käthe Kollwitz, Fritz Makensen, and Gustav Pauli.

Cambridge, Mass. Houghton Library, Harvard University. *Papers of Lyonel Feininger*.

Darmstadt. Bauhaus-Archiv. Letters from Lily Klee to Fritz Levedag, 1931.

Hamburg. Kunsthalle. *Reiseberichte von Gustav Pauli an die Kommission für die Verwaltung der Kunsthalle* (Archiv: 119a).

Hamburg. Letters from Ludwig Meidner and Conrad Felixmüller to Generalstaatsanwalt Ernst Buchholz, in the possession of Ruth Buchholz.

Hamburg. Staats- und Universitätsbibliothek. *Max Sauerlandt Nachlass*.

Hamburg. Staats- und Universitätsbibliothek. *Nachlass Richard und Ida Dehmel*,

letters from Erna Kirchner, Oskar Kokoschka, Rosa Schapire, and Karl Schmidt-Rottluff.

New Haven. The Beinecke Rare Book and Manuscript Library, Yale University. *Correspondence of the Kurt Wolff Verlag.*

New Haven. The Beinecke Rare Book and Manuscript Library, Yale University. *Katherine Dreier Correspondence.*

New Haven. The Beinecke Rare Book and Manuscript Library, Yale University. *The Papers of Gertrude Stein.*

New Haven. The Beinecke Rare Book and Manuscript Library, Yale University. *Société Anonyme Collection.*

New Haven. The Beinecke Rare Book and Manuscript Library, Yale University. *Alfred Stieglitz Correspondence.*

New York. New York Public Library. *John Quinn Memorial Collection.*

Nuremberg. Germanisches Nationalmuseum. Catalogue of unpublished artists' writings in German collections.

Paris. Fondation Jacques Doucet, Bibliothèque Sainte-Geneviève. Letters of Marcel Duchamp and Francis Picabia.

Paris, Institut d'Histoire Sociale Contemporaine. *Papers of Jean Grave,* letters from Frantisek Kupka, Paul Signac, *et al.*

Vienna. Nationalbibliothek. *Erinnerungen an Egon Schiele,* handwritten manuscript by C. V. Klima, January, 1946.

Worpswede bei Bremen. Haus im Schluh. *Nachlass Heinrich Vogeler.*

II. PUBLIC DOCUMENTS

France. Chambre des Députés. *Débats parlementaires,* December 3, 1912.

France, Paris. Archives Nationales. F^712910–12911, *Propagande par tracts, affiches, placards, etc.,* 1905–1908, 1912–17; F^713053, *Listes d'anarchistes et notes sur les groupements anarchistes,* 1897–1921; F^713054, 13055, 13058, *Groupes anarchistes de Paris,* 1911–19.

France, Paris. Archives de la Préfecture de Police. B a/310, *Registres d'adresses d'anarchistes;* B a/894, *Lieux de réunion d'anarchistes;* B a/1497–1499, *Menées anarchistes,* 1897–1914; B a/1500, *Listes et états d'anarchistes;* B a/1507, *Groupes anarchistes du 18ᵉ arrondissement.*

Germany. *Verhandlungen des Reichstages.* Vol. 231, 119. Session, March 11, 1908; Vol. 357, November 15, 1922; Vol. 358, February 14, 1923, February 20, 1923.

Germany, Koblenz. Deutsches Bundesarchiv. *Akten betreffend Kunstberatungsstelle im Reichsministerium des Innern (Reichskunstwart),* R 431/831, I, December 8, 1919–December 31, 1930.

Italy, Rome. Archivio Centrale dello Stato. Ministero Interno (CPC Busta 223; Cat F-1 Pacco 15); P.S. (Dir. Gen. Pubblica Sicurezza—Min. Interno, A5G, 3A and A5G 3B); III-75 Min. Interno P.S. (60 143[V] Parte).

III. PUBLISHED WRITINGS OF PAINTERS AND THEIR ASSOCIATES

A. *Creative Works, Memoirs, Diaries, Correspondence*

Alexandre, Maxime. *Mémoires d'un surréaliste.* Paris: La Jeune Parque, 1968.

"Aus den 'Erinnerungen' von Fritz Bleyl," *Bildnisse der Brücke-Künstler voneinander.* Stuttgart: Reclam, 1961, pp. 23–29.

Bahr, Hermann. *Tagebuch.* Berlin: Paul Cassirer, 1909.

Ball, Hugo. *Die Flucht aus der Zeit.* Lucerne: Verlag Josef Stocker, 1946. Reprint of 192[?] edition.

Beckmann, Max. *Briefe im Kriege.* Berlin: Verlag Bruno Cassirer, 1916.

———. *Sichtbares und Unsichtbares.* Edited by Peter Beckmann. Stuttgart: Christian Belser Verlag, 1965.

Boccioni, Umberto. "Diario di guerra" (1915), in Guido Ballo, *Boccioni.* Milan: "Il Saggiatore," 1964, pp. 425–31.

———. "Diario" (Milan, 1908), *ibid.,* 403–23.

———. "Diario padovano," *Poesia e Critica,* IV, No. 8–9 (May, 1966), 9–45.

———. *Gli scritti editi e inediti.* Edited by Zeno Birolli. Milan: Feltrinelli, 1971.

Brandenburg, Hans, *München leuchtete. Jugenderinnerungen.* Munich: Verlag Herbert Neuner, 1953.

Brassaï, Pierre. *Conversations avec Picasso.* Paris: Gallimard, 1964.

Burgess, Gelett, "The Wild Men of Paris," *Architectural Record,* XXVII, No. 5 (May, 1910), 400–14.

Cabanne, Pierre. *Dialogues with Marcel Duchamp.* New York: Viking, 1971.

———. *Entretiens avec Marcel Duchamp.* Paris: Pierre Belfond, 1967.

Carco, Francis. *De Montmartre au Quartier Latin.* Paris: Albin Michel, 1927.

———. *Mémoires d'une autre vie.* Geneva: Editions du Milieu du Monde, 1942.

Carrà, Carlo. *La Mia Vita.* Milan: Rizzoli, 1943.

Chagall, Marc. *Ma Vie.* Paris: Stock, 1957.

Chapiro, Jacques. *La Ruche.* Paris: Flammarion, 1960.

de Chirico, Giorgio. *Memorie della mia vita.* Milan: Rizzoli, 1962.

Derain, André. *Lettres à Vlaminck.* Paris: Flammarion, 1955.

Dix, Otto. *Der Krieg.* [East] Berlin: Deutsche Akademie der Künste, 1963.

Douglas, Charles [pseud.]. *Artist Quarter: Reminiscences of Montmartre and Montparnasse in the First Two Decades of the Twentieth Century.* London: Faber and Faber, 1941.

Duhamel, Georges. *Lumières sur ma vie.* 4 vols. Paris: Paul Hartmann, 1944–49.

Ehrenburg, Ilya. *Post-War Years, 1945–1954.* Translated by Tatiana Shebunina. London: MacGibbon and Kee, 1966.

Fechter, Paul. *An der Wende der Zeit. Menschen und Begegnungen.* Gütersloh: Bertelsmann Verlag, 1949.

Frank, Leonhard. *Links wo das Herz ist.* Munich: Nymphenburger Verlagsbuchhandlung, 1952.

Freundlich, Otto. *Aus Briefen und Aufsätzen.* Edited by Günter Aust. Cologne: Verlag Galerie Der Spiegel, [ca. 1960].

Gide, André. *Journal.* Vol. I, 1889–1939. (Bibliothèque de la Pléiade.) Paris: Gallimard, 1948.

Gleizes, Albert. "Les Débuts du Cubisme," *Albert Gleizes et le Cubisme.* Basel and Stuttgart: Basilius Presse, 1962, pp. 53–68.

Graf, Oskar Maria. *Gelächter von aussen. Aus meinem Leben, 1918–1933.* Munich: Verlag Kurt Desch, 1966.

———. *Wir sind Gefangene.* Berlin: Verlag der Büchergilde Gutenberg, 1928.

Griebel, Otto. "Künstler im Klassenkampf. Über den Einfluss der grossen sozialistischen Oktoberrevolution auf Kulturschaffende in Deutschland. Erinnerungen," *Es begann in Petrograd. Beiträge zu 50 Jahre deutsch-sowjetische Freundschaft.* [East] Berlin: Deutscher Kulturbund, 1967.

Gris, Juan. *Letters (1913–1927).* Edited by Douglas Cooper. London: privately printed, 1956.

Grisebach, Lothar, (ed.). *E. L. Kirchners Davoser Tagebuch. Eine Darstellung des Malers und eine Sammlung seiner Schriften.* Cologne: M. DuMont Schauberg, 1968.

———. *Maler des Expressionismus im Briefwechsel mit Eberhard Grisebach.* Hamburg: Christian Wegner Verlag, 1962.

Grosz, George. *Abrechnung folgt!* Berlin: Malik Verlag, 1923.

———. *Ecce Homo.* Berlin: Malik Verlag, 1923.

———. *Das Gesicht der herrschenden Klasse.* Berlin: Malik Verlag, 1921.

———. *Kleine Grosz Mappe.* Berlin: Malik Verlag, 1917.

———. *Ein kleines Ja und ein grosses Nein.* Hamburg: Rowohlt Verlag, 1955.

Halicka, Alice. *Hier: Souvenirs.* Paris: Editions du Pavois, 1946.

Hausenstein, Wilhelm. *Pariser Erinnerungen. Aus fünf Jahren diplomatischen Dienstes, 1950–1955.* Munich: Günther Olzog Verlag, 1961.

Herbert, Robert L., and Eugenia W. "Artists and Anarchism: Unpublished Letters of Pissarro, Signac and Others," *Burlington Magazine,* CII, Nos. 692, 693 (November and December, 1960), 473–82, 517–22.

Herzfelde, Wieland. *Immergrün: Merkwürdige Erlebnisse und Erfahrungen eines fröhlichen Waisenknaben.* [East] Berlin: Aufbau Verlag, 1949.

Hirsch, Karl Jacob. *Heimkehr zu Gott. Briefe an meinen Sohn.* Wuppertal: R. Brockhaus Verlag, 1967.

Huelsenbeck, Richard. *Deutschland muss untergehen. Erinnerungen eines alten dadaistischen Revolutionärs.* Berlin: Malik Verlag, 1920.

———. *En avant Dada. Die Geschichte des Dadaïsmus.* Hanover and Leipzig: Paul Steegemann Verlag, 1920.

Jacob, Max. *Correspondance.* 2 vols. Edited by François Garnier. Paris: Editions de Paris, 1953, 1955.

Jourdain, Francis. *Sans remords ni rancune: Souvenirs épars d'un vieil homme "né en 76."* Paris: Corrêa, 1953.

Jung, Franz. *Der Weg nach Unten.* [West] Berlin: Luchterhand, 1961.

Kahnweiler, D[aniel] H[enry]. "Du temps que les cubistes étaient jeunes," *L'Oeil,* I, No. 1 (January 15, 1955), 27–31.

———. *Entretiens avec Francis Crémieux: Mes galeries et mes peintres.* Paris: Gallimard,

1961. (Translated into English as *My Galleries and Painters*. New York: Viking, 1971.)

Kandinsky, Wassily. "Rückblicke," in *Kandinsky 1901–1913*. Berlin: Der Sturm, [1913].

Kessler, Harry Graf. *Tagebücher, 1918–1937*. Frankfurt a. M.: Insel Verlag, 1961.

Kirchner, E[rnst] L[udwig]. *Briefe an Nele und Henry van de Velde*. Munich: Piper-Bücherei, 1961.

Klee, Paul. *Tagebücher, 1898–1918*. Cologne: M. DuMont Schauberg, 1957. Published in English as *The Diaries of Paul Klee*. Berkeley and Los Angeles: University of California Press, 1964.

Kokoschka, Oskar. *Mein Leben*. Munich: Bruckmann, 1971.

———. *Schriften, 1907–1955*. Edited by Hans Maria Wingler. Munich: Langen-Müller, 1956.

———. *Spur im Treibsand*. Zurich: Atlantis Verlag, 1956.

Konstantin, Prinz von Bayern. *Die grossen Namen. Begegnungen mit bedeutenden Deutschen unserer Zeit*. Munich: Kindler Verlag, 1956.

Kubin, Alfred. *Die andere Seite. Phantastischer Roman*. Munich: Deutscher Taschenbuch Verlag, 1962. (First published in 1909.)

———. "Autobiography," in *The Other Side*. New York: Crown Publishers, 1967.

———. *Dämonen und Nachtgesichte. Eine Autobiographie*. Munich: R. Piper, 1959.

———. *The Other Side: A Fantastic Novel*. Translated by Denver Lindley. New York: Crown Publishers, 1967.

Macke, August, and Franz Marc. *Briefwechsel*. Cologne: M. DuMont Schauberg, 1964.

Marc, Franz. *Briefe, Aufzeichnungen und Aphorismen*. 2 vols. Berlin: Paul Cassirer, 1920.

———. *Briefe 1914–1916 aus dem Felde*. Berlin: Rembrandt Verlag, 1959. Reprint of most of the letters from the 1920 edition.

Marinetti, F[ilippo] T[ommaso]. *Marinetti e il Futurismo*. Rome and Milan: Edizioni "Augustea," 1929.

———. *Teatro*. 3 vols. Rome: Vito Bianco, 1960.

Mehring, Walter. *Die verlorene Bibliothek: Autobiographie einer Kultur*. Hamburg: Rowohlt Verlag, 1952.

Meidner, Ludwig. *Eine autobiographische Plauderei* (2d, rev. ed.). Leipzig: Klinkhardt und Biermann, 1923.

Mendelsohn, Erich. *Briefe eines Architekten*. Edited by Oskar Beyer. Munich: Prestel Verlag, 1961.

Metzinger, Jean. *Le Cubisme était né: Souvenirs*. Chambéry: Éditions Présence, 1972.

Mühsam, Erich. *Unpolitische Erinnerungen*. [East] Berlin: Verlag Volk und Welt, 1961. (Originally published in 1931.)

Nolde, Emil. *Briefe aus den Jahren 1894–1926*. Edited by Max Sauerlandt. Berlin: Furche-Kunstverlag, 1927.

———. *Das eigene Leben. Die Zeit der Jugend, 1867–1902*. (2d ed.). Flensburg and Hamburg: Verlagshaus Christian Wolff, 1949. (First published in 1931.)

————. *Jahre der Kämpfe, 1902–1914* (2d, enlarged ed.). Flensburg: Christian Wolff Verlag, [1958]. (First published in 1934.)

————. *Reisen, Ächtung, Befreiung.* Cologne: M. DuMont Schauberg, 1967.

————. *Welt und Heimat. Die Südseereise, 1913–1918.* Cologne: M. DuMont Schauberg, 1965. Written in 1936.

Olivier, Fernande. *Picasso et ses amis.* Paris: Librairie Stock, 1933.

Ompteda, Georg Freiherr von. *Sonntagskind. Jugendjahre eines Glücklichen.* Stuttgart, Berlin, and Leipzig: Deutsche Verlags-Anstalt, 1929.

Papini, Giovanni. *Passato remoto, 1885–1914.* Florence: L'Arco, 1948.

Pechstein, Max. *Erinnerungen.* Edited by Leopold Reidemeister. Munich: List Verlag, 1963.

Poiret, Paul. *En habillant l'époque.* Paris: Grasset, 1930.

Pulver, Max. *Erinnerungen an eine europäische Zeit.* Zurich: Orell Füssli Verlag, 1953.

Ray, Man. *Self Portrait.* Boston and Toronto: Little, Brown & Co., 1963.

Raynal, Maurice. "Le Banquet Rousseau," *Les Soirées de Paris,* No. 20 (January 15, 1914), 69–72.

Ribemont-Dessaignes, Georges. *Déjà jadis: Ou du mouvement Dada à l'espace abstrait.* Paris: Juillard, 1958.

Richter, Hans. *Hans Richter.* Introduction by Herbert Read. Neuchatel: Editions du Griffon, 1965. Contains an autobiographical text.

Rivera, Diego, with Gladys March. *My Art, My Life: An Autobiography.* New York: Citadel Press, 1960.

Rolland, Romain. *Journal des années de guerre, 1914–1919. Notes et documents pour servir à l'histoire morale de l'Europe de ce temps.* Paris: Editions Albin Michel, 1952.

Rouault, Georges, and André Suarès. *Correspondance.* Paris: Gallimard, 1960.

S., J. "'El Simultanisme' del Senyor i la Senyora Delaunay," *Vell i Nou,* Barcelona, III, No. 57 (December 15, 1917), 672–79. Contains letters from Robert Delaunay.

Sabartés, Jaime (ed.). *Picasso: Documents iconographiques.* Geneva: Pierre Cailler, 1954.

Salmon, André. *Souvenirs sans fin.* 3 vols. Paris: Gallimard, 1955–61.

Scheffler, Karl. *Die fetten und die mageren Jahre. Ein Arbeits- und Lebensbericht.* Munich and Leipzig: Paul List Verlag, 1946.

Schifferli, Peter (ed.). *Als Dada begann. Bildchronik und Erinnerungen der Gründer.* Zurich: "Die Arche," 1957.

Schlemmer, Oskar. *Briefe und Tagebücher.* Edited by Tut Schlemmer. Munich: Langen-Müller, 1958.

Schmitz, Oscar A. H., *Ergo Sum: Jahre des Reifens.* Munich: Georg Müller, 1927.

Schreyer, Lothar. *Erinnerungen an Sturm und Bauhaus.* Munich: List Verlag, 1966. Shortened edition.

Severini, Gino. *Tutta la vita di un pittore.* Milan: Garzanti, 1946.

Soffici, Ardengo. *Autoritratto d'artista italiano nel quadro del suo tempo.* 4 vols. Florence: Vallecchi Editore, 1951–55.

————. *Ricordi di vita artistica e letteraria* (2d, augmented ed.). Florence: Vallecchi Editore, 1942. (First published in 1930.)

Stein, Gertrude. *The Autobiography of Alice B. Toklas.* New York: Random House, 1933.

Szeps-Zuckerkandl, Berta. *Ich erlebte fünfzig Jahre Weltgeschichte.* Stockholm: Bermann-Fischer Verlag, 1931.

Szittya, Emil. *Das Kuriositäten-Kabinett. Begegnungen mit seltsamen Begebenheiten, Landstreichern, Verbrechern, Artisten, religiös Wahnsinnigen, sexuellen Merkwürdig-keiten, Sozialdemokraten, Syndikalisten, Kommunisten, Anarchisten, Politikern und Künstlern.* Constance: See Verlag, 1923.

Toklas, Alice B. *What is Remembered.* New York: Holt, Rinehart and Winston, 1963.

Uhde, Wilhelm. *Von Bismarck bis Picasso. Erinnerungen und Bekenntnisse.* Zurich: Verlag Oprecht, 1938.

Uhde-Bernays, Hermann. *Im Lichte der Freiheit. Erinnerungen aus den Jahren 1880 bis 1914.* Frankfurt a. M.: Insel Verlag, 1947.

Vlaminck, Maurice de [*sic*], *Portraits avant décès.* Paris: Flammarion, 1943.

———. *Tournant dangereux: Souvenirs de ma vie.* Paris: Stock, 1929.

Vogeler, Heinrich. *Erinnerungen.* Edited by Erich Weinert. Berlin: Rütten und Loening, 1952.

Vollard, Ambroise. *Souvenirs d'un marchand de tableaux.* Paris: Editions Albin Michel, 1937.

Walden, Nell, and Lothar Schreyer. *Der Sturm: Ein Erinnerungsbuch an Herwarth Walden und die Künstler aus dem Sturmkreis.* Baden-Baden: Waldemar Klein, 1954.

Werefkin, Marianne. *Briefe an einen Unbekannten, 1901–1905.* Edited by Clemens Weiler. Cologne: M. DuMont Schauberg, 1960.

B. *Manifestos and Theoretical Works on Art or Politics*

Adam, Paul. *L'Art et la Nation. Discours prononcé au banquet du 10 décembre* [*1906*]. Paris: "L'Abbaye" (Groupe fraternel d'artistes), 1907.

Ajalbert, Jean. *Une Enquête sur les droits de l'artiste.* Paris: Stock, 1905.

An alle Künstler! Berlin: 1919.

Apollinaire, Guillaume. *Chroniques d'art (1902–1918).* Edited by L[eroy] C. Breunig. Paris: Gallimard, 1960. Translated into English by Susan Suleiman as *Apollinaire on Art: Essays and Reviews, 1902–1918.* New York: Viking Press, 1972.

———. *Oeuvres complètes.* 3 vols. Edited by Michel Décaudin. Paris: André Balland et Jacques Lecat, 1965.

———. *Les Peintres cubistes: Méditations esthétiques.* Edited by L[eroy] C. Breunig and J. Cl[aude] Chevalier. Paris: Hermann, 1965. (Originally published in 1913.)

Apollonio, Umbro (ed.). *Futurist Manifestos.* New York: Viking Press, 1973.

"Appel aux travailleurs intellectuels," *Clarté* (2nd series), IV, No. 76 (July 15, 1925).

Ashton, Dore (ed.). *Picasso on Art: A Selection of Views.* New York: Viking Press, 1972.

Balla, Giacomo. "Arte fascista ed Esposizioni," *Arte fascista. Elementi per la battaglia artistica.* Turin: Sindicati Artistici, 192[7?], pp. 62–64.

Barbusse, Henri, Anatole France, Georges Duhamel, *et al.* "Aufruf zur inter-nationalen Solidarität," *Das Forum,* IV, No. 1 (October, 1919), 76–77.

Beckmann, Max. "Gedanken über zeitgemässe und unzeitgemässe Kunst," *Pan*, II, No. 17 (March 14, 1912), 494–502.

Behne, Adolf, "Graphik und Plastik von Mitgliedern der Novembergruppe Berlin," *Menschen*, II, No. 14 (December, 1919), 1–2.

Boccioni, Umberto. *Opera completa*. Edited by F. T. Marinetti. Foligno: Franco Campitelli, 1927.

———. *Pittura Scultura Futuriste (dinamismo plastico)*. Milan: Edizioni futuriste di "Poesia," 1914.

Canudo, Ricciotto. "Il Cenobio laico in Francia." *Avanti della domenica*, V, No. 10 (March 10, 1907), 3–4.

Carrà, Carlo. *Georg Schrimpf*. Rome: Edizioni di "Valori Plastici," 1924.

Carrrà, Futurista [Carlo Carrà]. *Guerrapittura*. Milan: Edizioni futuriste di "Poesia," 1915.

Cassirer, Paul. "Kunst und Kunsthandel," *Pan*, I, No. 14 and I, No. 17 (May 16, 1911 and July 1, 1911), 457–69, 558–73.

Colin, Paul. "Antwort an Edschmid und seine Gefährten," *Das Tribunal*, I, No. 10–11 (October–November, 1919), 111–12.

Dada Almanach. Edited by Richard Huelsenbeck. Berlin: Erich Reiss Verlag, 1920.

"Dada vor Gericht," *Der Ararat*, II ([January?] 1921), 180–81.

"Dadaistisches Manifest," *Der Zweemann*, I, No. 3 (January, 1920), 15–16. Signed by Arp, Ball, Grosz, Huelsenbeck, Hausmann, Janco, *et al.*

Däubler, Theodor. *Im Kampf um die moderne Kunst* (3d ed.). *Tribüne der Kunst und Zeit*, No. 3. Berlin: Erich Reiss Verlag, 1919.

Delaunay, Robert. *Du cubisme à l'art abstrait*. Edited by Pierre Francastel, with a *catalogue raisonné* by Guy Habasque. Paris: S.E.V.P.E.N., 1957.

Delphy, Jean. "L'Artiste est nécessairement anarchiste," *Le Libertaire* (6th series), XII, No. 44 (September 2–9, 1906).

"Deutsch-Holländische Kulturaktion," *Der Gegner*, II, No. 4 (1920–21), 119–20.

"I Diritti artistici propugnati dai futuristi italiani: Manifesto al governo fascista," *"Noi"* (2d series), I, No. 1 (April, 1923), 1–2.

Dix, Otto, George Grosz, Raoul Hausmann, Hanna Höch, *et al.* "Offener Brief an die Novembergruppe," *Der Gegner*, II, No. 8–9 (1920–21), 297–301.

Van Dongen, Kees. *Van Dongen raconte ici la vie de Rembrandt et parle, à ce propos, de la Hollande, des femmes et de l'art*. Paris: Flammarion, 1927.

Drudi Gambillo, Maria, and Teresa Fiori (eds.). *Archivi del futurismo*. 2 vols. Rome: De Luca, 1958, 1962.

Edschmid, Kasimir. "Appel à la jeunesse intellectuelle française," *Clarté*, No. 5–6 (December 13, 1919).

———. "Aufruf an die revolutionäre französische geistige Jugend," *Das Tribunal*, I, No. 8–9 (August–September, 1919), 95–97.

———. "La Situation des intellectuels en Allemagne," *Europe*, I, No. 1 (February 15, 1923), 88–101.

Endell, August. "Das Kunstprogramm des Kommissariats für Volksaufklärung in Russland," *Das Kunstblatt*, III, No. 3 (March, 1919), 91–94.

Eulenberg, Herbert. *Die Kunst in unserer Zeit. Eine Trauerrede an die deutsche Nation*. Leipzig: Ernst Rowohlt Verlag, 1911.

Felixmüller, Conrad. "Künstlerische Gestaltung," *Das Kestnerbuch.* Edited by Paul Erich Küppers. Hanover: Heinrich Böhme Verlag, [1919].

————. "Mein Werden," *Das Kunstblatt,* III, No. 3 (March, 1919), 71–74.

————. "Militär-Krankenwärter Felixmüller XI, Arnsdorf," *Menschen,* I, No. 3 (May 15, 1918).

————. "Zur Kunst," *Die schöne Rarität,* II, No. 3 (June, 1918), 40.

————. "Der Prolet (Pönnecke)," *Die Aktion,* X, No. 23–24 (June 12, 1920), 333–36.

Fidelis [pseud.]. "Gustav Landauers Kulturprogramm," *Das Forum,* IV, No. 8 (May, 1920), 577–99.

Fischer, Dr. Henri. *Industrie intellectuelle. Conférence faite à "Art et Travail."* Paris: L'Emancipatrice (Imprimerie Communiste), 1904.

Flam, Jack D. (ed.). *Matisse on Art.* London: Phaidon, 1973.

Freundlich, Otto. "Absage. Eine endgültige Auseinandersetzung mit den drei Instituten: Deutscher Werkbund, Arbeitsrat für Kunst in Berlin, Novembergruppe," *Die Erde,* I, No. 24 (December 15, 1919), 686–87.

————. "Bekenntnis eines Intellektuellen," *Die Aktion,* XIV, No. 1–2 (January 21, 1924), 31–33.

————. "Es wird ernst," *Die Erde,* I, No. 5 (March 1, 1919), 129–35.

————. "Die gesehene Form," *Die Aktion,* XIV, No. 22–23 (December, 1924), 687–88.

————. "In Tyranos Intellectuales," *ibid.,* X, No. 3–4 (January 24, 1920), 52–53.

————. "Moderne Kannibalen," *ibid.,* XIII, No. 19–20 (May 30, 1923), 262–63.

————. "Das Perpetuum-Mobile," and "Aktive Kunst," *Der rote Hahn,* No. 13. Berlin: Verlag Die Aktion, 1918.

————. "Die schöpferische Macht im Kommunismus," *Die Aktion,* XI, No. 39–40 (October 1, 1921), 550–52.

————. "Was wollt Ihr von Picasso?" *ibid.,* XII, No. 33–34 (September 1, 1922), 479–81.

————. "Die Welttragik der Lüge," *Die Erde,* I, No. 18–19 (October 1, 1919), 555–63.

————. "Wir gehen . . .," *Das Tribunal,* I, No. 7 (July, 1919), 83–84.

————. "Zur Synthese Architektur—Plastik—Malerei," *Die Erde,* I, No. 8 (April 15, 1919), 233–37.

Fry, Edward F. (ed.). *Cubism.* New York and Toronto: McGraw-Hill Book Company, [1966].

"Für Kandinsky: Protest," *Der Sturm,* III, Nos. 150–151, 152–153, and IV, No. 154–155 (March and April, 1913), 277–79, 288, and 3, 5.

Gleizes, Albert. "L'Affaire Dada," *Action,* No. 3 (April, 1920), pp. 26–32.

————. "Le Cubisme et la tradition," *Montjoie!,* Nos. 1 and 2 (February 10, 1913, and February 25, 1913).

————. *La Signification humaine du cubisme.* Sablons: Editions Moly-Sabata, 1938.

————. "Souvenir: Le Cubisme, 1908–1914," In *Cahiers Albert Gleizes,* I. Published by the Association des Amis d'Albert Gleizes. New York: George Wittenborn, 1957.

————. *Tradition et cubisme: Vers une conscience plastique.* Paris: Povolozky, 1927.

————. "Vers une époque de bâtisseurs," *Clarté,* Ser. 1, Nos. 13, 14, 15, 22, 32 (March 20, April 3, April 17, June 26, September 11, 1920).

————, and Jean Metzinger. *Du "Cubisme."* Paris: Eugène Figuière, 1912.

Grandjouan (Jules Félix). "L'Art et la misère," *La Guerre sociale,* II, No. 4 (January 8–14, 1908).

————. "L'Art et le peuple," *ibid.,* No. 15 (March 11–17, 1908).

Grave, Jean. "Qu'est-ce que l'art," *Les Temps nouveaux,* XVIII, No. 1 (May 4, 1912), 2–3.

Gropius, Walter. "Der neue Baugedanke," *Das hohe Ufer,* I, No. 4 (April, 1919), 87–88.

————. "'Sparsamer Hausrat' und falsche Dürftigkeit," *ibid.,* No. 7 (July, 1919), 178–80.

Grosz, George. "L'Art et la société bourgeoise," *Clarté,* Ser. 2, III, No. 61 (June 15, 1924), 271–75.

Grosz, George, and Wieland Herzfelde. *Die Kunst ist in Gefahr. Drei Aufsätze.* Berlin: Malik-Verlag, 1925.

Hausmann, Raoul. "Bilanz der Feierlichkeit," *Die Erde,* I, No. 16–17 (September 1, 1919), 519–20.

————. "Der Besitzbegriff in der Familie und das Recht auf den eigenen Körper," *ibid.,* I, No. 8 (April 15, 1919), 242–45.

————. *Courrier Dada.* Paris: Le Terrain Vague, 1958. Reprints of earlier articles and speeches.

————. "Der geistige Proletarier," *Menschen,* "Montagsblatt," No. 8 (February 17, 1919), p. 3.

————. "Der Häusserbund bekommt 22 800 Stimmen," *Die Aktion,* XIV, No. 9–10 (May 24, 1924), 232–35.

————. "Hurra! Hurra! Hurra!" *Der Gegner,* I, No. 10–12 (1919), 57–62.

————. "Der individualistische Anarchist und die Diktatur," *Die Erde,* I, No. 9 (May 1, 1919), 276–78.

————. "Intellektualismus, Gesellschaft und Gemeinschaft," *Die Aktion,* XIII, No. 25–26 (July 15, 1923), 347–51.

————. "Die Kunst und die Zeit," *Veröffentlichung der November-Gruppe,* 1. Edited by H[ans] S[iebert] von Heister and R[aoul] Hausmann. Hanover: Paul Steegemann Verlag, May, 1921.

————. "Die Macht liegt auf der Strasse," *Die Aktion,* XI, No. 33–34 (August 20, 1921), 474–76.

————. "Menschen, Leben, Erleben," *Menschen,* I, No. 10 (December 15, 1918).

————. "Die neue Kunst," *Die Aktion,* XI, No. 19–20 (May 14, 1921), 281–85.

————. "Pamphlet gegen die Weimarische Lebensauffassung," *Der Einzige,* No. 14 (April 20, 1919), pp. 163–64.

————. "PRÉsentismus gegen den Puffkeïsmus der teutschen Seele," *De Stijl,* IV, No. 9 (1921), 136–43.

————. "Der Proletarier und die Kunst," *Das Kunstblatt,* II, No. 12 (December, 1918), 388–89.

————. "Prothesenwirtschaft. (Gedanken eines Kapp-Offiziers)," *Die Aktion,* X, No. 47–48 (November 27, 1920), 669–70.

————. "Puffke beendet die Weltrevolution," *ibid.,* XI, No. 25–26 (June 25, 1921), 365–67.

—————. "Puffke propagiert Proletkult," *ibid.*, No. 9–10 (March 5, 1921), 131–34.

—————. "Schnitt durch die Zeit," *Die Erde*, I, No. 18–19 (October 1, 1919), 539–47.

—————. "Zur Auflösung des bürgerlichen Frauentypus. Unter Berücksichtigung eines Einzelfalles," *ibid.*, No. 14–15 (August 1, 1919), 461–65.

—————. "Zur Weltrevolution," *ibid.*, No. 12 (May 15, 1919), 368–71.

Heartfield, John, and George Grosz. "Der Kunstlump," *Der Gegner*, I, No. 10–12 [early 1920], 48–56. Reprinted in *Die Aktion*, X, No. 23–24 (June 12, 1920), 327–32.

Herbert, Robert L. *Modern Artists On Art*. Englewood Cliffs, N.J.: Prentice-Hall, 1964.

Herzfelde, Wieland. "Die beleidigte Reichswehr," *Der Gegner*, II, No. 7 (1920–1921), 271–73.

—————. "Gesellschaft, Künstler und Kommunismus," *ibid.*, Nos. 5, 6, 8–9, 10–11 (1920–21), 131–38, 194–97, 302–9, 362–70.

—————. *Schutzhaft. Erlebnisse vom 7. bis 20. März 1919 bei den Berliner Ordnungstruppen*. Berlin: Malik-Verlag, March, 1919.

Herzog, Wilhelm. "Unabhängigkeits-Erklärung des Geistes." *Das Forum*, III, No. 11 (August, 1919), 825–34.

Hiller, Kurt. "Künstler und Kämpfer," *Das Tribunal*, I, No. 1 (January, 1919), 7–8.

Hirsch, Karl Jacob. "Revolutionäre Kunst," *Der rote Hahn*, XXXI–XXXII. Berlin: Verlag Die Aktion, 1919.

Hotz, Charles. *Art et le peuple*. Marseille: Edition de la Société "Arts et Excursions," 1910. A speech given on June 15, 1910, to the Société Amicale des Employés de Tramways de Marseille.

Huelsenbeck, Richard. "Chauvinisten; hier und da." *Revolution*, No. 2 (November 1, 1913).

————— (ed.). *Dada. Eine literarische Dokumentation*. Hamburg: Rowohlt, 1964.

—————. *Dada siegt. Eine Bilanz des Dadaismus*. Berlin: Malik-Verlag, 1920.

Im Kampf um die Kunst. Die Antwort auf den "Protest deutscher Künstler." Munich: R. Piper & Co., 1911.

Ja! Stimmen des Arbeitsrates für Kunst in Berlin. Berlin-Charlottenburg, Photographischen Gesellschaft, 1919.

Jaffé, H. L. C. (ed.). *Mondrian und De Stijl*. Cologne: M. DuMont Schauberg, 1967. A selection of articles from *De Stijl*, 1917–32.

Jaurès, Jean. "Art et socialisme," *La Forge*, Nos. 5 and 6 (January and March, 1918), 1–14, 78–85. Reprint of a 1900 speech.

K. K. [Käthe Kollwitz?]. "Mütter, werdende Mütter," *Menschen*, "Montagsblatt," No. 11 (March 10, 1919), 2.

Kandinsky, Wassily. *Concerning the Spiritual in Art*. Translated by Michael Sadleir. New York: George Wittenborn, 1947.

—————. "Selbstcharakteristik," *Das Kunstblatt*, III, No. 6 (June, 1919), 172–74.

—————. *Über das Geistige in der Kunst* (8th ed.). Bern: Benteli Verlag, 1965. First published in 1912.

Kandinsky, Wassily, and Franz Marc. *Der blaue Reiter*. Reprint, edited by Klaus Lankheit. Munich: R. Piper & Co., 1965. First published in 1912.

Kerr, Alfred. "Auferstehung der Polizei," *Pan*, II, No. 26 (May 16, 1912), 741–45.

Kirchner, E[rnst] L[udwig]. "Die Chronik der 'Brücke.'" Facsimile in *Bildnisse der Brücke-Künstler voneinander*. Stuttgart: Reclam, 1961, pp. 30–32.

———. "Glaubensbekenntnis eines Malers," *Das Kunstblatt*, III, No. 6 (June, 1919), 168.

Kokoschka, Oskar. "Irrweg der 'Abstrakten,'" *Die Welt*, Berlin, October 11, 1953.

Komitee Künstlerhilfe für die Hungernden in Russland. "An alle Künstler und Intellektuellen!," *Der Gegner*, II, No. 12 (1920–1921), 415.

Die kranke deutsche Kunst. Auch von einem Deutschen. Leipzig: Verlag H. A. Ludwig Degener, 1911.

Kuschner, Boris. "Bürgerliche Zwischenrufe," *1919. Neue Blätter für Kunst und Dichtung*, II (May, 1919), 36–37.

———. "Die Kunst der Gemeinschaft," *ibid.*, 35–36.

Laqment, Marcel. "L'Artiste n'est pas nécessairement anarchiste," *Le Libertaire* (Ser. 6), XII, No. 46 (September 16–23, 1906).

Léger, Fernand. *Functions of Painting*. Translated by Alexandra Anderson. New York: Viking, 1973.

———. "Les Origines de la peinture contemporaine et sa valeur représentative," *Der Sturm*, IV, No. 172–73 (August, 1913), 76–79.

———. "Les Origines de la peinture et sa valeur représentative," *Montjoie!*, Nos. 8 and 9–10 (May 29, and June 14–29, 1913).

Lissitzky, El. Theoretical articles, in *El Lissitzky. Maler Architekt Typograf Fotograf*. Edited by Sophie Lissitzky-Küppers. Dresden: VEB Verlag der Kunst, 1967.

Lounatcharsky, A[natole]. "L'Art à Moscou," *Bulletin communiste*, II, No. 33 (August 11, 1921), 555–57.

———. "La Culture prolétarienne et la commisariat de l'instruction publique," *Le Phare*, II, No. 18 (March, 1921), 382–87.

———. "Le Gouvernement des soviets et la conservation des oeuvres d'art," *Bulletin communiste*, I, No. 14 (June 17, 1920), 3–5.

Lunatscharski, A[natol]. "Die III. Internationale und die Intellectuellen," *Das Forum*, V, No. 11 (August, 1921), 476–83.

———. *Die Kulturaufgaben der Arbeiterklasse*. (*Der rote Hahn*, No. 36.) Berlin: Verlag Die Aktion, 1919.

Märten, Lu. *Die wirtschaftliche Lage der Künstler*. Munich: Georg Müller, 1914.

"Manifeste," *Clarté*, No. 7 (December 27, 1919).

I Manifesti del Futurismo. Florence: Edizioni di "Lacerba," 1914.

Marc, Franz. "Anti-Beckmann," *Pan*, II, 1st semester (October, 1911–March, 1912), 555–56.

———. "Das geheime Europa," *Das Forum*, I, No. 12 (March, 1915), 632–38.

———. "Im Fegefeuer des Krieges," *Der Sturm*, VII, No. 1 (April, 1916), 2.

———. "Die konstruktiven Ideen der neuen Malerei," *Pan*, II, 1st semester (October, 1911–March, 1912), 527–31.

———. "Die neue Malerei," *ibid.*, 468–71.

Marinetti, F[ilippo] T[ommaso]. "A chacun, chaque jour, un métier différent (l'Inégalisme)," *Noi* (Ser. 2), I, No. 5 (August, 1923), 1–2.

————. *La Battaglia di Tripoli (26 ottobre 1911) vissuta e cantata da F. T. Marinetti*. Milan: Edizioni futuriste di "Poesia," 1912.

————. "La Camera degli artisti," *Arte Fascista. Elementi per la battaglia artistica*. Turin: Sindicati Artistici, 192[7?], pp. 27–34.

————. "Contro Vienna e contro Berlino," *Italia futurista*, I, No. 4 (July 25, 1916).

————. *Futurismo e Fascismo*. Foligno: Franco Campitelli, 1924.

————. *Guerra sola igiene del mondo*. Milan: Edizioni futuriste di "Poesia," 1915.

————. "Lettera aperta al Generale Cadorno," *Italia futurista*, I, No. 3 (July 10, 1916).

————. "La Migliore Batteria," *ibid.*, No. 2 (June 15, 1916).

Marsalle, Louis de [E. L. Kirchner]. "Über Kirchners Graphik," *Genius*, III, No. 2 (1921), 251–63.

————. "Zeichnungen von E. L. Kirchner," *Genius*, II, No. 2 (1920), 217–34.

Matisse, Henri. *Écrits et propos sur l'art*. Edited by Dominique Fourcade. Paris: Hermann, 1972.

————. "Notes d'un peintre," *La Grande Revue*, LII (December 25, 1908), 731–45.

Meidner, Ludwig. "An alle Künstler, Dichter, Musiker," *Das Kunstblatt*, III, No. 1 (January, 1919), 29–30. Also published in *Der Anbruch*, II, No. 1 (January, 1919).

————. "Bruder, zünd' die Fackel an. Zum Gedächtnis Carl Liebknechts und Rosa Luxemburgs," *Die Erde*, I, No. 4 (February 15, 1919), 115–18.

————. "Erinnerung an Dresden." *1918. Neue Blätter für Kunst und Dichtung*, I (June, 1918), 36–38.

————. "Tagebuches letzte Winter-Seiten," *Das Kunstblatt*, II, No. 2 (February, 1918), 58–60.

————. "Vom Zeichnen," *Das Kunstblatt*, I, No. 4 (April, 1917), 97–101.

Meisel, Victor (ed.). *Voices of German Expressionism*. Englewood Cliffs, N.J.: Prentice-Hall, 1970.

Mercereau, Alexandre, and Boris Sokoloff. "L'Art et le Bolchevisme," *La Forge*, No. 17–18 (July–August, 1919), 29–41.

Michel, Wilhelm. "Zum Weltkongress der Geistigen—Aux intellectuels de tous les pays," *Das Tribunal*, I, No. 8–9 (August–September, 1919), 97–98.

Motherwell, Robert (ed.). *The Dadaist Painters and Poets*. New York: Wittenborn, Schultz, 1951.

Mühsam, Erich. "Die Intellectuellen," *Die Aktion*, XI, No. 3–4 (January 22, 1921), 53–56.

"Das neue Programm," *Kunst und Künstler*, XII (1914), 299–314.

"Nie wieder Krieg." Friedensstimmen anerkannter Maler, Dichter, Pazifisten, Sozialistinnen und Sozialisten des In- und Auslandes. (2d ed.). Leipzig: [1926?].

"Opinions sur l'art Nègre," *Action*, No. 3 (April, 1920), 23–26.

Papini, Giovanni. *Il Mio Futurismo*. Florence: Edizioni di Lacerba, 1914.

Paul-Boncour, J[oseph]. *Art et démocratie*. Paris: Ollendorff, 1912.

Pechstein, Max. "Was ist mit dem Picasso?" Narrated by Walther Heymann. *Pan*, II, No. 23 (April 25, 1912), 665–69.

Pelloutier, Fernand. *L'Art et la Révolte*. Paris: Bibliothèque de l'Art Social, 1897.

Pinthus, Kurt (ed.). *Menschheitsdämmerung. Ein Dokument des Expressionismus*. Re-

print, Hamburg: Rowohlt Taschenbuch Verlag, 1959. First published in 1920 by Rowohlt, Berlin.

Raabe, Paul (ed.). *Expressionismus: Aufzeichnungen und Erinnerungen der Zeitgenossen.* Olten and Freiburg im Breisgau: Walter-Verlag, 1965.

"La Révolution d'abord et toujours," *Clarté* (Ser. 2), IV, No. 77 (October 15, 1925), 301–2.

Ribemont-Dessaignes, Georges. "Dadaïsme," *De Stijl*, VI, Nos. 2 and 3–4 (April, May–June, 1923), 28–30, 38–40.

———. "Dadaïsme," *Der Sturm*, XIII, No. 4 ([April, 1922]), 58–61.

Richter, Hans. *Dada—Kunst und Antikunst. Der Beitrag Dadas zur Kunst des 20. Jahrhunderts.* Cologne: M. DuMont Schauberg, 1964.

———. "Ein Maler spricht zu den Malern," *Zeit-Echo*, III (June, 1917).

Robin, Maurice. *L'Art et le peuple.* Paris: Bibliothèque des "Hommes du Jour," 1910.

Rolland, Romain. "Für die Unabhängigkeit des Geistes," *Die Sichel*, I, No. 4 (October, 1919), 59–60.

Sanouillet, Michel (ed.). *Marchand du sel, écrits de Marcel Duchamp.* Paris: Le Terrain Vague, 1958.

Saumanes, Louis de. "Le Peuple et l'art," *Les Temps nouveaux*, XVII, Nos. 45, 46 (March 9, and March 16, 1912).

Schmidt, Diether (ed.). *In letzter Stunde, 1933–1945. Schriften deutscher Künstler des zwanzigsten Jahrhunderts*, II. Dresden: VEB Verlag der Kunst, 1964.

———. *Manifeste Manifeste, 1905–1933. Schriften deutscher Künstler des zwanzigsten Jahrhunderts*, I. Dresden: VEB Verlag der Kunst, 1964.

Schöpferische Konfession. Edited by Kasimir Edschmid. (Vol. 13 of *Tribüne der Kunst und Zeit.*) Berlin: Erich Reiss Verlag, 1920.

Schwitters, Kurt. "Merz," *Der Ararat* (1921).

———. "Die Merzmalerei," *Der Zweemann*, I, No. 1 (November, 1919), 18.

———. "Was Kunst ist/Eine Regel für grosse Kritiker," *ibid.*, No. 5 (March, 1920), 11–12.

Severini, Gino. *Arte indipendente, arte borghese, arte sociale.* Rome: Danesi, 1944.

———. *The Artist and Society.* Translated by Bernard Wall. New York: Grove Press, 1952.

———. "La Peinture d'avant-garde." *De Stijl*, I, Nos. 2, 3, 4, 5, 8, 10 (1917), 18–20, 27–28, 45–47, 59–60, 94–95, 118–21.

Siegfried. "L'Art révolutionnaire," *Les Temps nouveaux*, XVII, No. 51 (April 20, 1912), 4.

[Signac, Paul]. "Impressionnistes et révolutionnaires," *La Révolte*, No. 40 (June 13–19, 1891).

Sorel, Georges. *Reflections on Violence.* New York: Collier Books, 1961. First published in 1906.

———. "La Valeur sociale de l'art," *Revue de métaphysique et de morale*, IX (1901), 251–78.

Sterenberg, D[avid] P[etrovich]. "Ein Aufruf der russischen Künstler," *1919. Neue Blätter für Kunst und Dichtung*, I (February, 1919), 213–14. Reprinted in *Die Pleite*, I, No. 1 (March, 1919), and *Menschen*, II, No. 5 (March 1, 1919).

Trotsky, Léon. "Révolution et culture," *Clarté* (Ser. 2), II, No. 46 (November 1, 1923), 426–27.

Umanski, Konstantin. "Neue Kunstrichtungen in Russland," *Der Ararat*, I, Nos. 4 and 5–6 (January and March, 1920), 12–13, 29–33.

Vaillant-Couturier, Paul. "L'Art en Russie: La Verité sur la Russie," *Clarté* (Ser. 1), No. 18 (May 29, 1920).

Vallier, Dora. "La Vie fait l'oeuvre de Fernand Léger. Propos de l'artiste recueillis," *Cahiers d'art*, II (1954), 133–77.

Vinnen, Carl, *et al. Ein Protest deutscher Künstler*. Jena: Eugen Diederichs, 1911.

Vlaminck, Maurice. "Homicide par imprudence," *Action* (March–April, 1922), 35–39.

Vogeler, Heinrich. "Abrechnung," *Die Aktion*, IX, No. 30–31 (August 2, 1919), 522–25.

———. "Nationalbolschewismus!," *Die Aktion*, X, No. 49–50 (December 11, 1920), 691–92.

———. *Das neue Leben. Ein kommunistisches Manifest*. (Vol. 13 of *Die Silbergäule*.) Hanover: Paul Steegemann Verlag, 1919.

———. *Proletkult. Kunst und Kultur in der kommunistischen Gesellschaft*. (Vol. 54 of *Die Silbergäule*.) Hanover: Paul Steegemann Verlag, 1920.

———. "Über die kommunistische Schule," *Das Forum*, IV, Nos. 7 and 9, V, Nos. 3–6 (April and June, 1920, December, 1920–March, 1921), 504–8, 660–64, 229–33.

Walden, Herwarth. "Erster deutscher Herbstsalon: Vorrede," *Der Sturm*, IV, No. 180–181 (October, 1913), 106.

———. *Gesammelte Schriften*. Vol. 1: *Kunstkritiker und Kunstmaler*. Berlin: Verlag der Sturm, 1916.

———. "Künstler, Volk und Kunst," *Der Sturm*, X, No. 1 [April, 1919], 10–13.

———. "Die Kunst der Abgeordneten," *Der Sturm*, IV, No. 158–159 (May, 1913), 19.

———. "Kunst und Leben," *Der Sturm*, X, No. 1 [April, 1919], 2–3.

W[estheim], P[aul]. "Aktivistische Malerei," *Das Kunstblatt*, I, No. 8 (August, 1917), 254–55.

Wlaminck [*sic*]. "L'Anniversaire," *Le Libertaire* (Ser. 3), VII, No. 56 (January 13–20, 1901), 5.

———. "Le Chemin," *ibid.*, No. 73 (July 13–20, 1901), 2–3.

———. "L'Entente," *ibid.*, VI, No. 55 (December 16–23, 1900), 2–3.

———. "Heures militaires: Croquis de révoltés," *ibid.* (Ser. 4), XI, Nos. 2, 3, 4, 5, (November 13–20, November 20–27, November 27–December 4, December 4–11, 1904).

"Zehn Jahre Novembergruppe," *Kunst der Zeit: Organ der Künstler-Selbsthilfe*, III, Nos. 1–3 (1928).

Zetkin, Klara. "L'Art et le prolétariat," *Clarté* (Ser. 1), Nos. 56 and 57 (March 4 and 11, 1921).

———. "Kunst und Proletariat," *Das Forum*, V, No. 2 (November, 1920), 107–21.

IV. CONTEMPORARY EXHIBITION CATALOGUES

Association of American Painters and Sculptors. *Catalogue of International Exhibition of Modern Art*. New York, Armory of the Sixty-ninth Infantry, February 15–March 15, 1913. Reprint, New York: Arno Press, 1972.

Der Blaue Reiter. Catalogues of the first and second exhibitions, 1911–12 and 1912, Munich.

Denkschrift des Sonderbundes auf die Ausstellung MCMX. Düsseldorf, Kunstpalast am Kaiser Wilhelm Park, June 16–October 9, [1910].

Erster Deutscher Herbstsalon, Berlin, 1913. Berlin: Der Sturm, 1913.

Internationale Kunstausstellung des Sonderbundes Westdeutscher Kunstfreunde und Künstler. Cologne, May 25–September 30, 1912.

Neue Künstlervereinigung München. Catalogues of first and second exhibitions, Moderne Galerie, Munich, 1909–10 and 1910–11.

Salon d'Automne. *Exposition de l'art russe.* Paris: Moreau, 1906.

Société des Artistes Indépendants. *Catalogue.* Paris: 1903–1904, 1907–13.

Société du Salon d'Automne. *Catalogue.* Paris: Grand Palais, 1903–13, 1919–20.

V. ALMANACS AND PERIODICALS CONSULTED IN THEIR ENTIRETY
(Individual articles of importance are cited above.)

Action: Cahiers individualistes de philosophie et d'art. Edited by Florent Fels and Marcel Sauvage. Paris: 1920–22.

Die Aktion. Edited by Franz Pfemfert. Berlin: 1911–32.

Das Aktionsbuch. Edited by Franz Pfemfert. Berlin-Wilmersdorf: Verlag der Wochenschrift die Aktion, 1917.

Der Almanach der neuen Jugend auf das Jahr 1917. Berlin: Verlag Neue Jugend, [1917].

Der Anbruch. Flugblätter aus der Zeit. Edited by Otto Schneider and Ludwig Ullmann. Vienna: 1917–22.

Der Ararat. Edited by Hans Goltz. Munich: 1919–21.

L'Assiette au beurre. Paris: 1901–13.

Avanti della domenica. Rome: 1905–1907.

Der Bildermann. Steinzeichnungen fürs deutsche Volk. Edited by Paul Cassirer. Berlin: 1916.

Der blutige Ernst. Edited by John Hoexter. Berlin, 1919.

Die Bücherkiste. Monatsschrift für Literatur, Graphik und Buchbesprechung. Edited by Leo Scherpenbach. Munich: 1919–21.

Bulletin communiste. Organe du comité de la troisième Internationale. Paris: 1920–33.

Cabaret Voltaire. Eine Sammlung Künstlerischer und literarischer Beiträge . . . Edited by Hugo Ball. Zurich: Meierei, 1916.

Clarté. Bulletin français de l'Internationale de la Pensée. Edited by Henri Barbusse. Paris: Ser. 1, 1919–21; Ser. 2, 1921–25.

Le Crapouillot. Gazette poilue. Edited by J[ean] Galtier-Boissière. Paris: 1915–19; new series, 1919–[?].

Dada. Zurich: 1917–19.

Der Dada. Edited by Raoul Hausmann. Berlin-Steglitz: [1919–20].

Demain. Pages et documents. Edited by Henri Guilbeaux. Geneva: J. H. Jeheber, 1916–18.

Der Einzige. Edited by Wilhelm Ruest and Mynona [S. Friedländer]. Berlin: 1919.

L'Élan. Edited by Amédée Ozenfant. Paris: 1915–16.

Die Erde. Politische und kulturpolitische Halbmonatsschrift. Edited by Walther Rilla. Breslau and Berlin: 1919–20.

Europa Almanach. Edited by Carl Einstein and Paul Westheim. Potsdam: Gustav Kiepenheuer, 1925.

Der Feuerreiter. Blätter für Dichtung und Kritik. Edited by Fritz Gottfurcht, later by Heinrich Eduard Jacob. Berlin: 1921–24.

La Forge. Revue d'art et de littérature. Edited by Luc Mériga. Paris: 1917–19.

Das Forum. Edited by Wilhelm Herzog. Munich: 1914–21.

Der Gegner. Blätter zur Kritik der Zeit. Edited by Karl Otten and Julian Gumperz, then by Gumperz and Wieland Herzfelde. Halle, Leipzig and Berlin: 1919–22.

Die Gemeinschaft. Dokumente der geistigen Weltwende. Edited by Ludwig Rubiner. Potsdam: Verlag Gustav Kiepenheuer, [1920].

Genius. Zeitschrift für alte und werdende Kunst. Edited by Carl Georg Heise, Hans Mardersteig, Kurt Pinthus. Munich: Kurt Wolff Verlag, 1919–21.

Das hohe Ufer. Edited by Hans Kaiser. Hanover: Verlag Ludwig Ey, 1919–20.

L'Italia futurista. Edited by Bruno Corra and Emilio Settimelli, later by Settimelli and A. Ginna. Florence: 1916–18.

Jedermann sein eigner Fussball. Edited by Wieland Herzfelde. Berlin: Malik-Verlag, 1919.

Das Kestnerbuch. Edited by Paul Erich Küppers. Hanover: Heinrich Böhme Verlag, [1919].

Kriegszeit: Künstlerflugblätter. Berlin: Verlag Paul Cassirer, 1914–16.

Das Kunstblatt. Edited by Paul Westheim. Weimar: Verlag Gustav Kiepenheuer, 1917–20.

Lacerba. Florence: 1913–15.

Le Libertaire. Edited by Sebastien Faure. Paris, 1898–1906.

Marsyas. Edited by Theodor Tagger. Berlin: Verlag Heinrich Hochstim, 1917–19.

Menschen. Monatschrift für neue Kunst. Edited by Heimar Schilling and Felix Stiemer. Dresden: Felix Stiemer Verlag, 1918–22.

Montjoie! Organe de l'impérialisme artistique français. Edited by Ricciotto Canudo. Paris: 1913–14.

Le Mot. Paris: 1914–15.

Die neue Bücherschau. Edited by Hans Theodor Joel and later by Gerhardt Pohl. Munich-Pasing: 1919–29.

Die neue Kunst. Edited by Heinrich F. S. Bachmair. Munich: 1913–14.

Das neue Pathos. Edited by Hans Ehrenbaum-Degele, Robert R. Schmidt, Ludwig Meidner, Paul Zech. Berlin: E. W. Tieffenbach, 1913–20.

1918. [1919. 1920.] Neue Blätter für Kunst und Dichtung. Dresden: Verlag Emil Richter, 1918–21.

"Noi." Rivista d'arte futurista. Ser. 2. Rome: 1923–25.

Pan. Edited by Wilhelm Herzog and Paul Cassirer, later by Alfred Kerr *et al.* Berlin: Verlag Paul Cassirer, 1910–15.

Le Phare. Education et documentation socialistes. (Organe officiel de la IIIe Internationale en Suisse romande.) La Chaux-de-Fonds: 1919–21.

Die Pleite. Edited by Wieland Herzfelde. Berlin: Malik-Verlag, 1919–24.

Poesia. Rassegna internazionale. Edited by Sem Benelli, V[italiano] Ponti, F. T. Marinetti. Milan: 1905–1909.

Revolution. Zweiwochenschrift. Munich: 1913.

La Rivolta. Settimanale anarchico. Milan: 1910–11.

Die rote Erde. Monatsschrift für Kunst und Kultur. Edited by Karl Lorenz and Paul Schwemer, later by Lorenz and Rosa Schapire. Hamburg: 1919–23.

Die schöne Rarität. Edited by Adolf Harms. Kiel: 1917–19.

Sciarpa nera. Rivista anarchica. Milan: 1909.

SIC. Edited by Pierre-Albert Birot. Paris: 1916–19.

Die Sichel. Edited by Josef Achmann and Georg Britting. Regensburg: 1919–21.

Simplizissimus. Munich: 1900–12.

Sirius. Monatsschrift für Literatur und Kunst. Edited by Walter Serner. Zurich: 1915–16.

Les Soirées de Paris. Edited by Guillaume Apollinaire, Jean Cerusse, André Billy. Paris: 1912–14.

De Stijl. Maandblad voor de moderne beeldende vakken. Edited by Theo van Doesburg. Leiden, Antwerp, Paris, Rome: 1917–27.

Der Sturm. Wochenschrift für Kultur und die Künste. Edited by Herwarth Walden. Berlin: 1910–32.

Le Surréalisme au service de la Révolution. Edited by André Breton. Paris: 1930–33.

Les Temps nouveaux. Edited by Jean Grave. Paris: 1895–1910.

391. Edited by Francis Picabia. New York, Barcelona, Zurich: 1917–24. Photographic reprint edited by Michel Sanouillet. Paris: Le Terrain Vague, 1960.

Das Tribunal. Hessische radikale Blätter. Edited by C. Mierendorff. Darmstadt: Die Dachstube Verlag, 1919–20/21.

Veröffentlichung der November-Gruppe. Edited by H[ans] S[iebert] von Heister and Raoul Hausmann. No. 1. Hanover: Paul Steegemann Verlag, May, 1921.

La Voce. Florence: 1908–16.

Der Weg. Edited by Walter Blume. Munich: 1919.

Zeit-Echo. Ein Kriegs-Tagebuch der Künstler. Edited by Otto Haas-Heye (1914–15), Ludwig Rubiner (1916–17). Munich: Graphik-Verlag, 1914–15; Bümpliz-Bern: Zeit-Echo Verlag Benteli, 1916–17.

Der Zweemann. Monatsblätter für Dichtung und Kunst. Hanover: Der Zweemann Verlag, 1919–20.

VI. INTERVIEWS

Dr. Peter Beckmann and Mathilde "Quappi" Beckmann, Ohlstadt, August, 1967.

Sonia Delaunay-Terk, Paris, summer of 1968.

Frau Heinrich Ehmsen, East Berlin, January, 1968.

Juliette Roche Gleizes, Paris and St. Rémy de Provence, summer of 1968.

Otto Griebel, Dresden, December, 1967, and January, 1968.

Wieland Herzfelde, East Berlin, January, 1968.

D. H. Kahnweiler, Paris, spring of 1967.

Nina Kandinsky, Neuilly sur Seine, summer of 1968.

Oskar Kokoschka, Villeneuve near Lausanne, June, 1968.

Christian Schad, Aschaffenburg, summer of 1967.

Giuseppe Sprovieri, Rome, spring of 1968.

SECONDARY MATERIALS

VII. BIBLIOGRAPHICAL AND BIOGRAPHICAL REFERENCE BOOKS

Bode, Ingrid. *Die Autobiographien zur deutschen Literatur, Kunst und Musik. 1900–1965. Bibliographie und Nachweise der persönlichen Begegnungen und Charakteristiken.* Stuttgart: J. B. Metzlersche Verlagsbuchhandlung, 1966.

Dizionario biografico degli Italiani. Rome: Istituto della Enciclopedia Italiana, 1960–.

Gebhardt, Walther. "Das *Sturm-Archiv* Herwarth Waldens," Offprint from *Jahrbuch der deutschen Schiller-Gesellschaft,* II (1958).

Künstler Lexikon der Schweiz. XX. Jahrhundert. Edited by Eduard Plüss and Hans Christoph von Tavel. Frauenfeld: Huber & Co., 1958–67.

Österreichisches Biographisches Lexikon. 1815–1950. Published by the Österreichische Akademie der Wissenschaften. Graz and Cologne: Verlag Hermann Böhlens Nachf., 1957–.

Raabe, Paul. *Die Zeitschriften und Sammlungen des literarischen Expressionismus. Repertorium der Zeitschriften, Jahrbücher, Anthologien, Sammelwerke, Schriftenreihen und Almanache. 1910–1921.* Stuttgart: J. B. Metzlersche Verlagsbuchhandlung, 1964.

VIII. EXHIBITION CATALOGUES

Albert Gleizes et la tempête dans les Salons, 1910–1914. Musée de Grenoble, June 19–August 31, 1963.

The Almost Complete Works of Marcel Duchamp. London, The Tate Gallery, June 18–July 31, 1966.

André Dunoyer de Segonzac. Oeuvre de guerre, 1914–1918. Paris, Université de Paris, Musée de la Guerre, 1967.

Anklage und Aufruf. Deutsche Kunst zwischen den Kriegen. East Berlin, National-Galerie, June–August, 1964.

Arp. Paris, Musée National d'Art Moderne, February 21–April 21, 1962.

Avantgarde Osteuropa. 1910–1930. Berlin, Akademie der Künste, October–November, 1967.

Camfield, William A. *Francis Picabia.* New York: Solomon R. Guggenheim Museum, 1970.

Casimir Malevic. Rome, Galleria Nazionale d'Arte Moderna, May 5–June 2, 1959.

Il Cavaliere Azzurro. Turin, Galleria Civica d'Arte Moderna, March 18–May 9, 1971.

DADA. Ausstellung zum 50-jährigen Jubiläum [*Exposition Commémorative du Cinquantenaire*]. Zurich, Kunsthaus, October 8–November 17, 1966; Paris, Musée National d'Art Moderne, November 30, 1966–January 30, 1967.

Dada 1916–1966. Documenti del movimento internazionale Dada. Rome, Galleria Nazionale d'Arte Moderna, [1966].

Donation André Dunoyer de Segonzac. Sceaux (Seine), Château de Sceaux, Musée de l'Ile de France, 1965.

Donation Pougny. Paris, Orangerie des Tuileries. Paris: Réunion des Musées Nationaux, 1966.

Les Duchamps. Jacques Villon, 1875–1963. Raymond Duchamp-Villon 1876–1918. Marcel Duchamp, 1887–. Suzanne Duchamp, 1889–1963. Rouen, Musée des Beaux-Arts, 1967.

Dorival, Bernard. *Raoul Dufy, 1877–1953.* Paris, Musée National d'Art Moderne, 1953.

Erinnerungen und Bekenntnisse [Souvenirs et témoignages]. Supplementary catalogue to *DADA. Ausstellung zum 50-jährigen Jubiläum.*

Exposition Marquet. Albi, Musée Toulouse-Lautrec, July 6–September 25, 1957.

Expressionismus. Literatur und Kunst, 1910–1923. Marbach a.N., Schiller-Nationalmuseum, May 8—October 31, 1960.

Fernand Léger, 1881–1955. Brussels, Palais des Beaux-Arts, October–November, 1956.

Fernand Léger. Paris, Grand Palais, October, 1971–January, 1972.

Franz Marc. Munich, Städtische Galerie im Lenbachhaus, August 10–October 13, 1963.

Franz Marc: Das graphische Werk. Bern, Kunstmuseum, April 8–May 15, 1917.

Freudenheim, Tom L. *Pascin.* Berkeley, University of California, University Art Museum, November 15–December 18, 1966.

Fünfzig Jahre Bauhaus. Stuttgart: Württembergische Kunstverein, May 5–July 28, 1968.

Gabriele Münter. Munich, Städtische Galerie im Lenbachhaus, October 13–December 2, 1962.

Geist, Sidney. *Constantin Brancusi, 1876–1957: A Retrospective Exhibition.* New York, Solomon R. Guggenheim Museum, 1969.

Giacomo Balla. Turin, Galleria Civica d'Arte Moderna, 1963.

Gino Severini. Paris, Musée National d'Art Moderne, July–October, 1967.

Giorgio de Chirico. Milan, Palazzo Reale, April–May, 1970.

Hans Purrmann. Munich, Haus der Kunst, March 23–May 20, 1962.

Heinrich Vogeler: Werke seiner letzten Jahre. [East] Berlin, Deutsche Akademie der Künste, 1955.

Henri Matisse. Exposition du Centenaire. Paris, Grand Palais, April–September, 1970.

Herbert, Robert L. *Neo-Impressionism.* New York: Solomon R. Guggenheim Museum, 1968.

Hommage à Jean Arp. Strasbourg, Ancienne Douane, June 11–October 1, 1967.

Hommage à Marc Chagall. Paris, Grand Palais, December, 1969–March, 1970.

Hommage à Pablo Picasso. Paris, Grand Palais and Petit Palais, November, 1966–February, 1967.

Impressionist and Post-Impressionist Paintings from the U.S.S.R. Loan exhibition from the Hermitage Museum, Leningrad, and the Pushkin Museum, Moscow. New York: M. Knoedler & Co., 1973.

Jacques Villon, Raymond Duchamp-Villon, Marcel Duchamp. New York, Solomon R. Guggenheim Museum; and Houston, Museum of Fine Arts, January–April, 1957.

Jean Pougny. Malerei Zeichnung Skulptur. Baden-Baden, Staatliche Kunsthalle, August 21–September 26, 1965.

Jugendstil and Expressionism in German Posters. Berkeley: University of California, 1965.

Karl Schmidt-Rottluff: Gemälde, Aquarelle, Graphik. Hanover, Kunstverein, November 17, 1963–January 5, 1964.

Käthe Kollwitz in ihrer Zeit. 1867–1945. Hamburg, Ernst Barlach Haus, June 30–September 15, 1967.

Käthe Kollwitz und ihre Zeitgenossen. [East] Berlin, Deutsche Akademie der Künste, 1967.

Karl Jakob Hirsch. 1892–1952. Berlin, Akademie der Künste, February 5–March 5, 1967.

Kurt Schwitters, 1887–1948. Cologne, Wallraf-Richartz-Museum, October 9–November 24, 1963.

Lang, Lothar. *Heinrich Ehmsen.* Leipzig, Museum der bildenden Künste, 1964.

Léger and Purist Paris. London, The Tate Gallery, November 18, 1970–January 24, 1971.

Der Malik-Verlag. 1916–1947. [East] Berlin: Deutsche Akademie der Künste, December, 1966–January, 1967.

Max Beckmann: Die Druckgraphik. Karlsruhe, Badischer Kunstverein, August 27–November 18, 1962.

Max Ernst. Cologne, Wallraf-Richartz-Museum, December 28, 1962–March 3, 1963.

1914–1918. Témoignages d'artistes et documents. Paris, Université de Paris, Musée de la Guerre, June–July, 1964.

Nathalie Gontcharova. Lyon, Musée des Beaux-Arts, 1969.

Oskar Schlemmer. New York, Spencer A. Samuels & Co., October 22–November 21, 1969.

Paula Modersohn-Becker. Lübeck, Museen für Kunst und Kulturgeschichte, Behnhaus, November 13, 1959–January 3, 1960.

Piet Mondrian (1872–1944). Centennial Exhibition. New York, Solomon R. Guggenheim Museum, 1971.

Pomerantz-Liedtke, Gerhard. *Der graphische Zyklus von Max Klinger bis zur Gegenwart.* [East] Berlin, Deutsche Akademie der Künste, 1956.

Pougny. Paris, Musée National d'Art Moderne, January 24–February 23, 1958.

Rétrospective Sonia Delaunay. Paris, Musée National d'Art Moderne, 1967–68.

Robert Delaunay. Paris, Musée National d'Art Moderne, May 25–September 30, 1957.

Robbins, Daniel. *Albert Gleizes: A Retrospective Exhibition.* New York, Solomon R. Guggenheim Museum, 1964.

Selz, Peter. *Emil Nolde.* New York, Museum of Modern Art, [1963].

———. *Max Beckmann.* New York, Museum of Modern Art, n.d.

Der Sturm. Herwarth Walden und die europäische Avantgarde. Berlin 1912–1932. Berlin, Nationalgalerie, September 24–November 19, 1961.

Taylor, Joshua C. *Futurism.* New York, Museum of Modern Art, 1961.

Tuchman, Maurice. *Chaim Soutine, 1893–1943.* Los Angeles, County Museum of Art, 1968.

Van Dongen. Paris, Musée National d'Art Moderne; and Rotterdam, Museum Boymans-van Beuningen, 1967–1968.

Wichmann, Siegfried (ed.). *Weltkulturen und moderne Kunst. Die Begegnung der europäischen Kunst und Musik im 19. und 20. Jahrhundert mit Asien, Afrika, Ozeanien, Afro- und Indo-Amerika.* Sponsored by the Organisationskomitee für die Spiele der XX. Olympiade. Munich, Haus der Kunst, June 16–September 30, 1972.

IX. BIOGRAPHIES, MONOGRAPHS, AND OTHER CRITICAL WORKS

Andersen, Troels. *Malevich: Catalogue raisonné of the Berlin Exhibition 1927, Including the collection in the Stedelijk Museum Amsterdam; With a General Introduction to His Work.* Amsterdam: Stedelijk Museum, 1970.

Aressy, Lucien. *La Dernière Bohème: Verlaine et son milieu.* Paris: Jouve & Cie., [1923].

Aust, Günter. *Otto Freundlich.* Cologne: Verlag M. DuMont Schauberg, 1960.

Avantgarde. Geschichte und Krise einer Idee. Volume 11 of *Gestalt und Gedanke,* published by the Bavarian Akademie der Schönen Künste. Munich: Verlag R. Oldenbourg, 1966.

Ballo, Guido. *Boccioni: La Vita e l'opera.* Milan: Il Saggiatore, 1964.

Banham, Reyner. *Theory and Design in the First Machine Age* (2d ed.). New York: Praeger, 1967.

Barr, Alfred H., Jr. *Matisse: His Art and His Public.* New York: Museum of Modern Art, 1951.

Barricelli, Anna. *Balla.* Rome: De Luca, n. d.

Baumgarth, Christa. *Geschichte des Futurismus.* Reinbek bei Hamburg: Rowohlt Taschenbuch Verlag, 1966.

Boeck, Wilhelm, and Jaimé Sabartés. *Picasso.* New York and Amsterdam: Abrams, 1955.

Boime, Albert. *The Academy and French Painting in the Nineteenth Century.* London: Phaidon, 1971.

Buchheim, Lothar Günther. *Der blaue Reiter und die ''Neue Künstlervereinigung München.''* Feldafing: Buchheim Verlag, 1959.

―――. *Die Künstlergemeinschaft Brücke.* Feldafing: Buchheim Verlag, 1956.

―――. *Otto Mueller: Leben und Werk.* Feldafing: Buchheim Verlag, 1963.

Carrà, Massimo. *Carrà: Tutta l'opera pittorica.* 3 vols. Milan: Edizioni dell'Annunciata, 1967–68.

Carrieri, Raffaele. *Futurism.* Translated by Leslie van Rensselaer White. Milan; Edizioni del Milione, [1963].

Caute, David. *Communism and the French Intellectuals, 1914–1960.* New York: The Macmillan Company, 1964.

Chaumeil, Louis. *Van Dongen: L'Homme et l'artiste—La Vie et l'oeuvre.* Geneva: Pierre Cailler, 1967.

Clark, T[imothy] J. *The Absolute Bourgeois: Artists and Politics in France, 1848–1851.* London: Thames and Hudson, 1973.

―――. *Image of the People: Gustave Courbet and the Second French Republic, 1848–1851.* Greenwich, Connecticut: New York Graphic Society, 1973.

Clément-Janin. *Les Estampes, images et affiches de la guerre.* Paris: Gazette des Beaux-Arts, 1919.

Clough, Rosa Trillo. *Futurism: The Story of a Modern Art Movement.* New York: Philosophical Library, 1961.

Courthion, Pierre. *Georges Rouault.* New York: Harry N. Abrams, n.d.

Damase, Jacques (ed.). *Sonia Delaunay: Rythmes et couleurs.* Paris: Hermann, 1971.

Diehl, Gaston. *Pascin.* Milan: The Uffici Press, n.d.

Ducasse, André, Jacques Meyer, and Gabriel Perreux. *Vie et mort des Français: 1914–1918. Simple histoire de la grande guerre.* Paris: Hachette, 1962.

Dunlop, Ian. *The Shock of the New: Seven Historic Exhibitions of Modern Art.* New York, St. Louis, San Francisco: American Heritage Press, 1972.

Easton, Malcolm. *Artists and Writers in Paris: The Bohemian Idea, 1803–1867.* New York: St. Martin's Press, 1964.

Egbert, Donald Drew. *Social Radicalism and the Arts: Western Europe.* New York: Alfred A. Knopf, 1970.

Fagiolo dell'Arco, Maurizio. *Balla: Compenetrazioni iridescenti.* Rome: Mario Bulzoni, 1968.

————. *Balla pre-futurista.* Rome: Mario Bulzoni, 1968.

————. *Balla: Ricostruzione futurista dell'universo.* Rome: Mario Bulzoni, 1968.

————. *Omaggio a Balla.* Rome: Mario Bulzoni, 1967.

Fédit, D[enise]. *L'Oeuvre de Kupka.* Paris: Editions des Musées Nationaux, 1966.

de Felice, Renzo. *Mussolini il rivoluzionario: 1883–1920.* Turin: Giulio Einaudi, 1965.

Fitzpatrick, Sheila. *The Commissariat of Enlightenment.* Cambridge: Cambridge University Press, 1970.

Francastel, Pierre. *Peinture et société. Naissance et destruction d'un espace plastique, de la Renaissance au Cubisme.* Paris: Gallimard, 1965.

Fry, Edward F. "Cubism 1907–1908: An Early Eyewitness Account," *Art Bulletin,* XLVIII, No. 1 (March, 1966), 70–73.

Gaudibert, Pierre. "Eugène Delacroix et le romantisme révolutionnaire," *Europe,* No. 41 (April, 1963), 4–21.

Gauthier, Maximilien. *Othon Friesz.* Geneva: Pierre Cailler, 1957.

Genevoix, Maurice. *Vlaminck: I. L'Homme. II. L'Oeuvre.* Paris: Flammarion, 1954.

George, Waldemar. *Larionov.* Paris: Bibliothèque des Arts, 1966.

Golding, John. *Cubism: A History and an Analysis, 1907–1914.* Boston: Boston Book and Art Shop, 1968.

————. *Duchamp: The Bride Stripped Bare by her Bachelors, Even.* New York: Viking, 1972.

Goldwater, Robert. *Primitivism in Modern Art* (rev. ed.). New York: Vintage Books, 1967.

Gordon, Donald E. *Ernst Ludwig Kirchner.* Cambridge: Harvard University Press, 1968.

Gramsci, Antonio. *Scritti politici.* Edited by Paolo Spriano. Rome: Editori Riuniti, 1967.

Gray, Camilla. *The Russian Experiment in Art, 1863–1922.* London: Thames and Hudson, 1962.

Greenberg, Allan Carl. "Artists and the Weimar Republic: Dada and the Bauhaus, 1917–1925," Ph.D. dissertation, University of Illinois, 1967.

Grochowiak, Thomas. *Ludwig Meidner.* Recklinghausen: Verlag Aurel Bongers, 1966.

Grohmann, Will. *Kandinsky: Life and Work.* New York: Harry N. Abrams, n.d.

————. *Paul Klee.* New York: Harry N. Abrams, n.d.

Hamann, Richard, and Jost Hermand. *Deutsche Kunst and Kultur von der Gründer-zeit bis zum Expressionismus.* 4 vols. appeared. [East] Berlin: Akademie Verlag, 1959–67.

Haskell, Francis. *Patrons and Painters: A Study in the Relations Between Italian Art and Society in the Age of the Baroque.* New York: Alfred A. Knopf, 1963.

Hauser, Arnold. *The Social History of Art.* 4 vols. New York: Vintage Books, n.d. First published in 1951.

Herbert, Eugenia W. *The Artist and Social Reform: France and Belgium, 1885–1898.* New Haven: Yale University Press, 1961.

Herbert, R[obert] L. "Les Artistes et l'Anarchisme," *Le Mouvement social,* No. 36 (July–September, 1961), 2–19.

Herzfelde, Wieland. *John Heartfield. Leben und Werk.* Dresden: VEB Verlag der Kunst, 1962.

Hess, Hans. *Lyonel Feininger.* New York: Harry N. Abrams, [1959].

Hilaire, Georges. *Derain.* Geneva: Pierre Cailler, 1959.

Hofmann, Werner. *Art in the Nineteenth Century.* London: Faber and Faber, 1961.

Hugnet, Georges, *L'Aventure dada.* Paris: Seghers, 1957, 1971.

Hütt, Wolfgang. "Materialien zur Darstellung der Novemberrevolution in der bild-enden Kunst in Deutschland," *Wissenschaftliche Zeitschrift der Martin-Luther-Universität Halle-Wittenberg,* VIII (1958–59), 161–70.

Joll, James. *The Anarchists.* London: Eyre and Spottiswoode, 1964.

————. *Three Intellectuals in Politics.* New York: Harper and Row, 1965.

Jourdain, Francis. "L'Art officiel de Jules Grévy à Albert Lebrun: Vingt ans de grand art ou la leçon de la niaiserie," *Le Point,* Mulhouse, XXXVII (April, 1949).

Kahnweiler, Daniel-Henry. *Juan Gris: Sa vie, son oeuvre, ses écrits.* Paris: Gallimard, 1946.

Kallir, Otto. *Egon Schiele: Oeuvre Catalogue of the Paintings.* New York: Crown, 1966.

Kliemann, Helga. *Die Novembergruppe.* Vol. 3 of *Bildende Kunst in Berlin.* Berlin: Gebrüder Mann Verlag, 1969.

Kornfeld, Eberhard W. *Verzeichnis des graphischen Werkes von Paul Klee.* Bern: Verlag Kornfeld und Klipstein, 1963.

Lafranchis, Jean. *Marcoussis: Sa vie, son oeuvre.* Paris: Les Editions du Temps, 1961.

Lahnstein, Peter. *Münter.* Ettal: Buch-Kunstverlag, 1971.

Lane, Barbara Miller. *Architecture and Politics in Germany, 1918–1945.* Cambridge: Harvard University Press, 1968.

Lang, Lothar. *Heinrich Ehmsen.* Dresden: VEB Verlag der Kunst, 1962.

Lankheit, Klaus. *Franz Marc. Watercolors, Drawings, Writings.* New York: Harry N. Abrams, 1960.

Lassaigne, Jacques. *Dufy.* Translated by James Emmons. Lausanne?: Skira, 1954.

Laude, Jean. *La Peinture française (1905–1914) et "L'Art nègre."* Paris: Editions Klincksieck, 1968.

Laurent, Jeanne. *La République et les beaux-arts.* Paris: Juillard, 1955.

Lebel, Robert. *Marcel Duchamp.* Translated by George Heard Hamilton (2d, rev. ed.). New York: Paragraphic Books (Grossman), 1967.

Lethève, Jacques. *La Vie quotidienne des artistes français au XIX^e siècle.* Paris: Hachette, 1968.

Lewis, Beth Irwin. *George Grosz: Art and Politics in the Weimar Republic.* Madison, Milwaukee, and London: University of Wisconsin Press, 1971.

Leymarie, Jean. *Braque.* Lausanne?: Skira, 1961.

Lissitzky-Küppers, Sophie (ed.). *El Lissitzky. Maler Architekt Typograf Fotograf.* Dresden: VEB Verlag der Kunst, 1967.

Löffler, Fritz. *Otto Dix.* Vienna and Munich: Anton Schroll, 1967.

Marguerite, Jean, "'Les Fêtes du Peuple': L'Oeuvre, les moyens, le but," *Cahiers du travail.* Paris: [1921].

Maxe, Jean [pseud.]. *Les Cahiers de l'Anti-France.* Nos. 3, 5, and 6. Paris: Editions Brossard, 1922–[24].

Meyer, Franz. *Marc Chagall.* New York: Harry N. Abrams, n.d.

de Micheli, Mario, and Mario Luzi. *100 Opere di Carlo Carrà.* Prato: Galleria d'Arte moderna Fratelli Falsetti, 1971.

Modigliani, Jeanne. *Modigliani senza leggenda.* Florence: Vallecchi, 1968. Originally published in 1961.

Moulin, Raymonde. *Le Marché de la peinture en France.* Paris: Les Éditions de Minuit, 1967.

Myers, Bernard S. *The German Expressionists: A Generation in Revolt.* New York: McGraw-Hill, n.d.

Nicolson, Benedict. *Courbet: The Studio of the Painter.* New York: Viking, 1973.

Nochlin, Linda. *Realism.* Harmondsworth, Baltimore, and Victoria: Penguin, 1971.

Ohff, Heinz. *Hannah Höch.* Vol. I of *Bildende Kunst in Berlin.* Berlin: Gebrüder Mann Verlag, 1968.

Pelles, Geraldine. *Art, Artists and Society: Origins of a Modern Dilemma.* Englewood Cliffs, N.J.: Prentice-Hall, 1963.

Pevsner, Nikolaus. *Academies of Art, Past and Present.* Cambridge: Cambridge University Press, 1940.

————. *Pioneers of Modern Design: From William Morris to Walter Gropius.* Harmondsworth: Penguin Books, 1960.

Pfefferkorn, Rudolf. *César Klein.* Berlin: Rembrandt-Verlag, 1962.

Pförtner, Matthias. *Georg Schrimpf.* Berlin: Rembrandt Verlag, 1940.

Poggioli, Renato. *Teoria dell'arte d'avanguardia.* Bologna: Il Mulino, 1962.

————. *The Theory of the Avant-Garde.* Translated by Gerald Fitzgerald. New York: Harper and Row, 1971.

Racine, Nicole. "The Clarté Movement in France, 1919–21," *Journal of Contemporary History,* II, No. 2 (April, 1967), 195–208.

Rademacher, Hellmut. *Das deutsche Plakat. Von den Anfängen bis zur Gegenwart.* Dresden: VEB Verlag der Kunst, [196?].

Reid, B[enjamin] L[awrence]. *The Man from New York: John Quinn and His Friends.* New York: Oxford University Press, 1968.

Rewald, John. *The History of Impressionism* (4th, rev. ed.). New York: Museum of Modern Art, 1973.

————. *Post-Impressionism: From Van Gogh to Gauguin.* (2d ed.). New York: Museum of Modern Art, 1962.

Robbins, Daniel. "From Symbolism to Cubism: The Abbaye of Créteil," *Art Journal,* XXIII, No. 2 (Winter 1963–64), 111–16.

Roethel, Hans Konrad. *Paul Klee in München.* Bern: Verlag Stämpfli & Cie., 1971.

Roger-Marx, Claude. *Dunoyer de Segonzac.* Geneva: Cailler, 1951.

Rosenblum, Robert. *Cubism and Twentieth-Century Art* (rev. ed.). New York: Harry N. Abrams, 1966.

Russell, John. *Max Ernst: Life and Work.* New York: Harry N. Abrams, n.d.

Russolo, Maria Zanovello. *Russolo: L'Uomo, l'artista.* Milan: Cyril Corticelli, 1958.

Sadler, Sir Michael. *Modern Art and Revolution.* (Day to Day Pamphlets, No. 13.) London: Hogarth Press, 1932.

Salmon, André. *La Terreur noire. Chronique du mouvement libertaire.* Paris: Jean-Jacques Pauvert, 1959.

Sanborn, Alvan Francis. *Paris and the Social Revolution.* Boston: Small, Maynard & Company, 1905.

Sanouillet, Michel. *Dada à Paris.* Paris: Jean-Jacques Pauvert, 1965.

Sauvage, Marcel. *Vlaminck: Sa vie et son message.* Geneva: Pierre Cailler, 1956.

Schmalenbach, Werner. *Kurt Schwitters.* New York: Harry N. Abrams, n.d.

Schmidt, Georg (ed.). *Sophie Taeuber-Arp.* Basel: Holbein Verlag, 1948.

Sedlmayr, Hans. *Art in Crisis: The Lost Center.* Translated by Brian Battershaw. Chicago: Henry Regnery Co., 1958.

————. *Verlust der Mitte.* Berlin: Ullstein, 1960.

Seligman, Germain. *Roger de La Fresnaye.* New York: New York Graphic Society, 1969.

Selz, Peter. *German Expressionist Painting.* Berkeley and Los Angeles: University of California Press, 1957.

Sénéchal, Christian. *L'Abbaye de Créteil.* Paris: Librairie André Delpeuch, 1930.

Shattuck, Roger. *The Banquet Years.* Garden City: Anchor Books, 1961.

Short, Robert S. "The Politics of Surrealism, 1920–36," *The Left-Wing Intellectuals Between the Wars, 1919–1939.* Edited by Walter Laqueur and George L. Mosse. New York: Harper Torchbooks, 1966, pp. 3–25.

Sichel, Pierre. *Modigliani.* New York: E. P. Dutton & Co., 1967.

Steneberg, Eberhard. *Russische Kunst. Berlin 1919–1932.* Vol. IV of *Bildende Kunst in Berlin.* Berlin: Gebrüder Mann Verlag, 1969.

Tomkins, Calvin. *The Bride and the Bachelors: Five Masters of the Avant-Garde.* New York: Viking Press, 1968.

Vaccari, Walter. *Vita e tumulti di F. T. Marinetti.* Milan: Editrice Omnia, 1959.

Vachtová, Ludmila. *Frank Kupka.* Translated by Zdeněk Lederer. London: Thames and Hudson, 1968.

van de Velde, Henry. "Frans Masereel," *Genius,* II, No. 1 (1920), 57–62.

Verkauf, Willy, Marcel Janco, and Hans Bollinger (eds.). *Dada: Monographie einer Bewegung.* Teufen: Verlag Arthur Niggli, 1965.

Vogt, Paul. *Erich Heckel.* Recklinghausen: Verlag Aurel Bongers, 1965.

Vriesen, Gustav. *August Macke.* Stuttgart: W. Kohlhammer, 1953.

Vriesen, Gustav, and Max Imdahl. *Robert Delaunay: Light and Color.* Translated by Maria Pelikan. New York: Harry N. Abrams, 1967.

Weiler, Clemens. *Alexej von Jawlensky. Der Maler und Mensch.* Wiesbaden: Limes Verlag, 1955.

———. *Alexej Jawlensky.* Cologne: Verlag M. DuMont Schauberg, 1959.

———. *Jawlensky: Heads Faces Meditations.* Trans. by Edith Küstner and J. A. Underwood. London: Pall Mall Press, 1971.

Wember, Paul. *Heinrich Campendonk: Krefeld 1889–1957 Amsterdam.* Krefeld: Scherpe Verlag, 1960.

White, Harrison C. and Cynthia A. *Canvases and Careers: Institutional Change in the French Painting World.* New York: John Wiley and Sons., 1965.

Wietek, Gerhard. *Schmidt-Rottluff: Graphik.* Munich: Karl Thiemig, 1971.

Wingler, Hans M. *Das Bauhaus.* Bramsche and Cologne: Gebrüder Rasch & Co. and M. DuMont Schauberg, 1962.

———. *The Bauhaus: Weimar Dessau Berlin Chicago.* Translated by Wolfgang Jabs and Basil Gilbert. Cambridge, Mass. and London: M.I.T., 1969.

Wittkower, Rudolf, and Margot Wittkower. *Born Under Saturn, The Character and Conduct of Artists: A Documented History From Antiquity to the French Revolution.* New York: W. W. Norton & Co., 1963.

Woodcock, George. *Anarchism: A History of Libertarian Ideas and Movements.* Cleveland and New York: World Publishing Co., 1962.

Index

Italic page numbers refer to footnotes; numbers in parentheses following italic page entries refer to specific notes found in the Notes section that follows the text.

Columbus, Christopher, 106
Commissariat of Enlightenment (Narkom-
 pros), 177
Commune, Paris, *see* Paris Commune
Communism, Communists, xi, 55, 126, 183,
 188, 195, 203ff, 222; political theory, 16; and
 art education, 124; artists' support of, 155,
 174, 183, 197ff, 207, 210, 239, 245ff, 257, 267,
 275; Clarté and, 182; opposition to, 184; in
 Germany, 186; demand for social themes in
 art, 189, 201, 204, 211; depictions of, 195;
 Dadaists and, 200; artists and, 205, 209, 214;
 academicism of, 206
Communist Party, 179, 209, 210, 214
Compagnons de l'Action d'Art, *286*(54)
Concept Art, 213, *295*(3)
Cone, Claribel and Etta, 77
Constructivism, Constructivists, 205, 208,
 247, 251
contemporaneity in art, 10ff, 60–61, 64, 91,
 101ff, 111, 113
copyright: artists' demands for, 124–125
Le Corbusier (Charles-Édouard Jeanneret-
 Gris), 181, 257, 258
Corinth, Lovis, 121, 188, 257
Cormon, Ferdinand, 260, 274
Corridoni, Filippo, 32
cosmopolitanism: of avant-garde, xiii, 105,
 114, 118ff, 159, 174, 175, 212; of the Left,
 119; during World War I, 138, 144ff, 159;
 Clarté and, 182
country: artists' residence in, 9, 62–65, 67; at-
 titudes to, 13, *282*(21); depictions of, 14, 15,
 61–62, 70, 100, 101; artists' origins in, 22;
 cost of living in, 73
Courbet, Gustave, xii, 3, 10ff, *24*, 48, 90, *176*,
 285(24); "L'Atelier du peintre," 14; "Burial
 at Ornans," 12
Cranach, Lucas, 95, 212, 239
Le Crapouillot, 140
Crimean War, 23
critics, criticism: of the avant-garde, 69, 96,
 116ff; and modern art, 119, 121, 224
Croce, Benedetto, *291*(5)
Cross, Henri Edmond, 16, 33
Crystal Palace, London (1851), 13
Cubism, Cubists, xi, xii, 20, 22, 35, *51*, 57, 61,
 69, 74, 75, 132, 137, 139, 204ff, 235, 238,
 243ff, 256, 259ff, 267, 268, 274, *280*(31); ex-
 hibitions, 50; in Paris, 52; subject matter, 60,
 62, 71, 102; theory, 68, 84, 88ff, 96; and
 primitive art, 97–98; criticism of, 117; and
 camouflage, 139; and World War I, 140; in
 1920s, 180–181; influence, 111, 176, 196,
 236, 242ff, 255, 256, 263ff, 270, 272

Dada, 159
Der Dada, 247
Dadaism, Dadaists, xi, 20, 22, 55, 85, 103, *104*,
 109, 133, 155, 159–162, 188, 266; origins,
 159; tactics, 69, 160–161; and politics, 197,
 200, 203–204, 209; in Germany, 156, 161–
 162, *190*, 197–198, 200, 203, 232, 239ff, 272;
 in New York, 162, 240; in Paris, 162, 181,
 182–183; in Zurich, 134, 159ff, 181, 200, 232,
 273
Däubler, Theodor, *94*
Daguerre, Louis, *92*
"dandies," 9, 70
Dante, 255; *Divine Comedy*, *108*
Darwin, Charles, Darwinism, 16, 106
Daumier, Honoré, xii, 10–11, 12, 33, 96, 124,
 149, 204; "Rue Transnonain," 149
David, Jacques Louis, 7, 10, 24, *90*; "Tennis
 Court Oath," 10
dealers, 116, 121, 205, 224; growth in num-
 bers, 7–8; of avant-garde, 56–57, 75–76, 77;
 attacks on, 124, 125; during World War I,
 132–133
Debschitz, Wilhelm von, 248, 252, 273
"Declaration of Independence of the Spirit,"
 175
decorative arts: in nineteenth century, 13–14;
 avant-garde and, 27, 95, 114
Degas, Edgar, 9, 15, 41, 262
de Gaulle, Charles, 239
"Degenerate Art" exhibition (Munich), 212,
 213, 234, 239, 243, 271, 272
Dehmel, Richard, 153, 154, 271
Delacroix, Eugène, 7ff, 120, 131, 233; "Les
 Femmes d'Alger," 267; "Liberty on the Bar-
 ricades," 10, 131
Delaunay, Élie, 268
Delaunay, Robert, 22, 232, 238, 242, 252, 259,
 269; biographical sketch, 237–238; quoted,
 130, *181*; social origin, 21, geographical
 origin, 22; and Blaue Reiter, 50; and moder-
 nity, 102; art theories, 181; during World
 War I, 133
Delaunay-Terk, Sonia, 233, 237; biographical
 sketch, 238; social origin, 21, 22; during
 World War I, 133; in 1920s, 180
democracy, democrats: art and, xii, 10, 221;
 artists' attitudes to, 85–86, 114, 185, 199
demonstrations: artistic, 50, 69, 108, 198; in-
 terventionist, 135–136, 137, 184
Denis, Maurice: "Soirée calme en première
 ligne," *140*
Derain, André, 84, 180, 241, 275; biographical
 sketch, 238–239; quoted, 26, 30, 142; geo-
 graphical origin, 22; education, 27; carica-